# Cast-Iron Furniture

## Georg Himmelheber

*(Philip Wilson, £75)*

THIS excellent survey, the fruit of 15 years of intensive research, offers a concise explanation and handsome illustrations of the range of iron furniture that was produced largely in Europe and in America during the 19th century. The advantages of iron for use in furniture are its intrinsic strength, its resistance to rot and the protection it gives from the effects of fire.

A historical account traces the use of iron from the Roman folding iron chair, *sella curulis*, to its use in the Middle Ages and Renaissance for chairs, metal chests, cupboards and caskets. The author's description and analysis of this development is concerned with the properties of iron, and with the stylistic character of different periods.

During the 19th century, iron was used for many previously unexplored purposes, particularly in building construction and engineering works, as well as in the domestic sphere. At the beginning of this period of 'euphoric enthusiasm' for cast iron, it was considered the material of the future. The earliest use of cast iron for furniture was patented by William Bullock in England, and was followed shortly afterwards by designs by Karl Friedrich Schinkel in Berlin. These were Classical in style, but other influences—Gothic, Naturalism, Rococo and Renaissance Revival forms—were adopted during the 19th century.

By the middle decades of the century, different types of cast-iron furniture—hall stands, umbrella stands, tables and flower stands—could be found in middle-class homes, as well as furniture made of tubular or solid metal iron rods, particularly bedsteads, of which England was the leading manufacturer.

Where others in the past have tended to consider developments in one country or another, this book gives a structured account of an international subject. The lucid, engaging text, and the excellent black-and-white illustrations, numbering more than 400, deserve praise.

This book will be enjoyed by those interested in furniture, particularly in the outdoors furniture of gardens and parks. It will appeal to students of the history of design, and also those with an interest in the application of iron during the 19th century. For the latter, it rightly deserves a place on the shelf with Gloag and Bridgwater's epic, *A History of Cast Iron in Architecture.*

EDWARD DIESTELKAMP

# Cast-iron Furniture

## and all other forms of iron furniture

# Cast-iron Furniture

## and all other forms of iron furniture

GEORG HIMMELHEBER

Philip Wilson

© C.H. Beck'sche Verlagsbuchhandlung, München 1996
Translation © 1996 Philip Wilson Publishers Ltd

English edition first published in 1996 by
Philip Wilson Publishers Ltd
143–149 Great Portland Street
London WIN 5FB

Distributed in the USA and Canada by
Antique Collectors' Club Ltd
Market Street Industrial Park
Wappingers' Falls
N.Y. 12590
USA

ISBN 0 85667 462 1

Translated from German by Judith Hayward
Designed and typeset by Malcolm Preskett
English translation edited by Muriel Gascoin
Printed in Germany

# Contents

# Foreword

WRITING a book about iron furniture presents many difficulties. Works of art made of other metals, especially silver and gold but bronze and brass, too, have always interested art scholars more than those made of iron. Many large museums which include the arts and crafts among their collections either have no department for iron at all, or treat it as a poor relation, often keeping objects made of iron in store rather than putting them on display. Where art historians *have* taken an interest in iron, it has been mainly in weapons and armour and, to some extent, wrought-iron grilles, mounts, locks and keys. But furniture?

Until the nineteenth century, it was relatively rare for furniture to be made of iron. In the century of iron, that selfsame nineteenth century, advances in iron casting techniques changed the situation and there was a marked upturn in the manufacture of iron furniture. Unfortunately, very little of that furniture has survived. Art historians have been interested in the nineteenth century for some time now and have brought to light a number of examples of iron furniture that have occasionally been shown in exhibitions. But here again, there appears to have been a certain reserve about engaging in wider research; there is a lot of repetition, and the same items are brought forward again and again. Moreover, the few studies devoted to specific aspects of iron furniture have generally been published in obscure places.

It has taken more than fifteen years of research to bring together the examples of iron furniture presented here. But in spite of every effort, there is still something fortuitous about the rich material gathered so far. The preponderance of English and Scottish examples is striking, partly due to the fact that the British iron industry was much more advanced than the rest of Europe, and partly – if not mainly – to the fact that in Britain nineteenth-century artifacts were not destroyed with such enthusiasm as on the Continent. It is hoped that this book will contribute towards filling in the many gaps that still exist in our knowledge of the subject.

Casting in iron makes it possible to produce in large runs; iron furniture models were generally used by foundries for decades. The piece itself gives no indication of the year in which it was cast. Therefore, in this book it is always only the design that is dated, the first manufacture. Once the piece had been cast, it could itself easily be used as a model to make a sand form, so there was no difficulty in casting copies – a practice that was universally followed without inhibition. There is, in fact, hardly a model of which copies were not cast in another foundry. Thus items here are ascribed only to the foundry that was the first to manufacture a particular model (though, of course, errors cannot be ruled out). So a piece illustrated here and ascribed to a certain foundry may also have been manufactured at another iron works; it may also be a later casting. However, an attempt has been made to give as complete a list as possible of the firms that cast copies of the model in question.

All the available literature on the subject has been studied. The bibliography lists only works that are in some way concerned with iron furniture (even if it is just an illustration) or provide information on the foundries under discussion. All the other sources used can be found in the notes at the appropriate place.

Many people have helped bring this book to fruition, and I would like to extend my heartfelt thanks to them all; unfortunately, it seems that it can no longer be taken for granted that mutual support will be provided in scholarly work. The increasing commercialization of museums is another problem for the art historian, for fees for reproducing photographs of

items are often so prohibitively high that it is impossible for scholars to illustrate their work.

Visiting the collections and viewing the manufacturing process at the Von Roll AG foundry in Clus near Solothurn and the Wasseralfingen foundry in Württemberg gave an important initial impetus to my work. I would like to express my sincere thanks for all the help and inspiration I encountered there. I also have very happy memories of my work in the Public Record Office at Kew, and all the charming, helpful people working there. I also received generous support from many museums and libraries, scholars and collectors. In particular I would like to thank the following: Eva Åhmann, Växjö, Sweden; H. Parrot Bacot, Baton Rouge, LA; Dr Geoffrey Beard, Bath, Avon; Dr Christoph Bertsch, Innsbruck; Prof. Dr Helmut Börsch-Supan, Berlin; Dr Werner Bornheim gen. Schilling, Wiesbaden; Samuel J. Dornsife, Williamsport, PA; Laos Dybdahl MA, Copenhagen; Gerd Otto Eggers, Hirzenhain; Dr Burkhardt Göres, Berlin; Gebhard Groetzner, Aachen; Dr Josef Grünenfelder, Zug, Switzerland; Dr Hans Martin Gubler, Zurich; David A. Hanks, New York; Dr Elisabeth Hidemark, Stockholm; Bernd Hildebrand, Aalen, Württemberg; Anne Marie Kappeler, Langwiesen, Switzerland; Dr Josef Kuba, Prague; Ian M. Lawley, Stoke-on-Trent; Dr Wingolf Lehnemann, Lünen, Westfalen; Dr Frauke Lühning, Schleswig; Mgr Eva Necasová, Blansko, Czech Republic; Ewe Nilsson, Kallinge, Sweden; Christopher Payne, London; John Powell, Ironbridge, Salop; Hans Pruth, Vaggeryd, Sweden; Rodris Roth, Washington; Mgr Danuta Skaluba, Gliwice, Poland; Sotheby's London and all branches of Sotheby's; Prof. Dr Hans Spiegel, Düsseldorf; Heidy Stangenberg, Munich; Graham S. Thomas, Horsell, Surrey; Clare Vincent, New York; Dr J.M.W. Baron Voorst tot Voorst, Warmond, The Netherlands; Dr Gretel Wagner, Berlin; Dr Clive Wainwright, London; Prof. Dr Ernst Werner, Duisburg; Dr Heinz Wübbenhorst, Essen; Dr Maria Zlinzky-Sternegg, Budapest.

I would like to thank Herbert Schauer for his critical appraisal of the manuscript and help in producing the typescript, and Judith Schauer, as so often in the past, for checking and correcting it. Thanks are due to Judith Hayward who created a clear and understandable English text from a German original that was certainly not easy to translate. My deepest gratitude, however, is as always reserved for my wife, Dr Irmtraud Jo Himmelheber, who has been continually and actively involved in work on the project, providing constructive criticism but above all collaborating closely with me and offering many helpful suggestions. Without her help, advice and patience this book could not have been written.

*Georg Himmelheber*

Munich, April 1996

# Introduction

IRON is not a precious metal, yet it is highly regarded. It does not occur in a pure form in nature, and has to be extracted from iron ore in a very complicated manner. The iron content of the ore is at best 65 per cent but generally only 30–40 per cent. Extraction is dependent on extensive technological resources and large amounts of energy (coal, water or steam power) as well as demanding a high degree of awareness of the chemical processes taking place in the smelting. The material eventually extracted is extremely hard and has a high melting point (1535°C); it can be forged, welded, cast, rolled and drawn. But these methods of working it again require great skill, physical strength and the appropriate technical equipment.

All these requirements and qualities make iron a special metal, and account for the high regard in which it has been held, as reflected in mythology, song and metaphor in the Bible, from antiquity to the present day.[1]

The hardness of iron meant that even at an early stage of history it was seen as suitable for making tools and weapons, and its high melting point meant that it could be used for pans, pots and ovens. Krünitz writing in 1785[2] commented:

> Without this metal agriculture, all trades, arts, crafts, commerce and seafaring, as well as everything which serves to improve, cultivate and adorn countries, would have come to a standstill, and we would have been unable to procure either the most vital foodstuffs or the necessary clothing without immeasurable arduous labour, if we had had no iron and no iron implements and tools.

The special status accorded to iron led to the production of the first iron furniture. This was the Roman *sella curulis*, a folding chair reserved for people of high rank; it was, therefore, made from an especially valuable material, or, indeed, from iron. Because the demands made on those who had to work such a hard material were also high, this led to highly contrived showpiece items of furniture being made from iron – pure *Kunstkammer* pieces. There were also purely practical reasons which led to the manufacture of iron furniture. Because of its hardness iron can give protection against violent attack, and because of its high melting point protection against fire. This led to the production of iron chests and cupboards. As iron is easier to keep clean than wood because of its smooth, compact surface, people discovered the advantages of iron beds. And finally, as iron withstands the weather far better than wood, it came to be used to make furniture for outdoor use.

However, casting techniques had to be improved before the large number of garden and street benches produced in the nineteenth century could be manufactured, and for the production of artistic cast iron. Because of its chemical and physical properties, iron is not easy to cast, unlike bronze. To make casting possible, the proper technical equipment, primarily the blast furnace, had to be developed. From the fourteenth century the barrels of guns, cannon balls and various small utensils had been cast in iron, and from the fifteenth century stove plates, where for the first time the pure functional form was given an added artistic dimension. Superb work was produced in this field in the sixteenth and seventeenth centuries, even though the technique of casting was still very primitive at that time.

From about 1700 the still very impure iron extracted from the blast furnace was remelted a second time to obtain a more fluid metal. The eighteenth century then brought further developments and inventions, paving the way for the mass production of cast-iron goods. The blast furnaces were stoked with coke (invented by Abraham Darby in 1709) instead of charcoal, they received blasts of air driven by steam engines, and the remelting was carried out in the cupola blast furnace, patented by Wilkinson in 1794, in which the composition of the iron could be better controlled for the casting process to be used. As a result of this invention, foundries were no longer tied to the site where blast-furnace operations were carried out. The decisive factor for improving the end result was the form made of sand with the model – generally made of wood – being laid in closed, but separable form boxes. The sand had to be arranged in such a way that the form did not alter when the iron was poured in, and it had to allow the gases that developed to escape. All these inventions contributed to perfecting the casting process that lay behind the development of cast iron as the most important, typical and dominant material of the nineteenth century. The *Taschen-Konversations-Lexikon für alle Stände* of 1829 says of iron: 'This most useful and best known grey gleaming metal beats all the rest in hardness, cohesion and extensibility.'[3] Horace Greely writing in 1873 spoke at length about iron:

> The progress of civilization may be said to be over iron, for iron is not only a column upon which civilization rests, but literally lies along the road,

like rails, upon which it moves…. Iron is the chief precious metal. It can be made, even for the most delicate purposes, many fold more valuable than gold.[4]

And even in 1903 the famous German encyclopaedia *Meyers Grosses Konversations-Lexikon* comments: 'Iron along with coal forms the basis of our industrial life.'[5]

It was *cast* iron, however, that was particularly well suited to meeting all the demands which the nineteenth century made of a material: it was available in inexhaustible quantities, it was cheap, it was durable and it could be formed into any shape desired. Thus not only did it conform to the principles of the early nineteenth century – the virtues of the Biedermeier style with its economy and propriety, and in particular with the patriotic component of the dictum 'Gold gab ich für Eisen' ['I gave gold for iron'] that typified the German Wars of Liberation against Napoleon, as well as the severe coolness of classicism with its uncoloured black – it also corresponded with the more luxuriant second half of the century with its complaisance in meeting the desire for any and every form.

In the first half of the nineteenth century, industrial production was synonymous with iron working. Everything conceivable was made from cast iron. Thus we may read in the *Illustrated London News* of 30 April 1853: 'The employment of iron may be traced through a long vista of ages; but it was reserved for our generation to produce the iron bridge, the iron road, the iron ship, and the iron house.'[6] But even much earlier in 1822 when cast iron was still a nine-day wonder a long satirical song came out:

> Since cast-iron has got all the rage,
> And scarce anything's now made without it;
> As I live in this cast-iron age,
> I mean to say something about it.

It then listed everything conceivable and inconceivable that was being made of iron or might be made of iron in the future.[7]

The manufacture of iron furniture expanded rapidly in the course of the first half of the nineteenth century. New models were constantly being developed and new fields opened up. The English and Scottish iron foundries in particular exported their goods throughout the world, helped by faster transport – in itself a result of iron working.[8] All models of cast-iron furniture could soon be bought everywhere – though this also meant that they could be copied everywhere. It was quite simple and obvious that casting forms could be made from objects that had already been cast. The attraction of copying lay partly in the object itself, in its manufacturing process and the material used. Admittedly, English laws protected every registered model from imitation, but only for three years, and this scarcely applied outside the country of origin.

The models for the iron furniture must have been developed in the foundries themselves. The large community associated with a fairly important foundry, comprising not only the plant but housing for the workers and their families, a school, a hospital and a church, also of course contained its own drawing office. Only a few great artists supplied the foundries with drawings. In Germany, it was Karl Friedrich Schinkel who had immediately recognized not only the opportunities offered by the material and the way it is worked, but also the challenge it posed for the artist. In England it was William Bullock and then in the second half of the century Christopher Dresser who were responsible for important designs for furniture. Both Schinkel and Dresser made substantial contributions to the development of appropriate styles for designing cast-iron furniture, though of course within the general artistic trends of the day. But it was the now unknown or forgotten designers, who were directly associated with the foundries, who knew about the potential of the material and what was required technically to enable their ideas to be sensibly realized, who in fact influenced the form of the product.

It must have fascinated artists like Schinkel and Dresser to see a unique artistic design mass-reproduced just as it was. But it was also the mass nature of production – one of the most crucial phenomena of the nineteenth century in all fields (bentwood or papier-mâché furniture too for instance) – that caused harsh criticism to be levelled at cast-iron manufacture, especially in the final third of the nineteenth century. Artists influenced by the arts and crafts movement and art nouveau were willing to accord artistic status only to wrought iron, to individual pieces forged with the hammer. The champions of the casting process on the other hand stressed the direct influence of the artist who had prepared the wood or clay model on the final form, which did not in fact have to be made solely by a craftsman.[9] However, apart from a few examples – though some of these are important – the development of cast-iron furniture had ended even before the art nouveau period. A new independent development of iron furniture did not restart until the tubular steel furniture of the twentieth century – designed by Mart Stam, Marcel Breuer and Mies van der Rohe in the mid-1920s. And finally it has been left to the present day and the most recent phase of historicism to reproduce many nineteenth-century models, whether in cast form (now often in aluminium) or wire rod.

# Wrought-iron furniture

## Seating

THE oldest iron furniture to have been preserved is of Roman origin. Especially in very richly furnished graves dating from the first to fifth century AD a variety of iron folding chairs have been found (PLATE 1).[10] Like the Egyptian folding chairs before it, the Roman *sella curulis* was a ceremonial chair the use of which was reserved to certain social ranks or for ceremonial occasions.[11] The surprisingly frequent use of iron for these chairs must have been based on practical considerations, related not only to the manufacture but also the function of such a movable item. But iron has a symbolic meaning here too. While iron is not rare, it is difficult to extract and laborious to work, and above all because of its hardness it has always occupied a special place among metals. It is mentioned in mythology and in the Old Testament. Hephaistos, the only craftsman among the ancient gods, was a smith. In his genealogy of the descendants of Adam, Moses mentions Tubal-cain, the 'forger of all instruments of bronze and iron', i.e. a smith – again the only craftsman – equal in rank to his half-brothers one of whom is a farmer and the other an artist.[12] The use of iron for the folding chairs must have been seen as enhancing the prestige of this type of furniture, an idea which is confirmed by the astonishing phenomenon that folding chairs continued to be made of iron right up to the eighteenth century.[13]

The Roman *sella curulis* in PLATE 1 is from the province of Rhaetia; it was made before the mid-third century; it folds twice, once at the middle pivot, and once along the longitudinal axis, which is why the front horizontal bar of the seat had to be broken.[14] S-shaped struts have been added to give it the necessary resistance when loaded. This form of folding chair belongs to a type already familiar from an example from Roman Britain that is about 100 years older.[15]

The tradition of iron folding chairs still continued after the end of the Roman Empire. A superb example, probably Lombardian, using exactly the same construction is thought to date from the sixth century and originate from northern Italy or southern France (PLATES 2, 3). Costly bronze damascening on the bars and the hoofs and heads at their ends indicates the high status of this piece of furniture.[16]

In the Lombardian necropolis at Nocera Umbra, six seventh-century iron folding chairs with bronze and silver inlay were buried. An interesting ninth-century example in which all four struts meet at one pivot can be seen at the Museo Civico in Pavia; it was found in the Tiber.[17] The severe, simple form of a chair which must have been made in Upper Italy in the tenth/eleventh century (PLATE 4) carries conviction: the bars are overlaid by a regular ornamentation of copper inlay and there are surviving traces of gilding.[18]

The tradition of the Roman *sella curulis* is perpetuated in the mediaeval faldistory – the seat of honour for secular and even more particularly clerical princes – though iron examples are known to us again only from the late Middle Ages. A fine specimen dating from the fourteenth century has been preserved in Bayeux cathedral (PLATE 5).[19] The supports of the lower and upper part are curved in catenaries which give the chair a seemingly labile outline and at the same time has great tension. The front and rear part of the frame are linked by a quatrefoil frieze.[20]

Associated with the iron folding chair in Gothic churches is the iron lectern that also folds. There is a French example dating from the fifteenth century in the Musée de Cluny in Paris (PLATE 7). Very fine flamboyant tracery forms the upper and lower borders of the book rest which is made of four cloth straps. The Walters Art Gallery in Baltimore owns a sixteenth-century Spanish example (PLATE 6). Here not only are the bars twisted and playfully curved, but the supports also are linked to a single pivot.

Religious folding chairs made of iron were produced in southern European countries in the Renaissance, too. A delicate early sixteenth-century example which may be Spanish is owned by the Bayerisches Nationalmuseum in Munich (PLATE 8). Not only can the chair be folded together round the central pivot, the struts can also be folded up or down towards the centre: a further means of reducing the size of the chair for transport, such as could be observed in a different form even in the Roman and Lombardian examples. Besides its squat spherical knobs, this chair was further decorated by the very thin, delicately turned link rods, most closely paralleled in the rich chapel grilles in Spanish cathedrals.[21] It might therefore have been made in Spain at the beginning of the sixteenth century.

Numerous iron folding chairs are still in use in churches today. Occasionally, they crop up in the art trade, such as a simple example that was sold at Sotheby's in London in 1981 (PLATE 9).[22] With its struts bent round

to the horizontal and the vertical, in form it represents a type that was current for a long time. But it is directly associated with an example of the same form in the Castel San Angelo – with similar brass knobs and elongated sleeves – that was made in 1570 for Gaspar de Zúñiga, Archbishop of Seville.[23]

While looking through old French inventories, Henry Harvard found several mentions of iron seating. In the list of property belonging to Clémence of Hungary dated 1328 a copper chair decorated with iron and with an iron back-rest is mentioned. An inventory of the possessions of the Duke of Bourbonnais dating from 1507 alludes to 'an iron chair which was fitted with velvet'. An 'iron chair' is also listed in the inventory of the Condé château of 1569, and 'an iron bench for sitting on' in that of Amédé Chalamont of 1571.[24] These inventory entries also indicate the high value assigned to iron seating. In 1572, as an expression of his pleasure at a newly found iron ore deposit in Zellerfeld in the Harz, Duke Julius of Braunschweig-Lüneburg sent his stepmother, Duchess Sophie, a chair made of iron.[25]

A curiosity in the collections at Schloss Ambras is a 'trap chair', which must be dated as belonging to the second half of the sixteenth century because of its openwork ornamentation; it was listed in the inventory of the estate of Archduke Ferdinand II in 1596 (PLATE 10).[26] It consists of steel panels screwed together behind which is hidden the mechanism for several arms which grip anyone sitting down on the chair across the chest, upper arms and thighs.[27] Only a person who knew how the mechanism worked could free the involuntarily trapped guest. This is one of the joke devices – which could be made of glass, silver or as here iron – so strangely popular with the people of that time. An iron chair serving quite a different purpose dates from about the same time, again known to us only from written sources: the chair in which the 'alchemist and poisoner' Anne Marie Ziegler was burnt in Wolfenbüttel in 1575.[28]

What must be the most artistically rich and magnificent iron chair in existence – it was made in Augsburg in 1574 – is in the possession of the Earl of Radnor, at Longford Castle in Wiltshire (PLATE 11). Interestingly enough, even this ceremonial throne is still in the form of a folding chair with the legs crossed and the armrests curving up in a high arch. However, it is equipped with a back rest, as can occasionally be the case with folding chairs.[29] All parts are completely covered with well over a thousand carved figures, linked into strapwork ornamentation. The feet end in grotesque masks, and larger figures from antique mythology stand or lean on their scrolls which are splayed to form podia. The front edges of the legs display trophy motifs, the sides personifications of the seasons, the virtues and the arts along with scenes from the

Trojan War. On the large knob up towards which the scrolls of the legs curve there is the signature: *Tomas Ruker – fecit Anno 1574*. The rest of the iconographic programme on the armrests and back rest is quite exceptionally lavish (PLATE 12): battles on land and at sea, executions, coronations and weddings, executed in the round and in openwork, a Roman victory procession, Nebuchadnezzar's dream (with its reference to iron which 'breaks to pieces and shatters all things'[30]) and finally above that the Last Judgement. In the uppermost frieze there is a medallion (also openwork) with the head of a man in the dress of the period, perhaps a portrait of Emperor Maximilian II, and as the ultimate finishing touch the coat of arms of the imperial city of Augsburg. The chair was commissioned by Thomas Holzheimer, a merchant and captain of the Augsburg City Guard, from Thomas Rucker (*c*.1532–1606), an Augsburg cutler, sword-maker and iron-cutter.[31] Like Philipp Hainhofer after him, Holzheimer obviously worked as an agent for arts and crafts. In 1579/80 Rucker lodged a complaint against Holzheimer with Emperor Rudolph II, claiming that Holzheimer had taken the *kunststückh* (work of art) without letting him share in the proceeds of the sale. The matter was settled on 17 November 1580, with Holzheimer purchasing outright ownership of the chair for the sum of 500 gulden. He then succeeded in selling it to the emperor. The throne is listed in 1607 in the inventory of the *Kunstkammer* in Prague. It was looted by the Swedes in the Thirty Years' War, becoming part of Queen Christina's art collection, and after her abdication went to the Stockholm Arsenal. Then in about 1758 the throne was sold for £200 to the Swedish collector Gustav Brander who was living in London, and from him it finally passed to Jacob, Viscount Folkstone, subsequently the 2nd Earl of Radnor, shortly before 1787.

At Schloss Charlottenhof in the Park of Sanssouci at Potsdam there is a steel armchair (PLATE 13) which was a present from Tsar Nicholas I to his brother-in-law, King Frederick William IV. This imposing piece is again a folding chair; like Rucker's chair it is signed at the pivot of the bars forming the legs: *Tula 1744 / Moslov Fabrik*. Rich, exceptionally delicate examples of openwork are stretched between the partly blued bar tracery; there are also fairly small gold and silver inlays. Thus in the mid-eighteenth century the tradition of designing ceremonial chairs – and that is, in fact, what a lavish, throne-like piece of furniture such as this is – as iron folding chairs was still preserved.

In 1712 Tsar Peter the Great had founded an armaments factory making hunting and showpiece weapons as well as implements of war in the town of Tula about 180km south of Moscow. However, a group of excellent craftsmen, who had worked together for many years, also

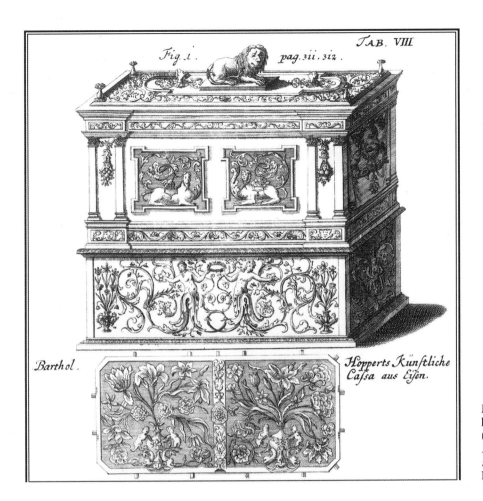

Masterpiece of the Nuremberg master locksmith Bartholomäus Hoppert, 1677. (Plate 8 from J.G. Doppelmayr, *Historische Nachricht von den nürnberg-ischen Mathematicis und Künstlern.* Nuremberg 1730.)

produced other valuable items made of iron and steel, including furniture.[32] Folding chairs were a speciality and were manufactured in considerable numbers; several examples have been preserved in Russian castles. In the late eighteenth century extremely precious pieces – chairs and small tables – were also produced in the French Louis Seize style; they were made of polished steel with applied gilded ornaments, with thousands of steel diamonds, gold and silver inlays and other decorative work (PLATES 17, 18).

The Tula armchairs are the last examples in the long line of iron folding chairs. After the late decorative furniture from Tula, absolutely no more iron seating was produced for indoor use for quite a long period. At the end of the eighteenth century it was replaced by a new product. Rather than ceremonial chairs for rulers, bishop's thrones or *Kunstkammer* items, it was now garden furniture that was made from iron.

In geometrically laid-out 'French' gardens, seating had been made of stone and could not be moved from the position assigned to it by the architect. It was only in the more freely and naturally designed landscape garden, a concept which spread from England across Europe in the second half of the eighteenth century, that the need arose for furniture that could be moved around more freely

according to one's mood, the time of day or the season. Now garden furniture was made sometimes of wood but mainly of iron, as it was better able to withstand the wind and the weather. Very few examples of this type of iron furniture from the early period of the English garden have been preserved. A simple chair in the neo-Gothic forms which were very popular from the second half of the eighteenth century in parks in particular, assembled from semi-circular iron hoops, can be found in Temple Newsam House (West Yorkshire), and one example has ended up in the Victoria and Albert Museum in London (PLATE 15).[33] This chair must have been made in about 1790, a forerunner of the manufacture of cast-iron garden furniture that was soon to get under way.

## Chests and cupboards

BECAUSE of its intrinsic qualities, iron offers protection against fire and theft. Therefore, from quite an early period things which had to be kept safe were shut up in iron receptacles. This practice is exemplified by the many chests which have been preserved from the Middle Ages. A fourteenth-century French chest in the Musée de Cluny in Paris a good example (PLATE 19). It is typical of the

wooden chests of the period made by joiners (for it is, in fact, made of wood) and is completely encased in wrought-iron panels. Rows of nails with diamond-shaped heads fix the plates of metal on to the oak core, and the joints are covered by narrow grooved bands, articulating the simple body of the piece by changes in the direction in which they run. This gives rise to a form of decoration derived from the properties of the material, decorating and articulating the surfaces while at the same time demonstrating stability and security – but also in fact ensuring it. Large rings on the sides make it possible to transport the chest with its valuable contents in case of danger. This chest may have been used to keep church treasures in, as can be shown to have been the case for a German example made only a short time later (PLATE 20). This second chest was used to keep the important and valuable relics at the Benedictine Abbey of Andechs, high above the Ammersee in Upper Bavaria. The simple box is dovetailed together from sturdy oak planks – a very advanced joinery technique – and covered in an unsophisticated way by the smith with wide overlapping strips of sheet iron. Two bands of iron run round the box and the lid, both forming the hinges and ending in a simplified lily at the front. Similar bands are taken across the front. On the inside of the lid there is an impressively simple depiction of the Man of Sorrows with the implements of his suffering and the Lamb of God. The accentuated lily form in which the iron bands terminate was very popular as the fourteenth century ended and the fifteenth began; the painting too confirms that the chest was made shortly before 1400.

Iron chests could also be used to store important and valuable records: the 'Domesday Chest' is an example (PLATE 21). It was made at the beginning of the fifteenth century, and the Domesday Book, the land register for England drawn up in 1086, was stored in it from the seventeenth century.[34] With its severe cubic shape and the powerful lid and the large nails securing the iron bands, this box too has a deterrent aspect, clearly protecting its contents. Three officials each had a key for one of the three separate locks.

A chest in the Guildhall in London dating from 1427 is made entirely from iron. Its vaulted lid can be locked by means of three padlocks; the butt straps conceal three keyholes which obviously gave access to the locks of a wooden inner case. This is, in fact, the only mediaeval chest made purely of iron that has been preserved.[35]

However, there are a large number of smaller caskets made entirely from wrought iron, i.e. without a wooden core. As objets d'art of ever smaller size, they ultimately became very popular in the sixteenth and seventeenth centuries. An early example is an imposing box with a high-vaulted lid dating from the fifteenth century (PLATE 23). A locksmith used to fine work has been busy here, someone who knew how to apply the two-layered tracery bands and ornamental buttresses as a decoration for the box, which carries conviction in its simplicity.

Created in a Flemish workshop, this strongbox (PLATE 24) was made as the Gothic gave way to the Renaissance. The tradition of closely set studs that could already be observed on the first example (PLATE 19) was continued on this chest which is almost 1.2m long. Its distinctive form gives the box a rather forbidding appearance, thereby visibly demonstrating that it is secure against illegal tampering. Nor does the powerful tracery on the front sides serve only as decoration; it also suggests added security and stability. The ability to give protection against forced entry that is inherent in iron as a material is further underlined here by the way in which it has been worked.

A chest probably made about 1600 in Tyrol is more classic, elegant and discreet in its effect (PLATE 22). The sides are structured by flat arches, and extended decorative balusters mark the arches and the edges. The nails required are still fitted with large heads, so determining the character of the piece, in conjunction with the simple iron panels. Only the handles on the front sides and the escutcheons covering the keyholes on the top are fashioned in a richer decorative form in the style of the day. The wooden plinth made for the chest in the late eighteenth century is an indication of how such an item of furniture was valued and how long it remained in use.

As well as chests, there were also iron-clad cupboards even in the Gothic period, precursors of nineteenth- and twentieth-century safes. In these, too, it was primarily the function that determined the form. An example that given its provenance must have been made in South Tyrol no doubt dates from the second half of the fifteenth century (PLATE 26). Narrow iron bands and large wedge-shaped nail heads determine the offputting exterior of the double-doored cupboard. In the corners of the doors and on the edges beside them the nails are transformed into simple flowers, small tongues of sheet metal radiating from a central boss; similar flowers can often be found on altar frames of this period in the form of ornamentation painted on using a stencil. A smaller safe cupboard with the same form and décor (PLATE 25) may also have been made in Tyrol, but in the first quarter of the sixteenth century. To form the front the smith who made the third example (PLATE 27) has invented a few modest decorations developed from iron strap, in line with his craft; these suggest that it was made no earlier than the very end of the sixteenth century. As to where it was made, one of the iron centres in Styria or Carinthia is a possibility.[36]

The safe cupboard from the civic court in Göttingen must have been made only a short time later (PLATE 28). The master who made this iron cupboard with a door which is locked seven times by an ingenious lock with a single key based his design on wooden furniture. The iron panels are fixed with profiled mouldings, imitating the framework and panels used by joiners. The profiles on the bottom and top edge also make the piece more closely resemble contemporary cupboards made of wood, in contrast to the earlier examples which had found a form appropriate to the material and solely corresponding to the purpose. Nonetheless, the large nailheads are still an important decorative element, demonstrating stability and indestructibility. The powerful curving hinges were also supplied in the same form by locksmiths to joiners for contemporary wooden furniture.[37]

The development starting with this Göttingen cupboard, with iron furniture beginning to look like wooden furniture, is continued in a small safe with two drawers in the lower part, and two doors in the superstructure (PLATE 29). This is a miniature piece of furniture barely 40cm high, a casket the entire form of which is derived from furniture of normal size.[38] The sawn-out applied ornamentation can be found on wooden pieces dating from around 1630.[39] On the other hand, the profile with its five projections, consisting of two concave fillets meeting in a sharp edge, is a definite metal form. While the surfaces are painted red, the ornamentation is made of polished iron, giving the whole piece a precious character, further accentuated by the gilded profiles. Thus more emphasis is placed on making a reference to its valuable contents than on demonstrating its utilitarian qualities.

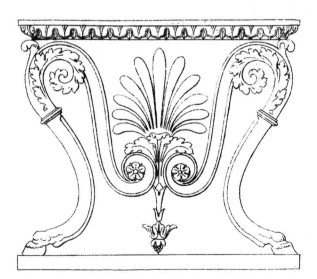

Design drawing of a table from Lewis Nockalls Cottingham, *The Smith and Founder's Director*. London 1824.

However, the chest still continued to be popular as a *cassa* along with the cupboard. In his comprehensive work *Historische Nachricht von den nürnbergischen Mathematicis und Künstlern,* J.G. Doppelmayr included a locksmith, Bartholomäus Hoppert, along with his masterpiece dating from 1677, an artistically decorated chest (ILL. p.13). A German chest dated 1716 is also particularly charming (PLATE 31). The smith uses it to display his skill, with forms that were in fact already old-fashioned, such as the pierced vine scroll work between the legs and the masks on the locks. But the turned columns at the edges, which had been popular since the baroque period, are highly original. To some extent, the master locksmith only reproduces the principle, in the form of a spirally twisted round iron rod. An example made in Carinthia *c.*1710/20 (PLATE 30) is a simple box covered with cast leafwork and strapwork ornamentation, now merely a decorative addition in the style of the period with no reference to defence or reinforcement. The chest was in use at Klagenfurt post office until 1890 – proof of its enduring usefulness and good workmanship.

The fact that a craftsman's skill and pride can go much further still is demonstrated by a casket, 85cm in length, the body of which is worked out in minute detail (PLATE 34). A powerful profile on the pedestal curves downwards on the long sides; projecting pilasters designate the edges and support a main cornice composed of multiple profiles on the upper edge and lid. As can also be the case where wooden furniture of the rococo period is concerned, the design pays no regard to the material. The chest must have been made *c.*1730/35 in Upper or Lower Austria where there are items of wooden furniture worked out in similar detail.[40]

Even earlier, however, there had been a move away from the pure utilitarian form, or one that was only slightly decorated. An example of this is an incomparably more magnificent, extravagantly decorated *Kunstkammer* piece, a cabinet made in Milan *c.*1560/65 (PLATE 33), i.e. almost at the same time as another *Kunstkammer* piece, the Rucker armchair from Augsburg (PLATES 11, 12). At that time Milan was a centre for the decoration of armour; Milanese suits of armour were sought after even by the emperor, and they were very costly. Thus this showpiece cupboard also found its way into the imperial treasure chamber in Vienna. All the arts used in iron craftsmanship are called on here: the figural reliefs are in repoussé work, the ground is partly polished and partly blued, the ornamentation is damascened in gold and silver. Antique deities, virtues and arts, jousts, a lawcourt scene, scenes from Ovid's *Metamorphoses*, pictures of the hunt, town views and a dense ornamentation leaving no area empty

typify the exterior and interior of the piece. The creator of this work of art was the Milanese armourer Giovanni Battista Serabaglio and his collaborator the damascener Marc Antonio Fava.[41] Possibly these two masters or other Milanese armour decorators working close to them may have made the showpiece items of iron furniture – a casket, two cabinets and a games table – that are in the Victoria and Albert Museum in London.[42] Fifty years later, yet another magnificent cabinet was made from steel in Italy for Cosimo II de'Medici, 4th Grand Duke of Tuscany, and it too is held in London.[43]

A chest made in Germany in the eighteenth century is beyond compare with regard both to artistic design and craftsmanship of execution and in its mechanism (PLATE 32).[44] As the inscription in the lid reveals, it is the masterpiece of the locksmith Johann Gottlieb Dittmann from Hirschberg; he made it in 1733 to the design of the town locksmith Sigmund Galckenhauer while working for him. Unfortunately, there is no indication regarding the place where Galckenhauer was town locksmith, so we cannot even surmise which of the many Hirschbergs existing in Germany was the place of birth of the master of this piece. Where the ornamentation is concerned the design is absolutely in line with the latest trends of the time. For the formal shape of the chest – which in the rococo period had long since been pushed aside as a type by the commode – the master quite logically reverted to the tradition of examples a hundred years older; the articulation of the sides by pilasters in front of an arcade can be found on chests and cupboards dating from the first half of the seventeenth century. In mixing forms revived from the past with the most modern forms of the period, the town locksmith has successfully evolved a style of his own, appropriate to the iron chest. The execution displays marvellous virtuosity, but the mechanism too is outstanding: a single key moves 24 bolts. The correspondingly complicated locking device is visible behind the *ajouré* strapwork panel. Finally, even gravity seems to be suspended, with the enormously heavy chest resting amazingly on airily curving ornamental forms.

After the middle of the eighteenth century, a master probably working in the Lower Rhine solved the problem of the strongbox which had become old fashioned in a different way (PLATE 36). He made it look like a commode with (apparently) three drawers, and a top which lifts up like the lid of a chest. To make the deception complete the whole upper surface is even painted with a wood-grain effect. This highly original version of a piece of iron furniture found no imitators. As if completely naturally, classicism reverted to the simple box forms of the chest (PLATE 35), including – for instance on the guild chest of

Design drawings for brackets, table-ends and chairs from John Claudius Loudon, *Encyclopaedia of Cottage, Farm and Village Architecture*. London 1833.

the Viennese gingerbread bakers made in 1822 (PLATE 37) – all the stylistic characteristics of Biedermeier: the excessively tall pilasters marking the edges which in fact support nothing, the flat arcades, the engraved grapevine motif. On the lid is the inscription: 'The Viennese main chest of the city's gingerbread bakers, 1822' and inside the names of the two guild masters: 'Andreas Graf, Joseph Clement'. Though they remained in use for a long time to come, these chests are, nonetheless, the last in line of this form of iron furniture. Soon afterwards they were replaced by safes with security systems against fire and theft which became ever more perfect.

However, the firms making safes wanted to lend distinction to their products by artistic design as well as perfect technology. At exhibitions they repeatedly showed models that not only displayed the most recent security systems but were at the same time masterpieces of craftsmanship. At the International Exhibition in London in 1862 Karl Hauschild from Berlin exhibited a large fireproof safe (PLATE 38); with its luxuriant forged-iron ornaments derived from late Gothic models, it represents an individual solution to the task for which it is designed: original in the best sense of the term. 'Of the numerous examples of this class in the Exhibition this was the most ornamental,' Waring wrote in his account of the exhibition.[45]

The mediaeval craft tradition which is here deliberately reflected in an industrially manufactured product is underlined by an archaizing verse inscribed in the interior: 'Safe against thief and fire/Am I through the locksmith's hand;/If God our Lord does not keep watch too,/Neither bolt nor lock is of avail.'

Ten years later, cabinets of the late Renaissance, mannerist and early baroque periods were seen as appropriate models. At the 1873 World Exhibition in Vienna the firm of F. Wertheim & Co., the 'largest factory in Europe and first factory in Austria with the royal and imperial warrant for the manufacture of fireproof and burglar-proof safes', showed a work of almost unsurpassable lavishness on which all the techniques of iron-working are represented (PLATES 39, 40). The architecturally structured inner show side in the style of a cabinet is completely covered with detailed ornamentation, cut, damascened or enamelled, as well as being provided with figures in the round: Kronos flanked by Voluptas and Paupertas, Invidia and finally Fafner with several dragons as well as caryatids and putti. On the entablature of the centre aedicule the master who executed the work has signed it: *Entworfen und ausgeführt von Anton Batsche* [Designed and made by Anton Batsche]. The cabinet was also the model for a 'jewel cupboard' designed by the architects' office of Ernst Eberhard Ihne & Paul Stegmüller in Berlin (PLATE 42). The ingenious piece displaying all the skill of the master locksmith who made it, A.L. Benecke, was shown at the Berlin Trade Fair held in 1879.

'Garden Table' from catalogue of James Yates, Effingham Works, Rotherham, 1843/48.

# Wrought iron in the rococo period

THE ART of smithing was at its most consummate in the eighteenth century, as is convincingly demonstrated by innumerable church grilles, park fences and gates, window grilles, balcony railings and stair banisters. The same craftsmanship in converting the design that led to the realization of these airily ingenious images was applied in isolated cases to certain types of furniture: iron rod curving and rolled in the most lively forms is covered with the ornamentation of the time – acanthus leaves, rocaille – made of repoussé sheet metal. It almost seems as if the leafwork and strapwork of *c.*1720 to 1730 had now found the medium most truly appropriate to them, their most logical implementation, in iron.

The need for furniture of this kind was, of course, small. A few examples can be found in churches, perhaps in connection with matching chapel grilles. A console table (PLATE 43) made by the master locksmith Alexis Benoît after 1725 comes from the monastery Verbe Incarné at Avignon.[46] It is easy here to imagine parallels carved in wood, and yet the iron furniture is based on an independent concept. When similarly rich furniture has been carved to produce just as curving forms in the legs, fillet and frame, the forms have had to be laboriously wrested from or forced on wood, against its texture and its natural properties; the same effect seems – and is – effortless, natural and convincing when done in iron. It is the ductile quality of iron, whether forged or repoussé, which enables it to be shaped into the forms required at this period with no perceptible struggle.

A console table dating from the same period in the church of St-Sauveur in La Rochelle (PLATE 41) is much more modest, almost entirely in repoussé work. The forged iron frame here becomes a support for a sheet-metal cladding and is visible in only a few places, as C-shaped curves on the fillet or the cross-buttressing on the frame. The lectern held in the Bayerisches National-museum (PLATE 44) must also surely be an item of church furniture. On the other hand, a table now to be found at Rouen in the greatest collection of iron in Europe (PLATE 45) may have stood in the *sala terrena* of a château.[47] The way in which rocaille motifs and blades of reed here play around the big C- and S-shaped curves, largely making them disappear, can best be compared with the extravagant decorations of the stucco artists of the rococo period. A distinguished masterpiece has been created not only through the design, but also in the craftsmanship of the execution, especially as all parts, including the luxuriant

rocaille motifs and the elongated leaves, have been forged and not embossed.

The art of smithing achieved its height in such works. In the late eighteenth century, furniture made of steel continued to be made only in Tula, though it was extremely delicate and refined (PLATES 17, 18).[48] There would be no move back to forged iron until the late nineteenth century, in conscious contrast to cast iron.

## Beds

IN August 1638 the Augsburg art agent Philipp Hainhofer sent one of his most important patrons, Duke August the Younger of Braunschweig-Lüneburg, a bill for 'a travelling bedstead completely made of forged iron which can be assembled, used in Italy against bedbugs and moths'.[49] In Italy people protected themselves from 'bugs and moths' – and obviously at that time only there – by using iron bedsteads, as these could be cleaned much more thoroughly and easily than comparable beds made of wood; there are no cracks, splits and holes in which the pests can escape destruction. Thus John Evelyn travelling in Italy with Lord Mowbray in 1645 also notes in his diary: 'The Bedsteads in Italy are all of forged Iron gilded, since tis impossible to keep the wooden ones from the Chimices [bedbugs]'.[50] The fact that Evelyn mentions gilded beds is a clear indication that he does not have simple inn beds in mind. In the Castello degli Acciaioli at Montegufoni there are two iron beds which must be similar to those the two travellers saw (PLATES 46, 47).[51] The scrolls with their large curves ending in points, their kinked S-shaped curves and the linking of the individual elements by straps can all be compared with forged iron grilles dating from 1620 to 1640.[52] A cradle (PLATE 49) dates from the same period, again made of iron for reasons of hygiene.[53] The frame for a canopy could be placed on the ends of the corner rods, as in the Nativity crib in PLATE 48. A hundred years after Evelyn's comments, it was again an Englishman who reported on the hygienic beds which were obviously still customary only in Italy, although it was certainly not only there that the plague of bedbugs was alarmingly great. In his 1749 travel guide *The Grand Tour,* the writer Thomas Nugent gives advice about spending the night in Italian inns: 'Their bedsteads are of iron, which secures them against the vermin so troublesome in London.'[54] In 1766 Samuel Sharp also wrote, 'In the hospital at London bugs are frequently a greater evil to the patient, than the malady for which he seeks a hospital.' Thus he appreciates all the more 'the contrivance used in the great hospitals here [in Florence] to avoid bugs; it is no other than a plain bedstead of iron, made so simple, that there is not a crevice where a bug can conceal itself.'[55] In the following year, 1767, a gradual start was made on installing iron beds in St Thomas's Hospital in London, 'greatly alleviating the terrible Inconvenience the Patients suffered from the Bugs'.[56] However, it is obvious from a book by the

Design drawings for two chairs and a table from
John Claudius Loudon, *Encyclopaedia of Cottage, Farm and Village Architecture,*
London 1833,

English doctor Charles White that even long after iron beds had been introduced at St Thomas's Hospital in London they were not used as a matter of course in English hospitals. On p.142 of the German edition of his book, *Treatise on the Management of Pregnant and Lying-in Women*, published in Leipzig in 1775, he stipulates: 'In a hospital used for childbirth, indeed I may add in any other, the bedsteads must be made of iron.'[57] In 1780, the fact that all the beds in the hospital at Montpellier were made of iron was reported from France as exemplary.[58]

Matthias Claudius makes an early mention of Swedish and English iron beds; in a letter dated 22 August 1778 he wrote:

> As far as my enquiries to date have revealed, neither Swedish nor English iron bedsteads are obtainable in Hamburg; but they are made here and cost 10 Reichstaler, that is for single ones. In Bramstädt there is a smith who is supposed to make them extraordinarily well, better than the English, but for a large bed he takes 20–22 Reichstaler.[59]

Goethe, too, appreciated Italian iron beds. In his *Italienische Reise* he recounts an occurrence in Naples on 31 May 1787:

> Today when we were walking through the endless junk in the extension of the citadel I saw a pair of iron bedsteads, painted to look like bronze, which I immediately haggled over and dedicated to my friend [the painter Christoph Heinrich Kniep] as a future basis for a peaceful, solid sleeping place. One of the porters who are always waiting ready took them and the necessary boards to the new lodgings.[60]

Goethe himself seems to have already been sleeping on an 'iron truckle bed', in any case since 1783, if the memory of his servant speaking to Eckermann 40 years later can be relied on.[61] In 1818 the painter Louise Seidler in her lodgings in Rome admired 'the bed, as usual in Italy, so wide that three or four people would have had room in it. It consisted of four boards resting on an iron underframe.'[62]

Even at the French court the advantages of iron beds were appreciated. The Dauphin, the son of Louis XV, was given an iron bed in 1765; Harvard quotes a contemporary description: 'Style of a bed with four iron columns, 8ft 6in. in height, 4ft wide, 6ft long, equipped with its iron frame, the top rail gilded, the bottom one water-coloured, wooden base supported on iron stirrups'.[63] Nor had the situation altered by the next generation. In 1784 an 'iron bed' was made for the 'Dauphin who is plagued by

bedbugs'.[64] As late as 1832 the heir to the Austrian throne slept in an iron cot, to the consternation of his newly appointed nursemaid who knew what that meant.[65]

Thus, even in the highest circles, iron beds were completely usual. When the furniture of the Elector of Saxony's business representative was auctioned in Paris in 1769 'an iron couch with ornaments' was on offer.[66] As the *Annonces, affiches et avis divers* of 16 December was able to report, the financier Paris-Duverney, who was famous in his day, owned 'a mechanical bed with columns nicely worked in polished iron'.[67] In 1776 it was reported that Karl Friedrich, Markgraf von Baden, usually used 'an iron bed which can be rolled on 8 feet' in his 'alcove-bedroom'.[68]

Besides these more or less artistically executed beds, however, travelling beds that could be assembled, such as Hainhofer had already procured from Italy, were coming to be imitated in other countries. On 29 January 1761 the *Berlinische Privilegirte Zeitung*

> informed the public that His Royal Majesty has graciously conferred the privilege of manufacturing the compact iron travelling bedsteads which can be packed in a box two and a half feet long, 6 inches high and 6 inches wide and both weighing only 36 pounds, from the master locksmith Johann Friedrich Kochfasser.[69]

In 1804 the Paris locksmith Desouches obtained a five-year patent for an iron field bed: 'A folding bed made of iron, transportable'.[70] Again in 1809 Desouches, who was locksmith at the imperial Garde-Meuble, supplied Napoleon with two of his field beds for the sum of 2,100 francs; he subsequently used them on all his campaigns and one of them accompanied him to St Helena (PLATE 53).[71] The bed which is forged from extremely thin round bar iron is very carefully worked. The four brass knobs can be removed, and a frame for a canopy could be added in their place. King Otto of Greece always took ten iron beds with him on his travels in the 1830s as part of his baggage, one for himself, the others for the gentlemen travelling with him.[72]

The construction of a 'tent bed' presented in 1796 in the *Magazin für Freunde des guten Geschmacks* (PLATE 51) is comparable to these travelling beds in its simplicity.[73] 'The bedstead is made of iron bars with rosettes, knobs and feet of metal', i.e. no doubt brass. The way the article continues is very revealing of the dominance then accorded to iron for beds: 'However the form of this bedstead can just as easily be imitated using wood [for financial reasons] if the strength of the supports and posts is a little reduced, and it can be given *an iron-like*

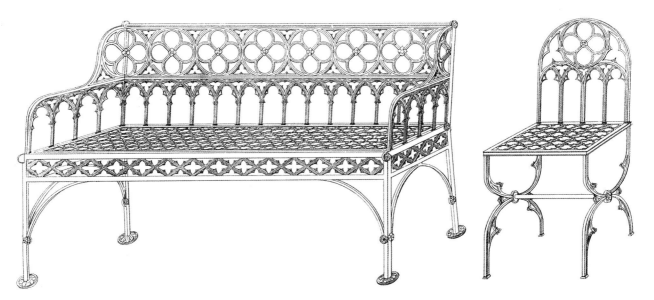

Design drawings for bench and chair from François Thiollet, *Serrurerie et font de fer*. Paris 1832.

*appearance* by paints and lacquered varnish.' So anyone who could not afford iron could fake it! This bed too could be fitted with a canopy. The article describing it explains:

> The idea illustrated below on this copper plate is for the person who likes sleeping in the open without bed hangings, while the second concept with hangings is ideal for the person who likes to stay lying in bed in the morning in a pleasantly dim light.

Another iron bed which may have been made for a distinguished patron by Jacques-Antoine Courbin, the 'Serrurier Ordinaire des Meubles de la Couronne' who became a master in 1772, also dates from the late eighteenth century (PLATE 50).[74] With this bed he created a simple type which was to continue to be used as a model for a long time to come. As late as 1837 Queen Hortense had a bed made in these forms for her small Schloss Arenenberg on Lake Constance. Alongside these, however, there were more richly made pieces of furniture. A bed combining classicist ornamentation with Gothic-style pointed arches in the Nissim de Camondo collection in Paris dates from the 1790s. A magnificent bed in the troubadour style (PLATE 54) must have been made around the mid-nineteenth century, although the name of the person who commissioned it is unfortunately not known.[75] With its lavish late-Gothic tracery, its twisted shafts and pinnacles and its leafwork, it is a superb illustration of the craftsmanship of wrought iron.

On the other hand, the utilitarian iron bed for the ordinary citizen was made of simple thin iron bars which could also be bent (PLATE 273), and soon also of metal tubes: because of the reduction in weight these were equally stable. As early as 13 April 1812 John Thomas Thompson, a 'Camp Equipage Maker from Long Acre in Middlesex', obtained a patent for 'Bedsteads and testers, and frames for bedsteads, of every sort, size, form, and description, with hollow iron or steel tube'.[76] Later he improved his invention and in 1826 obtained another patent for his bedsteads which consisted of tubes that could be inserted into one another.[77] That same year the London carriage-builder William Day also obtained a patent 'for bedsteads, sofas, armchairs etc which can be made wider, higher and lower at will', an invention which must therefore have outdone Thompson's.[78] Ludwig Börne saw similar beds made 'of iron, brass and copper tubes' as early as 1822 at the Industrial Exhibition in Paris. He wrote that they were 'so easily and conveniently arranged that they can be packed in a suitcase. You only need two minutes to assemble or dismantle them…. These field beds or constitution beds or Procrustean beds are not very dear to buy.'[79]

In 1823 the French administration entrusted the engineer Pihet with making iron beds for the army's barracks because the soldiers 'could no longer sleep because of bedbugs', as Dingler puts it.[80] As the beds were to be no dearer than wooden ones, Pihet constructed a machine to speed up production. Six of these machines were set up in the arsenal at Toulon, enabling a hundred bedsteads to be produced daily.[81] By 1826 Pihet had already supplied 30,000 bedsteads to the Ministry of War; in 1834 he received a further order for 60,000 more.[82] Iron beds of this description were displayed at the 'Exhibition of the French National Products' in October 1827 at the Louvre in Paris.[83]

In 1833 John Claudius Loudon recommended iron beds for country and garden houses because of the vermin. He displayed 'stump bedsteads', simple beds with no bottom bed-end, and 'half tester bedsteads', similar ones with a half-canopy, which were made by Cottam & Hallen in London,[84] as well as a 'couch bed' and a folding bed by William Mallet in Dublin 'who has made many thousands of them'.[85]

Iron beds were now increasingly mass-produced. A journeyman locksmith by the name of Zoller who had come from Stuttgart progressed to become court locksmith in Berlin and a millionaire to boot as a result of a collapsible bed that he had developed, obtaining a patent for it in 1834. At the same time he was given the contract for manufacturing iron bedsteads for all Prussian barracks, and built his own factory for the purpose.[86] In 1839 the Munich master locksmith Franz Schörg Jr was given a similar concession, as was the master jeweller K. Stadler in Haidhausen (now Munich) in 1845.[87] However, true mass production got under way in France,[88] but was soon surpassed by England. Shortly after the middle of the century, 5,000–6,000 bedsteads were being produced in Birmingham each week![89] The manufacture of cheap beds using tubes or iron rods – brass ones too for that matter[90] – continued uninterrupted throughout the nineteenth century. However, beds for more elevated purposes in richer forms were being produced by the foundries at the same time.

# The beginnings of cast-iron furniture

THE euphoric enthusiasm felt in the nineteenth century for cast iron which was being produced in ever better ways and ever greater quantities led to a desire to make everything, absolutely everything, in that material and using that technique. Thus it was an obvious next step to start casting furniture in iron. At the same time this makes it difficult for the historian to find the beginning, and pinpoint the first cast-iron furniture and its 'inventor', if there was such a person. Investigations of this kind are made even more difficult by the dearth of sources. For company archives of foundries were rarely kept and subsequent generations to a large extent destroyed their products. When tastes change, 'old fashioned' articles are disposed of, rather than being handed down and preserved. The possibility of recovering the raw material by melting down cast-iron products has also contributed greatly to their destruction.

At the end of the eighteenth century and the beginning of the nineteenth, all the new technical processes and innovations in the field of cast iron originated in England. Thus the first use of cast-iron parts in furniture also occurred in England. In June 1805, using the Garrard Act,[91] the sculptor William Bullock obtained protection for a leg for a piece of furniture which stood on a bird's talon and ended in the head of a bird of prey. In accordance with the legal provisions he cast in the signature at the same time: 'W. BULLOCK PUB. 1 JUNE 1805'.[92] Over a period of several years William Bullock's brother, the cabinet-maker George Bullock (1777/78–1818),[93] evidently used three of these elongated, curving legs in combination with a wooden pedestal and wooden top to make small tables or gueridons (tripods). A fine example where the legs are bronzed (i.e. the iron was not intended to be visible as such) and the wooden parts are provided with stucco trimmings (PLATE 205) can be precisely dated by the bill which has been preserved; on 18 June 1814 George Bullock sold '2 bronzed Griffin Tripods' for £18.18.0 to Samuel J. Day, Hinton House near Bath, where they remained until 1994 when they went to an art dealer.[94] However, it must remain an open question whether the first piece of furniture to be completely cast in iron was manufactured in England. In any case the first – and interestingly enough for a long time also the only – artist who was responsible for designing pure iron furniture came not from England, but from Berlin and as far as we know it was there too that the first iron furniture was cast.

The German foundries, with the initial help of English engineers in the later eighteenth century, had reached such a high standard that they were in a position to make casts of large objects of the finest quality. In 1782 a lifesize statue was successfully cast for the first time at the Lauchhammer foundry near Cottbus in Prussia, using the lost-wax process

adopted from bronze casting. This was a great and universally acclaimed achievement, and it resulted in the Lauchhammer works generally setting the pace for the artistic casting of iron.[95]

In the Königlich Preussische Eisengiesserei at Gleiwitz [now Gliwice] in Silesia[96] the first casts of *objets d'art*, initially predominantly medals, but also largish crucifixes, were made in 1798. Soon these were followed by vases, boxes, candlesticks, etc. The Berlin foundry came into existence in 1804 as a subsidiary of Gleiwitz.[97] The choice of location was expressly explained at the time by the wish to have the works close to the artists supplying the designs. Moreover, there continued to be close contact with the foundry at Gleiwitz; all models were cast in both places.[98] Karl Friedrich Schinkel drew the designs for all the large artistic objects which were now made, but the sculptors Christian Daniel Rauch (1777–1857) and Christian Friedrich Tieck (1776–1851) also collaborated with the foundry.

The custom of making the monarch and other influential personalities a New Year present of a cast-iron plaque depicting the most important objects produced in the past year was started in 1805 at the royal iron foundry in Berlin, and subsequently adopted by the other Prussian foundries. On the New Year plaque for 1820 a round three-legged table (PLATE 207) is proudly placed in the

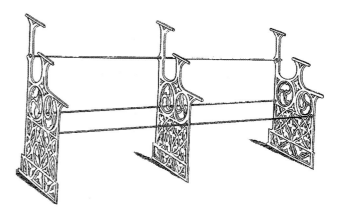

Flowerpot stand from catalogue of Gebr. Sulzer, Winterthur, *c.*1830/40.

middle. This first example with its somewhat obscure forms – the lion's paws look like boots that have been pulled on, and the acanthus leaves like baggy trouser legs – already exhibits all the problems of cast-iron furniture. The model was produced in two different sizes at both Berlin and Gleiwitz. In the statistics which were kept in Gleiwitz from 1798 it is listed as an 'antique table'.[99] Just five tables were cast in Gleiwitz in 1820 (no documents have been preserved from the early period of production in Berlin), in 1824 and 1826 one of each size, in 1827 and 1828 three of each; apparently none has been preserved to the present day.[100]

# Karl Friedrich Schinkel

LIKE all artists involved in the classicist movement Karl Friedrich Schinkel (1781–1841), from 1810 a member of Prussia's supreme building authority (the *Ober-Bau-Deputation*) and its leader from 1830, had visited Italy several times. However, as someone who was open to all modern developments, he also travelled in France and above all England and Scotland where he visited many factories. Schinkel was particularly impressed by big iron works and by iron roof and bridge structures.[101] Schinkel was very interested in craft and in promoting it. At the same time, contact with more progressive businesses that specialized in mass production was also important to him, e.g. Christoph Feilner's pottery which had worked that way since 1805, but first and foremost the

Berlin iron foundry. And that is where Schinkel's designs for cast-iron furniture were to be realized.

After the final defeat of Napoleon (1815) there was a lively upturn in building activity in Berlin, and elsewhere in Germany. Between 1816 and 1818 Schinkel built the Neue Wache and from 1818 to 1821 the Schauspielhaus – where for the first time in a German theatre the galleries were supported by cast-iron props. There were many building projects to be carried out for the royal family, including the Neuer Pavillon at Schloss Charlottenburg during 1824–5, the grounds of Schloss Glienicke in south-west Berlin from 1824 to 1827 and the diminutive Schloss Charlottenhof in Potsdam between 1826 and 1828. All were surrounded by large parks, with gardens laid out next

to the buildings. It was for these that the first garden benches designed by Schinkel were produced in 1825.[102]

Schinkel's earliest design for a bench (PLATE 56) is not based on any model, nor are there any parallels for it. Here a new type of seating was being developed specially for casting in iron. An extremely simple structure, it derives its decoration from elements of the French Empire style of the early nineteenth century, on which Schinkel often drew in designing interiors too. However, all the decorative forms, the one-legged griffins, the palmettes, stars and leaves, are part of the construction and as such they are essential. No single part could be removed. Thus the whole form of the bench down to the last detail is adapted to the casting technique. The individual elements are easy to assemble and can be increased to any number desired, i.e. the bench can be in two, three or four parts; a semi-circular arrangement is even possible (PLATE 55). All these adaptations have been preserved in the parks at Potsdam.

The bench appears to have been constructed from a row of individual chairs, a motif repeated by Schinkel – though of course he did not invent it – for mahogany furniture for the interior of the Neuer Pavillon, thus creating a link between inside and out.[103] The back rests, which look like sagging wide ribbons, are also to be found there. Schinkel was fond of using the Empire motif of heraldically designed griffins that draws its inspiration from the bronze or stone furniture of the type found at Herculaneum and Pompeii. Nonetheless, considered as a whole, these benches are nothing like antique or even Empire furniture. They are totally devoid of any pompous monumentality. The reduction of the volumes made possible by cast iron – and this is in fact clear even in comparison with wooden furniture – is used by Schinkel as a stylistic element in these pieces of garden furniture.

Schinkel's design for a second model of garden bench with a seat consisting of a marble slab (PLATE 57), must also have been created between 1824 and 1826. Here again cast iron's potential for delicacy is exploited to create a graceful seat – in spite of, or perhaps in contrast to, the marble slab! All the individual forms clearly demonstrate Schinkel's style of decoration. The armrests with their spiralling scrolls can be found cast in bronze on chairs which Schinkel had designed for the Palais of Prince Albrecht, and he also depicts them in his book of patterns. They recur constantly in his work in similar form.[104] Cloven feet, eagles, garlands and palmettes all come from his repertory of forms which, like other artists of the period, he had created by deliberately referring back to the Empire style toned down by Biedermeier. The bench also existed in a slightly altered form with a garland inserted into the rest between each eagle.[105]

A few years later, in about 1828, Schinkel once again turned to designing cast-iron garden benches (PLATES 58, 59). The side parts of both benches are the same. Below the seat there are ornamentally arched corner reinforcements, above it the ever recurring scrolls which here surround a winged lyre. The arm and back rests are formed in a regular curve for the comfort of the person seated, which makes these benches functionally superior to the other examples. The back rest of one bench is filled with vine scroll decoration in which mannerist forms mingle with Empire ones – a formal device very individual to Schinkel, which he also used on balustrades.[106] On the other model the back rest is filled with diagonal grillework. Schinkel himself obviously felt that this was his best design, for he had this bench cast most frequently and installed it in all the parks in Berlin and Potsdam.[107] It marks a high point in the creation of cast-iron garden benches in the second quarter of the nineteenth century.

A design for a chair was also created in 1824/26 for the park at Schloss Glienicke; initially, it may appear alien as a piece of garden furniture (PLATE 60). The extremely slim legs and supports for the rests do, however, make it clear that this product is made of cast iron, however much it may remind us – the seat especially – of an indoor wooden chair. To prevent the pointed legs from sinking into the ground, the front ones were linked to the back ones by rails (the iron bands going crossways are a later addition). Not only the whole form but all the details too, such as the inserted rest with the delicate vine scrolls and the palmette which grows out of the form of a capital, were repeatedly used by Schinkel on furniture as well as on architectural elements.[108] This model of chair was still available from the Gleiwitz foundry in 1847.[109]

Schinkel's most successful model, however, was a chair with armrests which must have first been cast c.1830 for the Römische Bäder in the park at Potsdam (PLATE 63). The 'Empire references' typical of Schinkel are now more subdued, becoming no more than decorative accessories to a timeless form in which one can almost feel the iron flowing. There are no sharp corners or angles, with each individual member curving into the next one. Because of the double-T cross-section of the 'rails' of the frame, a good structural form, the material used – and hence the weight – can be reduced still further. Even the seat now consists of iron too, no longer of wood or stone. Rainwater can run off between the close-set round rods. Unlike the four benches considered so far which were obviously produced only for the royal gardens, this garden seat went into general production and was also cast in other Prussian foundries. It is an open question whether Schinkel himself was responsible for a still more

drastic reduction omitting the cloven feet, rams' heads and palmettes (PLATES 61, 62).[110] In any case, even on these simplified models, the Schinkel motif of the winged lyre surrounded by scrolls can be found on the back rests in two different versions. From Winterthur in Switzerland to Rendsburg in the extreme north of Germany, from The Netherlands to Bohemia, almost all foundries cast copies of this chair – almost always the first more richly decorated version, sometimes expanding it into a bench (PLATES 66, 68). The earliest dated example is in the 1836 catalogue of Prince Fürstenberg's Amalienhütte in Bachzimmern. In the iron foundry and machine factory established at Güstrow in 1836 by Carl Andersen, a pupil of Schadow,[111] a bench of this type was cast, but at the same time the type was developed further (PLATE 70). Presumably Andersen's brother-in-law, the sculptor Heinrich Kaehler (1804–78) who took the business over in 1846, designed the furniture. He created a new motif for the back rest with palmettes and horns of plenty; on the underframe (PLATE 67) there are again the cloven feet which here curve up in elongated scrolls. Over ten years later the 'Schinkel bench' was still being copied in America, enhanced with modest rococo elements on the fillet and back rest, and using the seat with openwork scrolls so popular there (PLATE 73). The Andersen underframe is also found in American pieces (PLATE 74), but again in association with Schinkel's back motif. Thus not only did Schinkel design the earliest iron furniture, but also the model most frequently copied and produced in the first half of the nineteenth century.

During these years Schinkel also experimented with using cast parts – not invariably cast iron – on other furniture;[112] furniture cast in bronze was also made to his designs, for example for the diminutive Schloss Charlottenhof and the Neuer Pavillon in Charlottenburg.[113] A small ornamental table made in 1824/26 for the Berliner Schloss, very similar to the one made for Charlottenburg, is again pure cast iron (PLATE 206). The tightly rolled grooved scrolls growing out of calices of leaves are a motif that was used by Schinkel again and again (PLATES 57, 60).[114] Moreover, this little table is completely gilded; it was not therefore intended to be recognized as iron furniture, and this also applied to all other furniture made for royal dwellings where iron was used. The combination of white lacquer and gilding is also found (PLATE 208). Nearly always the tables have marble tops (PLATE 210),[115] and seating where there are cast parts is invariably upholstered. Thus, while iron as a material made the delicate ornamentation and dainty forms possible, it here seemed to require some ennoblement.

However, Schinkel appears also to have designed a garden table cast entirely in iron (PLATE 209). The kinked lion's feet which grow out of leaf scrolls are also found on other furniture by Schinkel (PLATE 208),[116] as is the grooved shaft which climbs up out of a calix of leaves. The tops of his little ornamental tables, with decorative bands arranged in the shape of a ring and vegetable and geometric forms interspersed, are also comparable.[117]

Schinkel's name remains closely and significantly associated with cast-iron furniture. A great artist left his unmistakable mark on these early products of what was shortly afterwards to be made by mass production. The fame of Berlin cast iron which was soon to spread throughout the world was largely due to him.[118] Schinkel made the potential afforded by the material and the technique of working it – casting – the basis of his designs. He was therefore not subject to any coercion which would curb his creative power, but at the same time he did not allow himself to be seduced by the material's compliance and the possibilities of working it. His cast-iron furniture is still furniture in the spirit of late classicism, constructed and conceived by an architect.

# Cast-iron Gothic

ON 14 November 1836 Washington Irving asked his friend, the painter George Harvey (1800/ 1801–78), to design an iron bench.[119] Since 1835 Irving had been creating his romantic residence known as Sunnyside in Tarrytown on the Hudson in association with Harvey and it was in the garden there that the bench was to be installed. Irving, in fact, already had certain ideas about how this garden furniture should look, as it had to fit into the ambience of his historicist creation. Irving was widely travelled, and in designing Sunnyside he was following a tradition which had started 70 years before with Horace Walpole's Strawberry Hill, at Twickenham, west of London: a seventeenth-century house transformed into a Gothic fantasy. The neo-Gothic started from a romantic and historicist concept which was realized in many park buildings dating from the second half of the eighteenth century, and had meanwhile undergone a change of meaning. As the nineteenth century became increasingly mechanized, the rational nature of Gothic design with its masterpieces of architectural technology, the cathedrals, became ever more important. It was almost

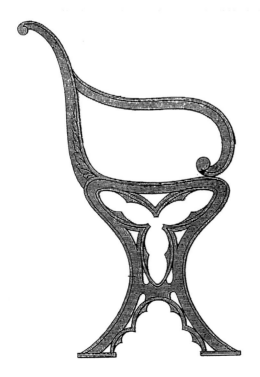

End of a garden bench from pattern sheet no.6 of the Grossherzoglich Badische Hüttenverwaltung Zizenhausen, c.1830/40.

logical that the Gothic decorative form of tracery – pure construction on the one hand, individual elements flowing into one another on the other – should become the ideal starting point for cast-iron ornamentation. Tracery combines the necessary individual parts by means of its simply constructed form, while being decorative and transparent in structure, thus achieving stability with very little weight, a necessary requirement for a piece of iron furniture. Consequently Irving's bench for Sunnyside consists simply of a sequence of very elementary tracery forms (PLATE 71). The West Point foundry in Cold-Spring-on-Hudson was responsible for casting after Harvey's drawing.

Of course, this bench was anticipated by the wrought-iron garden furniture of the late eighteenth century, such as the armchair from Temple Newsam House (PLATE 15), yet the step from furniture that was riveted together to cast furniture is clear. The three Gothic arches on the back rest are clearly inserted into the larger arch, the small quatrefoil has to be secured individually with bands of iron. On the other hand the tracery and the overlapping forms of the back and arm rests and legs of the bench grow out of one another, they 'flow' as a single entity from one end to the other. The seat consisting of a honeycomb pattern was completely novel and developed entirely from the casting technique, and in this Washington Irving's bench as a piece of cast-iron furniture is even more logically designed than Schinkel's benches for example, where the seat is made of wood, stone or iron rods.

The tracery bench from Sunnyside, the joint creation of two artists, gave a new direction to cast-iron Gothic which had started modestly in the first cast-iron bridges of the eighteenth century, and continued throughout the nineteenth century in a variety of fields, ranging from window-frames[120] through machine parts to railway station buildings, church steeples and even church buildings.[121]

'The introduction of iron into the furniture of farm houses would be attended with considerable economy,' John Claudius Loudon wrote in 1833.[122] Except when the examples he depicts are completely ordinary utilitarian items, they all illustrate neo-Gothic forms (ILL. p.16). Loudon recommends brackets for wall-tables (the top two rows of the figure) and table-ends (the bottom two rows), the latter mainly for 'country inns, taverns and coffee-houses…; and this is already becoming frequent in London. The Albion Tavern, at Drury Lane Theatre, may

be referred to as an example.' While the round table with a wooden top (ILL. p.18), as Loudon comments, seems appropriate for a country house, the two chairs are again intended more for country inns, the big chair 'for the entrance hall of an inn, or even a villa'. He provides the following explanation regarding the three-legged chair:

> This chair would do well for a luggage chair in inn bed-rooms; it being found convenient to have one strong chair with a boarded bottom in each bed-room, on which to set the trunks, etc., belonging to the guests, to prevent the lighter chairs from being injured by the weight.[123]

Thus the fear of damaging wooden furniture could become a motive for making iron furniture.

The designs for the neo-Gothic cast-iron furniture in Loudon's *Encyclopædia* were the work of Robert Mallet (1810–81) who had been joint owner of his father's iron foundry in Dublin since 1831. It should cause no surprise that he too used Gothic elements in his designs. It was in the fourth decade of the nineteenth century that there was in fact a marked increase in designs for the decorative arts using Gothic forms. *Der Bau- und Möbelschreiner*, the pattern book of the Nuremberg architect Carl Heideloff with designs for furniture exclusively in the Gothic style, was published from 1832 to 1837. In the second issue of his book of patterns published in 1834, Friedrich Wilhelm Mercker writes that 'in our times there are often demands

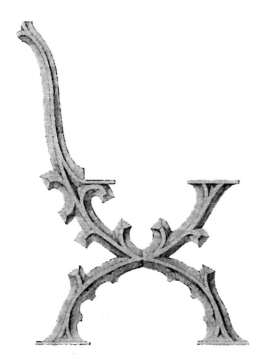

End of a garden bench from catalogue of
Clus and Choindez foundry, 1859.

for decorations in the Gothic style'.[124] Augustus Welby Pugin's influential work *Gothic Furniture in the Style of the Fifteenth Century* was published in 1835,[125] the same year as Thomas King's *Specimens of Furniture in the Elizabethan and Louis Quatorze Style*. Richard Bridgen's *Furniture with Candelabra and Interior Decoration*, which followed at the end of the decade in 1839, also included Gothic designs.[126] In Germany the neo-Gothic furniture in Schloss Rheinstein, Schloss Stolzenfels, Schloss Hohenschwangau and the Schloss in Detmold was made in these years.[127] In 1836 there was a classicist and a neo-Gothic design for the rebuilding of the Houses of Parliament in London, and the neo-Gothic one was chosen. All over England castles and manor houses were Gothicized during these years, or built from new in the Gothic style. In 1836 the Cambridge Camden Society was founded for the promotion of Gothic architecture. In France the *style à la cathédrale* was at its height, not uninfluenced by Victor Hugo's historical novels, particularly *Notre Dame de Paris* published in 1831.

For the iron industry, the 1830s were a decade of rapid expansion. Right across Europe and America railway building was in full swing. This meant a huge increase in the need for iron production, starting with the rails and including the carriages and engines with their wheels, rod-linkage and boilers, not to mention all the screws, rivets and nails. The railway for its part made it possible for the iron works and foundries to expand production in an undreamt-of and constantly progressing way. The transport of iron ore and coal became easier and faster, meaning that foundries could be set up wherever they were wanted. With the increase in production, the use of neo-Gothic ornament, recognized as lending itself well to casting as well as being good from the structural point of view, spread at the same time, being applied wherever possible.

A bench which must have been designed between 1830 and 1840 and cast for the first time by James Yates in Rotherham soon became extremely popular and continued to be so virtually throughout the century (PLATE 83). The model could be supplied in any length required, or even shortened into a chair with armrests, and there was also a table to go with it (ILL. p.17). Copies of this bench were cast on the Continent by the Fonderie de Calla fils in Paris, Bohemian foundries in Plass and Stiepenau, the iron foundry of L.I. Enthoven & Co. in The Hague,[128] and possibly also Russian foundries,[129] as well as in America by Janes, Kirtland & Co. in New York – where it was still available in their 1870 catalogue. However, copies were quite certainly also cast in other foundries too. The steep zigzag ornament with the trefoils and quatrefoils inserted

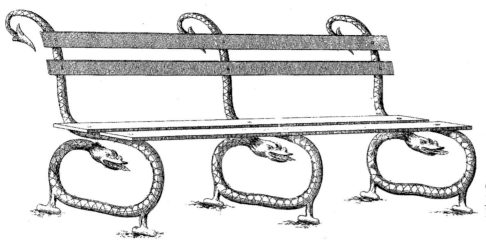

Garden bench from catalogue of
Johann Georg Neher iron foundry,
Lauffen am Rheinfall, *c*.1850.

into it has no direct model in the Middle Ages. It is an infinitely repeatable ornament specially developed for casting: with its straight members crossing over one another it reveals a new, almost mechanically-minded way of thinking. The semi-circle inserted into the armrests, while it derives its form from a Gothic tracery rose window, also has something of the character of a flywheel. The wave meander with Gothic cusps on the border stretched between the legs of the table can also be endlessly repeated, just as the dense honeycomb of the seat surface can be extended to form the table top. Its clear, simple, severe forms, which borrow fairly reticently from the Gothic, make it easy to understand the enduring success of this particular model.

The possibility of the endless repeat in Gothic tracery was also exploited by the architect François Thiollet (1782–1859) in a bench and a chair made by the foundry of M. Ducel fils (ILL. p.20). The model, published in his comprehensive book of patterns *Serrurerie et font de fer* in 1832, is richer, more detailed and playful than the British bench, but like it was copied by other foundries, for example by the iron foundry of L.I. Enthoven & Co. in The Hague. Another French chair which was cast by the Fonderie du Val d'Osne, probably in *c*.1840, is richly and playfully decorated with Gothic ornamental forms interspersed with orientalizing and Empire-style motifs (PLATE 88). It, too, was copied by Enthoven, with slight modifications, as well as by another Dutch foundry, De Prins van Oranje, and in 1847 by the Württemberg foundry at Wasseralfingen.[130]

Small applied art objects such as paperweights, inkwells, clock-stands, candlesticks, caskets and boxes made from blackened cast iron were a very important and extensive branch of production for the Prussian foundries in particular. 'Furniture' made an appearance here, too, for example in the pin cushions in the form of little chairs, again with

Gothic decoration (PLATES 84, 85). Both pin cushions were made in Gleiwitz between 1830 and 1834 and must also have been produced over a longer period. There is another version of the throne-like model where the tracery arcade in the back rest has been replaced by a mirror.[131] The playful approach towards stylistic models is revealed particularly in the smaller miniature chair with its naturalistic lion's feet and the lilies at the top of the back rest: they would appear to have been inspired by Empire models.[132]

Among the great designs of this early period of cast-iron furniture – such as Schinkel's grille bench (PLATE 59) and his armchair (PLATE 63), Washington Irving's bench (PLATE 71) and the garden bench of James Yates, Rotherham (PLATE 83) – we must include a seat only known to us through a 'pattern drawing' from the office of the Grand-Duke of Baden's foundry at Zizenhausen (ILL. p.25). The way the support rail for the seat curves into the legs which for their part are brought together to a middle fillet surpasses even Schinkel's armchair in elegant functionalism, though the connection of the seat and the back rest is resolved more convincingly by Schinkel. The tracery ornamentation stretched between the T-rails on the Zizenhausen bench is powerful, yet restrained; the acanthus leaf fitting closely to the back rest is again a reference, albeit very discreet, to the Empire style.

A flower-stand which was to enjoy great and lasting popularity as a form (ILL. p.22) was made right at the end of this innovative fourth decade of the nineteenth century. The first time this three-stage frame is illustrated is on the first plate in the *Gewerbeblatt für Sachsen*, year 5, 1840, but with no indication of the designer or even the foundry. It may have been created a short time before at the foundry of the Gebrüder Sulzer in Winterthur, and the cast copied soon afterwards by the Carlshütte in Rendsburg,[133] the Prinz Rudolph-Hütte in Dülmen, the Georg Neher iron foundry in Laufen am Rheinfall and another Swiss firm

Von Roll[134] – in whose 1891 catalogue it was still featured. In Von Roll's 1859 catalogue there is a bench, which may in fact have been designed rather earlier, which takes up the motif of the folding chair and is reduced completely to the rails required for its construction; its Gothic character comes only from stumps growing out like branches (ILL. p.26).

The neo-Gothic style remained popular for iron furniture throughout the nineteenth century: to such an extent that the description 'Gothic' almost became a trademark. The extraordinarily well-liked model of a bench created in 1846 using heavy rococo forms (PLATE 92) is described in some catalogues such as that of the Carron Company as a 'Gothic Settee', no doubt because of the grille or mesh-like design of the back rest, though we may search in vain for any Gothic elements.

On 5 February 1855 what must be the most important English foundry, the Coalbrookdale Company in Shropshire,[135] registered the model of a bench in extravagant neo-Gothic forms (PLATE 119) at the London Designs Office. The Gothic ornamentation of this bench again has no direct model in the Middle Ages; it is just as far removed from it as the severe models of the 1830s (PLATE 83), admittedly not as a result of reduction as there, but on the contrary as a result of piling on motifs. A free-ranging imagination looks first of all for vegetable elements in Gothic ornament. The Gothic 'thistle-leaf' grows wherever possible in the empty surfaces and rises up in the middle, and long-drawn-out vines seem finally to make the tracery sway. In the vine scroll work on the armrest (PLATE 121) there are dragons resembling the water-spouts on the eaves of cathedrals. Here the designer has taken up a fashion which emerged immediately after the middle of the century for using naturalistically reproduced fruit, flowers and all sorts of vegetation as decorative elements, and succeeded in combining it with neo-Gothic tracery forms.

Such a lavish and consequently expensive model as this bench was intended for the parks of the great English country houses, while more modest models were available for public areas. One bench of this type (PLATE 144) must have been created in the 1860s. The Gothic arches are simple and robust; in association with two small wheels – pierced with holes as railway wheels then were – this support element looks more like part of a machine than part of a piece of garden furniture. Moreover, the converging backward and forward curves of the rails forming the construction first used by Schinkel (ILL. p.25; PLATE 63) are here developed into a form which continued to be used for a long time for park benches where the seat and the back rest, fitted with slats, merge into one another.

Of course, there were also tables (PLATE 236) and beds with Gothic forms. A cot in Washington, for example (PLATE 282), in line with the designation at the head of the bed, 'NOYES & HUTTON PTEN'D SEP'T 1851', is a product of that foundry in Troy in New York State.[136]

———⟫●⟪———

Relatively few pieces of neo-Gothic iron furniture have been preserved. As has already been said, great losses have resulted from it being melted down. But over and above this, the destructive fury was directed particularly against neo-Gothic pieces. The intellectual style of the Gothic always had less chance of survival than any classical style. Neo-Gothic has suffered even worse. Examples of early neo-Gothic architecture have always been quite cheerfully sacrificed from the late nineteenth century on, and neo-Gothic buildings ruined in the Second World War, unlike their classical counterparts, have rarely been rebuilt. Cast Gothic items too, which were such an important component of the cast-metal output of the first half of the nineteenth century, shared the same fate.

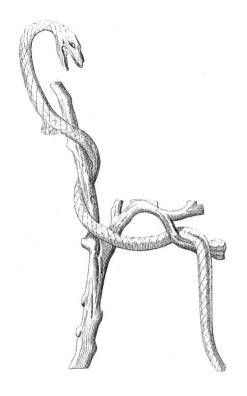

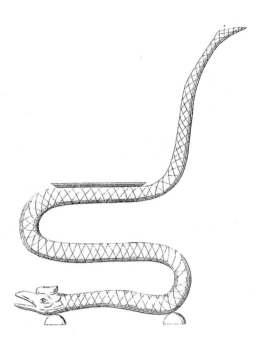

Ends of garden benches from catalogue of A. Sterkman & zn., De Prins van Oranje, s'Gravenhage, c.1840/50.

# Nature made of iron

THE inexhaustible supply of models from all periods and every region of the world available to the artists and craftsmen of the nineteenth century was (and still is) the great danger inherent in historicism – as in any enthusiastic immersion in the world of the past. It is typical of the intellectual approach of the period that its representatives, who certainly did not want to be mere copyists, were always self-critical and constantly in search of a 'genuine', 'true', 'individual' style. Around the middle of the century, at a period which took a particular delight in experiment, a certain fatigue resulting from repeated adoption and adaptation of models from a diversity of styles and periods led to a new, completely different approach, to some extent turning away from stylistic models from the past and towards nature. It now seemed that salvation lay in a realistic reproduction of the beauties nature gave freely to all. In 1849 the artist and theorist Richard Redgrave (1804–88) noted in the *Journal of Design* which he edited: 'The source from which everything new in ornament is to be derived, is the boundless stove of Nature.' And Theodor Fontane wrote in 1853: 'Realism in art is as old as art itself, or rather it is art.'[137] Eduard

Metzger's pattern book, *Ornamente aus deutschen Gewächsen zum Gebrauch für Plastik und Malerei,* in which the author turns against the ever emptier tradition of forms from the past, had appeared as early as 1841. As models for the decorative arts of his day, he advocates 'the motifs which nature not only freely offers to art, but presses upon it'. It was reported in 1855: 'In English and even more particularly in French furniture production a characteristic use of real, i.e. non-stylized, natural forms has recently gained ground.'[138] In England Christopher Dresser (1834–1904) had been publishing his programmatic articles on the necessary influence of botany on the arts and crafts since 1857.[139] At the Universal Exhibition of 1855 Gustave Courbet exhibited his pictures in his own 'Pavillon du Réalisme'; the following year the journal *Le Réalisme* appeared in Paris. In England furniture was made in this 'naturalistic' style between 1848 and 1853 after designs by Henry Eyles, Hughes Protat, John Thomas and others,[140] while in America it was predominantly the furniture of John Henry Belter on which naturalistically reproduced flowers and fruit were the only decoration, but similar examples have also been preserved from every other

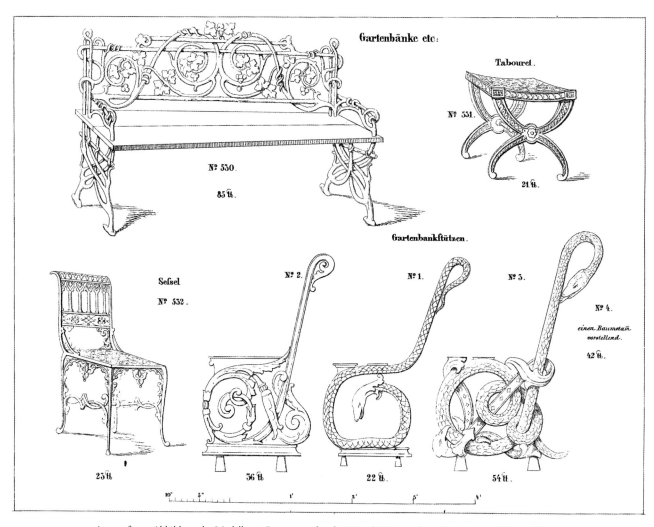

A page from *Abbildung der Modelle zu Gusswaaren bei der Königl. Württemberg. Eisengiesserey Wasseralfingen.*
Stuttgart 1847.

country.[141] 'Naturalism', which was talked of even by contemporaries, was finally taken so far that household articles were made from genuine antlers,[142] and this in turn resulted in furniture being carved from wood in such a way that it looked as if it had been made from genuine antlers.[143] So what could be more logical than making furniture for the garden, to be used in nature, that itself looked like a piece of nature?

A 'Rustic Settee' was first cast probably in the foundry of McDowall, Steven & Co. in Glasgow[144] in the early 1840s; it appears to consist of dried-up oak branches with just a few leaves tied together (PLATE 106). In fashioning garden seating in this way designers were completely at one with the garden theorists. They had suggested 80 or 90 years earlier assembling chairs and tables from branches and placing them in secluded spots in the garden.[145] Needless to say, this can be done much more advantageously in cast iron. No laborious search for suitable branches is required, no structural problems have to be overcome. After the model has been prepared once, it is possible to reproduce a playful trifle thousands of times in an enduring material. Naturalism is of the utmost importance in this model. The branches are laid together completely asymmetrically and irregularly, and even the cords tying them together have not been forgotten. Even where the seat is concerned comfort is disregarded. Yet this model was a huge success, especially in the United States where there are records of twelve firms from whom this bench could be obtained. There were copies and imitations in German foundries, too.[146] It continued to be cast right up to the end of the century, although sometimes only the ends, with the uncomfortable seat made of cast branches and the matching back rest being replaced by wooden planks.[147]

In a simplified form, a bench apparently assembled from dry branches became the most popular and widespread model of all garden and park benches up to the present day. Reduced to the ends, with or without armrests, all these models in fact go back to designs which were made between the 1840s and the early 1860s. John

Claudius Loudon even had an early, much simplified model in his book on the Derby Arboretum which was published in 1840; the benches are still there today (PLATE 102).[148] On these benches the armrests roll forwards to form scrolls, which is in fact at variance with natural growth, whereas on all other models (PLATES 103, 108) the armrests are arranged horizontally. However, the majority of these branch benches have no armrests, but the legs and back rests demonstrate the widest variety of shapes (PLATES 100, 101, 104, 107). This branch-work also seems well suited to double benches (PLATES 128, 130) as well as for benches where the seat curves into the steeply inclined back rest, which can give rise to some odd forms (PLATES 109, 129, 131). In 1851, the year of the Great Exhibition, the Coalbrookdale Company produced another branch-work bench, now in the exaggerated, extravagant forms of the mid-century, but more structured and perfected as garden furniture than the model designed more than ten years earlier (PLATES 106, 111, 118). Copies of this bench too were cast by several foundries.[149] Finally, the knobbly branches can also be replaced by bamboo or the dry vines of creepers (PLATES 99, 136) and these can then also be interspersed with leaves and fruit, and so to some extent still be 'fresh' (PLATES 134, 160).

This brings us to another important aspect of the use of forms from nature.

The move towards nature as a model for the artistic design of equipment of all kinds in the mid-nineteenth century was, of course, the result of what had gone before. From the second half of the eighteenth century a new cult of the garden, now extending to the middle classes, had

got under way. A large number of specialist publications provided horticultural expertise for their readers. Flowers played an ever larger role, particularly in the first third of the nineteenth century. Those who could cultivated them in their gardens and greenhouses, on balconies and in their houses. People were familiar with plants of all sorts and knew how to use the 'language of flowers'. A special class for flower-painting had been held at the Academy in Vienna since 1812. With the branch-work bench, the 'Rustic Settee', the mid-nineteenth-century enthusiasm for nature that was also reflected in many literary works – poems, sentimental songs, short stories and even the most trivial family magazines – found a materialization that expressed the age in a peculiarly typical way. Using iron, the popular material of the century and indicative of progress, human beings succeeded in manufacturing everything they wanted, even nature itself. At the very point when nature was being destroyed as a result of the rapidly expanding industrialization of the world, people were trying to capture the beauties of nature and collect them around themselves, using the resources of those same destructive industries.

It is still possible to see the – apparent – origin of the 'Rustic Settee' (PLATE 106) from looking at it: the branches have been taken from nature by man, and as they obviously appear to resist being transformed into a bench they have been tied together with cords. But then a further step was taken towards 'pure nature' in a model that was soon just as popular, the 'Vine Pattern Garden Seat',[150] which was cast shortly before 1850, possibly first at the foundry of Charles D. Young & Co. in Edinburgh (PLATE 114).[151]

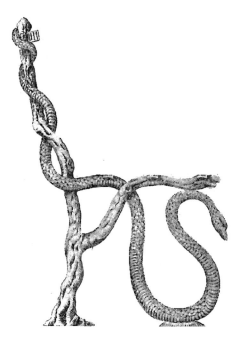

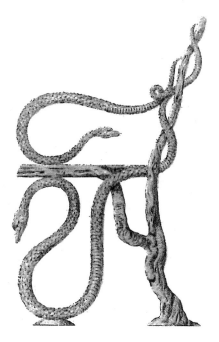

Ends of garden benches from catalogue of the Von Roll Iron Works, Solothurn. c.1850.

Nature itself now seems to flow straight out of the blast furnace. No cutting or tying hand has been active here, the vine tendrils sprout and wind as they apparently please – but mainly, in fact, as the caster pleases. It is he who ultimately has the power to let the leaves grow so large that they form legs capable of providing support for the bench and the person sitting on it. Copies of this bench, too, were soon cast on the Continent – we know of examples from two Bohemian foundries[152] – and it was so popular in the United States that hardly any of the major foundries there failed to produce it.[153] It remained available throughout the second half of the nineteenth along with many similar botanical siblings.[154] One of these was the very popular 'Fern and Blackberry Settee', of which many casts were produced; the Coalbrookdale Company registered it with the Designs Office in London in 1858 (PLATE 142). As was generally the case, it could also be supplied as an armchair (PLATE 150) and with an iron or a wooden seat. Copies were cast by McDowall, Steven & Co. in Glasgow, J. & C.G. Bolinder in Stockholm[155] and at least eight American firms,[156] and it was probably even produced in Melbourne.[157] In contrast to the 'Vine Pattern Settee' where nature appeared to ramble free, here one seems to sense an ordering hand: the intertwining fern leaves are arranged with strict symmetry and are held by a band running round them; the blackberries are suspended in small square 'meshes' in the band. Replacing the various honeycomb patterns of the seats (PLATES 83, 113) there are now openwork interlacing scrolls which had already also

been used on the second model of the 'Vine Pattern Settee' (PLATE 112).

The kinked band running round is featured in a similar way on two other garden benches which were developed a few years later, again at Coalbrookdale: on the 1860 'Laurel Settee' the plants on the back rest are ranged one beside the other in an orderly fashion, and the legs are no longer shaped like plants (PLATE 147). They have been replaced by swans stylized as one-legged creatures. The leaves of the 'Lily of the Valley' model (PLATE 158) are more densely intertwined; it was registered in 1863 as a 'single' and in 1864 as a bench, which could as usual be supplied as a three-, four-, or five-seater with a wooden or an iron seat.[158] The 'Passion Flower Settee' which the Coalbrookdale Company registered in 1862 (PLATE 149) also has one-legged birds as front legs and armrest supports; copies of it were cast in America by J.L. Mott, New York and Chicago[159] and the Kramer Brothers, Dayton, Ohio. Another series of models created in these years moves still further away from 'pure nature'. Vine foliage with its own bunches of grapes climbs over a grille, of the type already familiar from one of Schinkel's benches (PLATE 59), on a bench which the Yates, Haywood & Co. Works in Rotherham registered in 1854 (PLATE 117).[160] In outline it is reminiscent of sofas from the second rococo period, apparently marking the start of a tendency which was to become increasingly important in the latter part of the second half of the nineteenth century: a move towards forms used in wooden furniture. In the 'Oak and Ivy

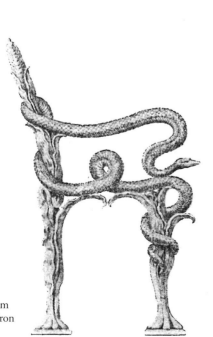

Ends of garden benches from catalogue of the Von Roll Iron Works, Solothurn. c.1850.

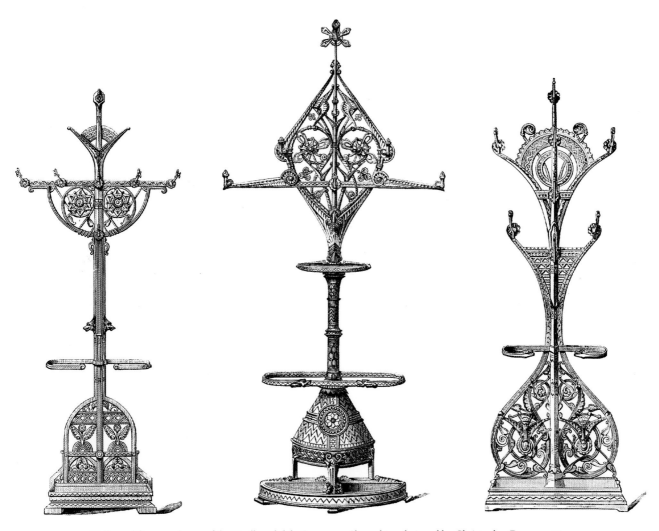

Hall stand from catalogue of the Coalbrookdale Company, Shropshire, designed by Christopher Dresser, 1867.

Garden Seat' (PLATE 143) the legs have a distant resemblance to a wood-carved rococo piece of furniture and the armrests are reminiscent of an upholstered sofa. The long-drawn-out vine-like branches with the oak foliage here become a geometric ornament. The sculptor John Bell (1811–95), who worked for Coalbrookdale on several occasions,[161] designed this bench which was registered at the Designs Office in 1859; he also supplied designs for papier mâché furniture and for ceramics and glass. As always, these models were again copied and cast by other foundries.[162] Reminiscences of upholstered furniture for the interior can also be detected in the almost cubically shaped 'Convolvulus Settee' (PLATE 146) that was first cast c.1855 in Coalbrookdale, but from 1858 was also copied in Philadelphia at Wood & Perot[163] and in the Carlshütte in Rendsburg. The matching chair was obviously much more popular than the bench, and is known to have been copied by nine American firms, sometimes with different legs.[164]

Vines with no leaves at all or only a few (PLATES 99, 133, 160) are also woven into severe ornamental forms in which

'living' birds can then dart about (PLATES 120, 133, 157, 305). There was absolutely no reticence either about casting the animal world in iron, with an initial preference for snakes. Perhaps it is the serpent from the Garden of Eden itself that has crawled out of the hellfire of the blast furnace and been forced to become a bench support (PLATES 94, 95). This type, too, must first have been cast in England shortly after 1840;[165] but it is soon found in the widest range of variations in the production of several foundries on the Continent (ILLS. pp.27, 29–32). Sometimes it is one snake on its own; sometimes it is wrapped round a dry branch; and there may even be two snakes with their tails touching. Was it the legendary cunning of the snake that was being used, was the intention to banish the danger with which these creatures can threaten people out of doors, or was it the (pleasant?) shudder in anticipation of the poisonous bite that led to the ever renewed designing of snake benches of this kind? As late as 1875 John Ruskin, who did not really appreciate cast iron as a material, poked fun at these benches (PLATE 94) in his *Fors*

*Clavigera*:[166] 'So they are supported on iron legs, representing each, as far as any rational conjecture can extend – the Devil's tail pulled off, with a goose's head stuck on the wrong end of it.'

In any case, the snake has the ability to coil up and so adopt every conceivable form, and this fascinated the designer of cast-iron striving to reproduce nature. Even in the 'Rustic Settee' (PLATE 106) two snakes are coiled side by side round the legs and round each other and end up nibbling the oak leaves hanging down from the seat. They are usually concealed in the lower part of the benches and seem also to relish grapes (PLATES 96, 110). For the designers of these seats the structurally important bracing in the underframe could be given a 'naturalistic' trimming by means of these snakes. But they also lend themselves to being used for the upper projections on umbrella stands or stands for fire irons (PLATE 313); many foundries expended a great deal of imagination on designing such small items of furniture as these.[167]

The dogs' heads which adorn the armrests on some benches deserve attention (PLATES 96, 143). John Bell, the designer of the 'Oak and Ivy' bench, exhibited a 'Deerhound Centre Table' (PLATE 230) at the 1855 Universal Exhibition that was widely acclaimed at the time (and again recently).[168] The showpiece table cast at Coalbrookdale takes naturalism to its extreme limit, especially in the lifesize dogs which support the serpentine top. The rim consists of cast-iron branches with leaves and fruit, there are trophies of the hunt hanging in the middle, the central column is formed from intertwining stems of ivy, but the leaves from which the fillet is made are transformed into elongated scrolls. The dogs modelled from nature are wearing collars with the coat of arms of the Hargreaves family from Broad Oak, proof of the fact that this table was not a showpiece made solely for the Universal Exhibition, but had been commissioned by a private client. As the casting forms had been made, the table remained available from the foundry, but apparently there were no further orders.[169]

However, there were also simpler tables in the naturalist style of the mid-century, primarily made to go with the branch benches (PLATES 214, 125). The small table with the thin leafless branches is like similar models in issue 2 of the Wasseralfingen catalogue which must have come out in 1847 or shortly afterwards.[170] But similar tables were made at Isselburg, Lünen and Stockholm, too. Vine scroll work interspersed with leaves and even flowers such as occurs on many benches (PLATES 106, 117, 134) can also be found on various small items of furniture (PLATES 341, 342).

Naturalism also spawned some monstrosities, such as the hallstand 1.70m tall that marks the end of this trend

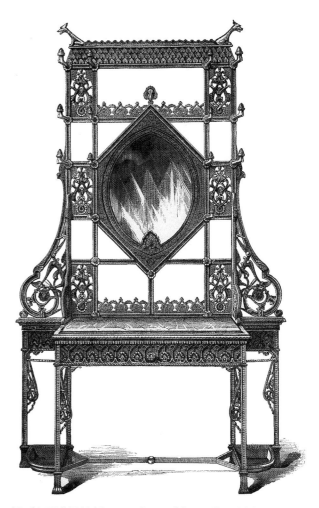

'Gothic Hall Table' from catalogue of the Coalbrookdale Company, Shropshire, designed by Christopher Dresser, 1867.

(PLATE 298). The temptation casting in iron represented for the designer, where everything is possible, here led to the unhappy combination of a seemingly naturalistic cast of the talon of huge mythical bird with a bird of paradise growing out of a leaf in mannerist style and a dry branch growing out of its beak – like a spout of fire with the flames frozen; the whole thing virtually makes a mockery of naturalism.

But attempts were also made to move away from naturalism in a disciplined manner. The leafwork on a bench produced at Coalbrookdale in 1866 is tightly ordered, ornamentally regulated and inserted between decorative bands (PLATE 170). This 'Nasturtium Settee' may well have been created partly under the influence of models by Christopher Dresser, as is also the case with the 'Horse-chestnut Settee' (PLATE 168) which Coalbrookdale registered with the Designs Office in 1868.[171]

The period when designers wanted every decoration on their manufactured products to be as exact a reproduction as possible of nature came to an end with Christopher Dresser. Dresser was a superb artist with a

special bond with nature, and he did in fact see it as an important model for design, but only as a departure point for his personal, innovative style of ornament. He was born in Glasgow in 1834 and in 1847 at the age of thirteen entered the School of Design at Somerset House.[172] While there, in 1852, he heard lectures by the famous botanist John Lindley who fired his enthusiasm for that science. He trained as a botanist and as early as 1855 taught 'Art Botany' at the School of Design. In 1857 and 1858 he published a series of articles entitled 'Botany, as adapted to the arts and art manufactures' in the *Art Journal*. In 1859 he published two purely scientific works on botany for which he was awarded a doctorate by the University of Jena the following year. However, in the end his inclination towards artistic creation won the upper hand, and as a result he became the first 'product designer' in the modern sense. In 1860 he founded a studio which soon employed a dozen people. Designs for ceramics, glass, metal, fabrics, carpets, linoleum, wallpaper and furniture were created there. At the 1867 Universal Exhibition he exhibited a few of his own works, including a cast-iron garden bench, which as usual could also be supplied as an armchair (PLATES 166–67). Coalbrookdale had registered the model at the Designs Office under the name 'Water Plant' on 18 February 1867; it was also exhibited at sub-sequent universal exhibitions,[173] proof of his pre-eminence within the arts and crafts world of the second half of the nineteenth century. In his designs for all media Dresser developed a very personal, sometimes surprisingly fore-sighted style. The transformation into ornament of leaves and flowers which seem frozen like ice-flowers – as for example in the 'Water Plant Pattern' – reveals the morphological approach of the botanist. But structural thinking underlies the total design which treats all structurally important parts as technical forms, leaving them visible and undecorated. In designs made for Coalbrookdale at the same time or only a short while later (ILL p.33; PLATES 319, 321) models from nature – buds, flowers, leaves, but still snakes as well – are intermingled with models from Romanesque or pre-Romanesque nordic art, so that Dresser is here indebted to the historicist proclivities of his century. (It has recently come to be thought that his colleague John Moyr Smith played a substantial role in their design.)[174] The pure naturalism of the mid-nineteenth century which had a more diverse and consistent impact on cast iron than on any other field of arts and crafts now came to an end both in England and on the Continent. Writing as early as 1863 Jakob von Falke said, '…it should be considered a fact that naturalism has already reached its height, or already passed it'.[175]

# Registered British furniture models

PROTECTION of patterns and designs giving the originator of a work of art or handicraft design a safeguard against his work being copied for a certain length of time was first introduced in France where the appropriate regulations were passed in 1744 for the benefit of the Lyons silk weaving trade. In Britain, Parliament passed similar laws in 1787, 1789 and 1794, again especially for textile patterns, though with a period of protection of only three months. The Garrard Act of 1798 went much further, ensuring all artists 'making new Models and Casts of Busts, and of Statues of Human Figures, and of Animals' sole rights for fourteen years. The author in question had to put his name and the date of 'publication' on the work of art.[176] All copies, if any were forthcoming in spite of the law, were destroyed.

The Design Copyright Act of 1839 extended the protection for textile designs 'and to designs of the ornamen-tation, shape or configuration of most other manufactured articles' to one year, and for designs in metal to three years. Another law, which remained valid until 1883, was passed in 1842, dividing the 'ornamental', i.e. artistic, output to be protected into thirteen categories, with periods of protection of varying lengths. Class I included all objects made from metal, from buttons and buckles by way of teapots and chandeliers to fire-surrounds and furniture, which continued to be protected for three years. A drawing of the item to be registered had to be lodged at the Office of the Registrar of Designs (Designs Office) where it was given a number. That number, or from 1842 a mark, the 'Diamond Mark', was to be applied to the object. From the mark, which had the letters 'R^{d}' standing for 'Registered' in the middle, the exact date of registration could be deduced (see page 37). A law passed in 1843 also protected 'useful articles' not based on an artistic design, again for three

years. A revision of the 1842 law, the Patents, Designs and Trade Marks Act of 1883, again removed all classifications; registration took place in the sequence of entry starting again from no.1, with no distinction made between 'ornamental' and 'useful' and irrespective of the material; the Diamond Mark was scrapped.

The illustrations of the items to be registered were stuck into outsize folio volumes in the Designs Office, together with the number.[177] Generally, they are in the form of pen and ink drawings. However, a few firms sent the relevant illustration cut out of their printed catalogue: thus furniture manufacture had already achieved a certain standing if the first examples had not already been cast. The Coalbrookdale Company, always in the vanguard, even started submitting photographs of the finished furniture to the Designs Office from 1855 onwards. Two parallel registers were kept, one for the firms making the applications and the other for the date of registration to be recorded; but unfortunately neither recorded the name of the artist designer.

Looking through these volumes gives an interesting overview of the production of cast-iron furniture between 1840 and 1883, even though no final conclusions as to the total output of the English and Scottish iron foundries can be drawn from them. Of course, there were a large number of foundries which produced no furniture at all. On the other hand, it is certain that not all models of furniture produced were submitted for registration as the firms may have been put off by the cost and trouble of the procedure. Some approximate values regarding the output of British iron furniture can, however, be obtained.

The iron industry was centred in Birmingham, with 49 foundries, and the surrounding area with Dudley having nine foundries, and Bilston, Walsall, West Bromwich, Wolverhampton, Smethwick and last but not least Coalbrookdale having one foundry producing furniture; also in the Midlands, Worcester, Redditch, Coventry and Leamington had one foundry and Northampton had two foundries making furniture. Further north, Derby had five foundries, Sheffield had twelve and Rotherham had five manufacturing furniture. Leeds, Bradford, Manchester, Salford and York each had one foundry making iron furniture. Of course, iron furniture was manufactured in London, too, by sixteen companies, and along the east coast in Colchester by two foundries, and by one foundry in Ipswich, Norwich and Newcastle-upon-Tyne. There were also large, important foundries in Scotland centred on Glasgow, which had six foundries, and Falkirk with seven making furniture. One of the most important firms (alongside the English Coalbrookdale Company) was the Carron Company, in Stirlingshire, founded as early as 1759; it also maintained a London warehouse. Finally, in southern Scotland a foundry making furniture is mentioned in Dalkeith.

The Coalbrookdale Company was the first firm to make use of the Design Copyright Act for a piece of furniture; on 24 August 1840 it registered the design of a hall stand. The Effingham Works of James Yates in Rotherham followed one month later with a 'side table' in rococo form. The firm of Henry Longdon & Son from Sheffield registered an umbrella stand in the naturalistic style on 14 October 1841, though there is no further record of them making furniture. Benjamin Cook from Birmingham, Charles Millard from London, B. Walton from Wolverhampton, Thomas Marsh from Dudley and James Yates again followed in 1842. The Carron Company was the first firm to make use of the revised law of 1842, registering a design for an umbrella stand on 24 February 1843. James Yates and a year later the Coalbrookdale Company followed, each with a hall stand. The Carron Company produced furniture that was admittedly particularly simple and harmoniously shaped, but they made very few items – only thirteen models altogether were registered; the other two firms lead the field by a long way. Up to 1883 Coalbrookdale registered 114 models and James Yates (from 1848 Yates, Haywood & Co., from 1852 Yates, Haywood & Drabble) 66. The first two types of furniture to be registered are indicative of the total production between 1840 and 1883: umbrella stands on the one hand and the widest variety of hall stand on the other, whether combined with an umbrella stand or a table, with a cupboard underneath, with a mirror or only with hooks for hanging up hats. In this period a total of 347 different designs for umbrella stands and 195 designs for hall stands[178] were submitted, whereas garden benches, for all that they were so important and popular, are represented by only 161 designs, round or octagonal small tables by only 74, rectangular tables by 34 and flowerpot stands for winter gardens and verandas occur in just 22 variations.

The number of items of furniture registered initially ranged from three to six a year – although both in 1846 and 1848 there were ten registered. In the 1850s the number ranged between ten and nineteen, and then took off in the 1860s. In 1864 only twenty models were registered, while in the other years of the decade there were always 40 or so, and in 1866 there were in fact 56, representing the absolute peak for the following period up until 1883 as well. Then the numbers fell, with nineteen in 1875, though in 1882 they were back up to 40. The varying quantities obviously also depended on the number of firms applying. As well as Carron, Yates and Coalbrookdale, there were two or three other foundries registering designs year by year. In this respect, too, activity was at its height in the

1860s; there were then three to five additional foundries, and in 1862 and 1866 another eight.

Beds figure largely in the furniture registered, but they are not included here as it is generally impossible to establish whether they were made of iron or brass. Important firms in this field of manufacture were Key, Hoskins & Co., Thomas Lloyd, Edward Look, Peyton & Peyton and James Tombs, all in Birmingham, and first and foremost the firm of R.W. Winfield also based there.[179] The latter was responsible for a few ingenious designs other than beds, such as a chair which could be folded up and transformed into a prie-dieu (1859), a version of the famous, universally popular and widely copied rocking-chair (1851, PLATE 356) as well as the curved 'Metallic Seats' made of springy metal sheets (1869) which were extremely popular, particularly in France (PLATES 395–6).

It is interesting to note from the records that some foundries – in any case at times – were under female management. In both July and August 1844 Susan Hooper, who was in charge of a foundry in Birmingham, submitted a design for furniture; her son Alfred took over the business in 1852. The Chunk Works, again in Birmingham, were managed by Amelia Clemm until Joseph Holder took over in 1859. When William Crawford died in 1860 his widow Ann Crawford carried on the business in Dudley. Charles Hufton's Conybere Works in Birmingham were managed by his widow Lydia Hufton from 1873 until their son Frederick Hufton took over in 1881.

The progressive nature of the foundries was also expressed in the social field. Nearly all the firms not only provided accommodation for their workers and their families, but also for furthering their education by setting up every conceivable kind of course, as well as for the education of the children. Large firms built and maintained their own schools and – for spiritual care – their own churches. There was a genuine sense of community among 'iron foundry people', and by no means only in England.

## Diamond Registration Mark

In accordance with the law of 1842, objects registered with the Designs Office were to be provided with a mark which on metal objects (Class I) could either be cast in *(left)* or applied in the form of a stamped plate *(right)*.

While the large $R^d$ in the middle meant that the object had been:
a) registered and was therefore protected from being copied;
b) the date of entry could be deduced from the individual numbers;
c, d) letters of the registration.
e) From 1842 to 1867, the order was:
a = Class (I = metal), b = year, c = month, d = day, e = firm;
From 1868 to 1883 it was: a = Class, b = day, c = firm, d = year, e =month.

*Letters stood for the following years:*
A 1845 and 1871; B 1858; C 1844 and 1870; D 1852 and 1878; E 1855 and 1881; F 1847 and 1873; G 1863; H 1843 and 1869; I 1846 and 1872; J 1854 and 1880; K 1857 and 1883; L 1856 and 1882; M 1859; N 1864; O 1862; P 1851 and 1877; Q 1866; R 1861; S 1849 and 1875; T 1867; U 1848 and 1874; V 1850 and 1876; W 1865; X 1842 and 1868; Y 1853 and 1879; Z 1860.

*And for the following months:*
A December; B October; C January; D September; E May; G February; H April; I July; K November; M June; R August; W March.

*Exceptions to the rules:*
In 1857 R stood for 1–19 September.
In 1860 K stood for December.
In 1878, from 1–6 March, W stood for the year and G for the month.

# Rococo and Renaissance

Historicist furniture designers were relatively late in discovering rococo as a model. It was only when the classicist style of Biedermeier came to end – and in fact contributing towards its eclipse – that the lively, lusher forms of the rococo enjoyed renewed popularity. Reviewers of art and industry exhibitions noted with surprise that furniture was cropping up there in these forms, e.g. in Berne in 1830, Vienna and Paris in 1839.[180] Then from about 1840 the masters responsible for the designs found an independent way of adapting the model by reducing the repertory of forms to the curving basic forms of rococo, flowing one into another, with almost no ornament. This attractive variant of historicism, modest in the best sense of the term, soon became very widespread indeed throughout both Europe and America, appreciated at court and in the middle-class home alike.[181]

It is not surprising that rococo forms achieved popularity in cast-iron furniture, too. The selfsame plastic, flowing, surging forms which are among the determining elements of that style and which had been realized in exemplary fashion in stucco, also a ductile material, were a natural model for casting in the highly malleable material represented by molten iron.

The earliest example of cast-iron furniture in these 'second rococo' forms that can be dated is a bench which was to enjoy extraordinary popularity (PLATE 92). The Carron Company registered this design with the Designs Office in London on 16 March 1846. The style on which the design is based – rococo – is clear from the overall outline of the piece as well as from numerous details, such as the C-curves, rocaille work and lanceolate leaves. However, as is always the case where designs from this phase of historicism are concerned, this is in no way a copy of an existing piece of furniture; nothing even approximating to it can be found in the eighteenth century. The designer has created a completely original piece of furniture, mixing ornamental forms from the early eighteenth century with others dating from the mid-eighteenth century. Again, there is no model in the baroque and rococo styles for the mesh-work on the back rest. Even in the nineteenth century, when this bench was created, no wooden furniture was being produced that could have served as a model. The unknown designer succeeded in creating a completely original piece of furniture for casting. In America, in particular, where copies were first cast as early as 1848,[182] this model was extraordinarily

popular. It is known to have been produced in fifteen American foundries and other firms probably made it, too.[183] In contrast to its wide distribution in America, the model appears to have been cast in mainland Europe by only two foundries, van Enthoven and De Prins van Oranje in The Hague. The description 'Gothic Settee' used in a number of firms' catalogues for this bench is indicative of the lack of concern with which historical models were treated at that time.

On 5 May 1847 the Coalbrookdale Company registered an 'Ornamental Chair' which appears in their catalogues under no.14 (PLATE 89). Here again the rococo model – especially in the shape of the legs – is clear, and yet again earlier elements, such as the latticework of the French Regence style, are mingled with later ones. The shell motif of the back rest was popular as an ornamental form in both the Regence style and rococo. Using openwork and enlarged in this way, however, it may recall bentwood chairs produced by the Viennese firm Michael Thonet at the same period. But it is a case of following similar formal design principles; any direct influence is out of the question. There can be no doubt that with this chair, too, an original item of iron furniture was created, neither an uninspired copy of an eighteenth-century piece nor an adaptation of a wooden chair of the same period. But there is clearly an attempt to draw closer to indoor furniture. This piece marks a first step towards domesticating iron furniture, as is also demonstrated by the description 'Hall Chair' which occurs in the catalogues. In any case, these chairs are no longer purely garden furniture. Copies were soon cast of this design too, by

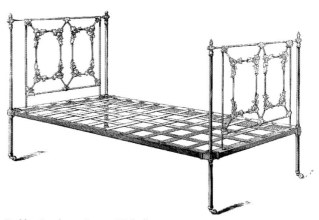

Bed by Cowley & James, Walsall.
Displayed at Great Exhibition, London 1851.

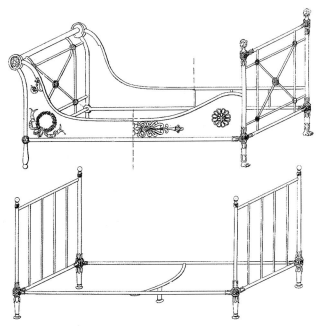

Design drawings for beds from François Thiollet,
*Serrurerie et font de fer.* Paris 1832.

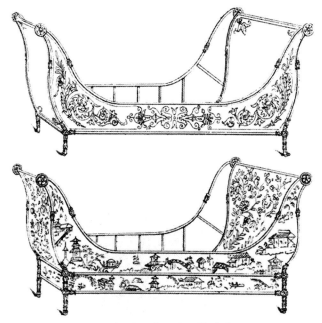

Design drawings for painted beds from
*Le Pandore du Tapissier.* Paris 1837.

McDowall, Steven & Co. in Glasgow and the two foundries in The Hague, L.I. Enthoven and De Prins van Orange, as well as at least eight American firms.[184]

At about the same time, McDowall, Steven & Co. probably developed a 'Hall Chair' of this type with an identical seat (PLATE 90). Here rococo forms are used even more freely. Scrolls turn into spiral flourishes from which the 'pea-pods' popular in mannerist art emerge, C-curves turn into free-standing supports, and lanceolate leaves into bulbous elements. The whole thing has the appearance of movement that has only just frozen, as if injected or drawn out of a ductile mass; it is thus closer to the artistic content of the style from which it is inspired than an exact copy would be. It was American firms again that took over the manufacture of this chair,[185] and it may have been a foundry in New Orleans that developed a bench to go with it (PLATE 98).[186] A German foundry, the Carlshütte in Rendsburg, and an Australian concern, James McEwan & Co. in Melbourne, also reproduced this chair.

A chair made in the iron foundry of L.I. Enthoven & Co. in The Hague (PLATE 87) provides an extreme illustration of the *outré*, exaggerated aspects of rococo forms. There are similar fanciful scrolls and projecting forms in French furniture designs of the 1840s.[187] But in wooden furniture, the construction, the structural aspect, always remains, and has to remain, in some way visible. A cast chair, on the other hand, seems to consist only of ornament, as if the wall on which the stucco ornament of the rococo is supported were removed, or the basic wooden ground behind the intarsia inlay were taken away. Only in cast iron can an ornamental framework that is

free-standing achieve the stability required for a chair. At the same time, the reduction in weight that is being sought is produced in this way, and this may also be a reason for putting the chair on only three legs.

An armchair developed in the foundry of Archibald Kenrick & Sons in West Bromwich and registered at the Designs Office in February 1853 moves a considerable step further away from using rococo as a model (PLATE 123). The curving legs and the C- and S-curves are clearly borrowed from the rococo formal repertory. But the infill ornament consists of vines with leaves and flowers in which mannerist stylistic elements are mingled with the naturalism of the mid-nineteenth century.

Naturalistically reproduced vines with the widest variety of blooms inserted in rococo forms can also be found on an armchair registered in London by W. Roberts, the proprietor of the Lion Foundry in Northampton, in May 1859 (PLATE 154). The designer was striving to make his furniture with its rounded back rest, the shape of the armrests and the legs and the curved front of its seat more like an upholstered armchair, that is a piece of indoor furniture. Because of its extravagant openwork ornamentation with bunches of grapes springing forth out of scrolls, lanceolate leaves ending in rams' heads and bands of material holding together the ring of the back rest, this piece of furniture could be made only in cast iron. The chair was supplied in a set of four, with children in the medallion on the back rest representing one of the four different seasons on each.[188]

The tendency to make liberal use of the inexhaustible repertory of forms from different periods – a trade mark of

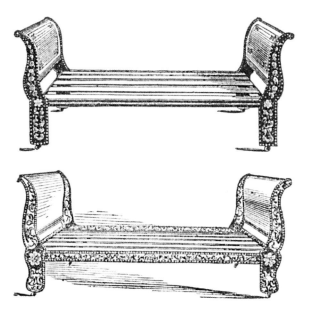

'French Pattern Bedstead' from catalogue of
Chase Brothers & Co., Boston, c.1855.

the experimental phase of historicism in the two middle decades of the nineteenth century – is also reflected in a bench that must have been created in an American foundry c.1855 (PLATE 127). Renaissance scrollwork ornamentation is combined with the C- and S-shaped curves of rococo, and the powerful acanthus of the Louis XV style, with pierced ovals such as were popular in the Louis XVI style. This dense interlocking of various forms of ornamentation can only be realized in cast iron, as already indicated.

Isolated Renaissance ornamental forms had always cropped up on iron furniture, but after the middle of the century seating was created which was wholly derived from Renaissance models. In March 1859 Crichley, Wright & Co. of Sheffield registered a chair with the Designs Office that uses Renaissance forms in a very imaginative way (PLATE 125). As it was originally fitted with a leather or fabric seat, this chair was undoubtedly intended for indoor use. Finally, a model registered by the Masbro Stove Grate Company in Rotherham in July 1868 (PLATE 177) shows to what extent attempts were made to approximate to indoor furniture. According to Elizabeth Aslin, the designer was Charles Green.[189] Not only the turned legs and the backrest supports but even the buttoned upholstery with the fringes hanging over the edge are faithfully reproduced in iron. Yet here again we are not dealing with a copy – or even a direct cast – of say an Elizabethan or a Dutch chair dating from the late seventeenth century, or a matching imitation of the type popular in the 1860s.[190] It is an original invention for cast iron. Thus the mesh-work on the back rest in particular could be made only in cast iron and not in wood. The caster's skill and the extraordinary quality of the casting are proudly and convincingly

demonstrated in that meshed lattice, and again in the detailed and delicate framing of the medallions and even in the ludicrous upholstery.

A similar 'indoor chair' (PLATE 178) must have been made in England c.1870, whereas another model (PLATE 126) was probably designed shortly after the middle of the century. The unabashed use of rococo and Renaissance forms argues in favour of the earlier date. There are copies of it in England and Australia.[191] A console table (PLATE 227) registered by the Coalbrookdale Company in February 1855 was also undoubtedly intended for the interior; it could be supplied in seven different sizes with a marble top or a marbled iron top.[192] The mixing of naturalistically reproduced plants with a combination of baroque and rococo forms popular around the middle of the century is again demonstrated on this piece. A second console table (PLATE 228) must have been made around the same time; its ornamentation drawn out to resemble stucco is reminiscent of the chair in PLATE 126. The feet projecting like jellyfish giving the heavy furniture stability are also indicative, having nothing whatsoever in common with the scrolled endings of the legs on genuine rococo chairs (PLATES 90, 126).

Rococo forms continued to be popular in the 1870s and 1880s (PLATES 242, 343), being used at the end of the century on particularly luxuriant small pieces of furniture produced mainly by German foundries (PLATES 257, 260–61). Then in the 1880s and 1890s, a type of bench described as a 'Renaissance Settee' was produced in America (PLATES 196–200). It is no longer possible to say which foundry first designed this type. The richest and most luxuriant model was registered at the Patent Office in Washington on 7 May 1895 (PLATE 197) by the Peter Timmes' Son iron foundry. Wilham Adams & Co. applied for patent protection for a rather daintier model (PLATE 200) after 1887.[193] However, it was also cast by Hinderer in New Orleans and again by Peter Timmes' Son, in whose catalogues it is featured under the name 'Curtain Settee'. J.L. Mott and the North American Iron Works, both in New York, also produced a bench of this type (PLATE 199), as did John McLean, New York, and B. Chambers, in a very simple form (PLATE 198).[194]

It is typical of the designers in this late phase of nineteenth-century historicism that they were always endeavouring to anchor their inventions in the past. Anyone who could work 'in period style', no matter which style that was, had demonstrated his capability. The inventors of these benches, which really have very little in common with Renaissance furniture, also believed they could only give them legitimacy by such an attribution; in fact, these benches are original creations which exploit all the potential of the material and its technology.

# Iron in the house

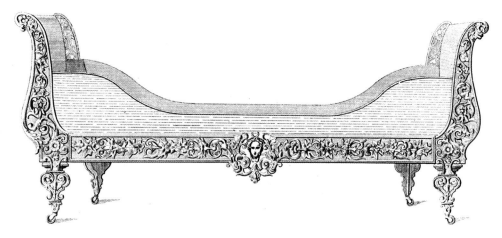

Bed from catalogue of foundry of A. Sterkman & zn.,
De Prins van Oranje, s'Gravenhage, *c*.1830/40.

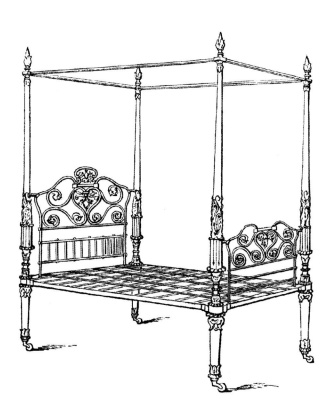

'Iron French bedstead, ornamentally japanned,
with brass mountings' by Peyton & Harlow, Birmingham.
Displayed at Great Exhibition, London 1851.

IT WAS through bedsteads that iron first gained access to houses in the nineteenth century. The fact that this access could happen as a matter of course was ensured by a long period of preparation.

## Beds

THE story of the iron bed begins in Italy in the seventeenth century.[195] Gradually this innovation was also introduced in other countries, initially primarily in hospitals and barracks. In the nineteenth century iron bedsteads were common in bedrooms, at least from the 1830s. Therefore, hardly any foundry failed to take advantage of this lucrative branch of production. The simpler models are assembled from round iron rods or, to reduce the weight without lessening the stability, iron tubes (PLATES 273–4).[196] In manufacturing beds of this kind, England was pre-eminent.[197] But there are also early examples in France, e.g. in the 1832 catalogue of François Thiollet (ILL p.39), with joints and a few decorative forms being added on his models as cast parts. What was new in the example illustrated here, something which was to blaze the trail for the whole of the nineteenth century, was that sheet metal was inserted on the sides, and soon on both bed-ends as well, removing the perception of the bed as perhaps all too well ventilated; the sheet-metal panels could also be used to receive decorative forms or could be painted. In outline these examples are derived from early nineteenth-century wooden beds; their typology is also featured in a book of patterns produced in 1837 (ILL p.39,

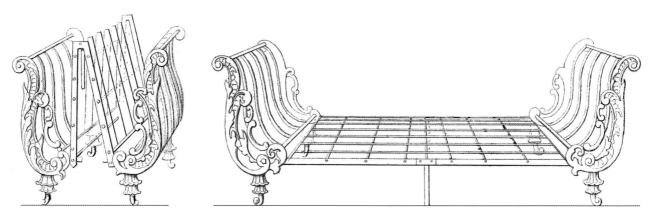

'Bedstead with hinge' from *Abbildung der Modelle zu Gusswaaren bei der Königl. Württemberg. Eisengiesserey Wasseralfingen.* Stuttgart 1847.

right). However, this shape which ultimately goes back to the French *lit en bateau* was soon superseded by beds with two flat bed-ends (PLATE 285) in which richer cast decorative elements could be incorporated. By means of such additions and painting, the type was adapted to the fashions current at the time. Even in the late nineteenth century the systematic principles underlying these iron beds had not changed (PLATE 287), and they could be found in countless numbers in middle-class bedrooms and many inns throughout the world.

At the same time, bedsteads made only of rods or tubes also continued to be popular throughout the century. At the Great Exhibition of 1851 in London several firms showed a wide range of models where cast-iron decorative elements could be added on (ILL p.38) or iron rods bent into scrolls could decorate the head or bottom bed-end (ILL p.40, PLATE 272).[198] Children's cradles were also made of iron rods and strap iron (PLATES 283–4).

However, cast-iron bedsteads were also soon being produced. One of the very earliest known examples is in fact a prominent piece, the bed of King Otto of Greece; he had used it since his accession in 1832 and also took it with him into exile to Bamberg (PLATE 275).[199] The bed is in

the heavy, opulent Late Empire form of the type developed at the court in Munich (the court of King Otto's father) by the architect Leo von Klenze for furniture and interior decoration;[200] it was probably cast at the Bodenwöhr foundry in the Upper Palatinate, the only one of the Royal Bavarian enterprises to exhibit artistic cast-iron work at the Munich Industrial Exhibition in 1835.[201] Among the many furniture designs Klenze produced for the court at Munich there is no state bed, so there is no directly comparable piece.[202] Nonetheless, Klenze's touch can be recognized in many of the details on this iron bed: the quiver-like corner posts with the lotus-leaf capitals, the fleshy leaf scrolls which in his hands tend to look modelled even when they are carved – and therefore lend themselves particularly well to casting – or the Egyptian-style palmettes. The widely spaced arrangement of small decorative elements, such as the balls along the lower edge, is also found on Klenze's furniture. The powerful weight of the overall appearance – the small tapering legs seem in some way to be at variance with this – is a feature of all his furniture. For the bed itself, where elaborate decorative forms would impede the placing of the mattress and bed linen, there is a strikingly simple ornamentation – and all

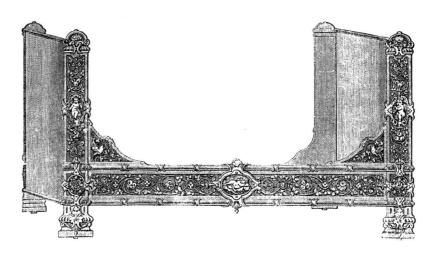

Bed by Charles Léonard, Paris. Displayed at Great Exhibition, London 1851.

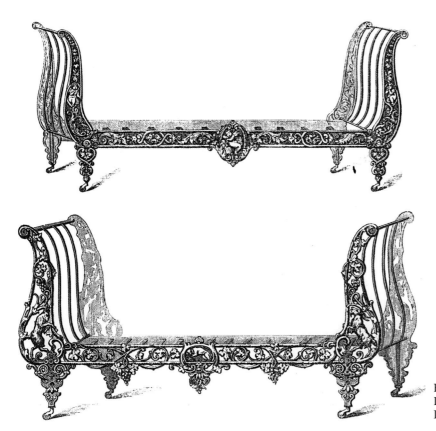

Beds by Charles Léonard, Paris.
Displayed at Great Exhibition,
London 1851.

the more attractive for being so – reminiscent of elements of folk art, possibly in fact Greek folk art. Altogether, this is a successful attempt to make a grand royal bed that consciously acknowledges the material from which it is made.[203]

Alongside the beds made from iron rods, another type was developed for the middle-class bedroom – probably in France in the later 1830s – carrying on the popular form with S-shaped curved bed-ends. The sides – often just one side if the bed was to stand against a wall or form part of a double bed – were provided with cast ornamentation, generally vines with every possible addition, leaves, flowers, animals, putti or masks (ILLS pp.40–3). The rococo formal repertory could also be used. One model that was developed in what must be the most important French foundry at Val d'Osne[204] was copied by the Dutch foundry De Prins van Oranje (ILL p.41). At the 1844 Industrial Exhibition in Paris the firm of Gaudillot showed beds of this kind.[205] Charles Léonard and other Parisian firms showed particularly richly decorated examples at the Great Exhibition of 1851 in London (above). The foundry of Chase Brothers in Boston expressly states in its catalogue that where beds of this type are concerned we are dealing with 'a French pattern of rich design' (ILL p.40). Often these beds can also be folded in the middle, as is demonstrated for instance in the 1847 catalogue of the Wasseralfingen

foundry (ILL p.42). The French model in Empire form (PLATE 278) is also featured in the 1853 *Illustrated Catalogue of Bedsteads* of the London firm Heal and Son where it is described as a 'Parisian Iron Bedstead'. Probably beds of this type were made in all European foundries (PLATES 276, 279–80); sometimes they also featured luxuriant openwork rococo forms (PLATE 277).[206]

Similar beds were produced in America too (ILLS p.40), but evidently not until after the middle of the century. The following passage appears in a Chase Brothers' catalogue which came out *c*.1855:

> Foremost among the articles of Household Furniture manufactured from Iron is the Bedstead. The graceful and elegant forms in which it is produced, its compactness, and, above all, its cleanliness are recommendations which American Housekeepers are beginning to appreciate. For many years Iron Bedsteads have been extensively used in Europe; and probably no other article of Iron Furniture is coming more rapidly or surely into general favor in this country.

The widest assortment of types is then presented in the catalogue, including very much simpler models, like the bed in Gothic forms (PLATE 282) that had been patented for Noyes & Hutton in 1851. A particularly attractive

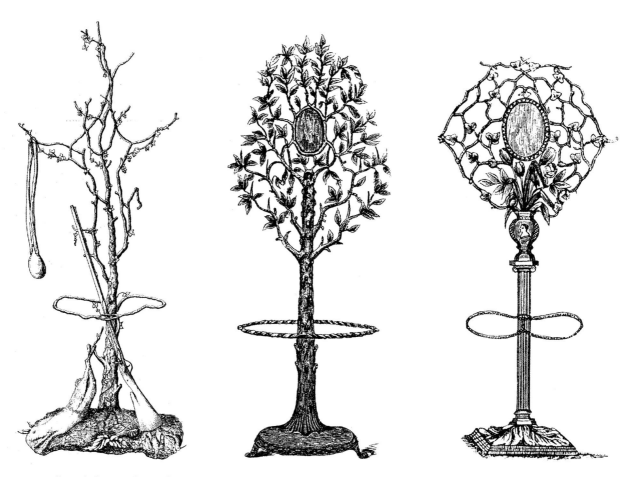

Hall stands from catalogue of A Sterkman and zn., De Prins van Oranje, s'Gravenhage, 1855 *(left)* and 'Hat and Coat Stands' from catalogue of J.W. Fiske, New York, 1868 *(centre and right).*

design which J.B. Wickersham introduced in his 1857 catalogue (PLATE 281) is conceived along similar lines.[207]

While a completely original cast-iron form evolved with these beds, at the same time very different types of design were being made in France expressly intended to disguise the material from which they were made. They were modelled on wooden bedsteads in forms which were described around the mid-nineteenth century as Renaissance (ILL. p.42). The most luxuriant ornaments of the most varied kind, intended to simulate carvings, decorate the sides. Appropriately painted, these beds were intended to fit into a suite of bedroom furniture otherwise made from wood. As the century drew to a close, it was these very beds – dissimulating the material from which they were made – that became increasingly popular. Because of this, the simplest designs (PLATE 287) were painted to look like wood grain.

# Hall stands

THE hall stand – a 'cloakroom' standing in the entrance hall – is an exclusively middle-class item of furniture and a genuine nineteenth-century invention. It was a necessary feature of a town residence where the guests did not drive up in their own carriages and no special room was available where they could prepare for their 'entrance'. The invention and development of this piece of equipment run parallel with the general expansion of cast-iron objects in the nineteenth century. Certainly there were also wooden hall stands,[208] but the vast majority must have been made of cast iron. Among items of iron furniture for the house, the hall stand enjoyed special popularity. The close link between all cast-iron equipment and fashionable design led to a constant need for new 'up-to-date' models – which is also a reason why the manufacture of cast hall stands came to an end in the twentieth century. There was a practical reason why they were manufactured in such high numbers in iron (rather than in wood), besides the popularity of the material: wet outdoor clothes could

not harm it. Chase Brothers' catalogue which came out *c.*1855 says:

> The very ornamental appearance of the bronzed Hat Stands, combining as they do, in one article, a receptacle for Hats, Coats, Canes and Umbrellas, has caused their general adoption throughout the country; and being more durable than those of wood, it is not only a matter of good taste, but of strict economy to give them the preference over all others.

Cast-iron hall stands all stood against the wall, so becoming fixtures in the house. They were all combined with an umbrella stand. A certain systematization in their formal design can be recognized. A narrow type (PLATES 288, 290–3, 296) consisting of thin rods assembled and interwoven to form soaring structures is relatively light and transparent; these structures were influenced by strapwork, a form of ornament typical of the early eighteenth century, but naturalistic vines can – and were intended to be – recognized in them. James Yates, Effingham, registered a 'Hat, Coat and Umbrella Stand' of this type, composed of C-shaped curves, at the Designs Office in London in February 1843. A year later, the Coalbrookdale Company and Thomas Marsh of Dudley followed suit with similar models; moreover, they could all be supplied in black, bronzed or painted to look like oak. This type was cast in all European (PLATES 288, 296) and American (PLATE 290) foundries. Christopher Dresser developed this slim type further in the late 1860s (ILL. p.33; PLATES 319, 321).

A second type not created until *c.*1855 is rather more elaborate (PLATES 289, 310, 312, 316). It first crops up among models registered at the Designs Office in 1856.[209] It tends to be broader, looks less 'floral' and more structural, and is assembled from parts. In accordance with the custom of the middle period of the nineteenth century, every conceivable reminder of historical styles can be found on this type, but naturalistically reproduced leaves and flowers turn up again and again as well. All the possibilities opened up by cast-iron ornamentation, whether crisscrossing in flowing or curving lines, or assembled stiffly, with sharp edges and acute angles, were used in making this particular item of iron furniture.

Finally, the most elaborate of all is a third type which appeared at the same time, distinguished by having a table inserted into it. The foundry of Yates, Haywood & Drabble exhibited a particularly magnificent example at the 1862 International Exhibition in London (it had already been registered at the Designs Office on 18 April 1861) distinguished by 'extremely good design', as a contemporary critic commented (PLATE 302).[210] These hall stands which had been turned into pieces of furniture by the

addition of the table always also had a mirror (PLATES 301, 307, 311, 315), although this could be inserted in the other models too (PLATES 290, 310, 316). The way these hall stands were assembled from individual cast parts meant that it was also possible to make some models available in a wide or a narrow version (ILL. p.46).

Designers' creative inventiveness where hall stands are concerned seems to have been inexhaustible. All the foundries' catalogues are full of the widest assortment of models of all three types in ever new variations. As well as these, however, there were also imaginative special forms, such as naturalistically reproduced trees, for example, where coats and hats could be hung on the leaves, vases standing on columns with flowers extending from them, or knobbly trees on which a hunter hung his weapon and his bag, or beneath which whole battles were in fact fought out (opposite; PLATE 298).[211]

# Umbrella stands

THE umbrella stand was an even more essential piece of equipment in every middle-class household than the hall stand. Like it, it was manufactured primarily from cast iron, and like it, it stood more or less immovable against the wall (PLATES 295, 299, 303, 308–9, 314, 317–18, 320, 322–3, 327–8, 331–4). Registrations at the Designs Office give some idea of the huge diversity of the inventions in England and Scotland, and, *mutatis mutandis*, this can also be applied to other European countries and America. From 1843 to the middle of the century one or two (in 1849 four) designs were submitted for registration annually. In the second half of the century numbers increased, though they fluctuated with special peaks: in 1861 there were 21 and 28 in 1866, while the numbers otherwise varied from four to fifteen new designs submitted annually. In the 1880s numbers again soared. Twenty-one designs were submitted in 1881, 25 in 1881 and in 1882 there were 27.

The same decorative forms can be found on models from every country as on other cast-iron furniture. Some also used animals executed in the round and forced into appropriate shapes to hold umbrellas: huge squirrels,[212] dogs with whips[213] or caught in vines,[214] herons or swans holding a coiling snake in their beaks,[215] or even two storks in the reeds,[216] and many other ingenious images. Finally, the inclusion of human figures in designs for umbrella stands was particularly popular. For instance, there are historical personalities such as the Scottish national hero Sir William Wallace (PLATE 318); the artist responsible quite obviously based his design on the figure of Saher de Quincy by James Sherwood Westmacott

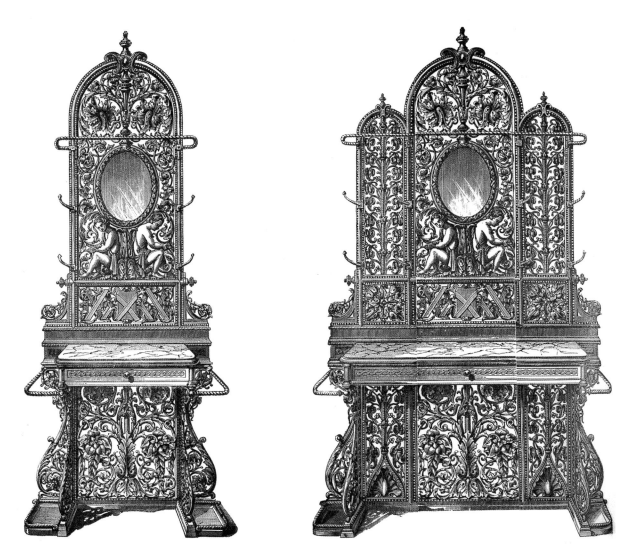

'Hall Tables' from catalogue of the Coalbrookdale Company, Shropshire, 1863.

which had been displayed at the Great Exhibition in 1851.[217] The foundry of Micklethwait & Co. in Rotherham inserted figures from everyday life into umbrella stands: a 'Woodman' with an axe,[218] a 'Sportsman' with a gun, a 'Reaper' with a sheaf of corn, and a 'Fruit Girl' with a basket of fruit (PLATES 328, 331). The designer of this series probably again based his figures on greater models.[219] Soldiers[220] and even small children had to help carry the umbrellas (PLATE 299); girls hold their hoops in an appropriate way[221] or sailors hold a rope (PLATE 314). Even Cupid holding his bow with outstretched arms[222] or the serpent with which Hercules struggled as a child (PLATE 317) could be so arranged for umbrellas to be placed behind them.

Stands for fire irons, tongs and a shovel were also made at the same time as umbrella stands (PLATES 294, 300, 304–5, 313, 324–6, 329–40). They are generally simpler, appear easier to move than umbrella stands and do not necessarily have to stand against a wall. The upper rails for holding the items are never continuous, the tray underneath for collecting rainwater from umbrellas is smaller and does not have the removable insert that was generally enamelled.

## Tables

CAST-IRON gained access to the home relatively early with the gueridon made by the Bullock Brothers from 1805 to 1815 (PLATE 205) and that designed by Karl Friedrich Schinkel in 1825 (PLATE 206). Apart from Schinkel's marble-topped tables of the early 1830s (PLATES 208, 210) which were displayed in royal residences, it was mainly small occasional tables intended to hold lamps, flowers or individual display items or where coffee cups could be set down that were designed and manufactured by the foundries. From an early period the tops of these

too were made of cast iron, ornamented and in openwork (PLATE 218), even though marble (PLATE 219) or wooden (PLATE 255) tops continued to be used. As a rule the foundries provided for all three eventualities on one and the same piece of furniture, leaving the customer to decide.

Basically, there were only two systems for creating these little tables: either three high-curving legs supported the top (PLATES 214–5, 229, 255, 263) – as on the tripod designed by Bullock – or the top rested on a central column which was again supported underneath by three feet or legs, as on Schinkel's gueridon (PLATES 218–20, 235, 241, 254). Then, in the late nineteenth century, a type of dainty little table was made, provided with two or even three surfaces, to some extent a halfway house between a gueridon and an *étagère* (PLATES 260–2, 264–6). They were extremely popular in Germany in particular, and were still available in many variations at the beginning of the twentieth century. According to its catalogue, in 1910 the Ilsenburg foundry alone still stocked 72 different models of this kind.

Larger rectangular iron tables must have been introduced indoors with the hall stand (ILL. p.46; PLATES 301, 302, 307, 311, 315). Where there was enough room an independent table could also be placed in the hall (PLATES 245, 251), possibly combined with an umbrella stand (PLATE 244) or as a wall table (PLATES 211, 227, 228). However, these rectangular tables fitted with a marble top were primarily used in inns (PLATES 249–50).

The model of a round table was developed by a few foundries in England and Scotland and continued to be produced for half a century, always with slight variations. Lund & Reynolds in Bradford had cast what must be the earliest example around the mid-nineteenth century (PLATE 248).[223] All these tables have three legs curved to form a shallow arch carrying a medallion, set in ornamental vines, at the upper end. Either allegories such as the head of Britannia (PLATE 248)[224] or contemporary historical personalities like Queen Victoria – cast no doubt by the Coalbrookdale Company for the Silver Jubilee of her Coronation (PLATE 247) – or W.G. Grace, the most famous cricketer of his period (PLATE 270), could be represented on these medallions. These tables were again supplied either with a wooden top or an openwork iron one, and were therefore intended for both indoor and outdoor use. Larger round tables with tops made of metal sheet but very carefully painted (PLATE 222) were no doubt intended to be placed inside. These could be quite costly. One table (PLATE 234) with a bulky stand further embellished by applied pewter casts is proper drawing-room furniture.

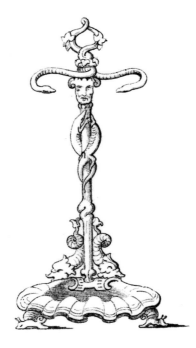

'Fire-iron stand' from *Abbildung der Modelle zu Gusswaaren bei der Königl. Württemberg. Eisengiesserey Wasseralfingen.* Stuttgart 1855.

But tables of this kind if they were provided with an openwork iron top were in fact generally intended for the garden, even though now and again they might have turned up indoors (PLATES 221, 223, 231, 237–8, 240, 242). So while a table from Wasseralfingen (PLATE 224), for instance, certainly has an openwork iron top, it is so exquisitely, even sumptuously, worked that it must have been intended more as a decorative piece. A hunting scene is depicted on the outside ring of the top, on the wide inner ring the Four Seasons and in the middle, in the style of mannerist casts from nature, a lizard consumes a butterfly. The three parts are each individually cast. The foot, too, with fanciful Renaissance ornamentation is very carefully designed. The table is illustrated in the firm's catalogue published between 1847 and 1866 under no.813. Another not quite so lavish but equally carefully worked table top was also made at Wasseralfingen around the mid-nineteenth century, illustrating nine scenes from Schiller's poem 'Ehret die Frauen' (PLATE 225). The two table tops represent the height of German cast-iron artistry in the nineteenth century.

As well as *étagères* (PLATE 341) there were also wall shelves (PLATES 342–3) and small cupboards that could hang on the wall. The Ilsenburg foundry[225] in particular stocked a whole range of such furniture c.1900. In making small safes (PLATE 346) cabinets from the mannerist and early baroque periods were used as models in the traditional way (see p.17 and PLATES 39, 40, 42). The doors of this example are copied from the ivory coin cupboard which Christoph Angermair made for Elector Maximilian

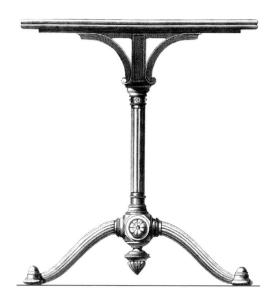

Inn table from the Gräflich Salmschen iron foundry at Blansko, designed by W. Flattich, chief engineer, Vienna, 1870.

I of Bavaria between 1618 and 1624, now in the Bayerisches Nationalmuseum in Munich.[226]

As well as fire-iron stands, foundries made coal scuttles. In England the globe shape (PLATE 335) where one half-sphere is pushed into the other when it opens was popular, a method which was already known from baroque vessels made by goldsmiths; it eventually also made its way into furniture construction, first of all with the globe writing tables made by the London cabinet-maker George Remmington, patented in 1806.[227]

Flower-stands for the winter garden were also popular items of cast-iron furniture and were produced in large numbers. It was the love of flowers in middle-class homes emerging in the Biedermeier period that created a corresponding need for such structures. A variety of such items had already been on offer in the foundries' catalogues from the 1830s (ILL. p.22). There are small, simple low tables (PLATE 213), straight, round or semi-circular staged frames (PLATES 340, 345) or quite elaborate structures providing a separate surface for each flower pot (PLATES 237–38).

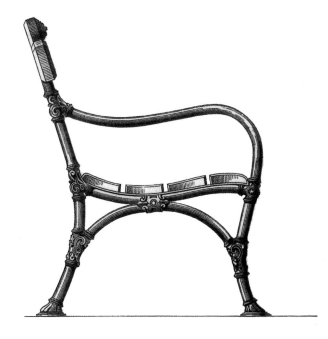

'Iron bench for a verandah' from Georg Schwab, Vienna, designed by W. Flattich, chief engineer, 1864.

# Iron on the street

THE nineteenth century was the century of expanding towns and cities. With the dismantling of old fortifications, new public spaces were created to be used as parks or grand boulevards. Whether it was paved or planted, public space began to play a new role, and it was increasingly 'furnished'. Parks and recreational areas were created for town-dwellers with no garden of their own; strollers with no carriage of their own could pause and watch the activity of the town from a bench at the side of the road. Even late in the evening streets could still be used because of the improvement in street lighting, particularly because of the introduction of gas lamps.[228]

Cast iron decisively affected the appearance of many towns: lamp-posts, bollards, railings in front of houses and gardens and round statues and fountains, even the fountains themselves, bandstands, bus and tram shelters, toilets, kiosks, clocks and weather vanes, pillar-boxes, fire-alarm boxes, pumps and of course benches for passers-by were all made of it.[229] Cast iron was in universal demand and provided by the foundries in every quantity and form.

Some of the benches that had been produced for private gardens were of course also suitable for public parks and street use. However, it was predominantly new, special models that were made, on offer in catalogues as 'Bänke für öffentliche Anlagen', 'Bancs de Ville', 'Boulevard Settees' or 'Railway Station and Park Seats'. J.L. Mott, New York, even developed a special 'Central Park Settee'.

The simple branch-work models already considered (see p.30; PLATES 100–3, 107–8) are most often found in public parks. Many other simple forms were developed at the same time (PLATES 75–6) with the seats and back rests always consisting of simple wooden boards.

While almost all garden benches were so designed that they were also suitable for use with a table, a special form was developed for the person resting in the park. The seat on its low legs curves seamlessly into the back rest in a long-drawn-out S-shape, and the comfort resulting from this makes it possible for a person to sit and relax in a way that would have been impossible even in the Biedermeier period (PLATES 129, 131–2, 135–6, 175). Narrow slats set side by side with gaps in between form the seat and back rest. The same form also existed with taller legs, better suited for placing along a street (PLATES 139, 144, 172).[230] If there was a view to be enjoyed on either side, there were similar double benches (PLATE 128).

A type was developed especially for the Paris boulevards with several lanes for traffic; two brackets for the seats extend from a middle stand which contains the backrest board serving both sides (PLATES 140–1, 194–5). The benches can be used from either side; however, no great value was attached to comfort. These are sturdy seats with little decoration; in some way, they seem to reflect the unceremonious hectic bustle of city traffic. City life no longer took place on the squares but along the boulevards where the stroller was disturbed by hurrying passers-by, where everything was bustling and nothing should get in the way of the hurrying crowds, but where stability was also essential. It was the age of the railways that was being worked out in these benches. The 'Central Park Settee' produced by the foundries of J.L. Mott and J.W. Fiske in New York was made to withstand such heavy demands, and its ponderous, completely undecorated forms were imitated by other foundries (PLATES 163–4).

Sometimes special models were made for grand squares. The popular snakes crop up on benches in luxuriant Late Empire forms that are to be found today in the Kongens Nytorv in Copenhagen (PLATE 79). They were designed by the architect Gustav Friedrich Hetsch (1788–1864), and were in fact originally installed on S. Annae Plads where Hetsch was then building a house.[231] The Empire forms reveal the fact that Hetsch trained under Charles Percier, working in his Paris studio from 1808 to 1812. The benches must have been cast in one of the foundries in Copenhagen.[232] In contrast, the elongated benches on Jackson Square in New Orleans, the main square in the old city that was designed in its present form between 1846 and 1856, are quite plain and simple (PLATE 72).

In London, the erection of the obelisk Cleopatra's Needle on the Victoria Embankment, after its long, adventurous journey from Egypt, was a great event. Between 1874 and 1878 the architect George Vulliamy landscaped the whole site; he also designed the benches which were cast in 1874 by the Albion Works, J.D. Berry & Son, Westminster (PLATES 184–5).[233] They brought the admired world of Ancient Egypt into a European city. The relationship between the original obelisk and the new creations – the steps, sphinxes and benches – intended to support and emphasize it can be seen as the completion of a historicist concept. Cast iron made possible the seemingly endless succession of sphinx benches along the Victoria Embankment, on the one hand preparing for and leading up to the monument, and on the other linking it with its historical home in a far-off place.

Einfache                                    Bettstelle.

Doppelte                                    Bettstelle.

Gartenmeubles                    und Blumentisch.

Beds and garden furniture
from Gaudillot Frères & Roy,
Besançon, *c.*1845.

# Furniture made of bent iron

FIRMS specializing in beds started bending iron rods relatively early in the nineteenth century, whether for constructional parts or merely for decorative additions (PLATES 272–3; ILLS pp.39, 40, 41).[234] At the Great Exhibition in London in 1851 R.W. Winfield of Birmingham, a firm known for its large output of beds, as well as showing extremely elaborate Renaissance-style beds, an 'Angel Cot' widely admired at the time and various lamps, exhibited a rocking-chair which had a perfection in the simplicity of its construction. Although the chair was made of brass, it needs to be mentioned here as several similar examples made of iron have been preserved (PLATES 352–57). Two sets of three iron rods or tubes, curved in various ways and inserted into one another, and linked together by means of straight, horizontal crossbars, form a working piece of equipment – with its inserted upholstery a comfortable seat as well – without any decorative forms and without even as much as a superfluous screw. The first mention of this model of rocking-chair in recent literature in this field can be found in *The Architect's Journal* of 1 September 1949 in an article by the designer Ernest Race. He comments with regard to the example illustrated on p.218 of the magazine: 'The chair is…made of…iron, and bears a brass label with the inscription "Dr. Calvert's Digestive Chair". It was exhibited in the 1851 Exhibition….' The rocking-chair did not turn up again in art history until 1962,[235] since when it has constantly appeared in numerous publications about nineteenth-century furniture and design. Elizabeth Aslin, who had evidently missed the 1949 reference, also points to the Great Exhibition of 1851 in London where R.W. Winfield presented this model for the example she makes known. In the official catalogue under the works exhibited by Winfield a 'brass rocking or lounching chair, with marocco furniture' is listed.[236] Since Aslin's publication, not only is Winfield continually named as the inventor, but the author's comment that the rocking-chair – 'unusually simple in design and obviously ahead of its time' – attracted no attention at the time is always repeated. As Aslin makes no mention of the illustration of the chair in the supplement to the exhibition catalogue[237], though unless she knew it she could not have ascribed it correctly, it is repeatedly stated that its 'proto-modern' form, supposedly incomprehensible to the people of the time, had even prevented it from being reproduced in the catalogue. However, the relatively large number of surviving examples alone, undoubtedly also made by various firms, is proof of the popularity of this model of rocking-chair at the time. Neither in 1851 nor earlier did Winfield register the model with the Designs Office in London for reasons which we will come back to, but ten (!) years later on 5 December 1861 he did register a variant where the tubes, or in this case in fact massive iron rods, had been twisted like rope.[238] So obviously at that time the model was still appreciated and sold. Ellen and Bert Denker[239] have pointed out that William Cunning of Edinburgh also showed an iron rocking-chair at the Great Exhibition at the same time as Winfield, although it is not actually illustrated in the catalogue. It is described as follows:

> Improved iron rocking-chair, for the drawing-room, in gold, covered with French brocatelle. In this chair the spine and back are supported, and the head and neck rest in a natural position. Exhibited as a useful invention for invalids and others.[240]

In 1867 Herman Berg and Richard Hoffmann obtained a patent for a similar rocking-chair in America.[241] However, it does not necessarily follow that an example in the Cooper Hewitt Museum in New York (PLATE 357), apparently formerly owned by Peter Cooper, was made in America.[242] The Coalbrookdale Company also brought out an 'Easy or Rocking Chair' of this type,[243] and as late as 1892 Schlesinger, Wiessner & Co., New York had such a chair in their catalogue, although it was embellished with a few struts.[244] In 1971 John Gloag[245] again refers to 'Dr. Calvert's Digestive Chair' from *The Architect's Journal* of 1 September 1949. He does, however, also mention a Frederick Crace Calvert (1819–73) by name, a chemist who had worked in the industry and apparently had an interest in industrial design. Is he in fact the same person as Dr Calvert? And does Dr Calvert have to be the inventor? He could have been a doctor who had recommended this chair, or merely a former owner of it.[246]

A rocking-chair which is in Budapest (PLATE 354) may have been made independently of the English models. Its still comparatively clumsy form and the Late Empire ornament on the upper part of the back rest may possibly even suggest that it was made in the early 1840s, i.e. earlier than Winfield's chair for the Great Exhibition. Winfield no doubt failed to apply for registration in 1851 because he was not in fact the inventor of this rocking-chair. Also

prior to his model of 1851, there is a picture of an almost identical model in Thomas Webster's *Encyclopaedia of Domestic Economy* published in New York in 1845: 'A rocking chair, for exercise. It is made wholly of iron, with a stuffed covering, but not very heavy' (below).[247] On an advertisement leaflet issued by John Porter, 'Manufacturer of the improved iron running park & field fences, hurdles, gates &c. wire fences, flower stands, trainers, every description of wire work – iron bedsteads of all kinds', besides all the objects listed there is also a picture of this rocking-chair in its quite simple form. A copy of that leaflet was sent to someone who had expressed interest at the time as early as 6 January 1840.[248] Thus, the time of the invention of the rocking-chair shifts quite substantially away from the middle of the century, at least to the year 1839; its originator was therefore neither R.W. Winfield nor Dr Calvert but – at least based on our present state of knowledge – John Porter of London.

These rocking-chairs with their clear, simple, undecorated form had therefore already been created by 1839 at least and were manufactured until the end of the century: are they really so alien to their time as the extravagant furniture displayed at the Great Exhibition of 1851 might make it appear, and those who sing their praises today would have us think? The very popularity of the chair over such a long period argues against this view. Moreover, the many other simple seats made of bent iron which we will be looking at shortly also argue against it. And again, the chairs and armchairs – including rocking-chairs! – made by Michael Thonet from bentwood over the same period argue against it; these were manufactured from the 1840s in similar convincingly simple forms and soon mass-produced in huge runs; so they must have been extremely

popular. The simple functional form did not in fact turn up out of the blue during these years: it had already been in use since the late eighteenth century in building waggons and carriages. The architecture of the very building used for the Great Exhibition of 1851, the Crystal Palace, was exceptionally logical and functional, as were the many English greenhouses that had been built since the 1820s and the station- and market-halls built soon after.[249] Pugin's well-thought-out neo-Gothic style led to structurally clear, simple furniture, constructed with intrinsic logic, in the 1840s and early 1850s, directly anticipating similar products by Street, Morris and Webb.[250] As was also the case in cast furniture, the material and the ways in which it could be worked constantly inspired designers to new and original forms. It is undeniable that the great range of possibilities afforded by iron could lead to tasteful errors of judgement, but they could also lead to masterpieces of purely functional thinking, and so to forms that won special recognition in their own period, and not just today.

Apart from rocking-chairs, seating was relatively seldom made from iron for interior use. Nonetheless, a few firms did make iron chairs for the home. The firm of Gaudillot Frères & Roy had existed in Besançon since 1829 producing rolled tubes, first for railings and balustrades, later for beds and garden furniture as well (ILL. p.50).[251] The tubes required two-thirds less material than solid iron, and their rigidity and the resulting lightness and cheapness were valued as advantages in their own right. The *Tischler- und Drechslerzeitung* said of a chair which Gaudillot Frères showed at the Industrial Exhibition of 1845 (ILL. p.55): 'it combines great lightness with unusual durability and is just as at home in the drawing-room in

'Balzac' from the pattern book of August Kitschelt, Vienna, 1845.

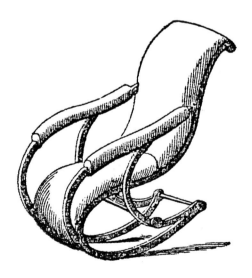

'A Rocking Chair for exercise' from Thomas Webster, *An Encyclopaedia of Domestic Economy.* New York 1845.

winter as in the garden in summer, when you may exchange the upholstered seat with one woven from rushes.'[252] In its form this chair is perfectly adapted to the interior, differing only slightly from a piece of wooden furniture.

In 1835 August Kitschelt together with Ernst Schneller founded a 'factory for cast-iron and bronze fancy goods' in Vienna[253] in which busts, candlesticks, writing materials and so on were initially produced. In 1842 Kitschelt, after parting company with his partner, started making furniture from iron tubes, mainly beds and garden furniture, but tables, sofas and armchairs for the home as well. The last two were upholstered furniture, and Kitschelt was absolutely alone in this field. In his firm's catalogue for 1845 there is a picture of a *chaise longue* using forms of the second rococo period, with the reclining surface, back rest and armrests upholstered (opposite). At the Great Exhibition of 1851 in London, as well as two tables he exhibited two armchairs and a footstool, both again upholstered.[254] A system had to be developed for fixing the prepared upholstery on to the iron frames. This furniture was designed by the Viennese architect Friedrich August Strache (1814–95). The firm of Kitschelt was also represented at an 1854 exhibition in Munich and at exhibitions in Paris in 1855 and 1867 with furniture. The table and the upholstered chairs (ILL. p.54) were made after the design of Joseph Storck (1830–1902), an architect who played a major role in the field of arts and crafts in Vienna; they were manufactured in 1864 and shown in Paris in 1867. Storck had understood how to develop a furniture form dependent solely on using tubes and rods that could be bent. Here nothing whatsoever has been borrowed from styles from the past; it is as if a technical pipeline system had playfully taken on a life of its own and found a new meaningful shape in the process. This was entirely appreciated by contemporaries. Valentin Teirich writes of Storck: 'With proper feeling this artist has not taken a clearly defined style as his model, but has followed the only correct path, completely adapting the form to the material.'[255] For the opening exhibition of the Österreichisches Museum für Kunst und Industrie in Vienna[256] in 1871, Kitschelt supplied a suite consisting of a sofa (ILL. p.54), an armchair, a chair and a table. Here the architect who designed them, Rudolf Bernt (1844–1914), has added a few modest decorative forms to the bent tubes, which again essentially determine the shape of the pieces of furniture.

The firm of Kitschelt was extraordinarily successful with furniture of this type, as well as similar items of its own design; it exported to many countries and was soon able to open branches in Prague, Brünn (now Brno), Bucharest, Trieste and even Constantinople (now Istanbul). In 1900 they were still offering beds and cradles, hall stands and even chests of drawers made from tubes and sheet metal in their catalogues. Like Thonet's, Kitschelt furniture played a part that cannot be overestimated in the total furniture production of the nineteenth century, and consequently in forming a quite definite trend in taste. However, unlike the products of Thonet and his imitators, the iron furniture made by Kitschelt was not mass-produced. The architect-designed, comfortably upholstered furniture met the needs of a modern-minded, well-to-do bourgeoisie and obviously disappeared completely with it.

From the late eighteenth century, seating for English parks was produced, assembled in simple forms from iron rod (PLATES 358–66). The rod was generally in the form of iron strap, often grooved, or semi-round rods which could be bent over their surface or over their edge to create decorative forms. The elements governing this furniture were in fact predetermined: the semi-finished product of iron strap or semi-round rods, the technical requirements for manufacture, and the formal reduction to a small number of simple components that could then be made into the type exemplified by the rocking-chair considered above. These benches and armchairs were produced throughout the nineteenth century by a whole series of firms in only slightly modified forms. It is therefore all but impossible to date an individual piece precisely. However, variations in form make it possible to infer a certain time sequence against the background of general stylistic development. A bench with armrests that are rolled outwards (PLATE 360) is still clearly redolent of the spirit of Sheraton and the late eighteenth century. The simple decorative forms based on the intersecting segments of a circle have been developed from working with the given material, and they remained convincing in a number of variations over a long period (PLATES 358–9, 361). More playful bends and scrolls in the manner of the late Regency occur c.1820/30 (PLATES 363–6). The legs too might now be curved in a way reminiscent of rococo. Lightness of weight was a constant design objective, emphasizing the difference between these benches and cast-iron products of the same period. They were therefore not tied to a fixed location and could be moved more easily; some even have small, specially fitted wheels to allow for this (PLATES 359, 362). On the other hand, there were also examples which could be installed as fixtures in a circle or a semi-circle round a tree. There were also models with a sun canopy or tent structure attached to them; Frederick Reynolds from Birmingham registered a bench of this type at the Designs Office in 1874.[257] From about the middle of the century benches must have been made where the seat and the back rest merged into one another, fitted with parallel iron straps (PLATE 371). Even after 1900 Van Dorn Iron Works

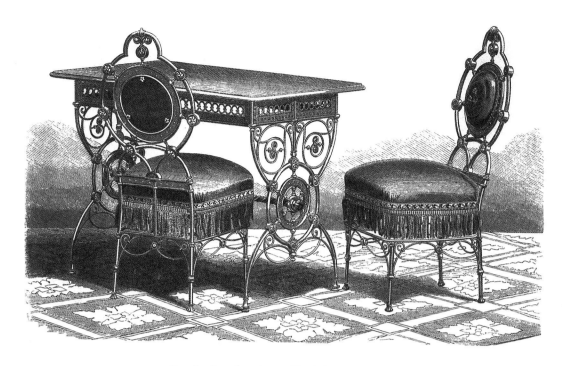

Iron furniture from August Kitschelt, Vienna, 1864,
designed by Josef Storck.

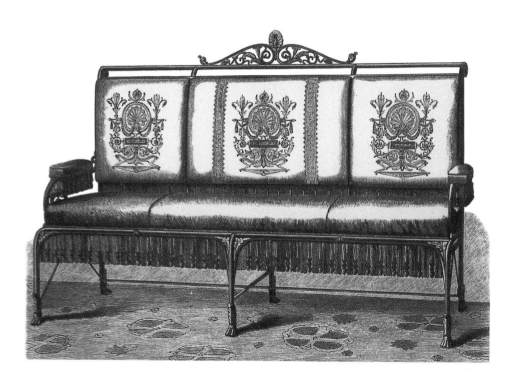

Sofa from August Kitschelt, Vienna, 1871,
designed by Rudolf Bernt.

Co. in Cleveland was lauding benches of this description in its catalogue: 'Our leader in Lawn seats, made entirely of steel, is the strongest seat made. Thousands of these seats are in use in parks and cemeteries, as well as private grounds.' Then in the 1860s park benches for relaxed, comfortable sitting were developed from this model, again made from iron strap and tilting back (PLATES 369, 372). However, the seat and back rest could also be fitted with wooden slats; an early example must have been made in France, using the forms of the Louis-Philippe style (PLATE 370). In garden furniture of this kind imagination could again reign supreme (PLATE 367), and even become patentable (PLATE 368). The desire for garden furniture to be movable finally led to the folding chairs and tables to go with them (PLATE 401) still found in many pub gardens today (PLATE 373). It was yet again Frederick Reynolds who registered a 'Folding Chair' of this type at the Designs Office in London in 1869.[258] As well as being made of round iron rods, iron strap and wooden slats, with advances in industrial techniques seats could also be made of perforated metal sheet or even wire mesh (PLATES 375–6), which would eventually lead to furniture being manufactured from wire.

The special nature of the open parks created in Paris (along with the boulevards) when the city was altered and extended required seating that could be adapted for individual use. A type of chair was needed that could be ranged in rows for large numbers at an open-air concert, grouped for private conversation, or placed singly for a nursemaid near children at play or for a solitary walker. Thus around the mid-nineteenth century a chair was developed in France that was able to meet the huge requirements of French cities for their public squares and gardens simply and cheaply. Light but tough chairs were made by bending thin iron rod, and they could be manufactured extremely cheaply by mass production on a hitherto undreamt-of scale (PLATE 377). The structure is very simple: a circular ring for the seat, consisting of punched sheet metal or interwoven steel straps, is supported by four U-shaped hoops made of round rods which in turn are assembled in such a way that the rods double up to form the feet (PLATES 378–83). A fifth U-shaped hoop forms the back rest which is then strengthened in a variety of ways, either by just two straight supports (PLATES 382–3), flat iron bars (PLATE 378) or imaginatively bent round iron rods (PLATE 381), punched sheet metal (PLATE 379) or wire mesh (PLATE 389). The linkage of the feet may be reinforced by annular cross-pieces (PLATES 378, 382). Apart from such simple chairs, there were also armchairs where the armrests like the back rests were bent in a wide variety of ways. Slight

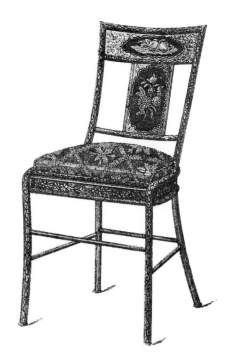

Drawing-room and garden chair from
Gaudillot Frères & Roy, Besançon, 1845.

adjustments embellish the structure: the seat can be right at the front (probably a somewhat later form); the legs can consist of a single rod rather than a double one, in which case cross-pieces or abbreviated U-hoops ensure stability (PLATES 380, 384, 390). Benches, too, could be made by this method in every possible combination (PLATES 386–7, 393). And finally, making the seat and back rest out of slightly arched steel strap provided greater comfort (PLATES 395, 396), a system that was also produced in England and America.[259] It was most probably invented by François A. Carré who obtained an American patent for it on 15 May 1866.

The benches and the association of armchairs with small tables indicate that these light pieces of iron furniture very quickly found their way into private gardens. Thus they served not only the 'masses' in the cities, but were also appreciated by the well-to-do, and even at court. In private gardens tables, too, were needed and they could be manufactured according to the same principles. This furniture was made in the widest range of variations and with its simple forms retained its place in our gardens over a long period (PLATES 397, 399, 400).

The immense quantity of this type of park furniture still in existence in France alone should demonstrate that we are dealing here with a French invention. However, it has not yet proved possible to discover the 'inventor' or the date of the 'invention'. In the Val d'Osne catalogue for 1867 (ILLS pp.56–7) twelve different models are available

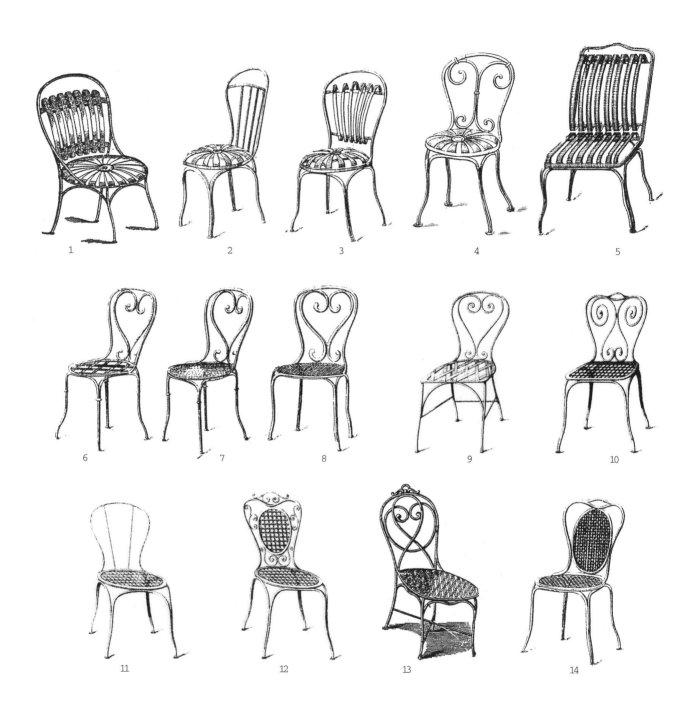

Chairs made of round iron rod.
1: Schlesinger, Wiessner & Co., New York, 1892; 2–3: Val d'Osne, 1867;
4–8: Paris, c.1890; 9–12: Val d'Osne, 1867; 13: Paris, c.1890;
14: Schlesinger, Wiessner & Co., New York, 1892.

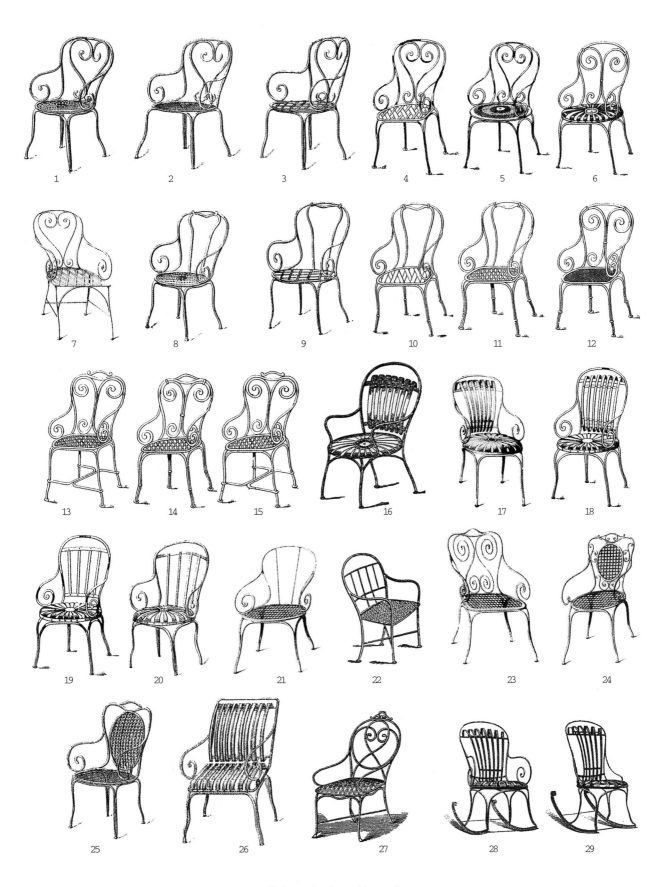

Chairs made of round iron rod.
1–6: Paris, c.1890; 7: Val d'Osne, 1867; 8–15: Paris, c.1890; 16: Schlesinger, Wiessner & Co., New York, 1892; 17: Val d'Osne, 1867;
18–19: Paris, c.1890; 20–21: Val d'Osne, 1867; 22: Schlesinger, Wiessner & Co., New York, 1892; 23–4: Val d'Osne 1867; 25–6: Paris, c.1890;
27: Schlesinger, Wiessner & Co., New York, 1892; 28–9: J.W. Fiske, New York, 1868.

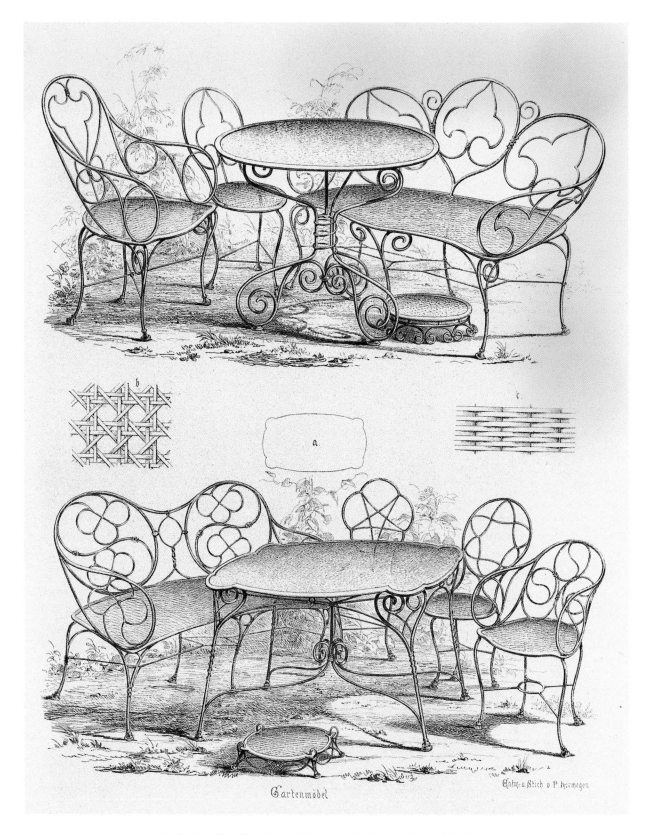

Garden furniture from J.L. Kaltenecker's sieve and wire-ware factory, Munich *c.*1855,
designed by Peter Herwegen.

*(Right)* Benches made of round iron rod.
1: Schlesinger, Wiessner & Co., New York, 1892; 2: J.W. Fiske, New York, 1868;
3–8: Paris, *c.*1890; 9–10: Schlesinger, Wiessner & Co., New York, 1892.

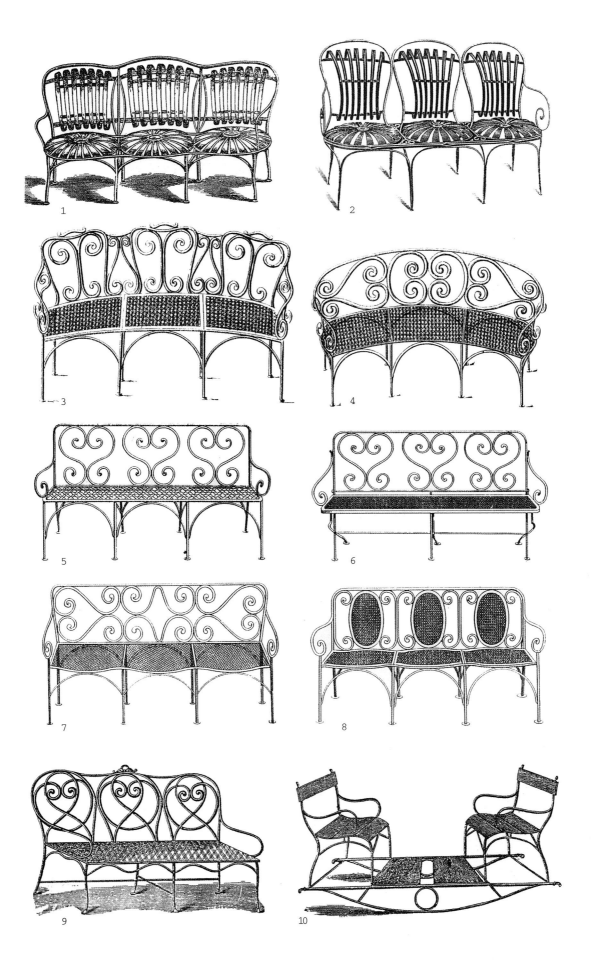

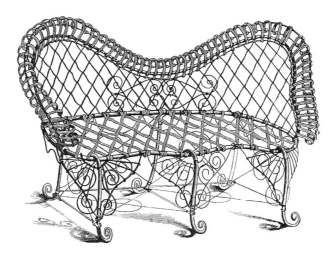

'Galvanized Wire Settee' from catalogue of J.W. Fiske, New York, 1868.

including some with a steel sprung seat. Therefore, at that point production must have already been in full swing; and of course, the date of a catalogue preserved by chance is no indication of the date of first production.

In 1855, in the Munich *Zeitschrift des Vereins zur Ausbildung der Gewerke,* the painter and artist craftsman Peter Herwegen (1814–93) presented seating and tables of this kind designed by him which were obviously manufactured in large numbers and even exported by the Königliche Hof-Sieb- und Drahtwarenfabrik of J.L. Kaltenecker in Munich (ILL. p.58).[260] Herwegen writes regarding his designs:

> This new treatment of fine iron strap and wire for the manufacture of luxury objects is mainly used when it is a question of greater strength or longer duration, resistance to weathering, etc…. Chairs, armchairs, stools, sofas, benches, tables, etc made of the material described…offer definite advantages in comparison with those made of cast iron which are heavy and hard to move, because of their good seating and lightness associated with elegant, tasteful forms, and because of their much greater durability and relative cheapness.

Further information given by Herwegen is interesting in two respects:

> This furniture is often seen, even in the city of Paris which sets the tone everywhere, painted to look like cane. Apart from the fact that it would not occur to anyone to have confidence in a cane chair of this form and appearance, and as the feeling that this furniture can be made only of metal is obvious, the better material (metal) is

evidently being downgraded into a worthless one by this paint. The most appropriate finishes here are always metal lacquers, oxidations, or bluish, bronze-toned and metallic paints…. The material always determines the form and construction.

Thus Herwegen is here pleading for truth to material, and incidentally informing us that in his day (1855) these chairs could be found in many places and particularly in Paris. Moreover, the multiple decorative loops and coils on his furniture suggest that this is not the first formulation of such a design.

The very versatile firm of Jakob Lorenz Kaltenecker in Munich exhibited a wide assortment of sieves at the Great Exhibition in London in 1851 as well as drums with a special tuning screw, garden fences and special wire-mesh racks for drying malt. But the manufacture of garden furniture from bent round rods was an important branch of production for the firm for many years (PLATES 380, 384–5, 390–1). In the early 1850s they stocked 22 different models of seating, tables and footstools in the style of those designed by Peter Herwegen.[261] More richly decorated seating must have been created only a short while later (PLATE 388).

The invention of these chairs made of round iron rods is brilliant in its simplicity, and manufacture therefore expanded rapidly in all countries. Just as several firms in France were involved in producing them, Kaltenecker was certainly not the only manufacturer in Germany. His output is characterized by certain peculiarities: the legs on the chairs always consist of a single round rod, not paired rods; they are almost always inserted into a cast-iron foot; thinner cross-pieces, sometimes arranged to form a cross, connect the legs with one another; the seats generally

curve forward a little in the middle (PLATES 380, 384, 390). The seats and infill for the back rests as well as the table tops often consist of latticework which imitates a cane pattern (ILL. p.58; PLATES 380, 388).

Other German firms, e.g. the Carlshütte in Rendsburg and L. Herrman in Dresden (the latter having showed 'wire garden furniture with a green lacquer' at the 1850 Dresden Exhibition), must have produced similar furniture, and it was also made in Austria, The Netherlands and England (PLATES 386–7, 392–3). The New York firm Hutchinson & Wickersham presented chairs of this type made of bent iron rod in its 1857 catalogue as 'a new article lately introduced'. They were also produced by other New York factories such as J.W. Fiske (in its 1868 catalogue), J.L. Mott (in its 1871 catalogue) and Schlesinger, Wiessner & Co. (in its 1892 catalogue); they all always offered them also with steel-sprung seats and back rests (ILLS p.56–57, 59).

---

AT THE same time as the chairs made of bent round iron rod, furniture started to be made that was constructed from relatively thin wire. Once again it is John Porter, the 'inventor' of the iron rocking-chair (see p.52), who makes the first surviving reference to furniture of this type. In his 1839 catalogue leaflet, wire flower baskets are presented in the widest variety of forms. The required stability is achieved by interweaving and tensioning the wires in such a way as to work equally through tension and compression. These technical requirements alone produce attractive airy structures which can be embellished further by all sorts of tangled foliage and curlicues (PLATES 402–3, 409). However, a particularly ingenious 'ornamental wire flower table' exhibited by John Reynolds of London at the Great Exhibition in 1851 (ILL. p.64) demonstrated that wire could also be used in a different way to make furniture. Here stability is achieved by the close-meshed linking of the wires; this at the same time makes an artistic design possible. This is a completely one-off piece of

furniture that had no subsequent impact whatsoever; but it does demonstrate the general interest felt by people at that time in experimenting with this material.

Garden seats (PLATES 404–5) too were produced by tensioning wires – as in Porter's flower baskets – and these were to enjoy great popularity in American in particular. The foremost manufacturers in this field were J.W. Fiske (ILL. opposite), the Barbee Wire and Iron Works and M. Walker & Sons, and the imagination of the designers, again unrestricted by material and technology, could ultimately result in the creation of some totally distorted structures.[262]

At the end of the century, yet another form of wire chair was developed. Its stability was no longer achieved by tensioning the wires but by twisting them together in places – its special charm is in fact derived from this – and bending them in as great lengths as possible into the widest variety of forms (PLATES 406–8). This time the earliest mention comes from Sweden. The Grytjöls foundry in Skönnarbo includes a plain chair, an armchair, a rocking-chair and a small table using this technique, bent and twisted from steel wire, in its 1892 price list (PLATE 408).[263] Oscar Högberg is named as the inventor of the 'patented twisting method'. According to the firm's catalogue, 'This steel furniture is cheaper than Viennese furniture [meaning Thonet's furniture] and better too because of its greater durability and more delicate appearance.' It was supplied in bronzed, nickelled or even gilded form.

It must have been only a short time later that the Royal Metal Manufacturing Company in Chicago began to produce similar twisted wire chairs which immediately became very popular (PLATES 406–7), and, like the Thonet chairs in the Vienna coffee-houses, they were supplied in large numbers for 'Ice Cream Parlors' and 'Soda Fountains' right across the continent. Soon other firms too went into production, e.g. the Brand Metal Manufacturing Company in Buffalo.[264] As late as 1909 the Royal Metal Manufacturing Company took out a patent on a matching child's chair.[265]

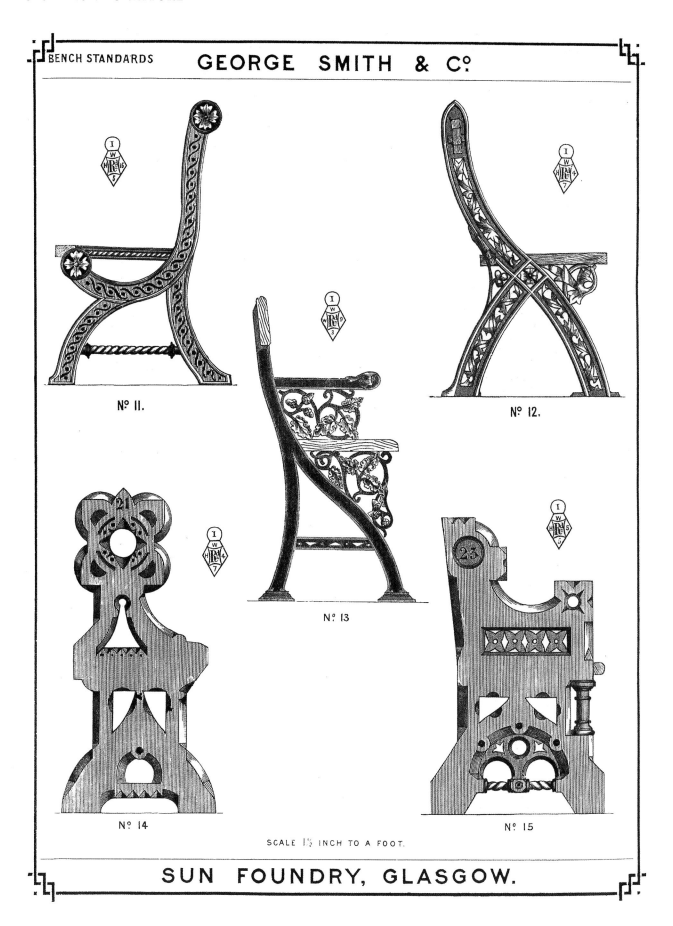

# GEORGE SMITH & Co.

Nº II.

Nº 12.

Nº 13

Nº 14

Nº 15

SCALE 1½ INCH TO A FOOT.

# SUN FOUNDRY, GLASGOW.

Church pews from catalogue of the Sun Foundry, George Smith & Co., Glasgow, 1865.

# Final observations

THE many properties which iron as a material combines in itself, whether in wrought or cast form or ennobled as steel, made it possible for inventors and makers always to come up with innovations in the field of furniture. One invention that was especially convincing because of its seeming simplicity was the folding reclining chair which, no doubt first made of iron and only later of wood, has been produced in countless millions up to the present day. An early example (PLATE 412) must have been made in France, probably in the 1780s and no doubt in an important factory such as that of Desouches in Paris. This superbly worked, fully developed model is certainly not the first trial piece. Its delicately and elegantly curving struts and supports, and the minimal decorative forms of turned knobs and tiny whorls are perfect in their detail and imbued with the spirit of the late eighteenth century.

A good 80 years later, a reclining chair of the same kind became a 'machine' (PLATE 415). George Wilson obtained a patent for his 'Adjustable Iron Chair' which can be moved into every conceivable position in Chicago on 21 November 1871. On 1 February 1876 Cevedra B. Sheldon patented an 'Invalid Chair' (PLATES 410–11); it was manufactured by the Marks Adjustable Folding Chair Company which existed in New York from 1876 to 1895. Sheldon was an outsider; there are records of him as a merchant in New York from 1873 to 1877.[266] On the armchair a foot support can be folded out at every possible angle, though it is hardly visible in the normal position. The back rest can likewise be adjusted in a variety of ways, and can even be folded down into a horizontal position so that the patented chair can also be used as a bed. The journal *The Cabinet Maker & Art Furnisher* made the following comment on 2 June 1889: 'The Marks Folding Chair is constructed to fulfil the requirements of lounge chair, smoking chair, library chair, deck chair and bed, and it plays these many parts in a thoroughly satisfactory manner.'[267] Similar systems were also made later by English companies, and in 1882 S. Griffin of London registered a similar invalid chair at the Designs Office (PLATES 413–14). But in fact 'bed-chairs' of this kind were in existence very much earlier. S.J. Arnheim of Berlin exhibited a folding iron chair of a similar form 'intended for the sick-room' at the Leipzig Industrial Exhibition held in 1850. 'By means of various hinges and springs attached partly to the lower sides of the back rest and partly to the ends of the left seat [it can] be moved to the most varied positions and also extended to form a bedstead.'[268]

At the 1851 Great Exhibition in London the American Chair Company, Troy, N.Y., exhibited a new type of upholstered chair and armchair for which Thomas E. Warren had already obtained a patent in 1849 (PLATES 416–18).[269] All that is known of the inventor is that he worked as a broker in Troy from 1849 to 1852.[270] His chairs are made of cast iron and upholstered; a steel-spring device is inserted between the seat and the base frame, and a contemporary reporter commented: 'It will allow of the greatest weight and freest motion on all sides.'[271] The official catalogue of the Great Exhibition notes: 'These chairs are constructed in a style peculiarly American.'[272] Many models can swivel round their middle axis, and others have casters under the four splayed feet. 'The freedom with which the chair may be turned on its centre, renders it very convenient to a person who may want to turn to his library-shelf or side table, as he can do so without leaving his seat.'[273] Similar seating – 'Piano Stools', 'Spring Revolving Chairs', 'Library Chairs' – was soon manufactured by other firms too, e.g. Chase Brothers & Co. in Boston from 1855. The firm of Gardner & Co. which operated in New York from 1863 to 1888 made a wooden chair with a plywood seat on a rigid iron frame with steel springs from 1872 (PLATE 419).

---

THERE IS hardly a single field where iron furniture failed to penetrate. Cast iron was used not only in parks and on the street, in winter gardens and living-rooms, but in schools and churches as well. On 16 May 1872 the Sheffield iron foundry of John Francis Moss registered three models of school bench at the Designs Office, one proudly described as 'The National School Board Desk'. Other British firms, too, took up this branch of production: Colman & Glendening of Norwich from 1873 (PLATE 351, *left*),[274] Walter Macfarlane & Co. of Glasgow from 1874 and Thomas Larmush & Co. of Salford from 1878; and in 1881 'The School and General Furniture Company' was founded in Birmingham. In the United States Charles H. Presbrey, Sterling, IL, obtained a patent for a school bench on 21 January 1873 (PLATE 351, *right*). But the largest manufacturer at the end of

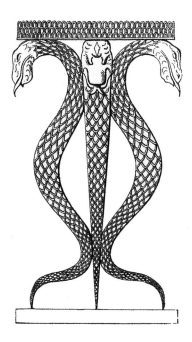

'Ornamental Wire Flower Table' by John Reynolds, London.
Displayed at Great Exhibition, London 1851.

the nineteenth century was the American School Furniture Company in Buffalo, N.Y., supplying the whole continent.[275] Of course, school benches were made with cast-iron frames in every other country too, though in Germany probably only from the end of the century (PLATE 350); for, as late as 1882, Professor J.G. Pfleiderer travelling in America admired the 'desks standing on their own with cast-iron frames'.[276]

Crucifixes and christening mugs were among the earliest *objets d'art* to be made in cast iron.[277] So it is hardly surprising that church pews too were made of cast iron. In 1858 the Swiss firm Von Roll was already able to offer more than ten different models. By adding a shelf for a hat and a desk support, the iron works in Horowitz transformed a garden bench model that was also cast in The Netherlands and Germany into a church pew (PLATES 151, 153). In Britain Walter Macfarlane (PLATE 152) and George Smith (ILL. p.62) supplied church pews, both firms producing a design of their own based on the 'Reformed Gothic Style'[278] of Pugin, Street and Bevan. Some forms were appropriate to the material, but there were also others where the ends of the pews look as if they had been hewn out of huge planks of oak.

THE PRODUCTION of iron furniture had become firmly established in all foundries in Europe, America and Australia from the mid-nineteenth century, so designing it also became a routine matter in the course of the second half of the century. Certain models proved to sell well and could be marketed for decades. A whole range of forms, whether taken from styles from the past or specially developed for casting, had not only proved themselves but even come to typify the object, as an immediately recognizable trade mark and proof of quality for 'iron furniture' as a concept. Each firm certainly prided itself on constantly bringing out new models; however, it was not to be expected that there would be an artistic upturn with genuine innovations in the last third of the century. Nonetheless, thanks to individual artists, a few outstanding achievements were still realized; at Coalbrookdale, for example, where Christopher Dresser was persuaded to work as a designer (see pp.34–5; ILLS pp.33–4; PLATES 166–7, 319, 321). Through his personal style influenced by his training in the laws of nature, geology, botany and zoology, he managed to encapsulate echoes of the early Middle Ages into a new form which he adapted to whichever material was being used. The ornamentation he developed for cast iron seems virtually to reflect the process of casting and the setting of the material. He had the production process and the technique of manufacture totally in mind. 'If iron is to be cast,' he wrote in 1870, 'the patterns formed should be so fully adapted to this method of manufacture that the mode of working may be readily apparent.'[279] The various elements of his formal canon can always be used in new combinations and individual parts of ornaments linked with others so that several variations of his furniture could always be made. The large hall stand of 1874 (ILL. p.34)[280] for example is a reduced version for the middle-class home of a similar showpiece example which had been displayed at the International Exhibition of 1867.[281] The qualities of Dresser's designs were fully recognized and appreciated by his contemporaries,[282] and they then influenced other foundries too, as is demonstrated by umbrella stands made by Charles Hufton in Birmingham (PLATE 322) or John Finch in Dudley (PLATE 323).[283]

The decisive influence Japanese art exercised on Europe after Japan was opened up to the West, particularly as a result of the 'Japanese court' at the London International Exhibition of 1862, had very little impact on the manufacturers of cast-iron furniture. Only Thomas Jeckyll (1827–81), an enthusiastic advocate of japonisme, designed grilles in this style for the Iron Works of Barnard, Bishop & Barnards[284] in Norfolk from 1873; these proved very popular. In association with the same foundry, he created for the centenary exhibition held in Philadelphia in 1876 a large 'Japanese' pavilion which was surrounded by cast-iron benches (PLATES 186–7). Barnard, Bishop & Barnards registered this model with the Designs Office the following year[285] and put it into production. At the same time, a matching chair was designed with a back rest developed from the fan motif on the side of the bench;[286] there were five different flower motifs for the back rest of the chair. Both items were offered in pale green, chestnut brown or bronzed, and could still be supplied in the 1880s.[287]

But this remained an isolated case. It was only years later that a few other foundries experimented with japoniste forms. Between 1878 and 1880 a few fire surrounds in this style were submitted to the Designs Office. Japoniste forms were adopted for the design of a few umbrella stands: because of their large turnover on the one hand and their small dimensions on the other these were the easiest items to adapt to the prevailing fashion. In October 1880 the foundry of Robbins & Co. in Dudley registered two such umbrella stands in London,[288] and in 1882 Yates, Haywood & Co. of Rotherham another two.[289] But there could not have been many more made.

Art nouveau was initially hostile to industry. John Ruskin and William Morris could see artistic progress only in a return to craft methods of manufacture. Therefore cast iron had no place in their arts and crafts movement. There had always been voices raised in criticism of cast iron. As early as 1841 Pugin wrote: 'Cast-iron is a deception' and 'it can but rarely be applied to ornamental purposes'.[290] Ruskin was even more categorical in expressing his opinion in 1849:

No ornaments…are so cold, clumsy and vulgar, so essentially incapable of a fine line or shadow, as those of cast iron…. There is no hope of the progress of the arts of any nation which indulges in these vulgar and cheap substitutes for real decoration.[291]

Macmurdo's Century Guild founded in 1882 and Ashbee's Art Worker's Guild founded in 1884 and transformed into the Guild of Handicrafts in 1888 were striving to renew the arts along the lines indicated by Ruskin and Morris. Gallé in France and Tiffany in America were themselves craftsmen. It was therefore only logical that wrought iron was now appreciated as the only possible artistic method of working iron. As early as 1866 W.C. Aitken wrote that cast iron was 'hateful to the artist's eye', going on to say:

In cast iron we recognize only the machine-made copy of a copy; in wrought-iron we feel the presence of the thought which the craftsman has stamped upon his work. One brings us face to face with matter, the other with mind.[292]

And in 1874 Jakob von Falke wrote: 'Nothing was left to us in our century other than the generally inartistic process, cast iron.' Writing about the Viennese World Fair of 1874 he reports: 'Wrought iron is becoming more widely appreciated artistically too.'[293] Of course, such widely expressed criticism was not intended to influence foundries to make their cast products look like wrought-iron pieces (PLATE 344), but it once again demonstrates that in cast iron everything is possible and that the industry could adapt to each new demand.

Again, it was only on small items, ignored and little valued by artists, that a few foundries tried out art nouveau forms: umbrella stands (PLATE 332), flower tables (PLATE 336) or mirror stands (PLATE 267). Only Hector Guimard (1867–1942) recognized that casting was actually the most appropriate process for conveying in a durable material the flowing, curving, floral forms that typified the art nouveau movement first and foremost in France and Belgium, but in Germany, too, through Henry van de Velde. From 1899 Guimard was responsible for designing the Paris *métro* entrances and his green-patinated cast-iron structures made a lasting mark on the Parisian cityscape. He designed several items for the Fonderies Artistiques pour Constructions, Fumisterie, Articles de Jardin et Sépultures in Saint-Dizier, including benches and tables (PLATES 203–4, 269).[294] They mark a unique and ultimate high point in the design and making of cast-iron furniture.

# Notes

1. Ref. Raff, pp.55, 61–3, also p.9, note 3.

2. Johann Georg Krünitz *Ökonomisch-technologische Encyclopädie.* Part 10. Berlin 1785, p.546.

3. *Allgemeines deutsches encyclopädisches Handwörterbuch oder wohlfeilstes Taschen-Conversations-Lexikon für alle Stände.* Augsburg 1829, vol.12, p.1825.

4. Horace Greely *The Great Industries of the United States.* Hartford 1873, p.379. See also pp.381–3.

5. *Meyers Grosses Konversations-Lexikon.* 6th edn. Leipzig 1903, vol.5, p.481.

6. Quoted after Robertson 1960, p.44. Even in 1878, in his introduction to *A practical treatise on casting and founding,* London 1878, N.E. Spretson writes: 'Cast-iron is now applied to a multitude of purposes, the articles made from it ranging in size from a half-pint saucepan up to an anvil block, which takes months to cool down after it has been cast.'

7. Roy Palmer *A Touch on the Time.* Harmondsworth 1974, pp.31–2.

8. English iron export figures were 118,000 tons in 1830, 783,000 tons in 1850 and over a million tons annually in 1870. See John R. Harris *The British Iron Industry.* London 1988, p.64.

9. Matheson, p.221: 'In short, while cast iron may be made to any shape that plastic clay will take, or to any which can be carved in stone, marble, mahogany, or oak, it is nearly equal to hammered iron in giving delicacy of form. Moreover, some designs which are too delicate to be utilized in such materials as clay, stone and wood, are of sufficient strength if made in cast iron…. Indeed, an art-workman has greater scope for design in the earlier stages of cast iron manufacture [i.e. in the clay model] than in wrought iron.'

10. Ref. Hans Ulrich Nuber and Aladar Radnoti 'Römische Brand- und Körpergräber aus Wehringen' in *Jahresberichte der Bayerischen Bodendenkmalpflege* 10. 1969, pp.27–49. Eva B. Bónis 'Das kaiserzeitliche "Wagengrab" Nr.3 von Környe' in *Folia Archaeologica* 33. 1982, pp.119–56. Hans Jörg Kellner and Gisela Zahlhas *Der römische Tempelschatz von Weissenburg.* Mainz 1993, cat. no.109.

11. See *Paulys Real-Encyclopädie der classischen Altertumswissenschaft,* 2nd series, vol.2. Ole Wanscher *Sella Curulis, The Folding Stool, an Ancient Symbol of Dignity.* Copenhagen 1980.

12. Genesis 4:22. See also p.12 and note 30.

13. Isidore of Seville speaks of *'ferrum, quod domat omnia',* for Hrabanus Maurus iron stands for the perception of the spirit, the inscription on the wheel candelabra at Grosskomburg sees the virtue of patience in the hardness of iron, and according to Honorius Augustodunensis iron designates 'those who control their passions'. See Raff, pp.55, 61, 62.

14. In reconstructing the seat made of material it failed to cut into it as far as the middle.

15. Wanscher, p.145.

16. For the setting cf. e.g. *I Langobardi e la Lombardia.* Exhib. Milan 1978, plates XVII, XXV, XLII. There were also iron folding chairs in eight Nubian kings' graves dating from the 5th/6th century at Ballana, south of Abu Simbel.

17. Good illustrations in Colombo, pp.25–7.

18. All examples in Wanscher, pp.143–6, 192–201, 323, 331, with all further bibliography references.

19. Wanscher, p.236.

20. Wanscher illustrates an iron folding chair with an almost identical openwork connection – a little larger, and on the lower part too – on p.325. However, his information that the chair is in the church of Cham in Switzerland is not correct. Its present location could not be ascertained.

21. See e.g. Höver, plates 75–7 and Gardner, plates 24, 26.

22. Sotheby's, London, 26 July 1981, no.108. See also Hugo Helbing, Frankfurt, 1–5 November 1934, nos 242–3; Neumeister, Munich, auction 175, 1977; Galerie Fischer, Lucerne, 9–16 November 1982, no.14. More iron folding chairs are illustrated in Wilhelm von Bode *Die italienischen Hausmöbel der Renaissance.* Leipzig 1920, fig.36; and in Frieda Schottmüller *Wohnungskultur und Möbel der italienischen Renaissance.* Stuttgart 1921, figs 391–2; and in Pedrini, figs 310–11.

23. Wanscher, p.237. A Spanish drawing of 1597 shows an iron folding chair either with a simple seat, with a cushion or with cloth stretched across it; see Peter Thornton *The Italian Renaissance Interior, 1400–1600.* London 1991, fig.204.

24. Henry Harvard *Dictionnaire de l'ameublement.* Paris 1887–9, vol.2, cols 683–4. The inventory of the church treasures of Lyons still lists 'une chaize pliante étant de fer' in 1724.

25. Beck, vol.2, p.786.

26. *Kunsthistorisches Museum, Sammlungen Schloss Ambras. Die Kunstkammer.* Innsbruck 1977, no.383.

27. The figure shows the chair with the gripping arms extended but when it is not being used they are concealed in the back-rest supports.

28. Hermann Kopp *Die Alchimie.* Heidelberg 1886, vol.1, p.173.

29. Ref. Wanscher, pp.246–8, 335.

30. Daniel 2:36–40.

31. For the history of the chair see Hayward and Rieder, Hayward in *The Burlington Magazine,* and Hayward in 'Welt im Umbruch'.

32. Malchenko, figs 15–30.

33. Christopher Gilbert *Furniture at Temple Newsam House and Lotherton Hall.* London 1978, pp.99–100, no.94.

34. Celia Jenning *Early Chests in Wood and Iron*. London 1974, p.6, chest X. See also chests VI, VII and XI. I am indebted to Mrs Jane Geddes, University of Aberdeen, for this reference.

35. Eames.

36. A French example is in the Musée Carnavalet, Paris. See Nicole de Reyniès *Principes d'analyse scientifique. Le mobilier domestique*. Paris 1987, vol.2, fig.2054.

37. Cf. e.g. Otto von Falke *Deutsche Möbel des Mittelalters und der Renaissance*. Stuttgart 1924, p.193. Heinrich Kreisel/Georg Himmelheber *Die Kunst des deutschen Möbels*, vol.1. Munich, 3rd edition, 1981, fig.298.

38. Ref. Georg Himmelheber *Kleine Möbel*. Munich 1979.

39. Cf. e.g. Kreisel/Himmelheber (as note 37), fig.459, and Wolfram Koeppe *Die Lemmers-Danforth Sammlung*. Heidelberg 1992, p.98.

40. Cf. e.g. Kreisel/Himmelheber (as note 37), vol.2, Munich, 2nd edition, 1983, fig.677, and Franz Windisch-Graetz 'Barocke Möbelkunst in Österreich' in *Mitteilungen des oberösterreichischen Landesarchivs* 10. 1971, fig.38.

41. Franz Windisch-Graetz recently dealt with this piece of furniture in detail in *Möbel Europas, Renaissance und Manierismus*. Munich 1983, pp.41–4, figs 96–9.

42. Inv. nos 570–1899, M 668–1910, M 22–1952, 176–1885.

43. Marian Campbell, fig.66.

44. Alvar Gonzáles-Palacios *Objects for a 'Wunderkammer'*. London 1981, pp.64–5.

45. J.B. Waring *Masterpieces of Industrial Art & Sculpture at the International Exhibition*. London 1862, plate 30.

46. Ref. G. Armand d'Aguel *Le Meuble. Ameublement provençal et contadin*. Paris/Marseilles 1913, pp.341–6, plates 125–7.

47. D'Allemagne, vol.2, plate 310.

48. Malchenko, figs 15–30; also *La France et la Russie au Siècle des Lumières*. Exhib. Paris 1986–7, cat. no.571.

49. Ronald Gobiet *Der Briefwechsel zwischen Philipp Hainhofer und Herzog August d.J. von Braunschweig-Lüneburg*. Munich 1984, no.1239.

50. *The Diary of John Evelyn*. Ed. E.S. de Beer. Oxford 1955, vol.2, p.470. I am indebted to Mrs Frances M. Buckland, London, for this reference.

51. Lensi Orlandi, figs 124–5.

52. See e.g. Höver, pp.177–9; Pedrini, figs 36, 163–5, 205; Colombo, pp.74–7.

53. Arthur Macgregor *Tradescant's Rarities. Ashmolean Museum*. Oxford 1983, no.210. On dating cf. Pedrini, figs 33–4 and 47.

54. Quoted after *Guidebooks and Tourism. The British in Italy*. London 1980.

55. Samuel Sharp *Letters from Italy*. London 1767. Quoted after Boynton, p.25.

56. Ibid.

57. White also presents an iron invalid bed with illustrations which 'D. Vaugham, a skilled doctor in Leicester, had invented and had manufactured in Birmingham'. Both quoted in detail in Krünitz (as note 2), Berlin 1789, vol.47, p.40. Adjustable sick beds were also constantly being presented in specialist journals. See e.g. *The London Journal of Arts and Sciences* 3. 1829, pp.156, 223.

58. Boynton (as note 55), p.25. Later, too, endeavours were constantly being made to bring iron beds into general use in hospitals. Even in 1828 the factory-owners in Mulhouse in Alsace decided to donate twenty iron beds to the hospital there, to be made by the Risler brothers for 60fr. each. (*Bulletin de la Société Industrielle de Mulhausen* 2. 1829, pp.203–9; plate 18). That same year in *Dinglers Polytechnisches Journal* (30. 1828, pp.83–6) it is argued: 'It is truly incomprehensible, or…can be explained only by the so rarely punished stinginess of the majority of hospital administrators that the most pitiful rattletraps of wooden bedsteads can still be tolerated in most hospitals and nursing homes in Germany when they are real breeding grounds for verminous insects.' The writer suggests a simple iron bedstead that does not have to be perforated as in the Pihet process (see p.20). The previous year at the Arts and Crafts Exhibition in Berlin the firm Werner & Neffen had exhibited iron beds: 'These well constructed bedsteads should…be very desirable for public residential and care institutions representing…the surest means against the bedbugs which are as common as they are bothersome in such institutions.' (*Der Handwerker und Künstler Fortschritte und Muster* 3. 1827/28, p.64).

59. Matthias Claudius *Botengänge. Briefe an Freunde*. Berlin 1965, p.262.

60. *Johann Wolfgang Goethe, Gedenkausgabe*. Zurich 1950, vol.11, pp.373–4.

61. *Johann Peter Eckermann, Gespräche mit Goethe. Gedenkausgabe*. Zurich 1948, vol.24, p.70 (13 November 1823).

62. *Erinnerungen der Malerin Louise Seidler*. Ed. Hermann Uhde. Berlin 1929, p.114.

63. Harvard (as note 24), col.684.

64. *Registre des Ordres et Décisions de M. Le Commissaire Général*. Paris, Archives Nationales O 3302, p.78. Information kindly passed on by Mrs Frances M. Buckland, London.

65. *Die Kindheit unseres Kaisers. Briefe der Baronin Louise von Sturmfeder aus den Jahren 1830–1840*. Vienna n.d. (1910), p.119.

66. Harvard (as note 24), col.684.

67. Ibid. col.684.

68. Jan Lauts *Karoline Luise von Baden*. Karlsruhe 1980, p.288.

69. *Berlinische Privilegirte Zeitung* 1761, 13th issue, 29 January 1761, p.52. First reference in Berger, p.71.

70. *Description des Machines et Procédés spécifiés dans les Brevets d'Invention, de Perfectionnement et d'Importation*, vol.3. Paris 1820, no.159, 7 February 1804.

71. J. Vacquier *Souvenirs of Napoleon Bonaparte*. Strasbourg 1928, pp.108–10. Another example with higher bed-ends top and bottom is illustrated in Regniès (as note 36), vol.2, fig.808.

A similarly magnificent item is the folding chair that may have accompanied Murat on his campaigns (plate 14).

72. B. von Roda 'Aus dem Nachlass der griechischen Majestäten' in *Kunst und Antiquitäten* 1983, vol.6, p.70.

73. Vol.2, no.V, plate 2.

74. Sotheby's Monaco, 21/22 June 1987, no.1083.

75. Sotheby's London, 24 November–8 December 1989, no.355.

76. British patent no.3560 of 13 April 1812, sealed 27 June 1812.

77. *The Repertory of Patent Inventions* 5.1827, pp.107–9. Also mentioned in *Dinglers Polytechnisches Journal* 22. 1826, p.95, and 28. 1828, pp.257–8.

78. *The Repertory of Patent Inventions* 5. 1827, pp.249–52. *Dinglers Polytechnisches Journal* 26. 1827, p.454.

79. Ludwig Börne *Schilderungen aus Paris. Börnes Werke.* Bibliothek Deutscher Klassiker. Berlin/Weimar 1981, pp.278, 285.

80. *Dinglers Polytechnisches Journal* 30. 1828, pp.81–3.

81. Berger, p.72.

82. Jules Burat *Exposition de l'industrie française, année 1844.* Paris 1844, vol.2, p.42.

83. *Zeitblatt für Gewerbetreibende und Freunde der Gewerbe* 1. 1828, p.306.

84. Edward Cottam constantly improved his beds. In 1851 at the Great Exhibition in London he displayed a model with spiral springs open to view. See *Der Kunst- und Gewerbsfreund.* Ed. Ludwig Fernow. Halle n.d. (*c.*1851), pp.8–9 with fig.

85. John Claudius Loudon *Encyclopaedia of Cottage, Farm and Village Architecture.* London 1833 (new edition with supplement 1846), pp.329, 332, figs 684, 691–3. William Mallet's business was built up into a thriving concern by his son Robert Mallet (1810–81). From 1865 to 1869 the latter was editor of the *Practical Mechanics Journal.* See also p.26.

86. *Elend und Aufstieg in den Tagen des Biedermeier. Erinnerungen und Tagebuchblätter von Friedrich Maurer.* Ed. Walter Meyer. Stuttgart 1969, p.89.

87. *Kunst und Gewerbe-Blatt.* Ed. by the Polytechnischer Verein für das Königreich Bayern 29. 1843, cols 146–7 with fig. and 31. 1845, col.299.

88. Beds assembled from tubes, and sofas too, were also supplied in large numbers by the Parisian firm of Bainée. See Burat (as note 82), vol.2, p.42.

89. Edward Peyton 'Manufacture of Iron and Brass Bedsteads' in Timmins, pp.624–7.

90. 'On 4.12.1827 Robert W. Winfield, a caster in bronze in Birmingham, obtained a patent for improvements to tubes or rods…for bedsteads and other articles.' *Dinglers Polytechnisches Journal* 27. 1828, p.151.

91. See p.35.

92. The provision states that 'every person…shall cause his or her name to put thereon, with the date of publication'.

93. On Bullock see Joy, pp.164–70.

94. I am extremely grateful to Mr Martin Levy, H. Blairman & Sons Ltd, for allowing me to view this furniture in detail and giving me access to all archival sources and documents. See H. Blairman & Sons Ltd 'Furniture and Works of Art'. London 1994, cat. no.8. I am indebted to Dr Clive Wainwright, London, for first informing me of this piece.

95. The Lauchhammer foundry was founded by Benedikta Margarete v. Löwendahl in 1725 with two blast furnaces. In 1776 Detlef Graf von Einsiedel inherited the works where he promoted primarily artistic casting. Together with Wasseralfingen, Lauchhammer was the leading German foundry *c.*1800; in 1815 it already employed 100 workers. See Eduard Vollhann *Beyträge zur neueren Geschichte des Eisenhüttenwesens.* Eichstätt/Leipzig 1825, p.158; also Schmidt 1981, pp.25–33.

96. The Königlich Preussische Eisengiesserei in Gleiwitz (now Gliwice) in Silesia was built in 1793–6 in a region where iron had been worked since the sixteenth century. Thanks to advice from the English technician Baildon the plant prospered rapidly. Cast goods for defence purposes, for machine-making, simple commercial articles and – from 1798 – artistic cast-iton articles were produced. Family houses were built for the workers, and a school opened for their children in 1812. Throughout the nineteenth century Gleiwitz was regarded as a model from the technical, economic and social points of view. See Seidel, Schmidt 1981, pp.34–45.

97. The Königlich Preussische Eisengiesserei in Berlin was founded in 1804 with six workers; the following year it employed 24 people; by 1806 150,000kg of iron were already being worked. Initially, mainly small articles were produced: knife rests, furniture mounts, medals, jewellery. In 1806 objects were exhibited at the Akademie Exhibition in Berlin for the first time, and at the same time the bridge at the Schloss on the Pfaueninsel was made, then from 1811 large sculpted items too. In 1848 the plant burnt down; therefore, hardly any documents have been preserved which could provide exact information and dates regarding items made in Berlin. Because of its refined recipes for mixing iron, the quality of its sand forms and its surface treatment 'Berlin Iron' or 'Font de Berlin' soon won international acclaim. See Schmidt 1981, pp.46–69.

98. To this extent documents preserved in Gleiwitz allow inferences to be drawn regarding production in Berlin.

99. Hintze, pp.53, 98–9.

100. In his book of patterns, *The Smith and Founder's Director*, published in London 1824, Lewis Nockalls Cottingham illustrates two tables (ILL. p.15); with their heavy rather exaggerated forms they must have been intended to be cast. Nonetheless, it must remain open to question whether such tables were ever made. Even so, these designs prove that the manufacture of cast-iron furniture was still being undertaken in England.

101. Karl Friedrich Schinkel *Reise nach England Schottland und Paris im Jahre 1826.* Ed. Gottfried Riemann. Berlin/Munich 1986, p.190.

102. Sievers, pp.40–2.

103. Sievers, fig.186.

104. Sievers, figs 43, 53, 74.

105. Sievers, fig.62.

106. Sievers, fig.76.

107. In any case, as far as I can ascertain, only one example which has lost the infill parts of the armrests has been preserved, in the Dorotheenstadt cemetery in Berlin.

108. Cf. Sievers, figs 139–41, 167–8, 181, 211.

109. *Abbildungen von gegossenen eisernen Kunst-Erzeugnissen in der Königl. Eisengiesserei bei Gleiwitz.* New series 1847, plate 38, fig.1.

110. Cf. also a chair with no armrests and with a different back rest: plate 64.

111. For the years 1821–2, Schadow mentions his assistant, 'Andersen from Rostock', as being 'especially skilled in carving ivory' and relates: 'Later he moved to Güstrow where he successfully set up an iron foundry.' Johann Gottfried Schadow *Kunstwerke und Kunstansichten. Kommentierte Neuausgabe.* Berlin 1987, vol.1, p.144, vol.2, p.626. From 1838 to 1840, the machine builder Dr Ernst Alban owned a share of the foundry. In 1846, after Andersen's death, his brother-in-law the sculptor Heinrich Kaehler took over the business which first operated under his name, and from 1918 as the Van Tongelsche Stahlwerke until it was dismantled in 1945. *Mecklenburgische Monatshefte* 4. 1928.

112. On tables and seating for Charlottenhof, 1827 (Sievers, figs 33, 139); for the Palais Prinz Karl, 1828 (Sievers, figs 34–5, 39, 74, 86); for the Palais Prinz Wilhelm, 1829 (Sievers, fig.54); for the Palais Prinz Albrecht, 1831 (Sievers, figs 36–7, 49–8, 53, 59–10).

113. Sievers, figs 33, 57.

114. Cf. also Sievers, figs 36–8, 53–4.

115. *Karl Friedrich Schinkel, Architektur, Malerei, Kunstgewerbe.* Exhib. (West) Berlin 1981, cat. no.253.

116. Sievers, fig.59.

117. Cf. Schmidt 1981, fig.139. Schinkel's design drawings for iron furniture have not been preserved. In this respect, the information in Schmidt (p.156) should be corrected. In the designs for a table and chair in folio XXXVIIc (not XXXVIc) mahogany is expressly specified for the frame, and in folio XLIIIa and b there is only one drawing (sheet 86) for a piece of furniture which was probably to be cast, a frame for pot plants, but iron is not specifically mentioned as the material.

118. The fame of Berlin cast iron is also reflected in the fact that the black colour in which the furniture could always be supplied, as well as in bronzed or green versions, was described in England as 'Berlin black' right up into the twentieth century. (It is defined by Timmins on p.680: 'Berlin black, an expensive black, drying "dead" without heat, and used by makers of superior stoves, ranges and fenders, also by edge tool makers and others'.) In 1857 in the magazine *The Horticulturist* an item of American iron furniture is introduced with the remark that it is 'quite perfect in its form and rivalling the beautiful castings in Berlin'.

119. Joseph T. Butler *Washington Irving's Sunnyside.* Tarrytown, N.Y. 1974, pp.42–3. The letter is in the Seligman Collection in the New York Public Library.

120. Matheson (p.225) writing even in 1873 says: 'While the ordinary window frames…are almost always of wood, the more elaborate patterns of an Elizabethan or Gothic design may be, and are, produced in metal to great advantage.'

121. For example, the two churches in Liverpool built in 1814 or 1815 entirely from cast iron, a collaboration between the architect Thomas Rickmann and the caster John Cragg of the Mersey Iron Foundry, Liverpool. Ref. Wendy Slemen 'Liverpool's Cast-Iron Churches' in *Foundry Trade Journal* 1975, pp.307–312. The most important examples of neo-Gothic cast-iron church steeples are the tower over the crossing at Rouen cathedral, designed in 1823 by Jean Alavoine (completed in 1863) and the tower on Riddarholms church in Stockholm, designed by Erik Göthe in 1846.

122. Loudon (as note 85), p.634, no.1376. See also p.21, and John Gloag *Mr. Loudon's England.* Newcastle 1970, pp.128–31.

123. Loudon (as note 85), pp.654–5, 704–5.

124. Friedrich Wilhelm Mercker *Practische Zeichnungen von Meubles.* Leipzig 1831–44.

125. See also his influential work: *Contrasts, or a Parallel between the Noble Edifices of the Middle Ages and the Correspondent Buildings of the Present Day.* London 1836. Finally on Pugin, Paul Atterburg and Clive Wainwright *Pugin. A Gothic Passion.* New Haven/London 1994.

126. Ref. Edward Joy et al. *Pictorial Dictionary of British 19th Century Furniture Design.* Woodbridge 1977, and Georg Himmelheber *Deutsche Möbelvorlagen 1800–1900.* Munich 1988.

127. See Georg Himmelheber *Klassizismus, Historismus, Jugendstil, Die Kunst des deutschen Möbels*, vol.3, Munich, 2nd edition, 1983, figs 612–38.

128. Lion Israel Enthoven (1787–1863) established his foundry in The Hague in 1824 together with Eduard B.L. Moritz. At the 1858 exhibition in Dordrecht he exhibited a wide range of cast-iron furniture. In 1865 the business employed c.800 workers. Its main competitor was the De Prins van Oranje foundry, also in The Hague, founded in 1840 by Albertus Sterkman. As the foundation stone for the plant was laid on the day of the birth of the Crown Prince, the son of William III, Sterkman named the foundry De Erfprins (from 1858 De Prins) van Oranje. After Sterkman's death in 1846 his widow continued to run the business with her son, and in 1859 he brought in J.J. van Coeverden as a partner. In 1865 c.400 workers were employed. The two firms in The Hague often manufactured the same designs. In addition, there were another twelve foundries in The Netherlands that made furniture. See Voorst tot Voorst, pp.142, 170–2, 228–30, 285–7, 342, 444–6, 537, 563–4, 585, 701, 709–10.

129. N.N. Sobolew *Tschugonnoje litjo w russkoi architekture.* Moscow 1951, fig.233.

130. See their 1847 catalogue, vol.2, no.532. Wasseralfingen was founded in 1671 as the Fürstpröpstlich Ellwangisches Werk and

later combined with the Abstgmünd and Unterkochen forges. After 1802, in what was by then Württemberg, it was amalgamated with the Christophtal, Ludwigstal and Wilhelmshütte foundries, making the Königlich Württembergische Erzgiesserei into the leading concern in South Germany. The sculptor Georg Konrad Weitbrecht (1796–1836) had a decisive influence on artistic casting from 1823, and was inspector of pattern moulding from 1825. See v. Kerner, Schall.

131. Himmelheber (as note 38), cat. no.151.

132. W. Avery & Son, Redditch, submitted a small pincushion chair of this kind to the Designs Office in London on 2 February 1876 as a design to be protected (no.298075).

133. The Carlshütte was founded in 1827 by Marcus Hartwig Holler (1796–1858), initially with a smelting furnace. The first blast furnace was built in 1830. The first artistic cast objects were shown at the Trade Exhibition in Copenhagen in 1834. Holler set up a pension and sickness fund and cooperative shopping for his workers, and he built houses for them. After Holler's death the business was at first carried on by his son, then converted into a stock company in 1869. From 1941 Julius Ahlmann ran the works as a limited partnership. See Arenhövel.

134. In 1810 Ludwig Leo Freiherr von Roll (1771–1839) combined several iron extraction businesses in Choindez, Klus, Olten and elsewhere which initially traded under the name Choindez & Clus, later simply as Von Roll. The firm is still in existence today and is even making iron furniture again.

135. In 1707/8 Abraham Darby moved the iron foundry he had founded in 1699 to Coalbrookdale where in 1709 he became the first person successfully to produce iron using coke. Four generations of Darbys continually improved the iron industry through important inventions. In the nineteenth century Coalbrookdale was surrounded by nineteen blast-furnace businesses and forges, with links between them and the destinations they were supplying provided by a dense transport network (roads, canals and railways). See Raistrick.

136. Noyes & Hutton founded a 'Hollow Ware Foundry' in Troy in New York State in 1848, which carried on in business from 1852 under the name Noyes & Tillmann.

137. *Theodor Fontane: Unsere Lyrische und epische Poesie seit 1848*. Complete works, Hanser Munich 1969, Essays I, p.238.

138. *Zeitschrift des Vereins zur Ausbildung der Gewerke* 5. 1855, p.26.

139. See pp.34–35.

140. This development found a very early critic in Ralph Nicolson Warnum. See his comments on the subject in *The Art Journal. The Industry of All Nations, Illustrated Catalogue*. London 1851, Appendix, p.XXI.

141. *World Furniture*. Ed. Helena Hayward. New York/ Toronto 1965, figs 791, 794–5, 796, 928, 961. Aslin 1962, figs 9, 39, 51. Himmelheber (as note 127), figs 703, 786, 797.

142. Simon Jervis 'Furniture in Horn and Antler' in *The Connoisseur* 196. 1977, pp.190–201.

143. See Himmelheber (as note 127), fig.772. There is also branch-work furniture carved in wood: see e.g. J.M.W. van

Voorst tot Voorst *Meubles in Nederland 1840–1900*. Lochem 1979, vol.1, fig.30, vol.2, figs 168, 190, 192.

144. The Milton Works of McDowall, Steven & Co. were founded in Glasgow in 1834.

145. George Edward and Matthias Darly *A New Book of Chinese Designs*. London 1754, plates 66, 86–7, 117; W. Wighte *Ideas for Rustic Furniture proper for Garden Seats, Summer Houses, Hermitages, Cottages, etc. on 25 Plates*. London n.d [1790]; Johann Gottfried Grohmann *Ideenmagazin für Liebhaber von Gärten, Englischen Anlagen und für Besitzer von Landgütern*. Leipzig 1796, vol.1, nos 3, 4; vol.2, no.6; vol.6, no.9. In *A Collection of Designs for Household Furniture* of 1808, George Smith even mentions a similar bed, 'suitable to a cottage or country residence'. On this topic see also Morrison Heckscher 'Eighteenth-Century Rustic Furniture Designs' in *Furniture History* 11. 1975, pp.59–65, and Sue Honacker Stephenson *Rustic Furniture*. New York 1979, figs 1–4, 8, 9, 12–13.

146. The Rustic Settee is listed in the following firms' catalogues: Barbee Wire and Iron Works, New York; Bartlett, Robbins & Co., Baltimore; Samuel S. Bent, New York; Boston Ornamental Iron Works; Chase Brothers, Boston; J.W. Fiske, New York; Hutchinson & Wickersham, New York; Janes, Beebe & Co. (Janes, Kirtland & Co.), New York; J.L. Mott Iron Works, New York; J.W. Orr, New York; Phoenix Iron Works, Utica, N.Y.; John A. Winn & Co., Boston; McDowall, Steven & Co., Glasgow; Königshütte, Lauterburg. There is an example in the Coalbrookdale Museum, but it is not signed. It is striking that with two exceptions these are all American foundries. The first public announcement of this model was in 1857 in *The Horticulturist and Journal of Rural Art and Rural Taste* (New Ser.7. 1857, p.498), a magazine published in Philadelphia.

147. Examples in Sleepy Hollow Restaurations, Tarrytown, N.Y.

148. I am indebted to Dr Clive Wainwright, London, for this information and the photographs.

149. McDowall, Steven & Co., Glasgow; L.I. Enthoven & Co., The Hague; De Prins van Oranje, The Hague; J. & C.G. Bolinder, Stockholm.

150. Other foundries use the descriptions 'Grape Settee' or 'Piazza Settee'.

151. The 1850 catalogue states: 'This is a new pattern lately brought out, and from the rich design has sold well.'

152. Metternich iron factory in Plass and iron foundry in Stiepenau.

153. Barbee Wire and Iron Works, New York; E.T. Barnum, Detroit; Chase Brothers & Co., Boston; J.W. Fiske, New York; Hansen & Kirk, Philadelphia; Hutchinson & Wickersham, New York (already in 1857 catalogue); Janes, Kirtland & Co., New York; J.L. Mott Iron Works, New York; Phoenix Iron Works, Utica, N.Y.; W.A. Snow & Co., Boston; Peter Timmes'Son, Brooklyn; John A. Winn & Co., Boston; Robert Wood & Co., Philadelphia, and probably other foundries as well. There is a version of this model where the legs, in line with the back rest, are formed as vines with grapes (PLATE 112).

154. There is a model adapted into a round bench on a circular ground plan in the park at Plas Newydd, Anglesey. Information kindly passed on by Mr Martin D. Drury, The National Trust, London. See also Sotheby's Sussex, 1 June 1993, no.261.

155. In Sweden and Norway there were several foundries that made furniture. J. & C.G. Bolinder's Mekaniska Verkstads regularly issued illustrated catalogues. The foundry in Lessebo which went back to the seventeenth century was expanded and developed by Johan Lorens Aschan from 1802. Under his management (until 1856) garden benches (plate 77) were produced among other things. In 1886 the firm was wound up. The Örmo foundry in Konga was bought up by the Kockums Jernwerk in Kallinge in 1846; in 1888 production was transferred to Kallinge. They produced small items of furniture, benches and beds. The foundries in Näfvequarns and O. Mustad & Søn in Christiania (Oslo) also offered a versatile range of furniture.

156. Barbee Wire and Iron Works, New York; E.T. Barnum, Detroit; Samuel S. Bent, New York; Hansen & Kirk, Philadelphia; J.L. Mott Iron Works, New York; Phoenix Iron Works, Utica, N.Y.; The Van Dorn Iron Works Co., Cleveland; A.B. and W.I. Westervelt, New York.

157. See Robertson 1960, p.163, fig.154. Whether it was also cast in France seems doubtful. But see Renard, p.107. There is a simplified version in Tarrytown, N.Y., Sleepy Hollow Restaurations.

158. The 'Lily of the Valley' and 'Laurel' patterns were evidently produced only in Coalbrookdale.

159. Still in the 1897 'A' catalogue. The foundry was established in 1828. 'The North American Iron Works' was a later subsidiary company.

160. Copies were cast by both foundries in The Hague, O. Mustad & Søn, Christiania, as well as by Wood & Perot in Philadelphia and James McEwan in Melbourne; possibly also in Russia (see Sobolew, figs 230, 238). Wood & Perot also produced the bench with the 'Vine Pattern' legs. There is an example of this type, marked 'Wood & Perot Makers Ridge Avenue Phila', in the Museum of Rural Art, Louisiana State University, Baton Rouge, LA.

161. See p.34.

162. Carlshütte, Rendsburg; L.I. Enthoven & Co., The Hague; Kramer Brothers, Dayton; J.L. Mott, New York; Robert Wood & Co., Philadelphia.

163. The smith Robert Wood (1813–85), born to poor parents, established his foundry in Philadelphia in 1839. In 1845 he built the first iron building in New York. In the mid-nineteenth century his foundry was the foremost iron business in the continent of America. From 1858 to 1867 the firm was called Wood & Perot, and from 1867 Robert Wood & Co. From 1859 to 1861 there was a subsidiary in New Orleans called Wood, Miltenberger & Co. which was taken over by William Ebert in 1861. See Philadelphia. Three Centuries of American Art. Exhib. Philadelphia 1976, p.368.

164. Chase Brothers & Co., Boston (in 1855[?] catalogue: 'Designed for the Piazza and Garden, also for Cemeteries'); J.W. Fiske, New York (1868); Hutchinson & Wickersham, New York (1857: 'Morning Glory Chair'); Janes, Kirtland & Co., New York; Phoenix Iron Works, Utica, N.Y.; A.W. Snow, Boston; Peter Timmes'Son, Brooklyn, N.Y.; John A. Winn & Co., Boston.

165. Simon Jervis (Furniture History 9. 1973, p.108, note 61) was able to track down examples in Grimston Park, Yorkshire, Dunbar and Berwick-on-Tweed.

166. Vol. V, p.300.

167. See p.48. There are many other examples of 'naturalistically' designed articles in the foundries' catalogues: small decorative tables, console tables, umbrella stands, hall stands, etc.

168. Auctioned at Sotheby's London on 7 November 1985, now in the Victoria and Albert Museum, London. This forgotten furniture was first mentioned again by Aslin, pp.45, 49.

169. The table is illustrated in the 1860 catalogue, but no other versions are known.

170. Issue 1 is dated 1847; issue 2 does not differ either in the title page or the way the objects presented are depicted. Issue 3, which is laid out differently, appeared in 1855.

171. Copies cast by J. & C.G. Bolinder, Stockholm.

172. For the most recent assessment of Dresser see Durant.

173. London 1871; Vienna 1873; Paris 1878.

174. Durant, p.19.

175. Gewerbehalle 1. 1863, p.144.

176. See George Bullock's tripod, p.21, plate 205.

177. Since 1911 the volumes have been in the Public Record Office, now in Kew, identified as BT 42, BT 43, BT 44, BT 50, BT 51.

178. They are described as 'Hat and Umbrella Stand', 'Hat, Coat and Umbrella Stand' or as 'Hall Table'.

179. Robert Walter Winfield had founded his firm in Birmingham in 1829. His business was in existence until 1900 and already employed 800 workers in 1866. Ref. B.M. Eccleston 'The Metal Furniture of R.W. Winfield' in Antique Collecting 19. 1985, pp.73–5. See also note 90.

180. Karl Brunner Bericht über die im Julius 1830 in Bern eröffnete Industrie-Ausstellung. Berne 1830; Zeitschrift für Österreichischen Handel und Gewerbe 1839, p.127; Allgemeine Modenzeitung 41. 1839, no.5.

181. See Marianne Zweig Zweites Rokoko – Innenräume und Hausrat in Wien, 1830–1860. Vienna 1924; World Furniture (as note 141), figs 788, 790, 922–3, 929, 931, 933, 961–3, 973, 1004, 1015, 1271; Himmelheber (as note 127), pp.168–9.

182. 19th Century America. Furniture and other Decorative Arts. Exhib. Metropolitan Museum, New York 1970, cat. no.119.

183. Barbee Wire and Iron Works, New York; Bartlett, Robbins & Co., Baltimore; Brown & Owen, Atlanta (?); Chase Brothers & Co., Boston; J.W. Fiske & Co., New York; Hanson & Kirk, Philadelphia; Hutchinson & Wickersham,

New York; Janes, Kirtland & Co., New York; Kramer Brothers, Dayton, OH.; J.L. Mott, New York; Phoenix Iron Works, Utica, N.Y.; A.W. Snow & Co., Boston; Stewart Iron Works Co., Cincinnati, OH.; Vulcan Iron Works, New Boston, IL.; John A. Winn & Co., Boston.

184. Chase Brothers & Co., Boston; J.W. Fiske, New York; J.L. Mott, New York; Peter Timmes'Son, Brooklyn; John B. Wickersham, New York; John A. Winn & Co., Boston; Wood, Miltenberger & Co., New Orleans; Robert Wood & Co., Philadelphia.

185. J.B. Ewans & Co., Smyrna, DE.; Hanson & Kirk, Philadelphia; Robert Wood & Co., Philadelphia.

186. In the nineteenth century there were up to 50 iron foundries in New Orleans, though some of them existed only for a short time and several specialized in manufacturing specific articles. It can be proved that at least two firms also produced furniture: Wood, Miltenberger & Co. and Hinderer's Iron Works. There were also M. Bastian's Iron Bedstead Manufactury and the Louisiana Mattress Iron & Spring Bed Company. See Masson, pp.45–50.

187. Cf. e.g. *Meubles und Verzierungen im modernsten Geschmacke. Nach Osmonts Methode zu Paris.* Augsburg 1838–40; D. Guilmard *Le Garde-Meuble.* Paris 1840. See also Himmelheber (as note 126) nos 2667, 2672, 2678.

188. There is a complete series in the Art Institute, Chicago. A two-seat example was auctioned at Sotheby's Sussex on 23/24 September 1987.

189. Aslin 1963, p.936, fig.2.

190. See e.g. Joy (as note 126), p.113 bottom, or Himmelheber (as note 126), nos 2769, 2776. The designer may have been familiar with L. Grüner's book *The Decorations of the Garden-Pavilion in the Grounds of Buckingham Palace,* 1846. Ref. *World Furniture* (as note 141), fig.780.

191. Robertson 1972, fig.213. Sotheby's Belgravia 11 February 1981. Sotheby's Sussex 23/24 September 1987. A rectangular table using these kinds of forms derived from wooden furniture was produced by the Coalbrookdale Company (*Catalogue of Castings,* sec. II, no.56).

192. *Coalbrookdale Catalogue of Castings,* sec. II, no.19.

193. A similar chair in the National Museum of American History, Washington has the following cast inscription: 'Wm. ADAMS & CO. 960 N.9. ST.PHILA/PAT.APP'D FOR'. The foundry traded from 1876 to 1886 under the name Adams & Storry, from 1887 to 1904 as Wilhalm Adams & Co. and from 1905 as Wilhalm Adams Foundry Co.

194. Two further examples of each illustrated in Snyder, figs 10 and 13 and in the 1896 catalogue of Peter Timmes'Son (plates 78, 81).

195. See p.18.

196. See also Joy (as note 126), pp.1–5.

197. See p.21.

198. Regarding this type of bed, the *Art Journal* of 1851, p.144, comments: 'The great points which should be aimed at in the manufacture of these bedsteads are lightness and elegance, in almost direct opposition to those of French make, where solidity is chiefly required.'

199. Roda (as note 72), p.70.

200. Cf. Veronika Schäfer *Leo von Klenze. Möbel und Innenräume.* Munich 1980, fig.15; Oswald Hederer *Leo von Klenze.* Munich, 2nd edition, 1981, p.171. Himmelheber (as note 127), figs 523–38.

201. *Bericht der…Ministerial-Commission über die im Jahre 1835…in München stattgehabte Industry-Ausstellung.* Munich 1836. The kgl. Berg- und Hüttenämter of Bergen, Bodenwöhr, Weierhammer and Sondhofen exhibited there. Bodenwöhr showed a grave monument, a relief of St John and a crucifix.

202. At this time, the court in Munich had state beds supplied by the Parisian firm of Jacob.

203. An iron bed with gilded bronze decorations was made for the Queen of Sardinia in 1834. See 'Cultura figurativa e architettonica negli Stati del Re di Sardegna. 1773–1861'. Exhib. Turin 1980, cat. vol.2, no.694.

204. The foundry was established by Thomas Régnault in 1827 at a place called Osne-le-Val between the Marne and the Saulx (Hte Marne) with a royal privilege. In 1833 J.P. Victor André took over the firm. In 1836 he gave it the name Val d'Osne. After his death in 1851, his widow carried on running the business and in 1855 also bought the Société Barbezat & Cie, and the foundry continued to operate under that name until 1867. From 1867 it was owned by the Société Fourment, Houille et Cie., and in 1870 it became the Société Anonyme des Hauts-Fourneaux & Fonderies du Val d'Osne. The firm had its heyday under André, and at the end of the century it could supply 40,000 products.

205. Burat (as note 82), vol.2, p.42 with fig.

206. See Reyniès (as note 36), vol.1, figs 835–6; Voorst tot Voorst (as note 143), vol.2, p.75.

207. Regarding the manufacture of cast-iron beds in Philadelphia, Edwin T. Freedley in *Philadelphia and its Manufactures.* Philadelphia 1858, p.295, states: 'Iron bedsteads, of all sizes, are made largely by at least two firms, Messrs. Walker & Sons, and Samuel Macferran. The Ornamental Iron Bedstead of Mr. Macferran is highly recommended by the Franklin Institute, as an article combining neatness, and light weight, with sufficient strength.'

208. An early example in wood in Georg Himmelheber *Kunst des Biedermeier.* Munich, 2nd edition, 1989, cat. no.171. See also Himmelheber (as note 126), nos 3430, 3440 and Joy (as note 126) pp.355–65.

209. Submitted by Yates, Haywood & Co. on 20 June 1856.

210. *Illustrated Catalogue of the International Exhibition 1862. The Art Journal.* London 1862, p.188.

211. Ulftsche Ijzergieterej Becking & Bongers.

212. J. & C.G. Bolinder's Mekaniska Verkstads, Stockholm, 1891 catalogue, no.6.

213. Model 214 by the Coalbrookdale Company, 10 June 1852 (85 297). Copies cast by J. & C.G. Bolinder, Stockholm.

214. Model 220 by the Coalbrookdale Company, 13 June 1856 (105 057).

215. Model 215 by the Coalbrookdale Company, 1853 (94 341) and model 43 by W.H. Micklethwait & Co., Rotherham, 17 June 1880 (351 021).

216. Model by William Crawford, Dudley, 2 November 1853 (93 166).

217. *Illustrated Catalogue. The Industry of all Nations. The Art Journal.* London 1851, p.108.

218. Registered on 17 June 1880 (351 022).

219. Fruit Girl and Reaper (the latter turned sideways) were offered as zinc figures at Sotheby's Belgravia, 1 July 1981, no.116.

220. Model 2049 by L.J. van Enthoven & Co. iron foundry, The Hague.

221. Model 227 by the Coalbrookdale Company, 21 May 1862 (151 920).

222. Model 216 by the Coalbrookdale Company, 11 November 1853 (93 339).

223. Later examples by James John Harrop, Manchester, registered on 23 September 1880, and Frederick Hufton, registered on 17 August 1883. They were also used as frames for sewing machines which in the early days were always round.

224. McDowall, Steven & Co., Glasgow also similar.

225. The Stolberg-Wernigerodesche Hüttenwerk had been founded as early as the fifteenth century; in 1543 the first blast furnace was fired. In the sixteenth and seventeenth centuries its superb stove plates were famous far and wide. From the early nineteenth century, following the model of Gleiwitz and Berlin, artistic casting was practised. At the international exhibitions the casts after Renaissance models manufactured from 1840 were widely admired.

226. Georg Himmelheber *Kabinettschränke. Bayerisches Nationalmuseum Bildführer 4.* Munich 1977, p.29.

227. Ref. James Parker 'A Regency Sewing and Writing Table by Morgan and Sanders' in *Metropolitan Museum of Art Bulletin* 22. 1963/4, pp.125–7.

228. London 1814, Berlin 1826.

229. Ref. also Warren, pp.133–5.

230. The form of seat and back rest shaped to fit the body and made of wooden slats was retained for seating in railway carriages up until the middle of the twentieth century.

231. Soren Palsbo/Nils Kr. Zeeberg 'Byens Nips – om brandhaner, lygtepaele og andet godt' in *Sporvejshistorisk Selskab* 1974. I am indebted to Mr Lars Dybdahl MA of the Danske Kunstindustri Museum, Copenhagen, for pointing out this publication.

232. The first Danish foundries were established in the 1760s in Frederiksvaerk and – by the Scotsman Thomas Potter – in Christianshavn. In 1811 Heinrich Meldahl established a foundry in Copenhagen, as did M.A. Heegard in 1828. See Axel Nielsen *Industriens Historie i Danmark.* Copenhagen 1943/4 and Aase Faye 'Stobejern – et modemateriale fra den tidligste industritid' in *Arv og Eje* 1976, pp.121–6. I am indebted to Dr Frauke Lühning, Schleswig, for pointing out these publications.

233. Warren, pp.133–5.

234. See pp.19–21.

235. Aslin 1962, p.45.

236. *The Official Descriptive and Illustrated Catalogue of the Great Exhibition of the Works of Industry of All Nations,* 1851, vol.3, p.639.

237. Vol.4, plate 380: 'Rocking or Lounching Chair, formed of tube.'

238. No. 147 343: 'Reclining Chair'. Apart from the twisted iron, this variant too is devoid of any form of decoration, like the one at the Great Exhibition. An example made of iron bands illustrated by Eccleston (fig.2, but not in the Victoria and Albert Museum) is closest to this, also because of the forward scrolled stop, and not as Eccleston thinks the chair made of tubes – iron tubes moreover, not brass ones! (fig.352). An example similar to fig.356 but with just three screws on the seat is in the Kunstindustrimuseet in Oslo.

239. Denker, p.76.

240. Catalogue vol.2, p.746.

241. Denker, p.77, note 5.

242 The fairly widespread assumption repeated for some time in specialist literature that this rocking-chair was made in Cooper's iron foundry has meanwhile been contradicted. See Robert Bishop *Centuries and Styles of the American Chair 1640–1970.* New York 1972, fig.630.

243. *Catalogue Castings Section II and III: Chairs,* no.43.

244. Model no.60.

245. John Gloag 'The rocking chair in Victorian England' in *Antiques* 99. 1971, pp.241–4. Gloag mentions another example that belonged to Hans Christian Andersen in the Andersen Museum, Odense, Denmark.

246. This example with the brass plate has not so far turned up again.

247. P.306, no.1253, fig.469. The first reference to this is in Celia Jackson Otto *American Furniture of the 19th Century.* New York 1965, fig.307.

248. In the late 1970s at Weinreb & Breman Ltd, London, with the address and appropriate post mark. I am indebted to Mr Geoffrey Beard, Bath, for this information. The leaflet is reproduced in Geoffrey Beard *The National Trust Book of English Furniture.* London 1985, p.233, and Derek E. Ostergard (ed.) *Bent Wood and Metal Furniture: 1850–1946.* New York 1987, p.211.

249. See the important and excellent first juxtaposition by Wend Fischer *Die verborgene Vernunft.* Munich 1971.

250 Ref. Atterburg and Wainwright (as note 125), p.15, fig.31, p.131, fig.230, p.135, figs 241–3, p.141, fig.257; also Charlotte

Gere and Michael Whiteway *Nineteenth Century Design. From Pugin to Mackintosh*. London 1993, plates 32, 36, 38, 75, 77, 94, 106, 108, 172.

251. *Allgemeine Bauzeitung* (Vienna) 2. 1837, pp.274–8.

252. *Tischler- und Drechslerzeitung* (Weimar) 1. 1845, vol.3, plate 3.

253. Ref. the first scholarly work on this firm by Eva B. Ottilinger.

254. *Official Descriptive and Illustrated Catalogue*, vol.3, pp.1031–2.

255. Valentin Teirich *Die moderne Richtung in der Bronze- und Möbelindustrie*. Vienna 1868, p.108.

256. Now Österreichisches Museum für andgewandte Kunst.

257. No.280 562, 17 February 1874. Walter F. Johnson, Leicester, registered a table and a chair using iron strap on 25 April 1873 (nos 272 352 and 272 353).

258. 28 April 1869, no.228 936. Reynolds registered a second model, no.280 560, on 17 February 1874. Wooden folding chairs had also been developed in America from the 1860s. See Hanks, pp.149–56.

259. See p.37.

260. *Zeitschrift des Vereins zur Ausbildung der Gewerke* 5. 1855, vol.4, sheet 3.

261. I would like to thank Messrs Ernst and August Hofmann, the current owners of the firm of J.L. Kaltenecker & Sohn Nachfolger, for their kind support in my researches into the history of the business.

262. See Joseph T. Butler *American Antiques 1800–1900*. New York 1965, p.80, fig.46; Wendell D. Garret et al. *The Arts in America. The Nineteenth Century*. New York 1969, p.331; Hanks, pp.86–7; Bishop (as note 242), fig.695.

263. I am indebted to Dr Elisabet Hidemark, Stockholm, for pointing out this furniture.

264. Hanks, p.68.

265. See Bishop (as note 242), fig.629.

266. Hanks, pp.136–9.

267. Quoted after Hanks, p.136.

268. *Deutsche Gewerbezeitung* 15.1850, p.232 with fig.

269. G.W. Yapp *Art Industry. Furniture, Upholstery and House Decoration*. 1879, in Joy (as note 126), p.265; Bishop (as note 242), pp.368–70.

270. Ref. Hanks, pp.126–8.

271. *The Art Journal* 1851, p.152.

272. *Official Descriptive Catalogue*, vol.III, p.1438.

273. *The Illustrated Exhibitor*. Quoted after Hanks, p.126.

274. Also patented in America on 3 February 1880 (no.224,174).

275. Bishop (as note 242), fig.638.

276. J.G. Pfleiderer *Amerikanische Reisebilder*. Bonn 1882, p.33 with fig. on p.176.

277. Gleiwitz cast thirteen crucifixes in 1798.

278. Simon Jervis *High Victorian Design*. Woodbridge 1983, pp.99–121.

279. In *The Technical Educator*, quoted after Durant, p.100.

280. The Cooper-Hewitt Museum, New York, was able to acquire an example of this hall stand a few years ago (inv. no.1989–64–1). An illustration of this beautiful and important item of furniture was unfortunately ruled out by the exorbitant photography charges requested by the museum.

281. Gere/Whiteway (as note 250), p.120.

282. *The Furniture Gazette* 6. 1876, pp.327–8, 386, 400.

283. An umbrella stand made by the Coalbrookdale Company to Dresser's design illustrated in *Christopher Dresser 1834–1904*. Exhib. London 1979 and Middlesborough 1980, cat. no.3, p.16.

284. Charles Barnard established an iron foundry in Norwich in 1826 and took John Bishop into partnership in 1846. After Barnard's two sons came into the business in 1859, it operated as Barnard, Bishop & Barnards. Their collaboration with the architect Thomas Jeckyll lasted from 1862 until the late 1870s. The firm was in existence until 1955.

285. 23 July 1877, no.311 249.

286. I am indebted to Dr Clive Wainwright, London, for information about this furniture. Mr Michael Whiteway kindly made photographs available. The chair is illustrated in Gere/Whiteway (as note 250), p.161, fig.200.

287. Nos 435 and 436 in catalogue of Barnard, Bishop & Barnards.

288. 15 and 23 October 1880, nos 356 719 and 357 099.

289. 22 June 1882, no.382 482 and 28 September 1882, no.387 146.

290. A. Welby Pugin *The true principles of pointed or Christian architecture*. London 1841, pp.29–30.

291. John Ruskin *The Seven Lamps of Architecture*. London 1849, II § 9–12, 20.

292. W.C. Aitken *The revived art of metal working* in Timmins, p.544. In contrast to all these criticisms, see note 9.

293. Jakob von Falke 'Die Wiener Weltausstellung und die Kunstindustrie' in *Gewerbehalle* 12. 1874, p.19. See also Jakob von Falke *Aesthetik des Kunstgewerbes*. Stuttgart 1883, pp.276, 285.

294. *Catalogue sommaire illustré des nouvelles acquisitions du Musée d'Orsay. 1980–1983*. Paris 1983, nos 457–8.

# Bibliography

*Only titles mentioned in the text and containing references to iron furniture are listed.*

Arenhövel, Willmuth 'Eisenguss am Beispiel einer norddeutschen Hütte' in Tilmann Buddensieg and Henning Rogge (ed.) *Die nützlichen Künste.* Exhib. Berlin 1981, pp.251–62

Arthur, Eric and Thomas Ritchie *Iron. Cast and Wrought Iron in Canada from the Seventeenth Century to the Present.* Toronto 1982

Aslin, Elizabeth *Nineteenth Century English Furniture.* London 1962

Aslin, Elizabeth 'The Iron Age of Furniture' in *Country Life* 1963, pp.963–4.

Bäumer, Wilhelm 'Die Eisen-Industrie und ihre Beziehung zur Architektur' in *Gewerbehalle* 1. 1863, pp.65–7

Beard, Geoffrey *The National Trust Book of English Furniture.* London 1985

Beck, Ludwig *Geschichte des Eisens.* Braunschweig 1891–9

Berger, Hermann *Die deutsche Stahlmöbelindustrie. Wesen, Grundfragen und Gestaltung.* Düsseldorf 1937

Bimler, Kurt 'Die Gleiwitzer Eisengiesserei und die Bildhauer Kalide und Kiss' in *Oberschlesien, ein Land deutscher Kultur.* Gleiwitz 1921, pp.53–60

Bishop, Robert *Centuries and Styles of the American Chair 1640–1970.* New York 1972

Björkenstam, Nils 'The Swedish Iron Industry and its Industrial Heritage' in *Ironworks and Iron Monuments. Study, Conservation and Adaptive Use. Symposium Ironbridge, 23–25.10.1984.* ICCROM. Rome 1985, pp.37–49

Boynton, L.O.J. 'The Bed-Bug and the "Age of Elegance"' in *Furniture History* 1. 1965, pp.15–31

Brygan, John Albury 'Molded Iron in the Middle West' in *Antiques* 43. 1943, pp.79–81

Butler, Joseph T. 'American Mid-Victorian Outdoor Furniture' in *Antiques* 75. 1959, pp.564–7

Butler, Joseph T. *American Antiques 1800–1900. A Collector's History and Guide.* New York 1965

Butler, Joseph T. *Washington Irving's Sunnyside.* Sleepy Hollow Press Book. Tarrytown, N.Y. 1974

Campbell, Barbit, Cole and Tim Benton (ed.) *Tubular Steel Furniture.* London 1979

Campbell, Marian *An Introduction to Ironwork.* London 1984

Campbell, R.H. *The Carron Company.* Edinburgh 1961

Clouzot, Henri *La Ferronnerie Moderne.* Paris n.d.

Colombo, Silvano *Ferro Lombardo. Ricognizione di alcuni oggetti di ferro battuto rinvenuti in Lombardia.* Milan 1976

Cottingham, Lewis Nockalls *The Smith and Founder's Director, Containing a Series of Designs and Patterns for Ornamental Iron and Brasswork.* London 1824

D'Allemagne, Henri René *Musée le Secq des Tournelles à Rouen. Ferronnerie Ancienne.* 2 vols. Paris 1924

Denker, Ellen and Bert Denker *The Rocking Chair Book.* New York 1979

Dezzi Bardeschi, Marco *Le officine Michelucci e l'industria artistica del ferro in Toscana. 1834–1918.* Pistoia 1981

Durant, Stuart *Christopher Dresser.* London 1993

Eames, Penelope 'An Iron Chest at Guildhall of about 1427' in *Furniture History* 10. 1974, pp.1–4

Eccleston, B.M. 'The Metal Furniture of R.W. Winfield, Birmingham Brassfounder and Tube Manufacturer' in *Antique Collecting. Journal of the Antique Collectors Club* 19. 1985, pp.73–5

Edwards, George and Matthias Darly *A New Book of Chinese Designs, Calculated to Improve the Present Taste, Consisting of Figures, Buildings, & Furniture, Landskips, Birds, Beasts, Flowers and Ornaments.* Northumberland-Court in the Strand 1754

Edwards, Paul *English Garden Ornament.* London 1965

*Der Eisenguss aus Gliwice. Tradition und Gegenwart.* Exhib. Gliwice and Mosigkau. Dessau 1988

Falke, Jakob von 'Die Wiener Weltausstellung und die Kunstindustrie' in *Gewerbehalle* 12. 1874, p. 19

Falke, Jakob von 'Das Kunstgewerbe' in Carl von Lützow *Kunst und Kunstgewerbe auf der Wiener Weltausstellung* [1873]. Leipzig 1874

*La Ferronnerie française aux XVIIe et XVIIIe siècle. Décoration ancienne,* Ser.3. Paris 1909

Ffoulkes, Charles *Decorative Ironwork from the XIth to the XVIIIth Century.* London 1913

Freedley, Edwin Troxell *Philadelphia and Its Manufactures.* Philadelphia 1858

Fritz, Rolf 'Eisengusswaren der Gewerkschaft Prinz Rudolph' in *Dülmener Heimatblätter* 1960, pp.39–43

Gardner, John Starkie *Ironwork.* 3 vols. London 1892–1922 (numerous later editions)

Garret, Wendell D., Paul F. Norton, Alan Gowans, Joseph T. Butler *The Arts in America. The Nineteenth Century.* New York 1969

Gere, Charlotte and Michael Whiteway *Nineteenth Century Design. From Pugin to Mackintosh.* London 1993

Gloag, John 'The Rocking Chair in Victorian England' in *Antiques* 99. 1971, pp.241–4

Gloag, John and Derek Bridgwater *A History of Cast Iron in Architecture.* London 1948

Göres, Burkhardt 'Entwürfe und Ausführungen von Möbeln und anderem Kunsthandwerk' in *Schinkel-Ehrung in der Deutschen Demokratischen Republik. Karl Friedrich Schinkel 1781–1841.* Exhib. Berlin 1991, pp.221–54

Greeley, Horace et al. *The Great Industries of the United States: being an Historical Summary of the Chief Industrial Arts of this Country.* Hartford, CT. 1873

Grolich, Vratislav *Blanenská Umèlecka Litina.* Catalogue, Okresni Muzeum, Blansko 1991

Gubler, Hans Martin 'Baukunst aus dem Baukasten. Gusseiserne Ornamente im 19. Jahrhundert' in *Heimatspiegel.* Illustrated supplement to the *Zürcher Oberländer* no.7, July 1981, pp.49–55

Hanks, David A. *Innovative Furniture in America from 1800 to the Present.* New York 1981

Hayward, John F. and W. Rieder 'Thomas Rucker's Iron Chair' in *Waffen- und Kostümkunde* 3. Series 18.1976, pp.85–104

Hayward, John F 'Thomas Rucker, Eisensessel, 1574' in *Welt im Umbruch.* Exhib. Augsburg 1980, cat. vol.2, no.894

Hayward, John F. 'A chair from the "Kunstkammer" of the Emperor Rudolf II' in *The Burlington Magazine* 122. 1980, pp.428–32

Hecht, August Daniel 'Offenbacher Eisenkunstgiesser. Johann Conrad Geiss 1771–1846. Alfred Richard Seebass 1805–1884' in *Alt-Offenbach. Blätter des Offenbacher Geschichtsvereins* 7. 1931 (February) pp.1–3.

Hillegeist, Hans Heinrich 'Die staatliche Königshütte bei Lauterberg und ihr Kunstguss im 19. Jahrhundert' in *Studien zum künstlerischen Eisenguss. Festschrift für Albrecht Kippenberger.* Marburg 1970, vol.1, pp.196–220

Himmelheber, Georg 'The Beginnings of Cast-Iron Garden Furniture Production' in Elisabeth Schmuttermeir and Derek E. Ostergard (ed.) *Cast Iron from Central Europe. 1800–1850.* Exhib. New York 1994, pp.86–99

Hintze, Erwin *Gleiwitzer Eisenkunstguss.* Breslau 1928

Höver, Otto *Das Eisenwerk.* Berlin 1927

Howe, Katherine S. and David B. Warren *The Gothic Revival Style in America, 1830–1870.* Exhib. cat. Houston TX. 1976

Hussey, Christopher *English Country Houses, Late Georgian, 1800–1840.* London 1958

Joy, Edward T. *English Furniture 1800–1851.* London 1977

Kauffmann, Henry J. *Early American Ironware, Cast and Wrought.* Rutland VT. 1966

Kerner, von 'Beschreibung der K. Eisenwerke und Erzgruben' in *Württembergische Jahrbücher für vaterländische Geschichte, Geographie, Statistik und Topographie* 1822, pp.188–203; 1823, pp.81–95

Kuba, Josef (ed.) *Böhmischer Eisenkunstguss.* Exhib. Prague and Eisenstadt. Burg Schlaining 1983

Lensi Orlandi, Giulio *Ferro e architettura a Firenze.* Florence 1978

Lichten, Frances *Decorative Art of Victoria's Era.* New York 1950

Lister, Raymond *Decorative Cast Ironwork in Great Britain.* London 1960

Madigan, Mary Jean *19th Century Furniture. Innovation, Revival, and Reform.* New York 1982

Märker, Peter *Eisenkunstguss aus der ersten Hälfte des 19. Jahrhunderts.* Exhib. Frankfurt 1975

Malchenko, Marija *Art Objects in Steel by Tula Craftsmen.* Leningrad 1974

Mang, Karl *Geschichte des modernen Möbels.* Stuttgart 1978

Masson, Ann M. and Lydia J. Owen *Cast Iron and the Crescent City.* Exhib. New Orleans 1975

Matheson, Ewing *Works in Iron. Bridge and Roof Structures.* London 1873

Mipaas, Esther 'Cast-Iron Furnishings. Sitting Pretty in the Garden' in *American Art & Antiques* 2. 1979 (May–June), pp.34–41

Ottilinger, Eva B. 'August Kitschelts Metallmöbelfabrik und das Wiener Metallmöbel des 19. Jahrhunderts' in *Österreichische Zeitschrift für Kunst und Denkmalpflege* 42. 1988, pp.162–71

Otto, Celia Jackson 'Nineteenth-Century Contour Chairs' in *Antiques* 93. 1965, pp.193–5

Otto, Celia Jackson *American Furniture of the Nineteenth Century.* New York 1965

Pedrini, Augusto *Il Ferro Battuto.* Milan 1929

Peyton, Edward 'Manufacture of Iron and Brass Bedsteads' in *The Resources, Products, and Industrial History of Birmingham and the Midland Hardware District.* London 1866, pp.624–7

Potter, Henry Ingle *Notes of some works by Alfred Stevens from 1850 to 1857. As shown by the original drawings and models in the possession of Messrs Henry Hoole and Co. Ltd. of Green Lane Works, Sheffield.* Sheffield n.d. (c.1912)

Pusztai, László *Magyar öntöttvasmüvesség.* Budapest 1978

Raff, Thomas *Die Sprache der Materialien. Anleitung zu einer Ikonologie der Werkstoffe.* Munich 1994

Raistrick, Arthur *Dynasty of Iron Founders. The Darbys and Coalbrookdale.* London 1953

Rasl, Zdenek *Decorative Cast Ironwork.* Prague 1980

Reade, Brian *Regency Antiques*. London 1953

Renard, Jean-Claude *L'Âge de la fonte. Un art, une industrie, 1800–1914*. Paris 1985

Robertson, Edward Greame *Victorian Heritage. Ornamental Cast Iron in Architecture*. Melbourne 1960

Robertson, Edward Greame *Ornamental Cast Iron in Melbourne*. London 1972

Röder, Josef 'Bilder und Pläne zur Geschichte der Sayner Hütte und der Sayner Giesshalle' in *Jahrbuch der Stadt Bendorf* 1974, pp.60–8; 1975, pp.103–17

Romaine, Lawrence B. *A Guide to American Trade Catalogues 1744–1900*. New York 1960

Schaefer, Herwin *The Roots of Modern Design. Functional Tradition in the 19th Century*. London 1970

Schall, Julius *Geschichte des Königl. Württ. Hüttenwerkes Wasseralfingen*. Stuttgart 1896

Schiffer, Herbert, Peter Schiffer and Nancy Schiffer *Antique Iron. Survey of American and English Forms, Fifteenth through Nineteenth Centuries*. Exton, PA. 1979

Schlothfeld, Hans *Ahlmann*. [Cast-Iron Museum of Ahlmann GmbH.] Rendsburg 1974

Schmidt, Eva *Der Eisenkunstguss*. Dresden 1976

Schmidt, Eva *Der preussische Eisenkunstguss. Technik, Geschichte, Werke, Künstler*. Berlin 1981

Schmidt, Hans and Herbert Dickmann *Bronze- und Eisenguss*. Düsseldorf 1958

Schmitz, Hermann *Berliner Eisenkunstguss*. Munich 1917

Seidel, R. 'Die Königliche Eisengiesserei zu Gleiwitz' in *Zeitschrift für das Berg-, Hütten- und Salinen-Wesen im preussischen Staate* 34. 1896, pp.373–86

Sievers, Johannes *Die Möbel. Karl Friedrich Schinkel Lebenswerk*. Berlin 1950

Slemen, Wendy 'Liverpool's Cast-Iron Churches' in *Foundry Trade Journal* 1975, pp.307–312

Snyder, Ellen Marie 'Victory over Nature: Victorian Cast-Iron Seating Furniture' in *Winterthur Portfolio* 20. 1985, pp.221–42

Sobolew, N.N. *Tschugonnoje litjo w russkoi architekture* [Cast Iron in Russian Architecture]. Moscow 1951

Southworth, Susan and Michael Southworth *Ornamental Ironwork. An Illustrated Guide to its Design, History & Use in American Architecture*. Boston 1978

Stamm, Brigitte *Blick auf Berliner Eisen. Aus Berliner Schlössern. Kleine Schriften 6*. Berlin 1979

Stockbauer, Jacob 'Stilistisches über Metallindustrie' in *Gewerbehalle* 13. 1875, p.165

Stolle, Walter 'Die Friedrichshütte bei Laubach in Oberhessen und ihre Erzeugnisse' in *Studien zum künstlerischen Eisenguss. Festschrift für Albrecht Kippenberger*. Marburg 1970, vol.1, pp.182–95

Stummann-Bowert, Ruth *Eisenkunstguss. Die Sammlung der Buderus-Aktiengesellschaft. Kunstguss Museum Hirzenhain*. Wetzlar 1984

Thiollet, François *Serrurerie et font de fer. Application aux planches et combles, aux ponts, escaliers, machines diverses etc., portes, devantures de boutiques, grilles, rampes d'escalier, balcons, candélabres, cheminées, poeles, etc. etc*. Paris [1832]

Timmins, Samuel *The Resources, Products, and Industrial History of Birmingham and the Midland Hardware District*. London 1866

Trinder, Barrie Stuart *The Industrial Revolution in Shropshire*. Chichester, 2nd edition, 1981

*Victoriana. An Exhibition of the Arts of the Victorian Era in America*. Exhib. New York 1960

*Victorian and Edwardian Decorative Arts*. Exhib. London 1952

Voorst tot Voorst, J.M.W. van *Tussen Biedermeier en Berlage. Meubel en Interieur in Nederland 1825–1895*. Amsterdam 1992

Wallace, Philip B. *Colonial Ironwork in Old Philadelphia*. New York 1930

Wanscher, Ole *Sella Curulis. The Folding Chair. An Ancient Symbol of Dignity*. Copenhagen 1980

Waring, J.B. *Masterpieces of Industrial Art & Sculpture at the International Exhibition, 1862*. London 1863

Warren, Geoffrey *Vanishing Street Furniture*. Newton Abbot/London 1978

Wathner, J. *Praktischer Eisen- und Eisenwaaren-Kenner. Enthält alle in Eisenhandel vorkommenden Arten von Berechnungen, ausserdem nahezu 2500 Adressen von Eisen-Industriellen aus allen Kronländern der Monarchie*. S. l. 1860

Yapp, G.W. *Art Industry – Metal-Work*. London 1877

# THE PLATES

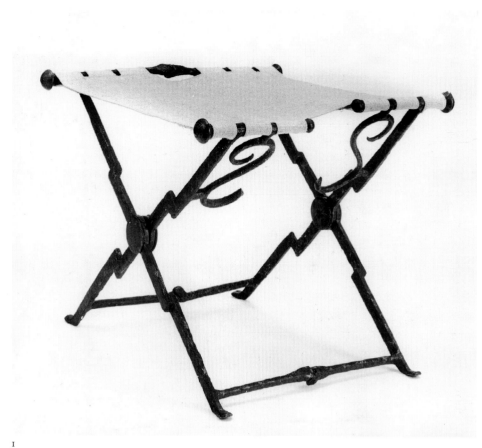

1

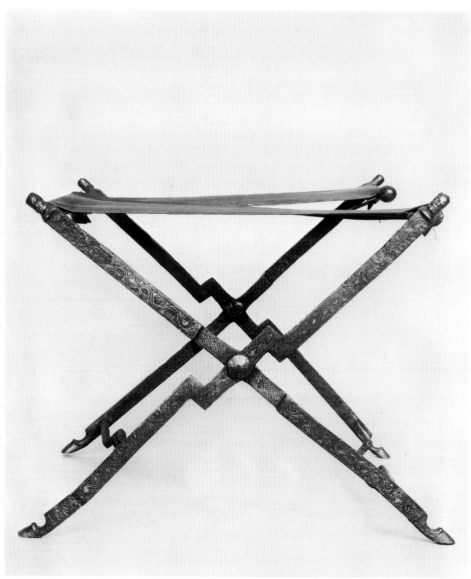

2

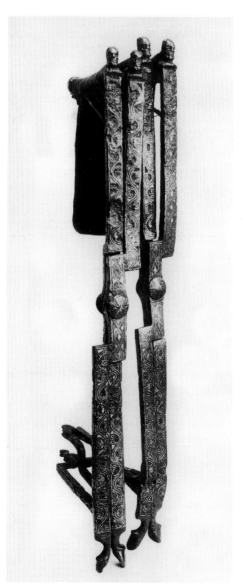

3

1. Römisch, um 250 n. Chr.
*Roman, c. 250 AD*

2. Langobardisch, 6. Jahrhundert
*Lombard, 6th century*

3. Faltstuhl der Abb. 2, zusammengeklappt
*The faldistorium shown in Pl. 2, folded*

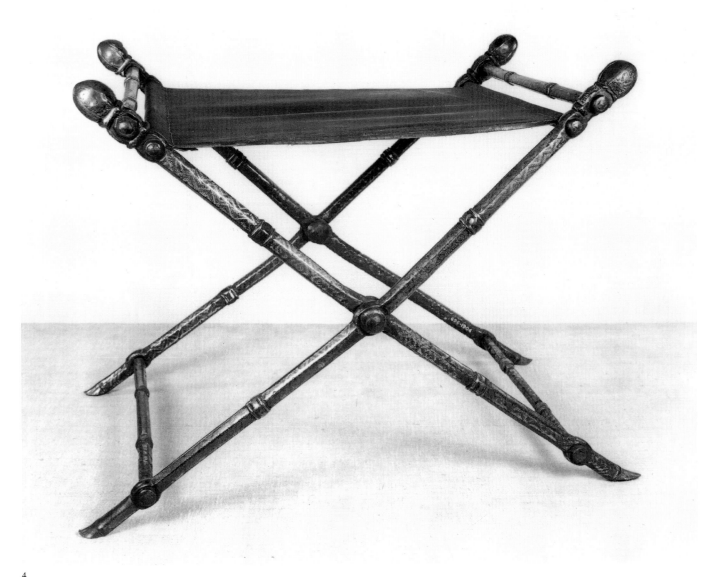

4

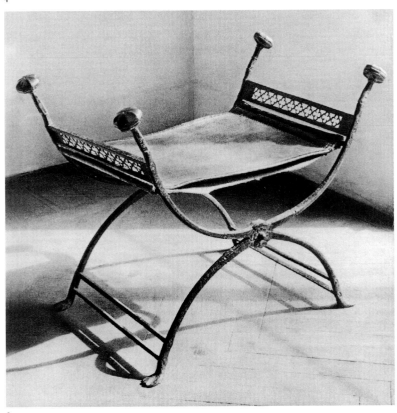

4. Oberitalien, 10./11. Jahrhundert
*Upper Italy, 10th–11th century*

5. Frankreich, Ende 14. Jahrhundert
*France, end 14th century*

5

6. Spanien, 16. Jahrhundert
*Spain, 16th century*

7. Frankreich, 15. Jahrhundert
*France, 15th century*

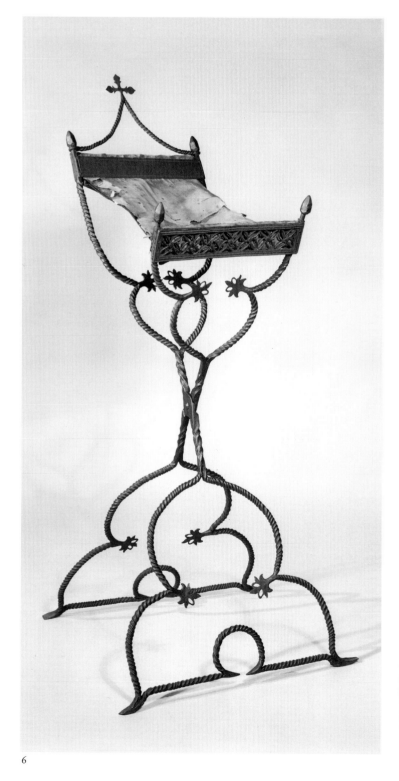

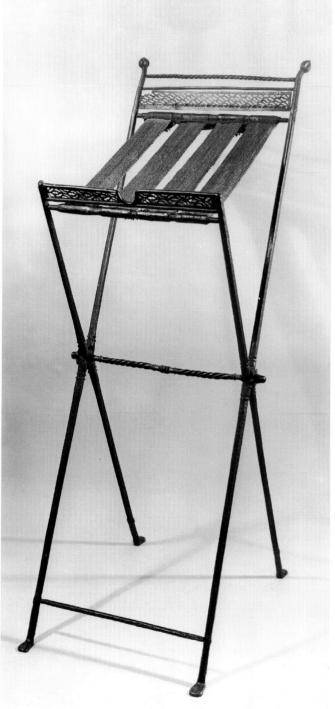

6

7

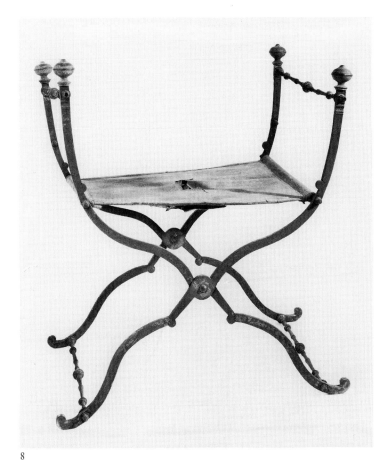

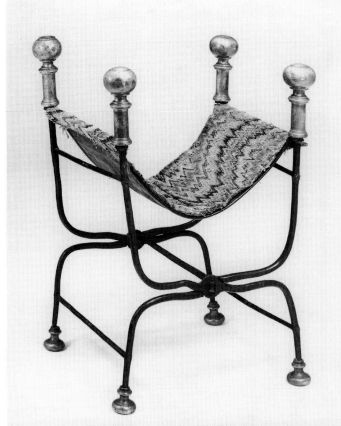

8 9

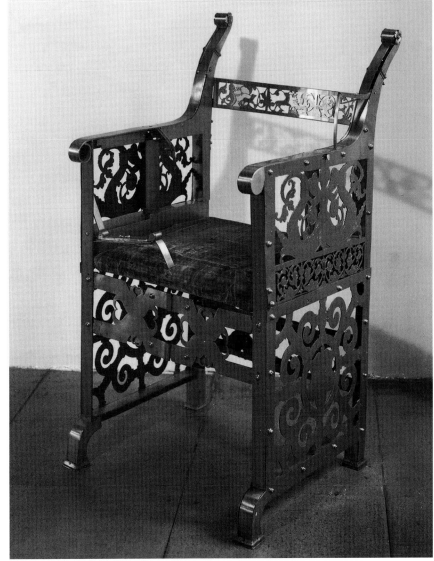

8. Spanien, Anfang 16. Jahrhundert
*Spain, early 16th century*

9. Italien, *Italy,* c. 1600

10. Süddeutsch oder Österreich, 2. Hälfte
16. Jahrhundert
*South Germany or Austria, 2nd half 16th century*

10

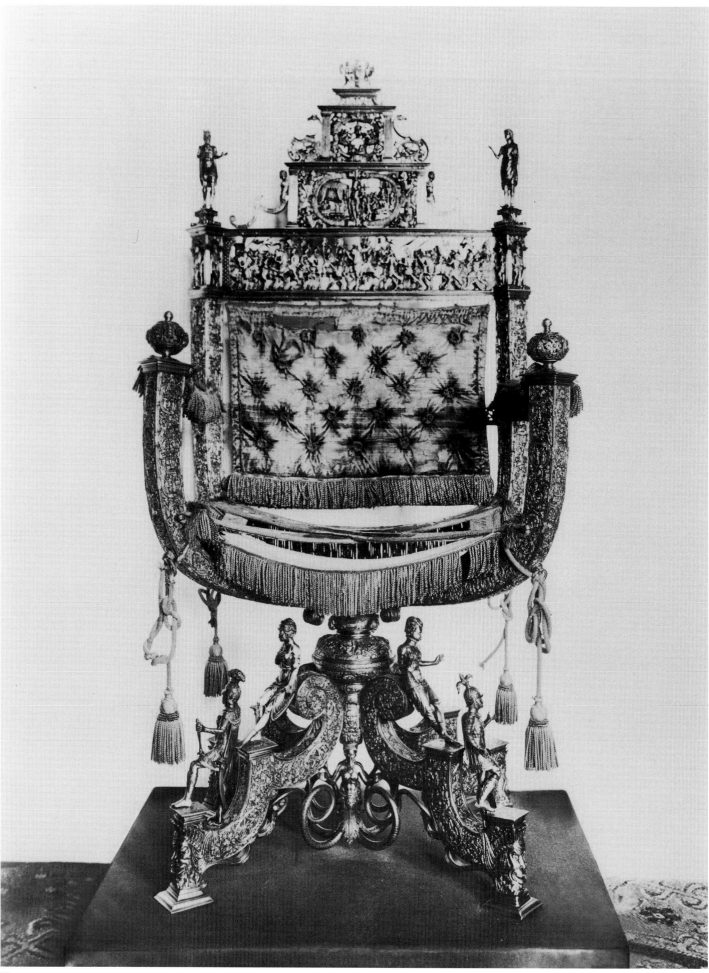

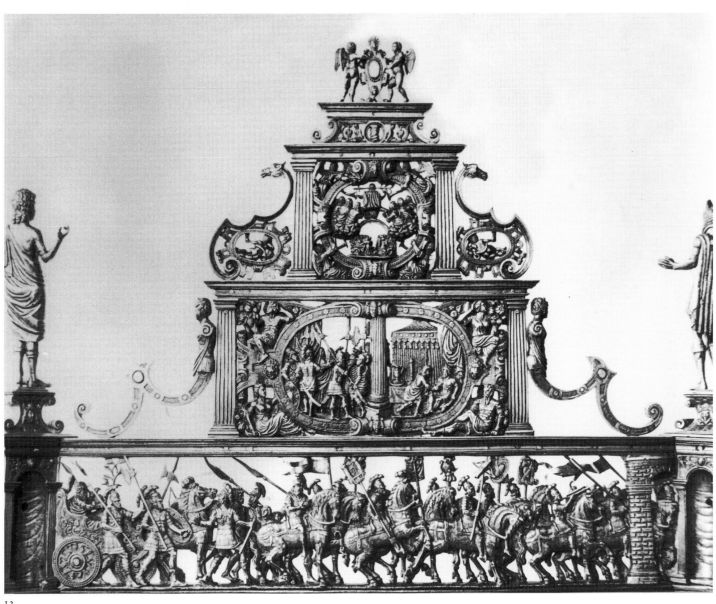

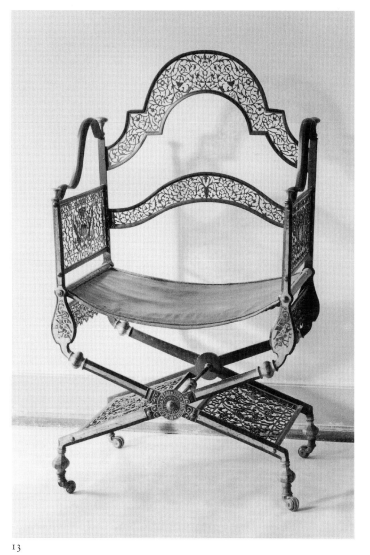

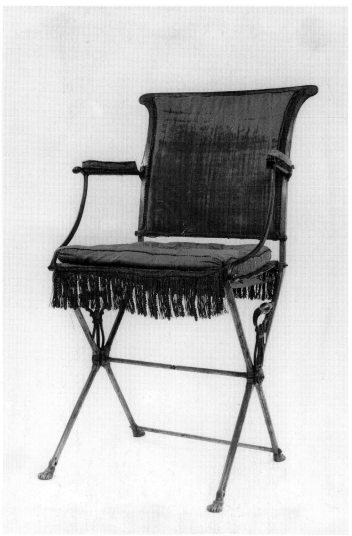

13                                                          14

13. Tula, 1744        15. England, c. 1790        18. Tula, 1798

14. Paris, c. 1800    16. England/USA, c. 1770/90

                      17. Tula, 1801

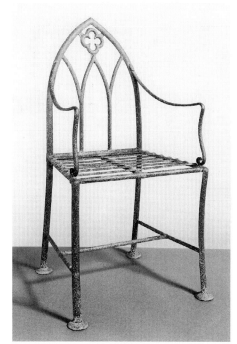

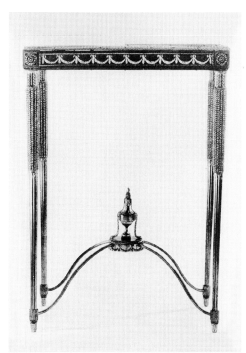

15                          16                          17

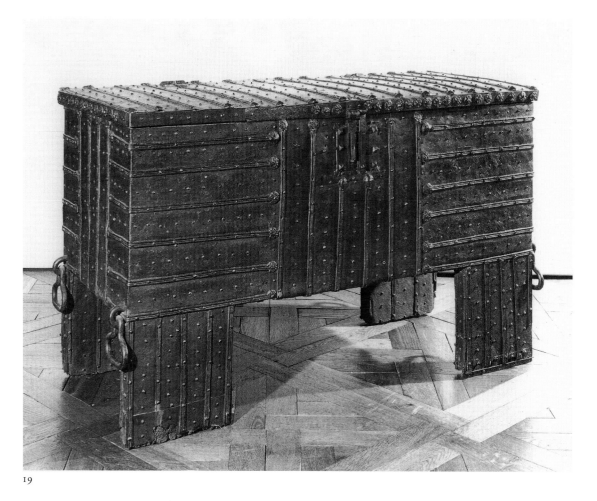

19

19. Frankreich, 1. Hälfte 14. Jahrhundert
*France, first half 14th century*

20. Bayern, Ende 14. Jahrhundert
*Bavaria, end 14th century*

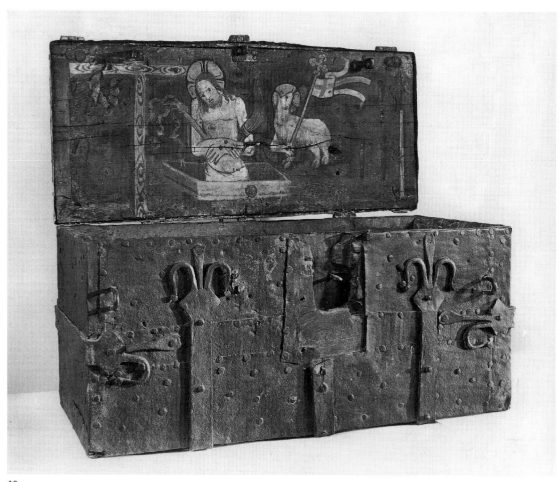

20

21. London, c. 1400-1410

22. Tirol, c. 1600, hölzerner Sockel Ende 18. Jahrhundert
*Tyrol, c. 1600, wooden base end 18th century*

23. Deutschland, 15. Jahrhundert
*Germany, 15th century*

24. Flandern, 1. Hälfte 16. Jahrhundert
*Flanders, first half 16th century*

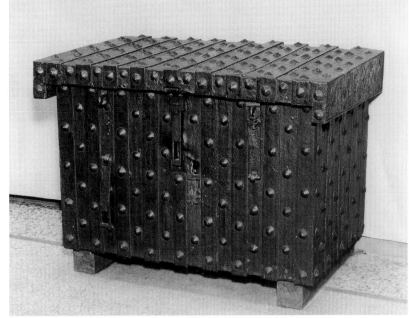

21

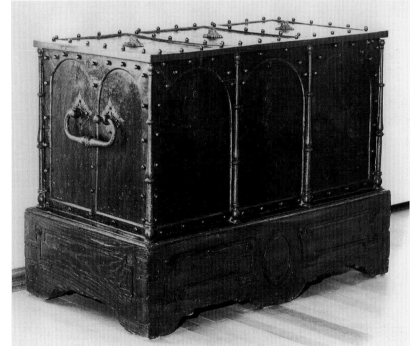

22

23

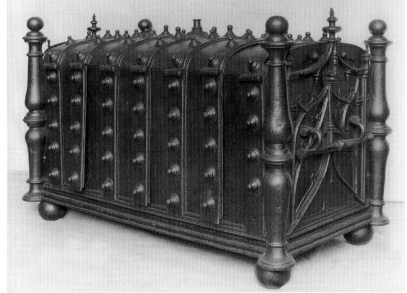

24

25. Südtirol, 1. Viertel 16. Jahrhundert
*South Tyrol, first quarter 16th century*

26. Südtirol, 2. Hälfte 15. Jahrhundert
*South Tyrol, second half 15 th century*

27. Steiermark oder Kärnten, 16./17. Jahrhundert
*Styria or Carinthia, 16th -17th century*

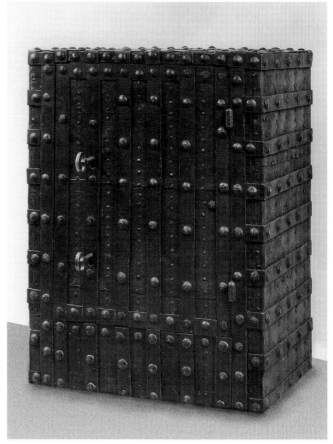

25

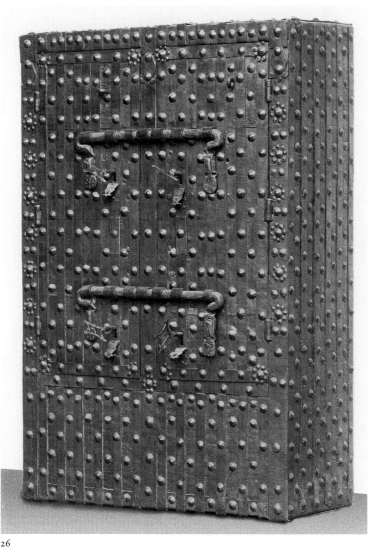

26

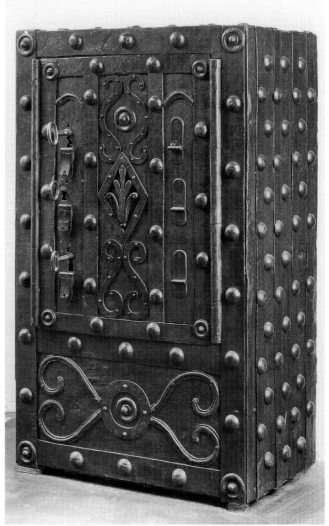

27

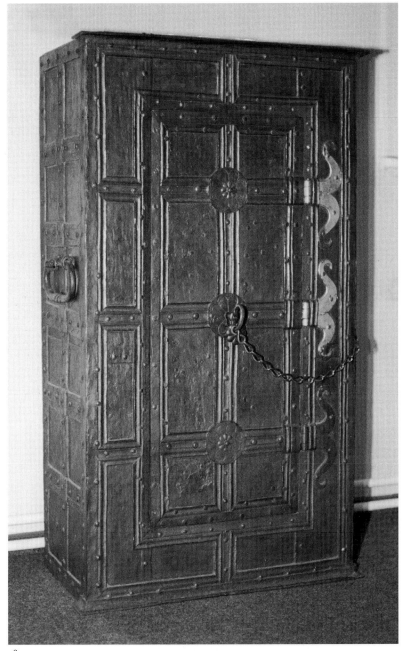

28

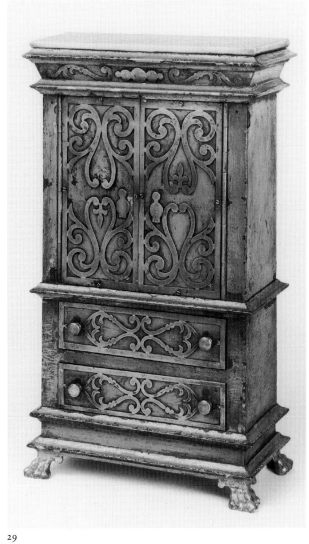

29

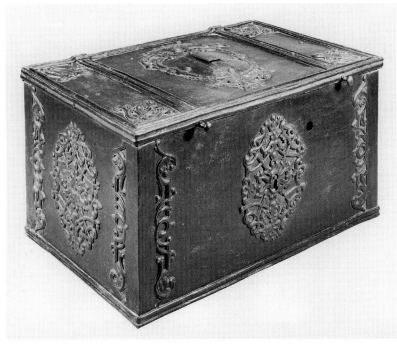

30

28. Göttingen, c. 1600

29. Niederlande, *The Netherlands*, c. 1630

30. Klagenfurt, c. 1710/20

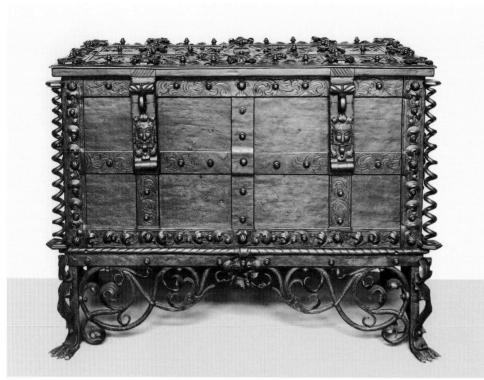

31

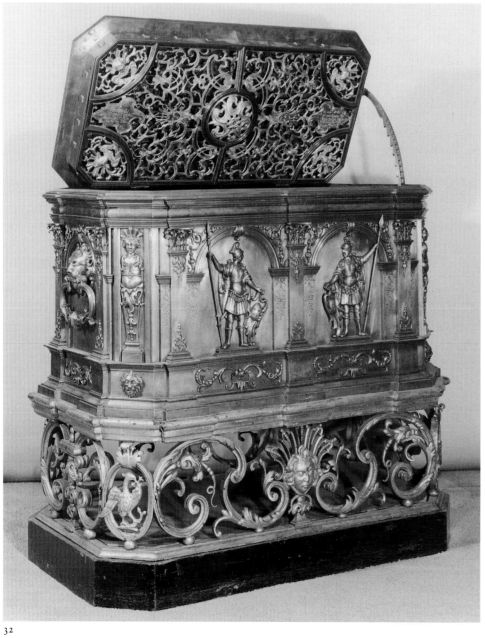

32

31. Deutschland, *Germany*, 1716
32. Johann Gottlieb Dittmann, 1733

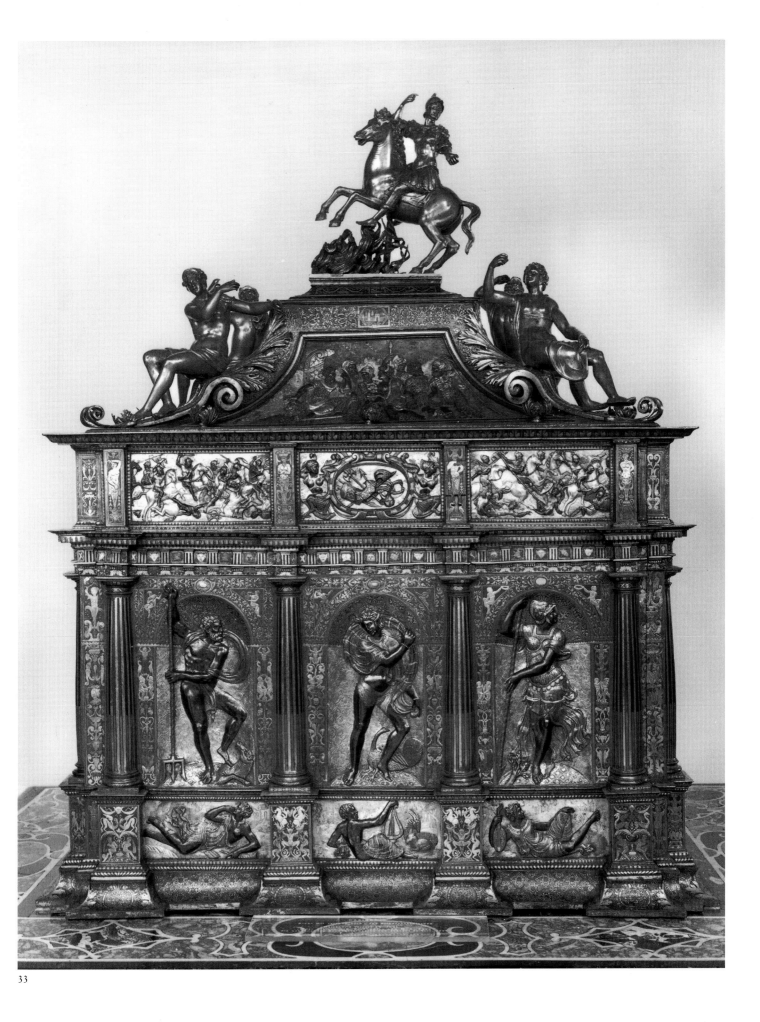

33

33. Milano, Giovanni Battista Serabaglio, Marc Antonio Fava, c. 1560/65

34

35

36

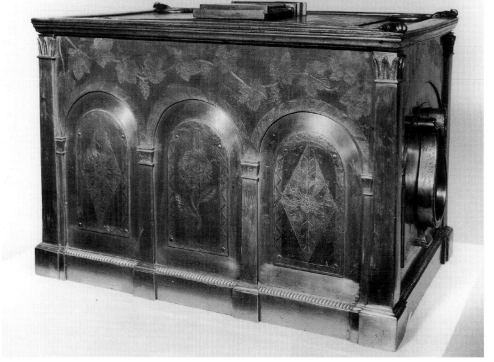

34. Österreich, *Austria,* c. 1730/35

35. Wien, c. 1800-1810

36. Niederrhein, *Lower Rhineland,* c. 1760

37. Wien, 1822

37

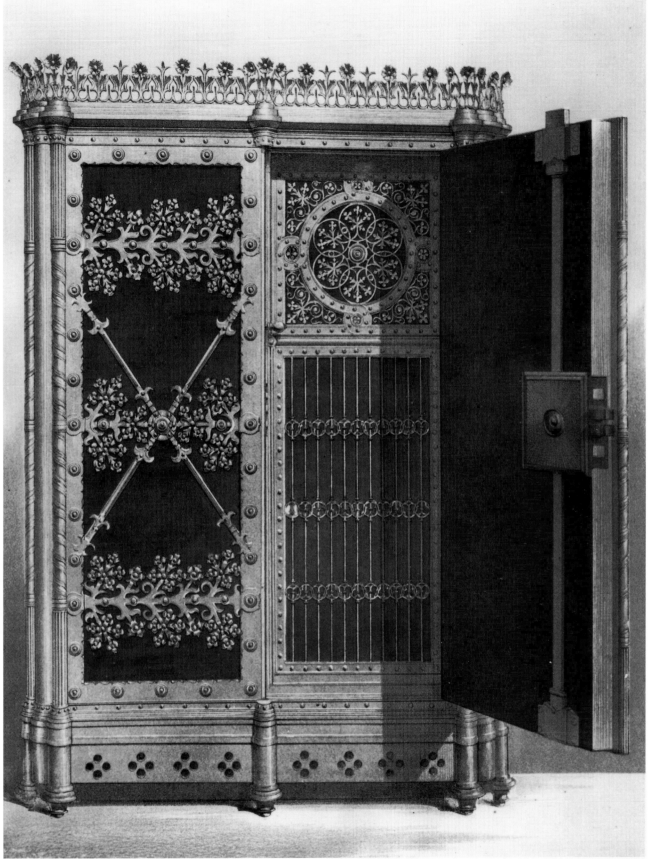

38

38. Berlin, Karl Hauschild, 1862

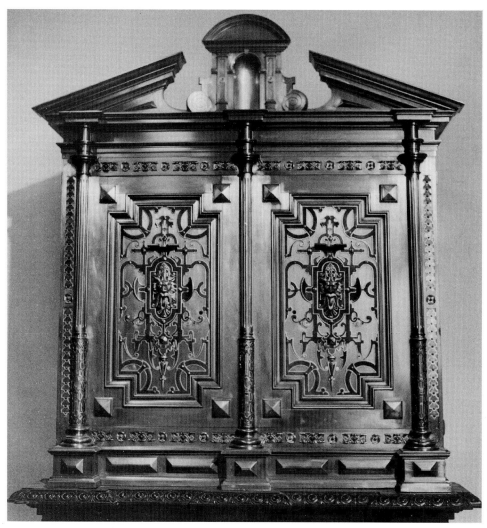

39

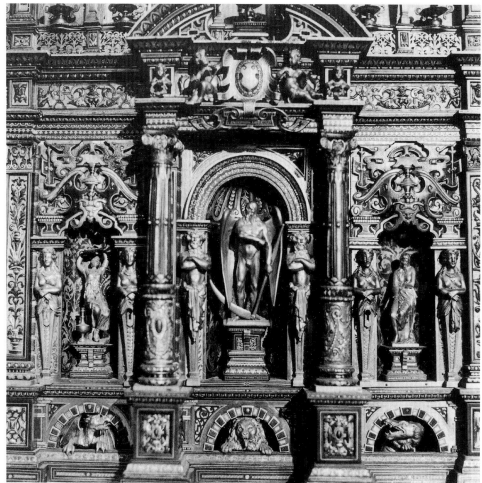

40

39. Wien, F. Wertheim & Co./Anton Batsche, 1873

40. Detail der Innenfront vom Kassenschrank der Abb. 39
*Detail of interior of safe shown in Pl. 39*

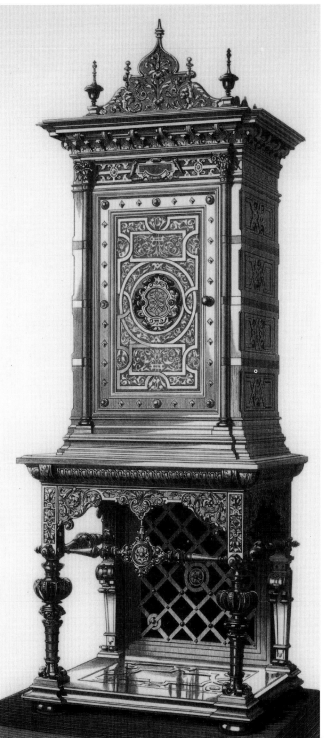

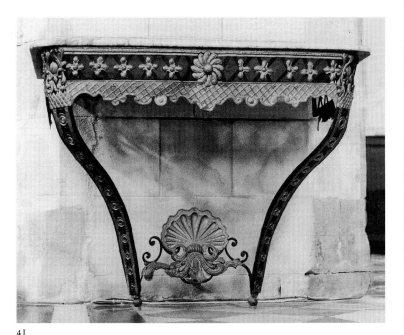

41

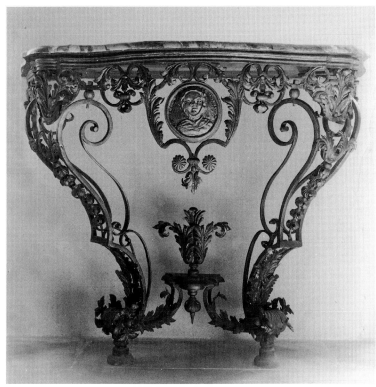

43

42

41. Nordfrankreich, *Northern France,* c. 1725

42. Berlin, A. L. Benecke/Ihne und Stegmüller, 1879

43. Avignon, Alexis Benoît, c. 1725

44. Süddeutschland, 1. Hälfte 18. Jahrhundert
*South Germany, first half 18th century*

45. Frankreich, *France,* c. 1750

44

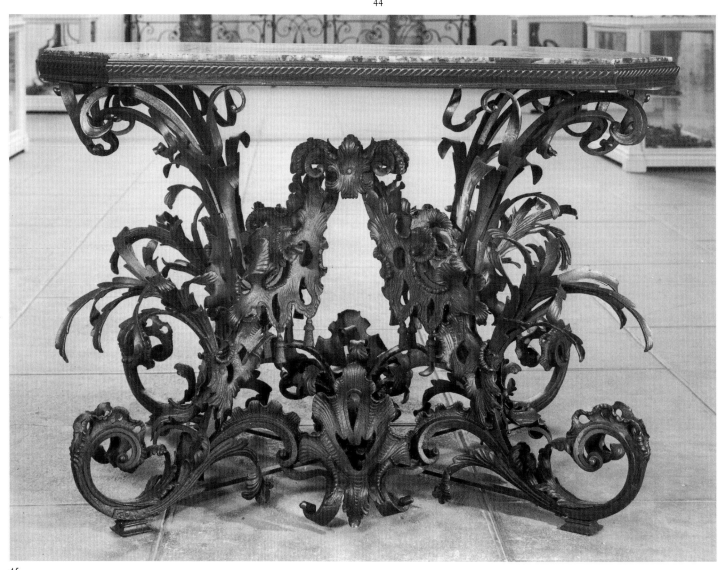

45

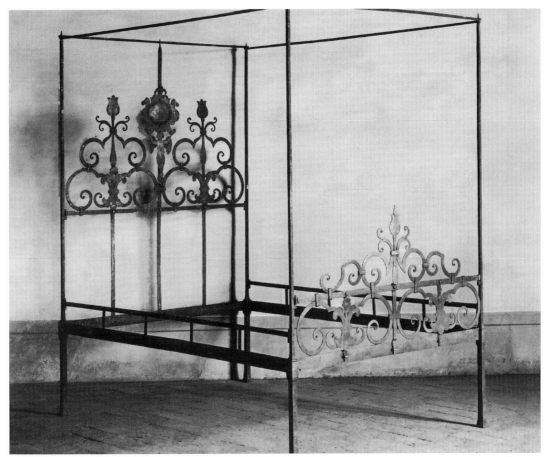

46

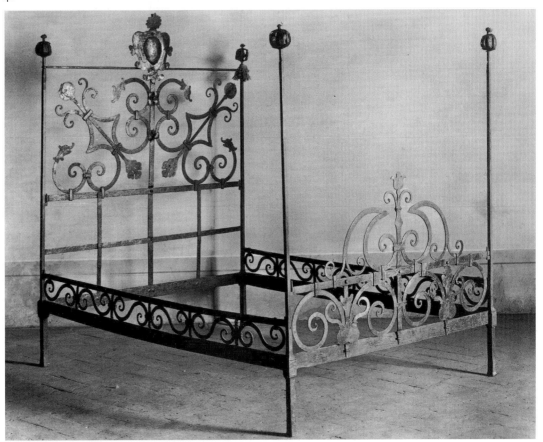

47

46, 47. Italien, *Italy,* c. 1620/40

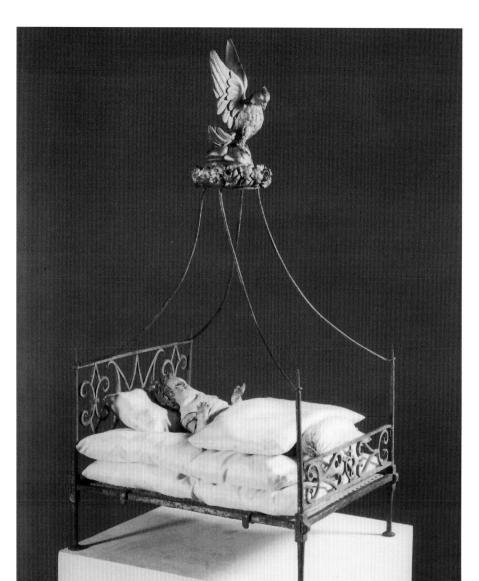

48

48. Frankreich, 2. Hälfte 17. Jahrhundert
*France, second half 17th century*

49. Italien, *Italy,* c. 1620

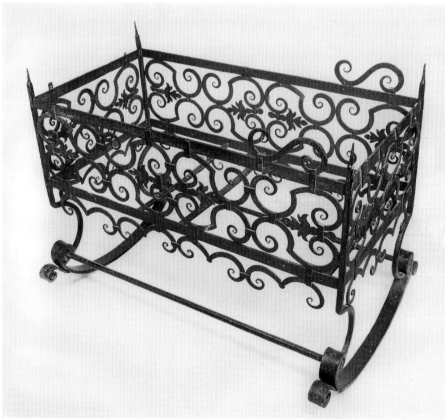

49

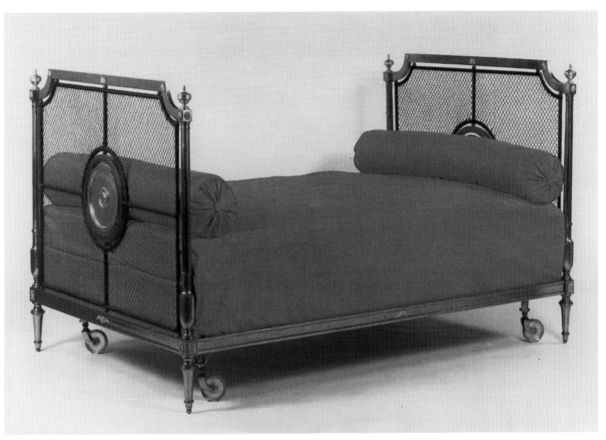

50

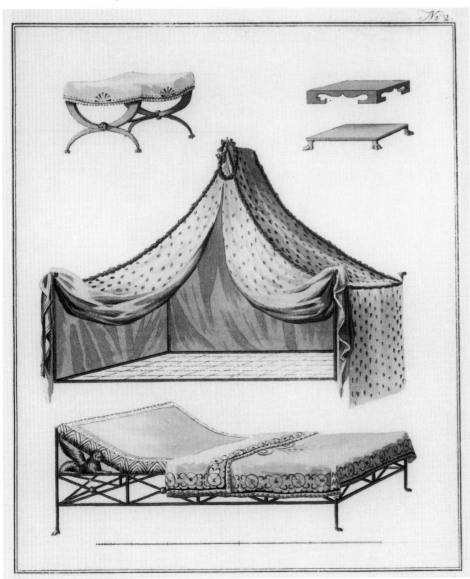

50. Paris, Jacques-Antoine Courbin (?), c. 1785

51. «Zeltbett», *Tent-bed*, 1796

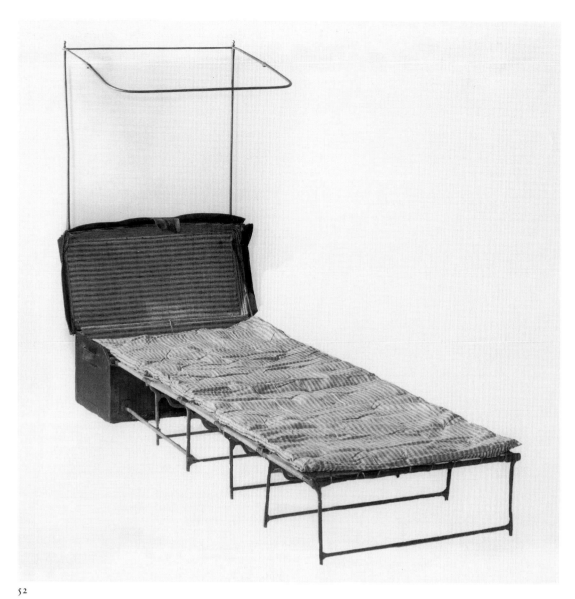

52

52. USA, c. 1780
53. Paris, Desouches, 1809

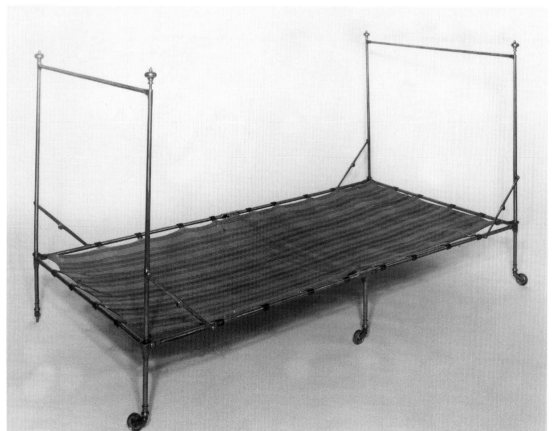

53

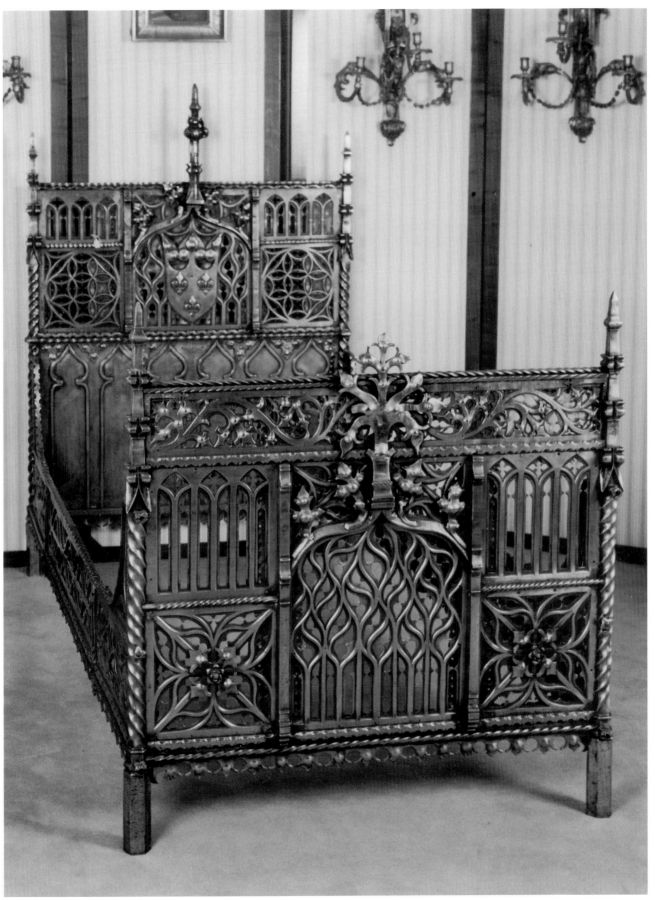

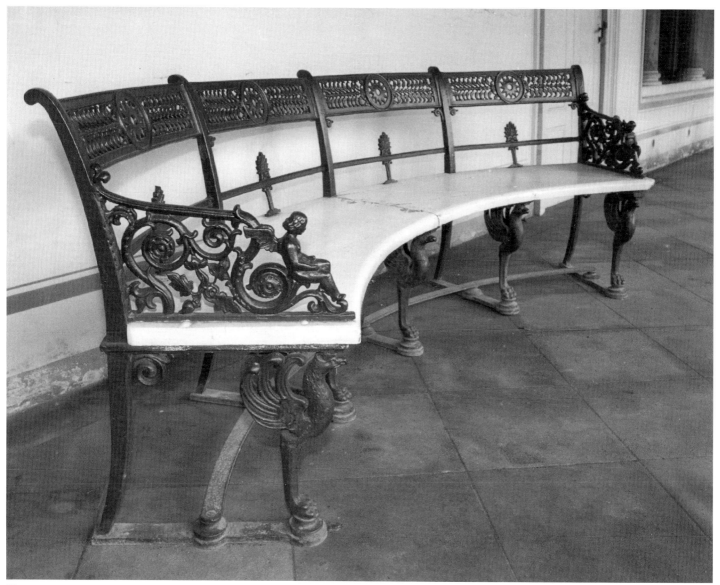

55

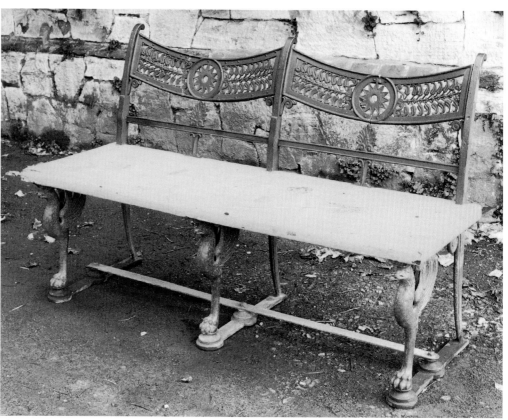

55, 56. Berlin, c. 1824/26

56

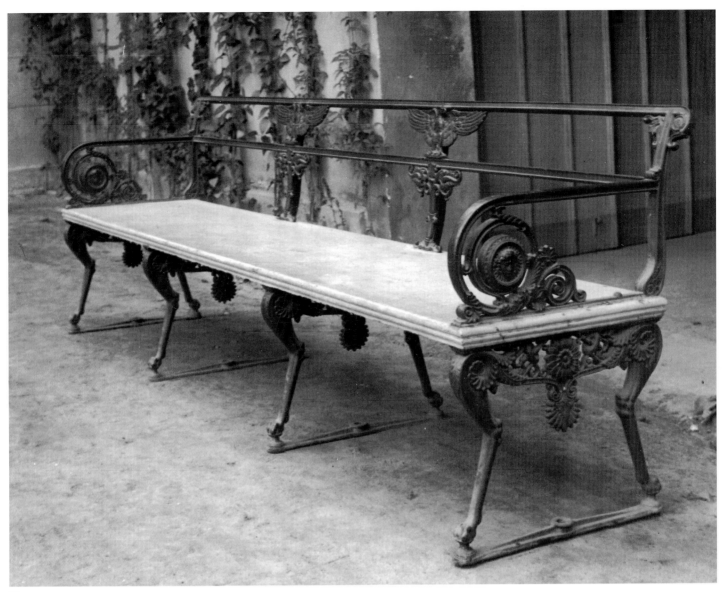

57

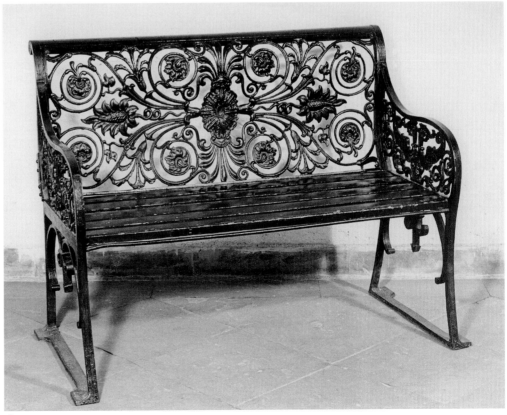

57. Berlin, c. 1824/26
58. Berlin, c. 1828

58

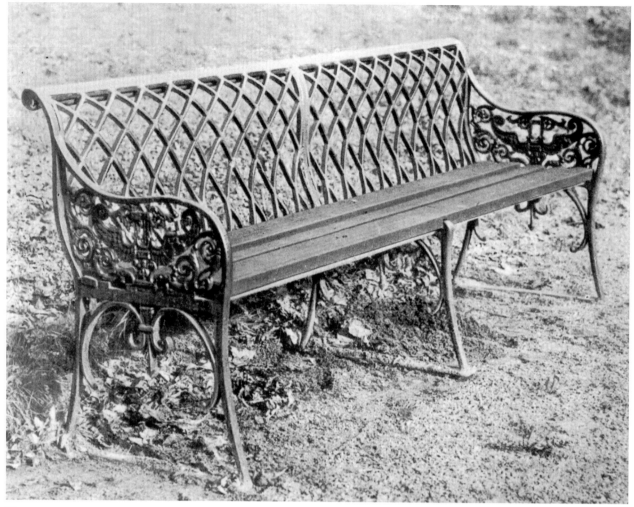

59

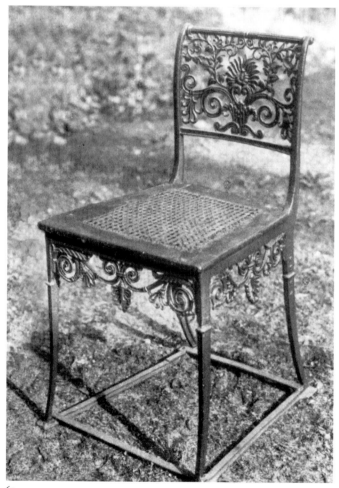

59. Berlin, c. 1828

60. Berlin, Gleiwitz, c. 1824/26

61. Alle preußischen Eisengießereien, c. 1830
*All Prussian foundries, c. 1830*

62. Sayn, c. 1830

63. Alle preußischen Eisengießereien, c. 1830
*All Prussian foundries, c. 1830*

64. Alle preußischen Eisengießereien, c. 1830
*All Prussian foundries, c. 1830*

60

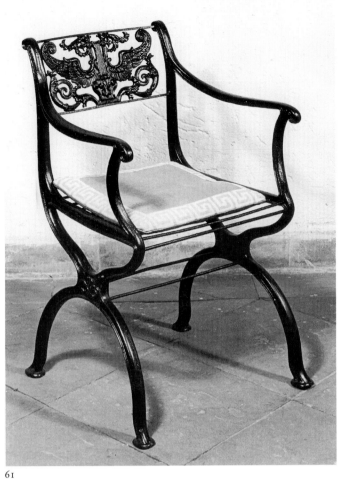

61

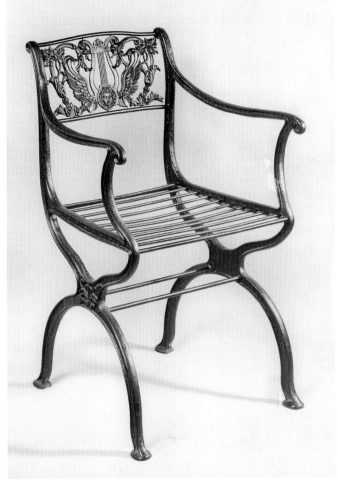

62

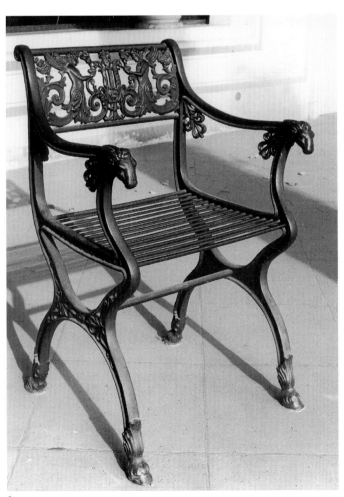

63

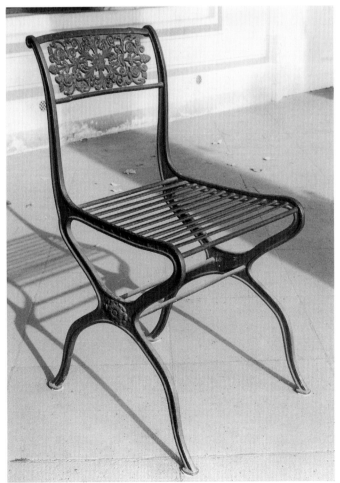

64

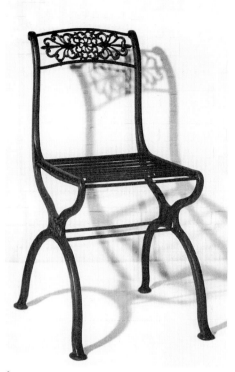

65

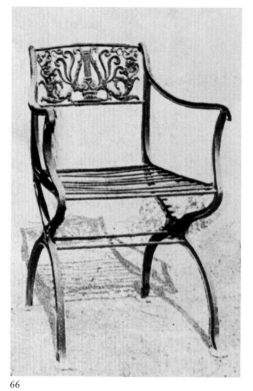

66

67

65. Rendsburg, c. 1830/40    67. Güstrow, c. 1846

66. Stiepenau, c. 1830    68. Niederlande, *The Netherlands,* c. 1830

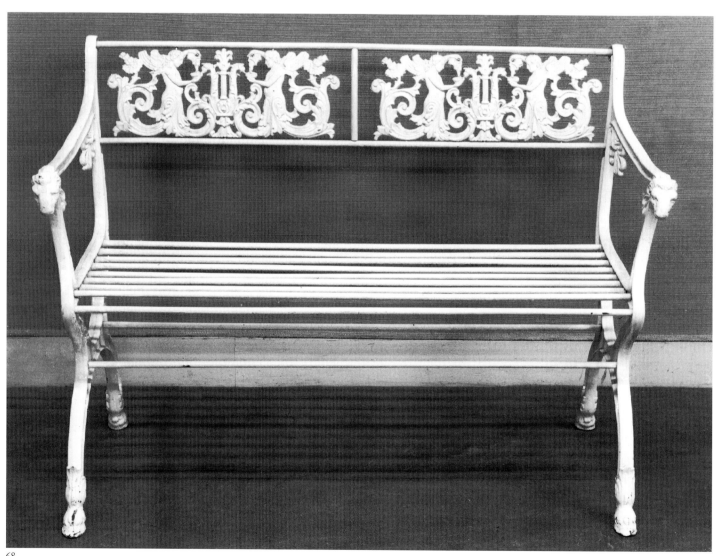

68

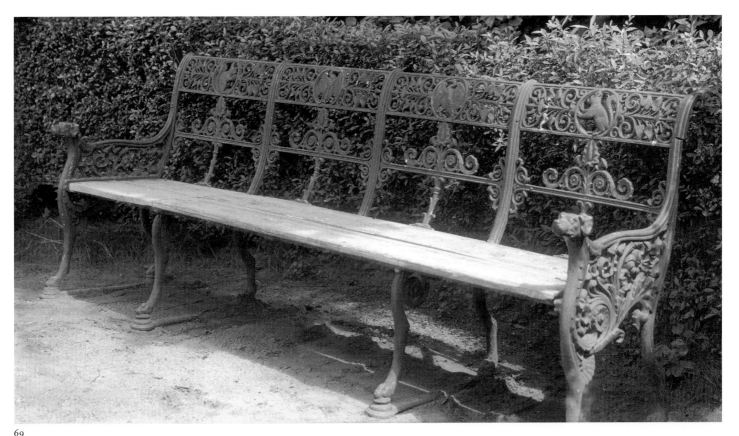

69

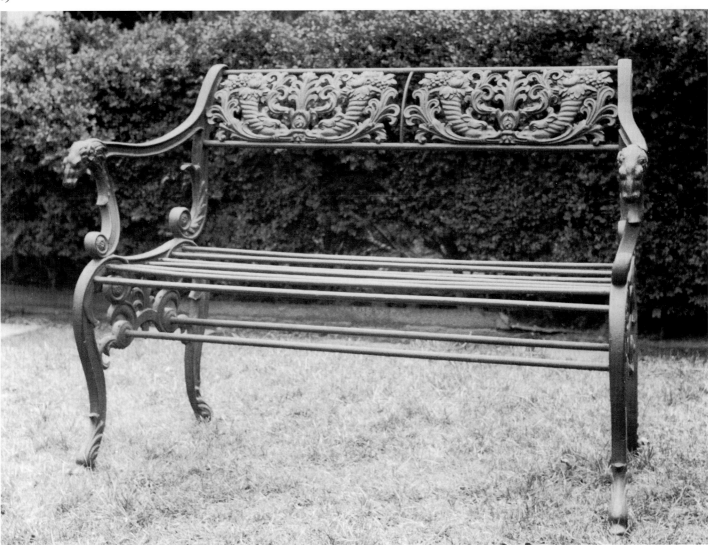

70

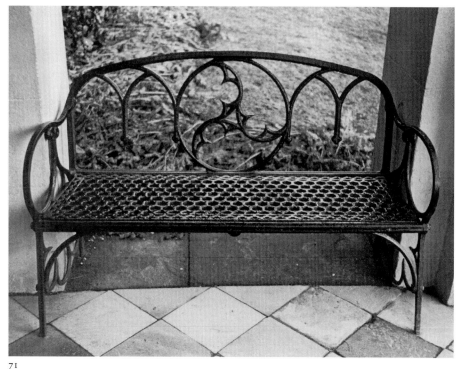

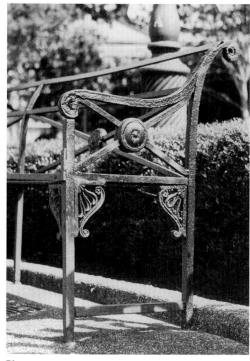

71

72

71. Cold-Spring-on-Hudson, NY, West Point Foundry, 1836

72. New Orleans, c. 1850

73. USA, c. 1840

74. USA, c. 1845

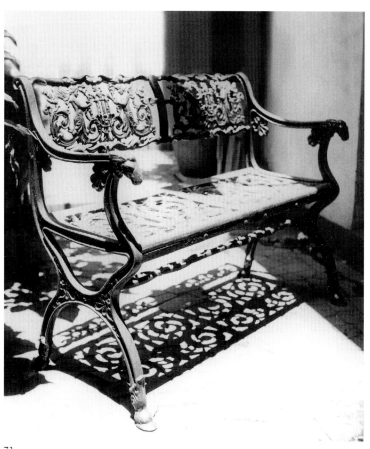

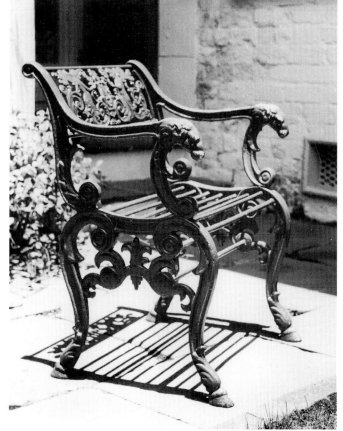

73

74

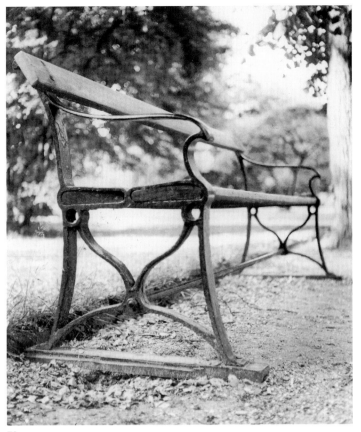
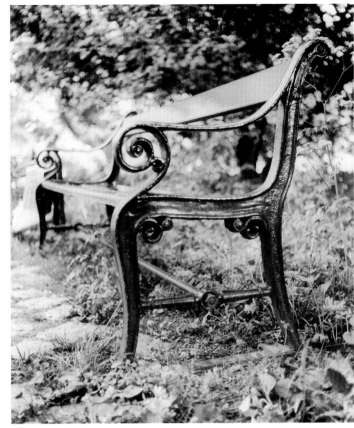

75                                              76

75. Konga, Småland, c. 1835/40    76. Dänemark (?), *Denmark (?)*, c. 1835/40

77. Lessebo, c. 1840

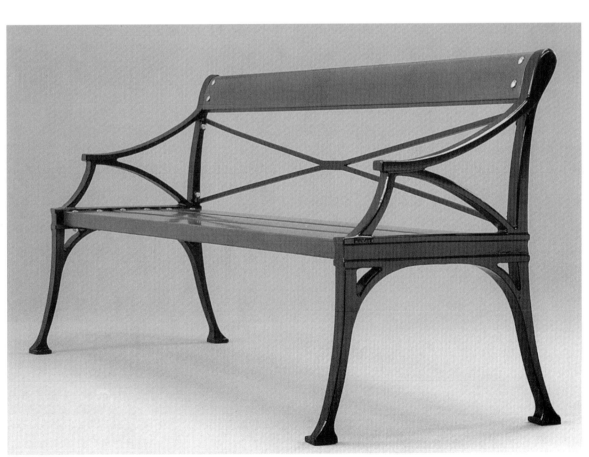

77

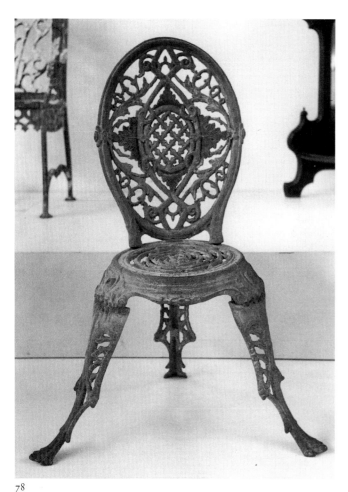

78

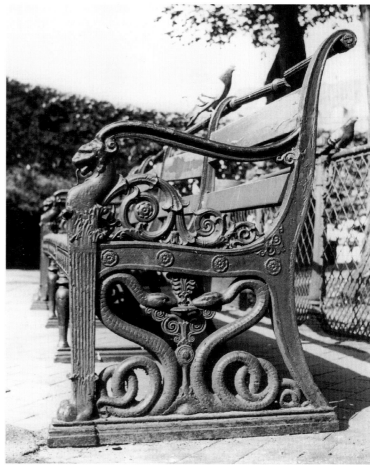

79

78. New York, J. W. Fiske, c. 1840

79. Skandinavien, *Scandinavia,* c. 1835

80. USA, c. 1840/50

81. Val d'Osne, c. 1840/50

82. Wasseralfingen, c. 1845

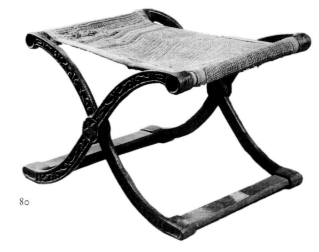

80

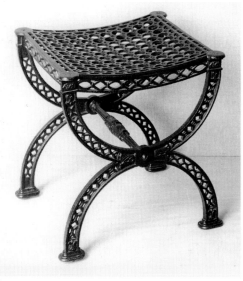

81

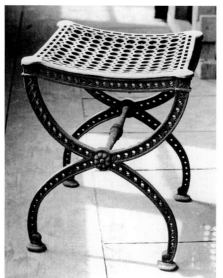

82

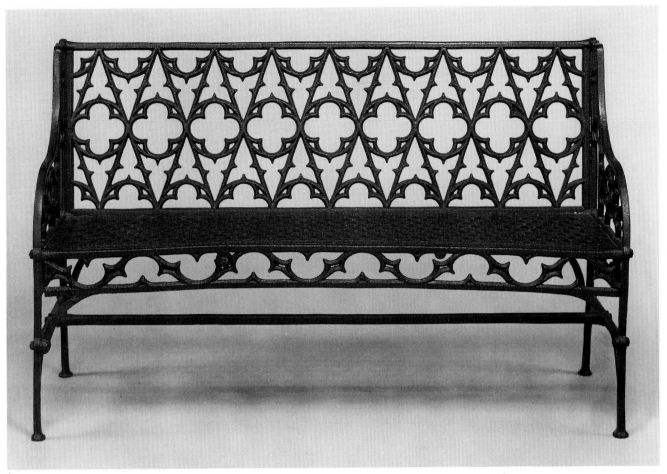

83

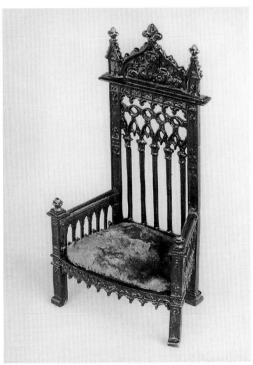

84

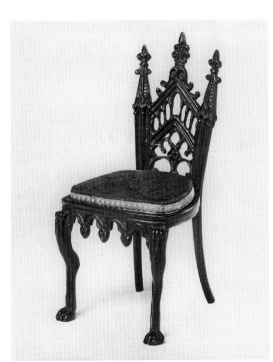

83. Rotherham, James Yates, Effingham Works, c. 1840
84, 85. Gleiwitz, c. 1830/34

85

86. Rendsburg, c. 1845/50

87. 's Gravenhage, L. I. Enthoven & Co., c. 1845/50

88. Val d'Osne, c. 1840

89. Coalbrookdale, 1847

90. Glasgow, McDowall, Steven & Co., c. 1850

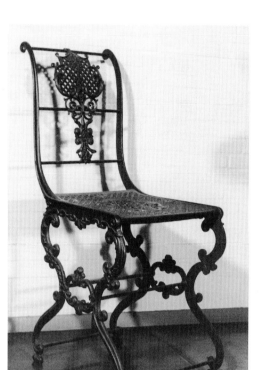

86

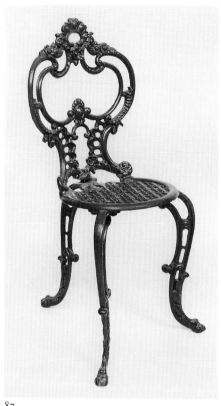

87

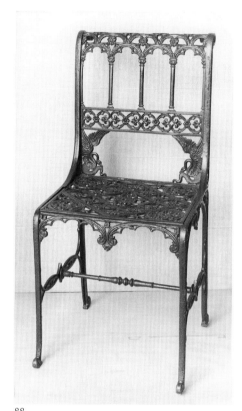

88

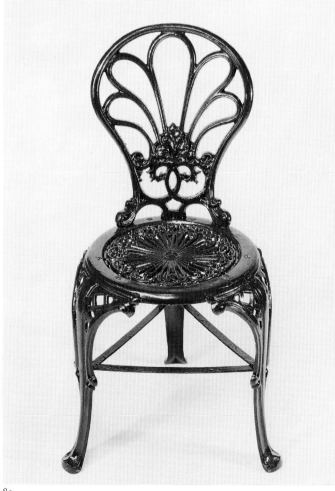

89

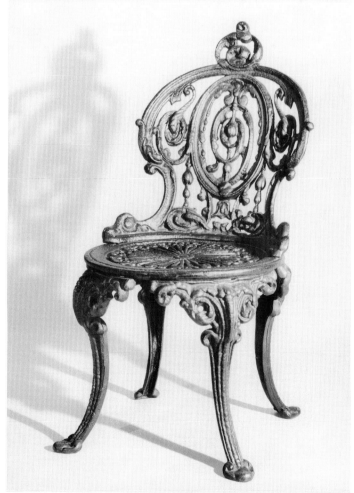

90

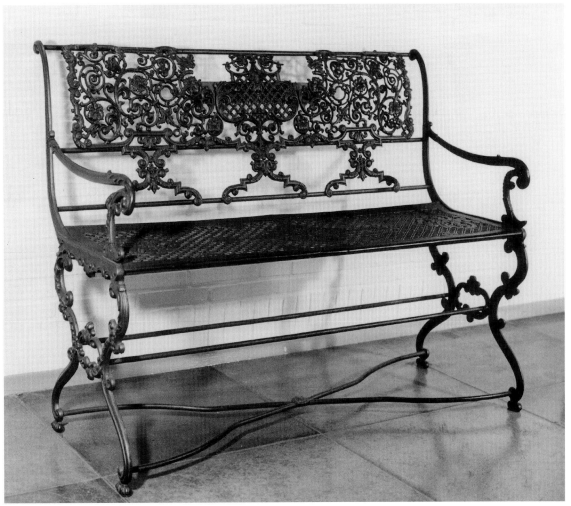

91

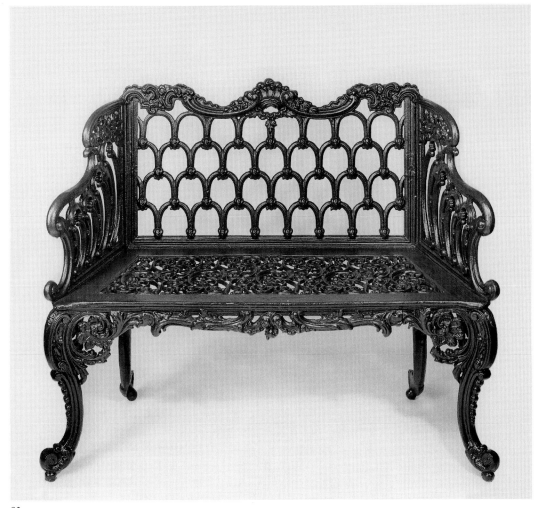

91. Rendsburg, c. 1845/50

92. Stirlingshire, Carron Company,
1846

92

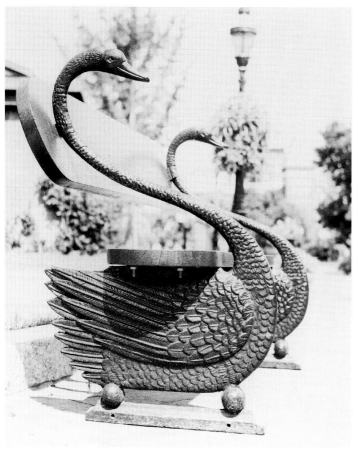

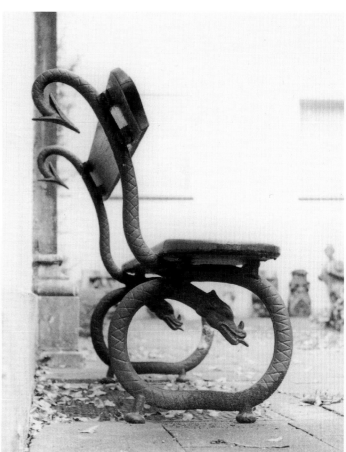

93

94

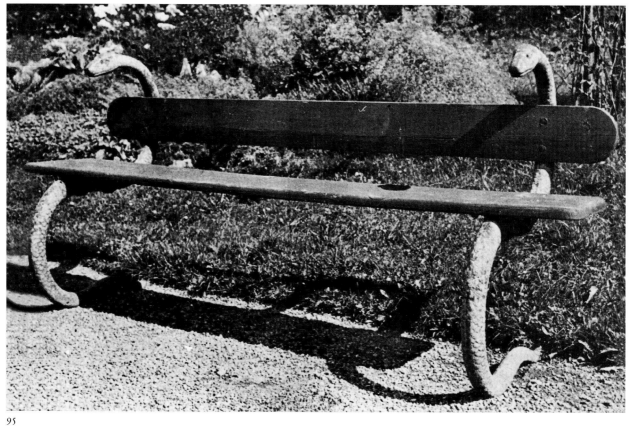

95

93. USA, c. 1840

94. 's Gravenhage, De Prins van Oranje, c. 1840

95. Zöpfau, c. 1840

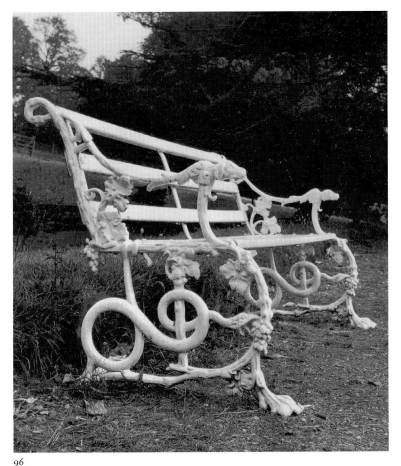

96

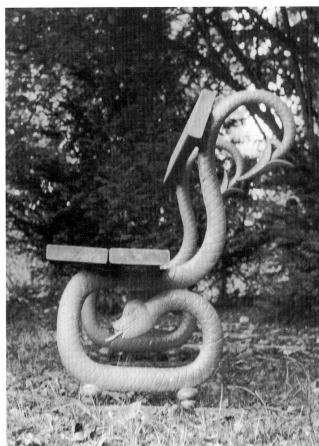

97

96. Coalbrookdale, 1844     97. England, c. 1840

98. New Orleans (?), c. 1850

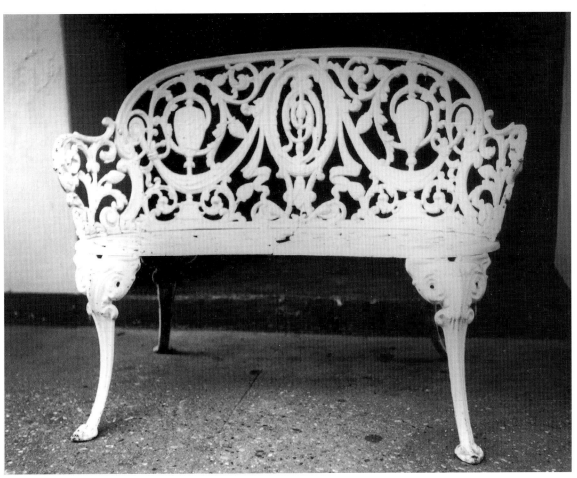

98

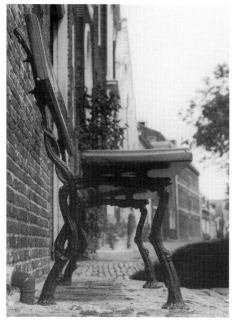

99

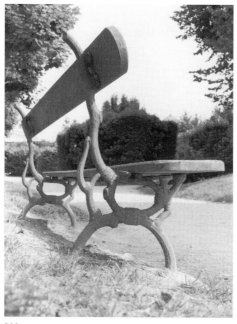

100

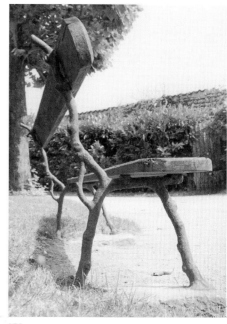

101

99. Niederlande, *The Netherlands,* c. 1850

100, 101. Frankreich, *France,* c. 1845/50

102. England, c. 1840

103. Wasseralfingen, 1847

104. Niederlande, *The Netherlands,* c. 1850

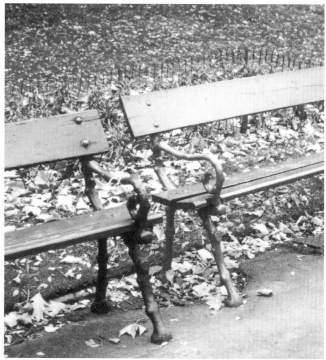

102

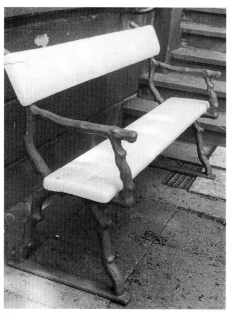

103

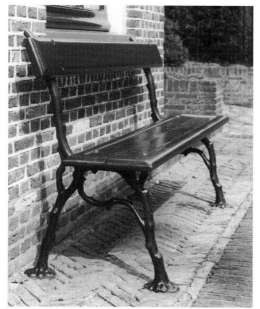

104

105, 106.  Glasgow, McDowall, Steven & Co., c. 1840

107.  Wasseralfingen, 1847

108.  Wasseralfingen, c. 1845/50

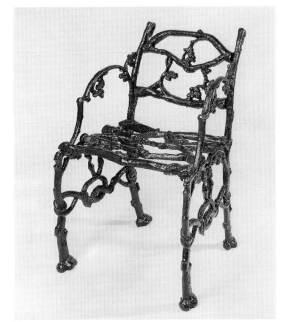

105

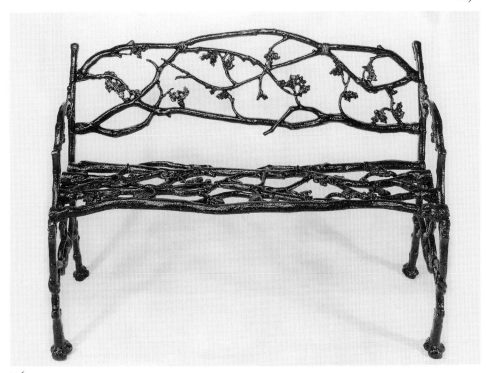

106

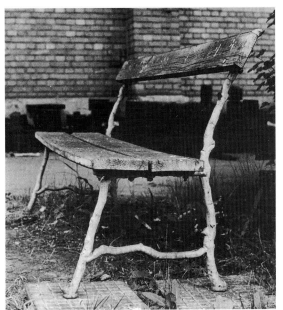

107

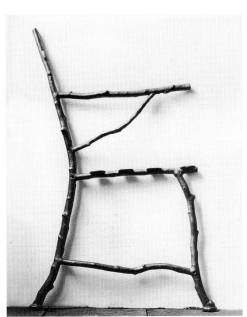

108

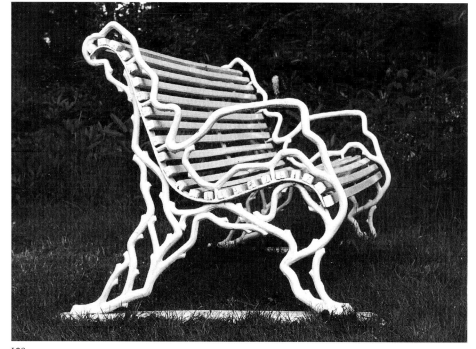

109

109. England, c. 1850

110. Frankreich, *France*, c. 1850

111. Seitenansicht der Gartenbank der Abb. 118
*Side view of garden bench shown in Pl. 118*

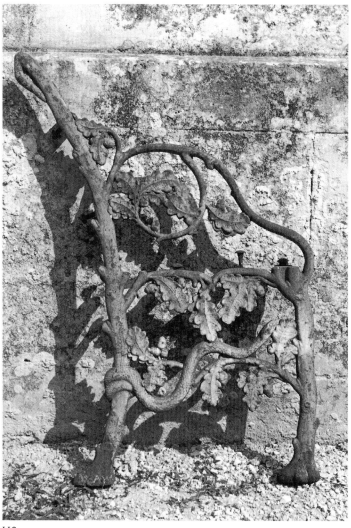

110

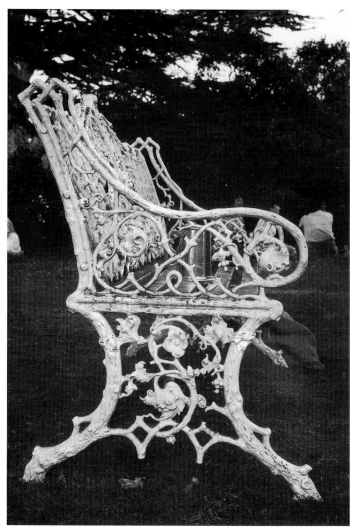

111

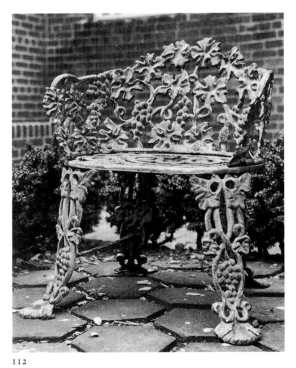

112

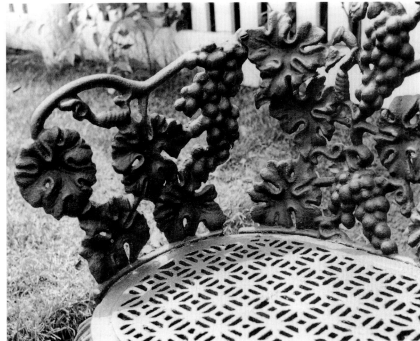

113

112. Philadelphia, Wood & Perot (?), 1858

113. Detail der Gartenbank der Abb. 114
*Detail of garden bench shown in Pl. 114*

114. Edinburgh, Charles D. Young & Co., c. 1850

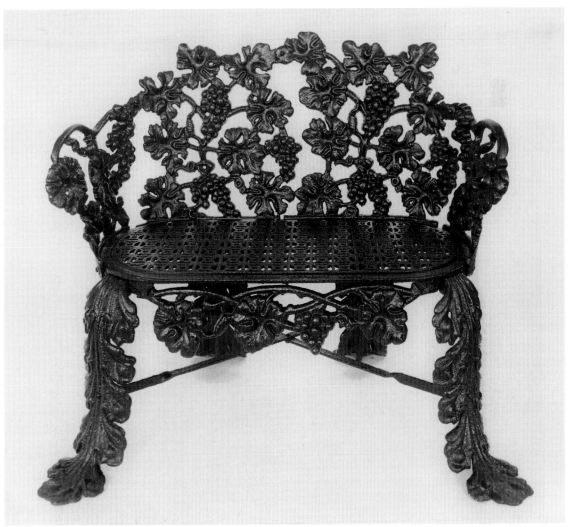

114

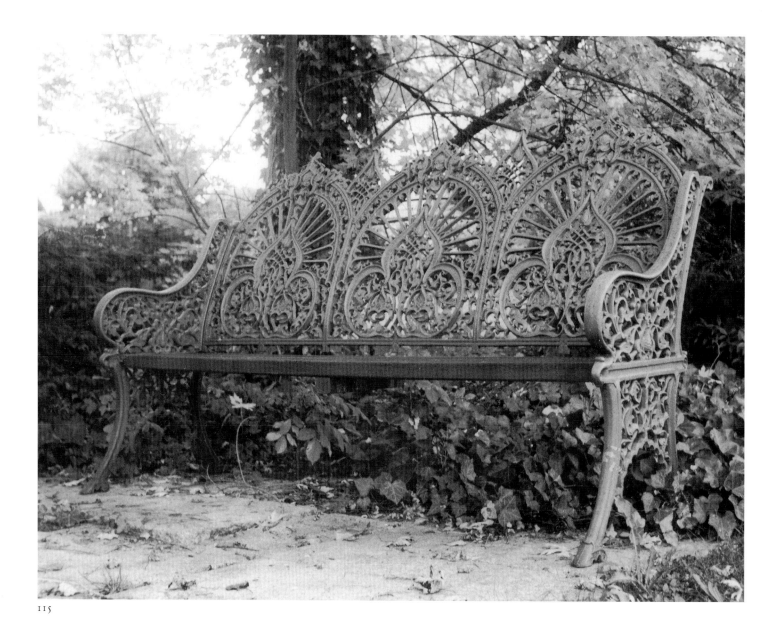

115

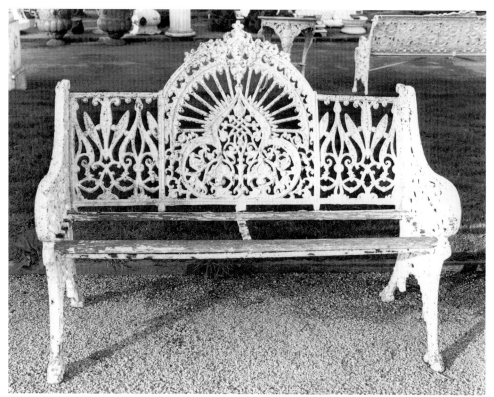

116

115. Coalbrookdale (?), c. 1853

116. Coalbrookdale, 1853

117. Rotherham, Yates, Haywood & Co.,
1854

118. Coalbrookdale, 1851

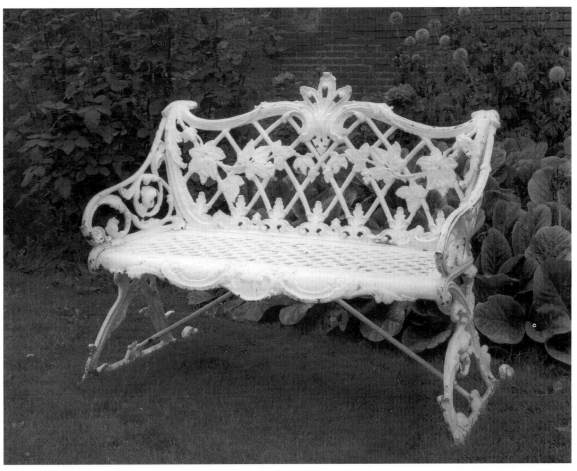

117

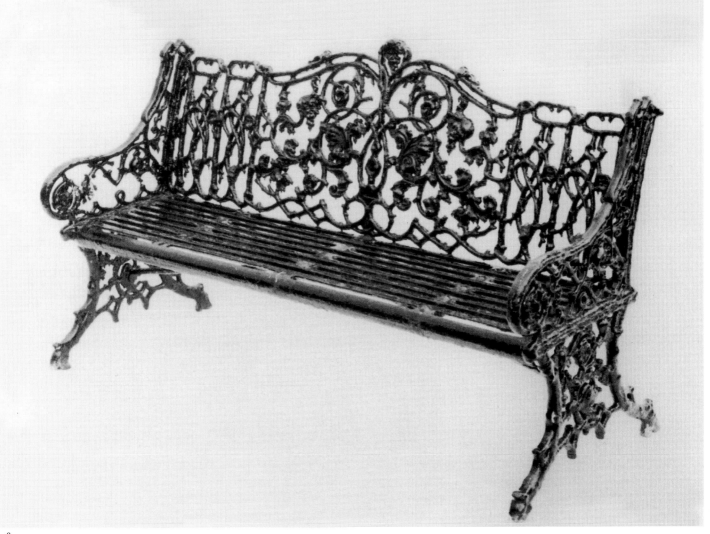

118

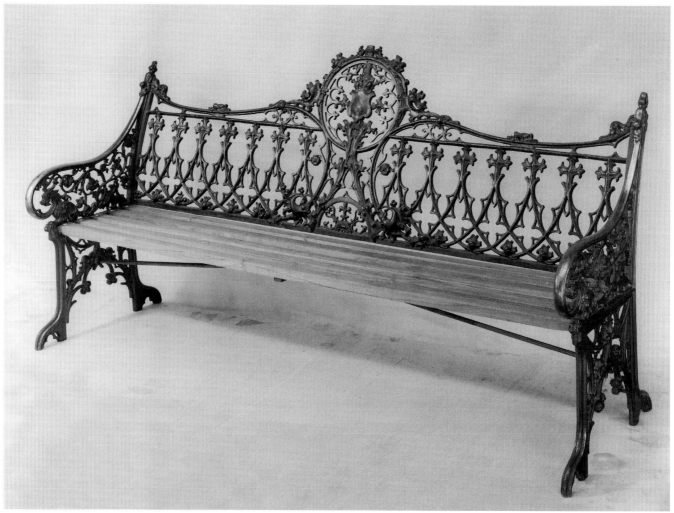

119

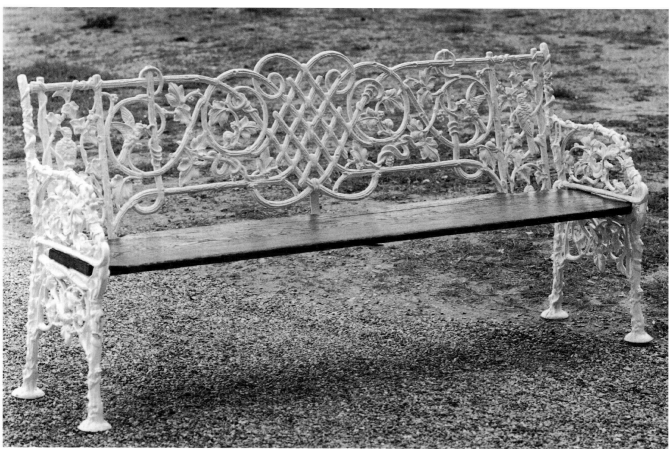

120

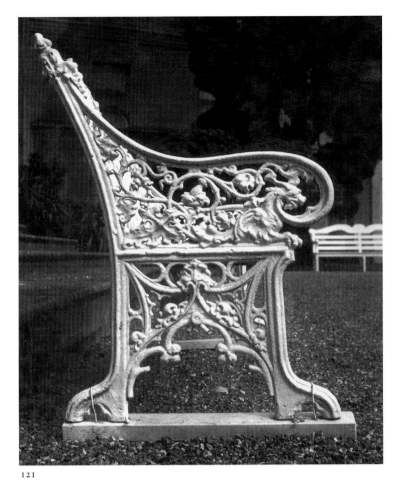

121

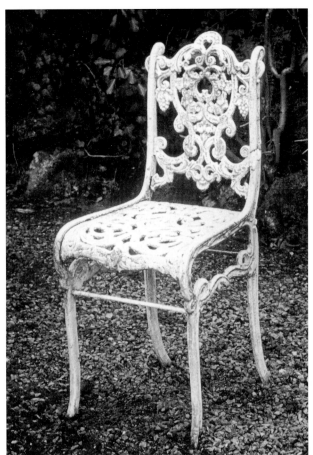

122

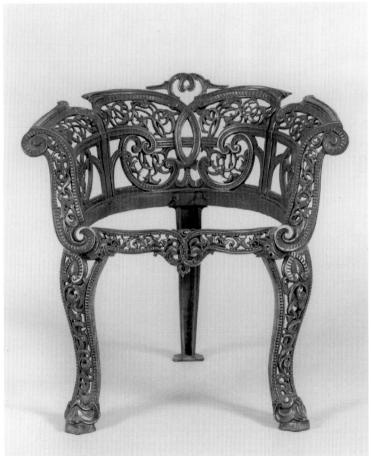

123

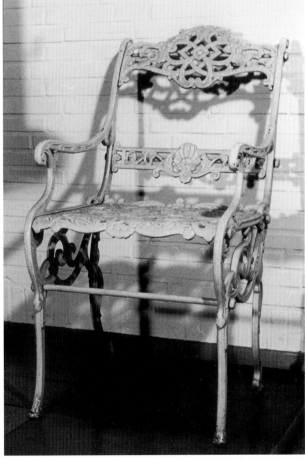

124

121. Seitenansicht der Bank von Abb. 119
*Side view of the bench shown in Pl. 119*

123. West Bromwich, Archibald Kenrick & Sons, 1853

122. Hochstein, Pfalz, c. 1855

124. Rendsburg, c. 1855

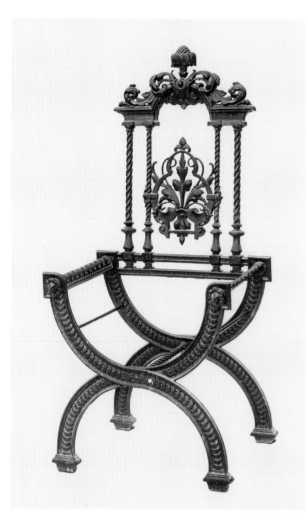

125

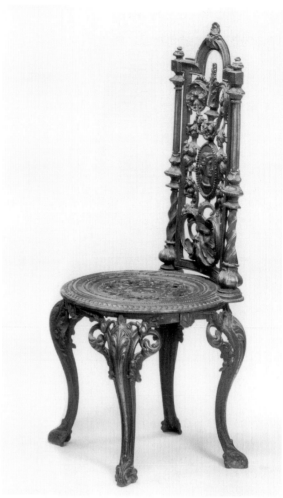

126

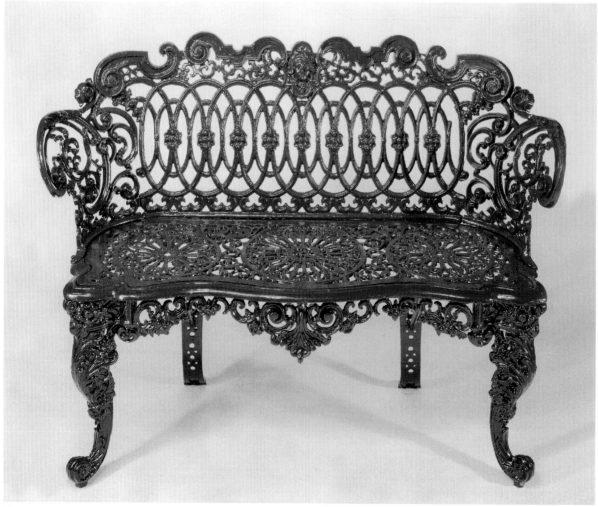

127

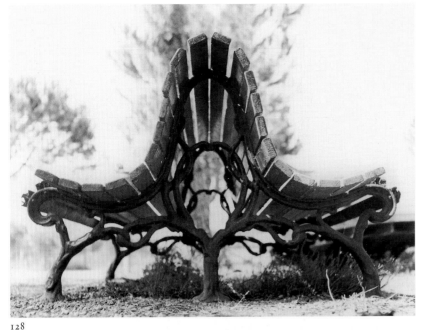

128

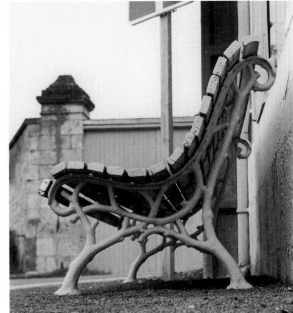

129

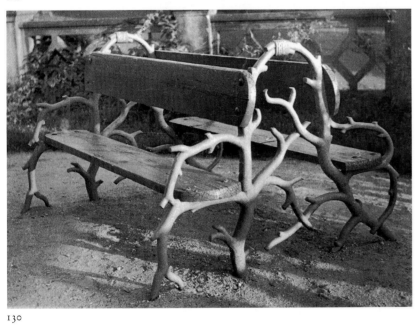

130

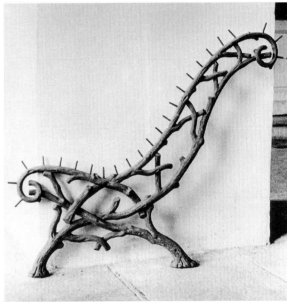

131

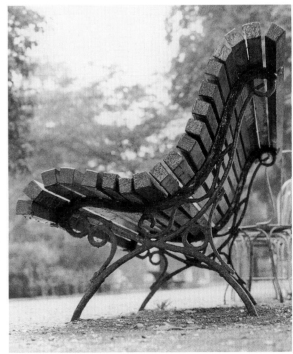

132

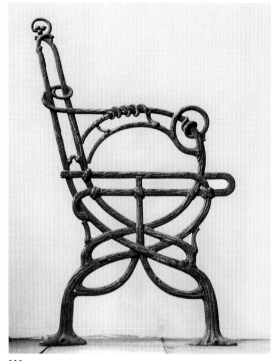

133

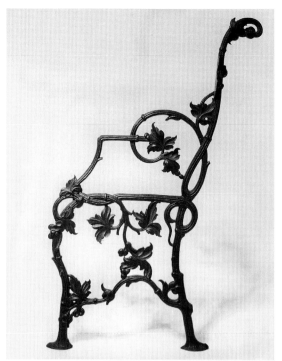

134

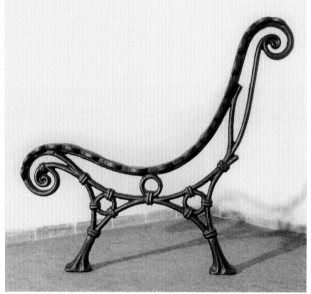

135

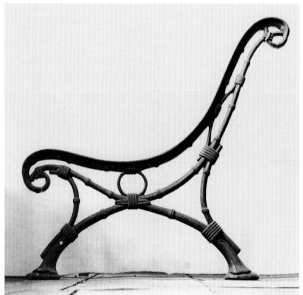

136

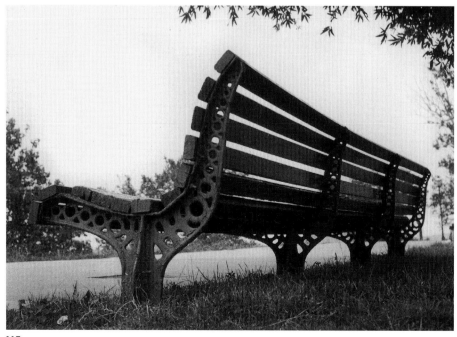

137

133. Val d'Osne, c. 1858

134. Blansko, c. 1860/70

135. Blansko, c. 1850/60

136. Val d'Osne, 1858

137. Baltimore, Bartlett, Robbins & Co., c. 1860

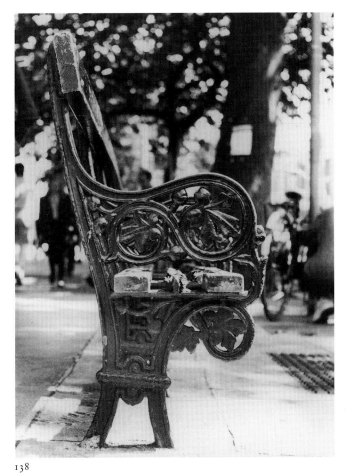

138

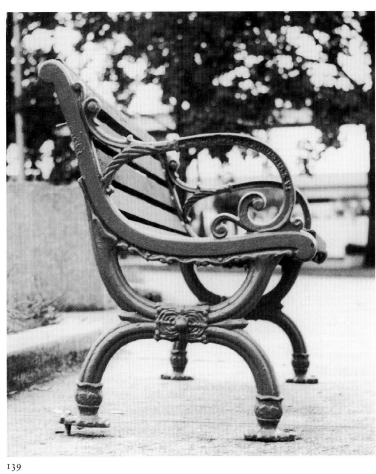

139

138. Glasgow, Walter Macfarlane & Co., 1860

139. Dudley, Thomas Marsh & Son, 1858

140. Sommevoir, A. Durenne, c. 1860

141. Skandinavien, *Scandinavia,* c. 1860

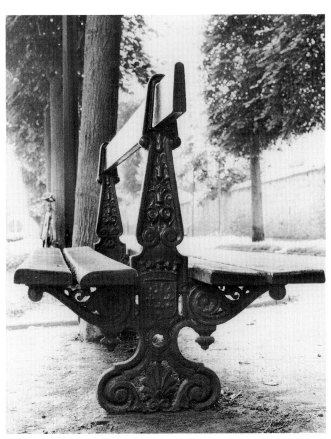

140

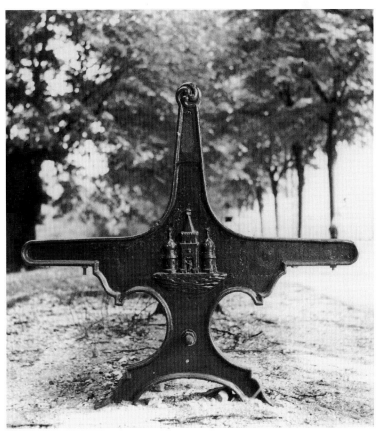

141

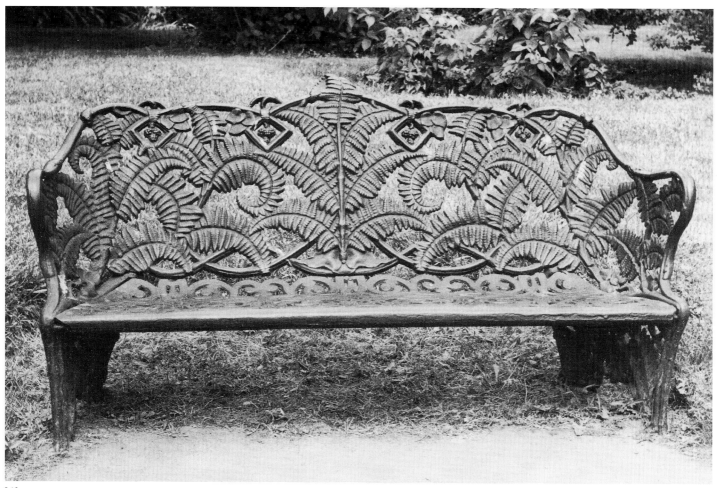

142

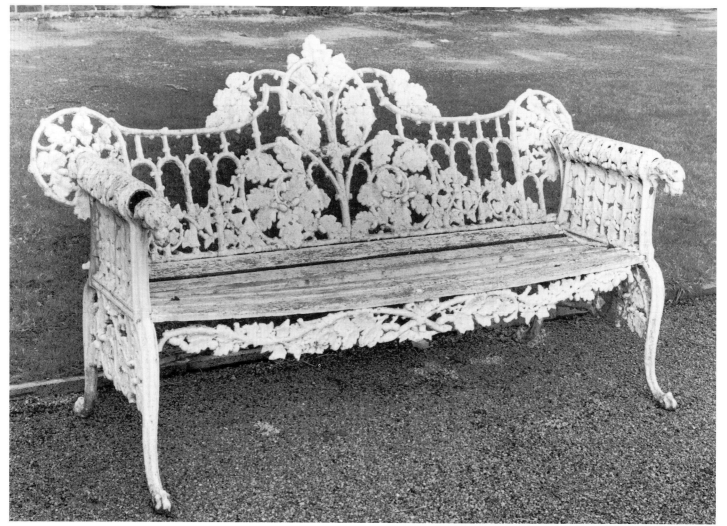

143

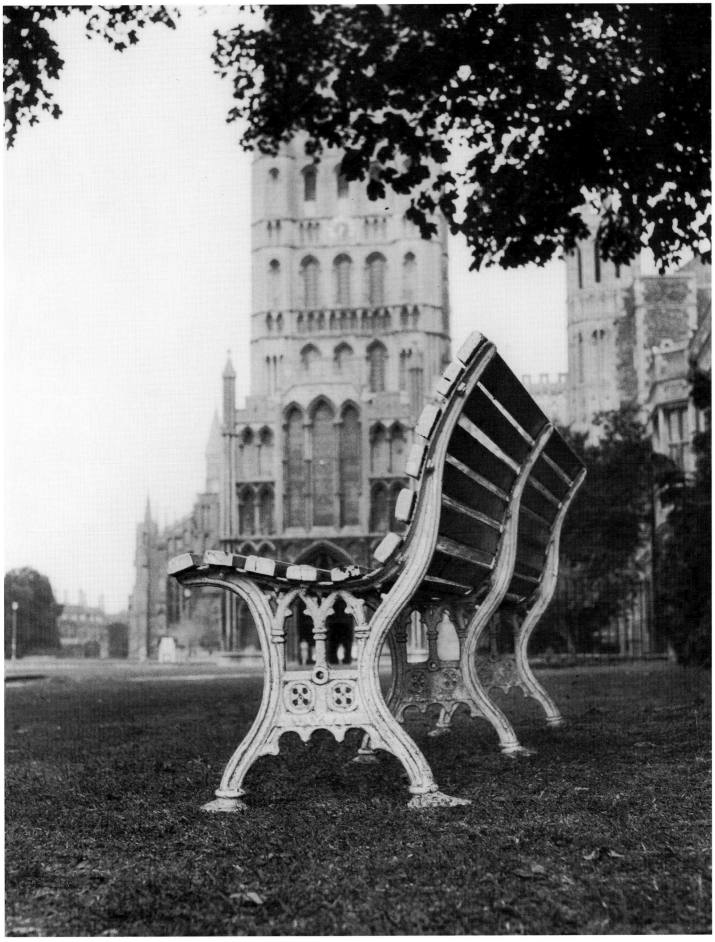

144

142. Coalbrookdale, 1858      144. England, c. 1860/65

143. Coalbrookdale, 1859

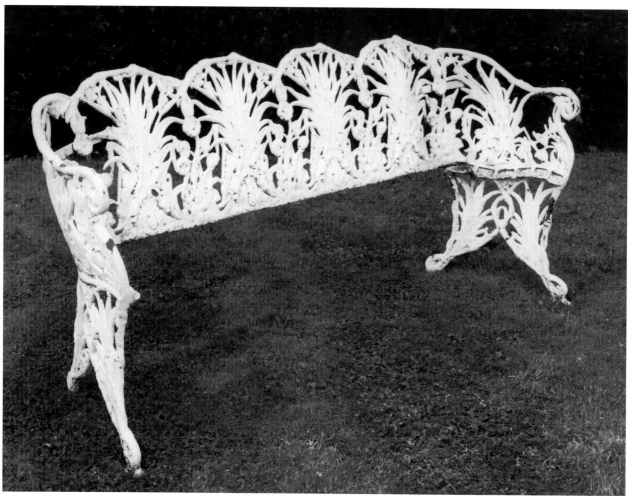

145

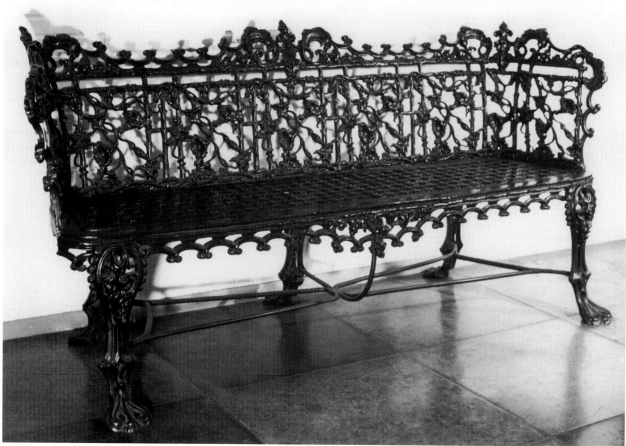

146

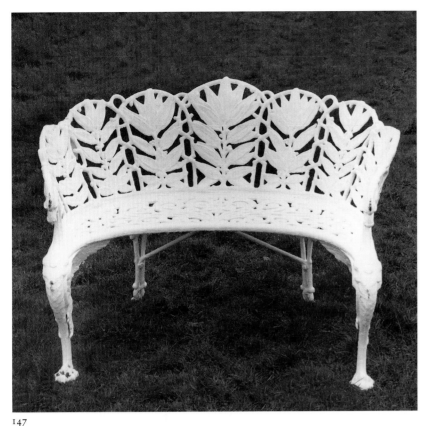

147

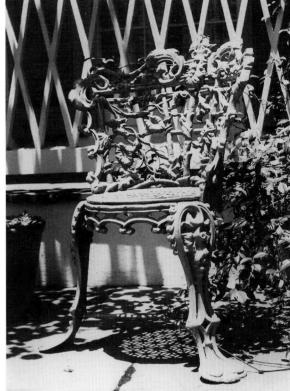

148

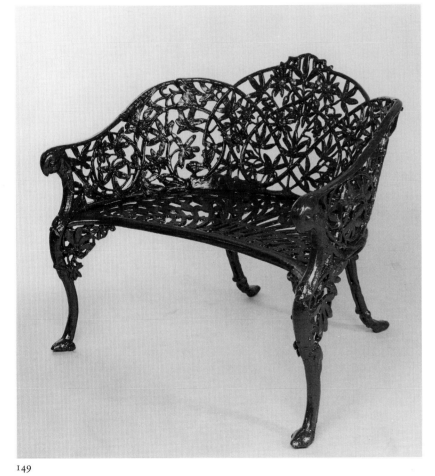

149

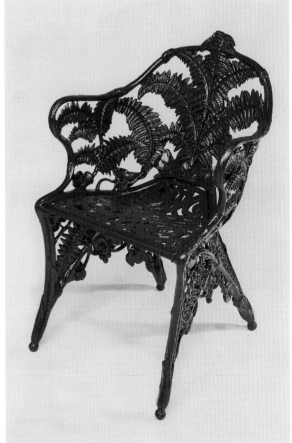

150

147. Coalbrookdale, 1860    148. New York, Hutchinson & Wickersham, c. 1855

149. Coalbrookdale, 1862    150. Coalbrookdale, 1858

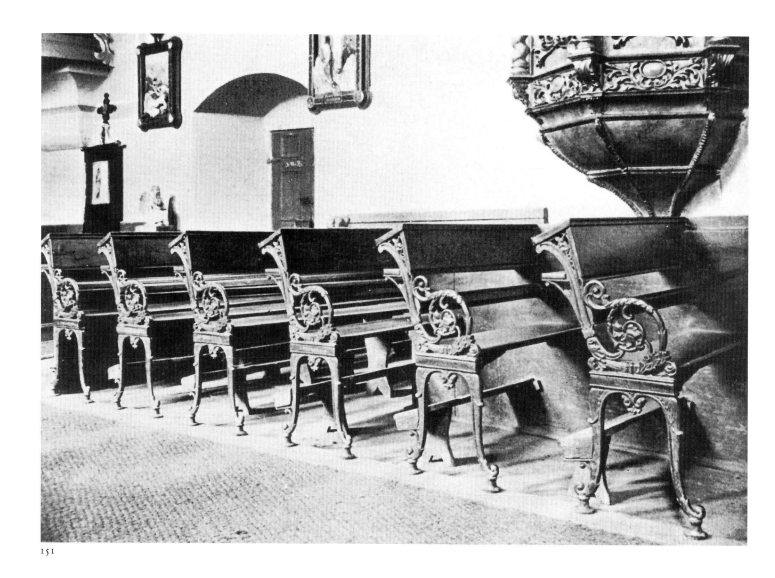

151

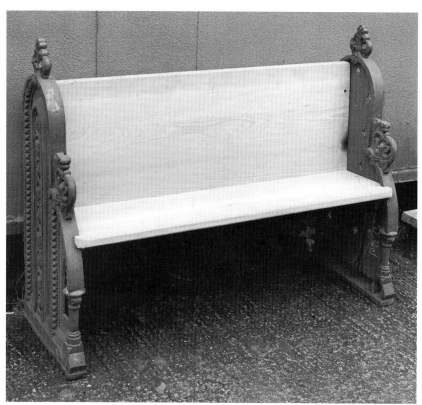

152

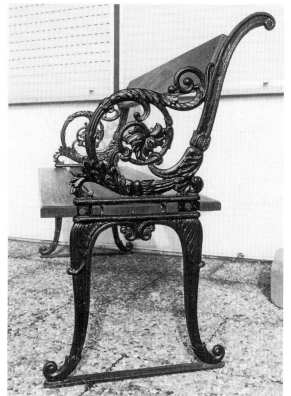

153

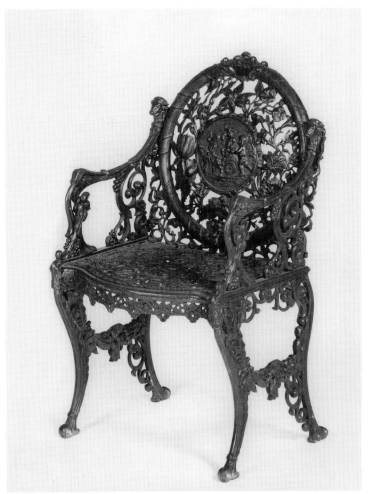

154

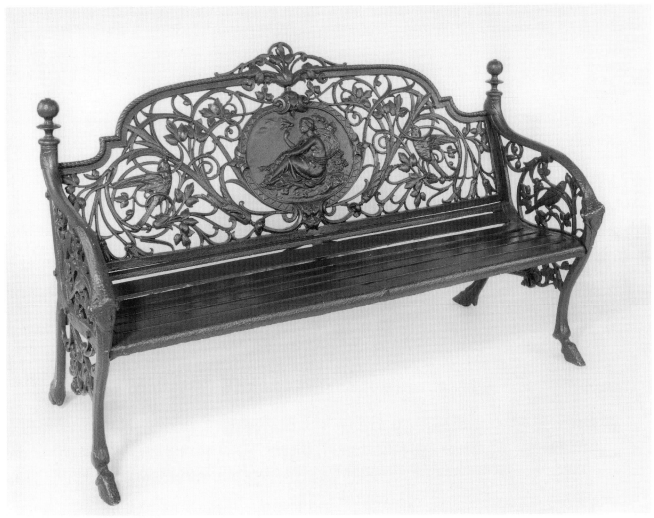

155

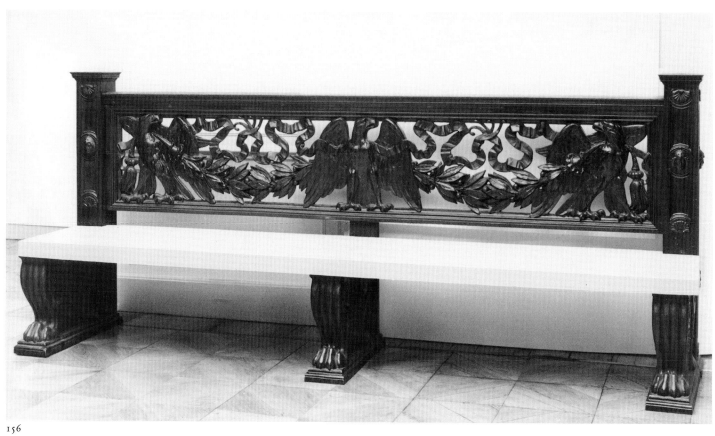

156

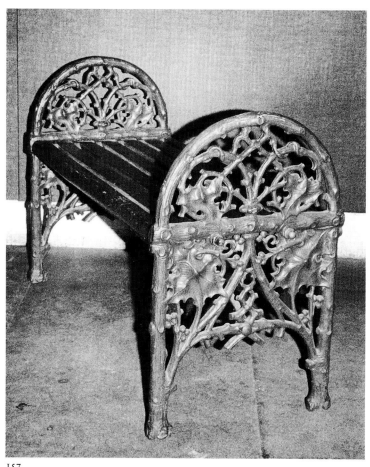

157

158. Coalbrookdale, 1864

159. Falkirk, 1862

160. Falkirk, 1865

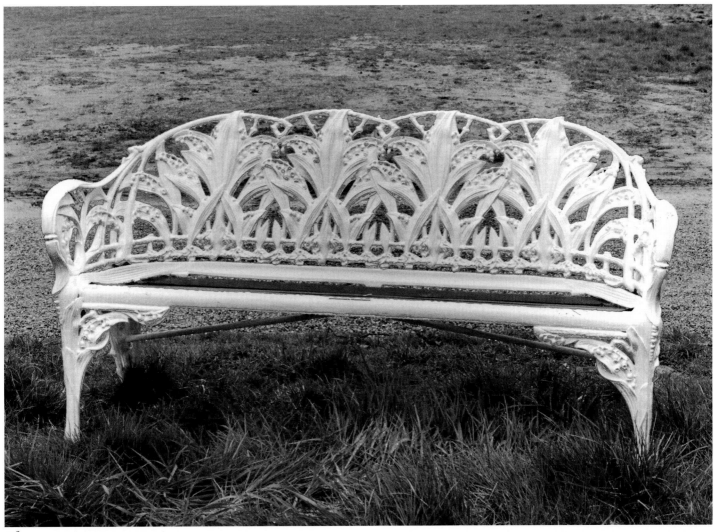

158

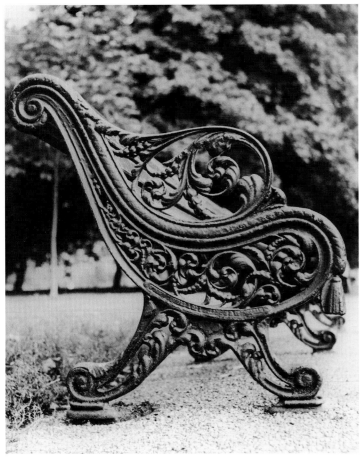

159

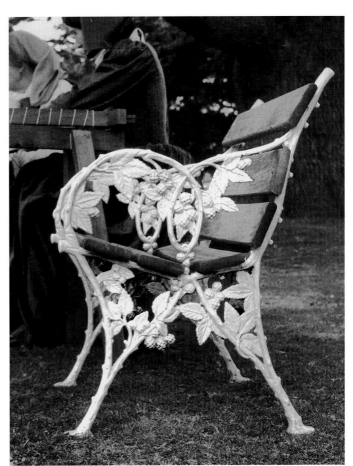

160

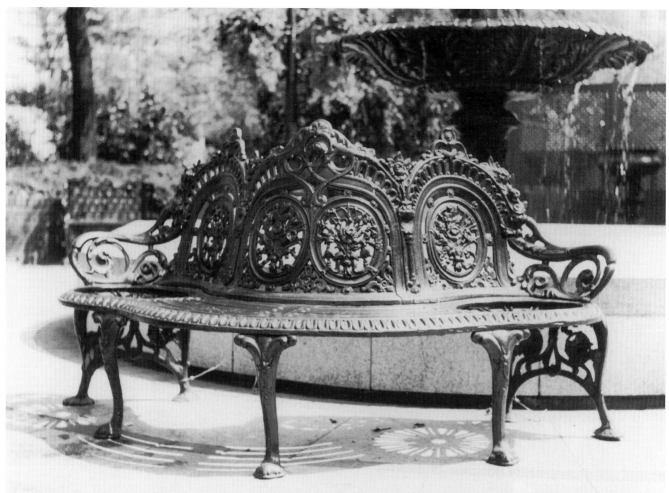

161

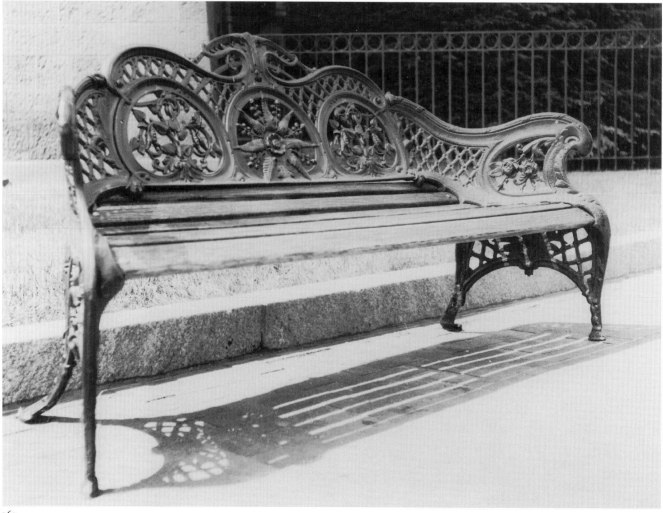

162

161. Dalkeith, W. & R. Mushet, 1866
162. Dalkeith, W. & R. Mushet, 1865

163

164

163. Frankreich, *France,* c. 1865/70    164. New Orleans (?), c. 1865/70
165. New Orleans (?), c. 1865

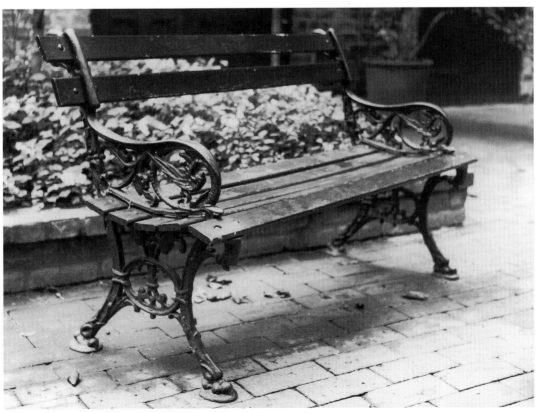

165

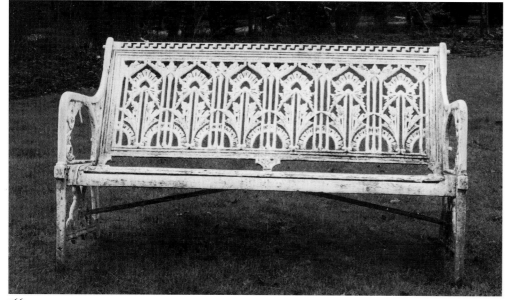

166

166, 167.  Coalbrookdale, 1867

168.  Coalbrookdale, 1868

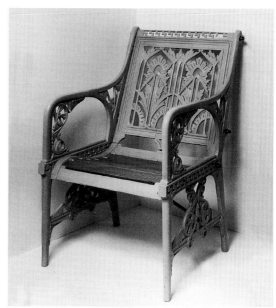

167

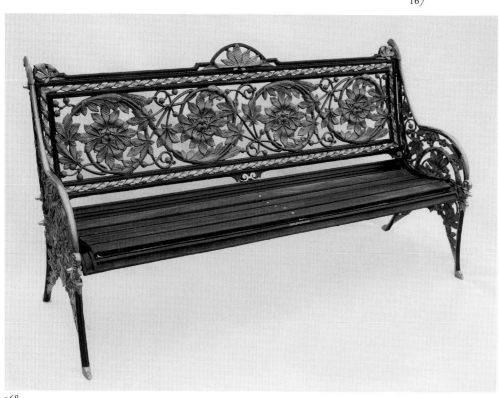

168

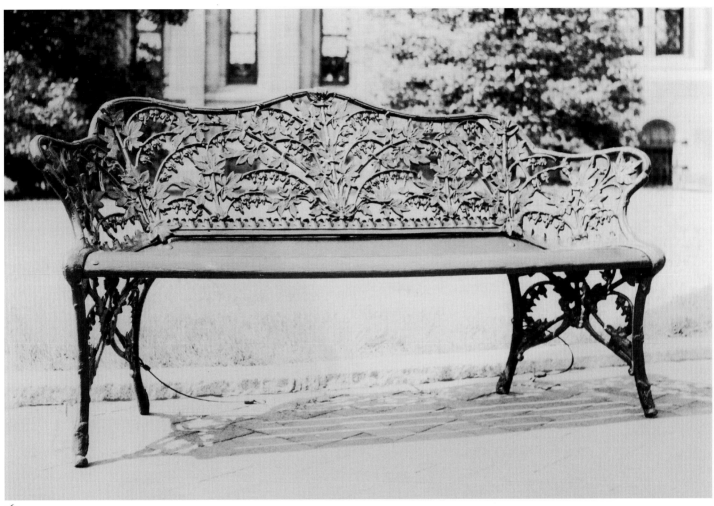

169

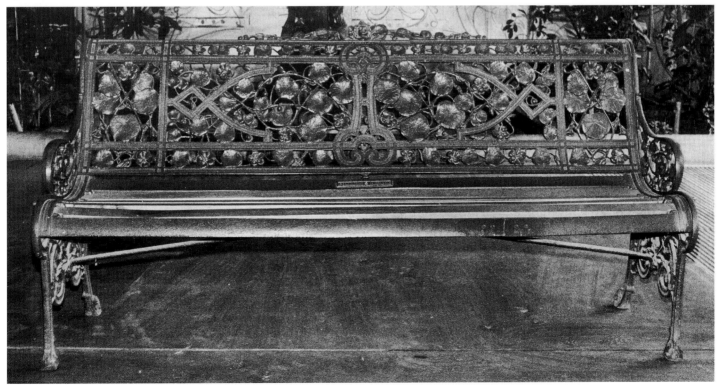

170

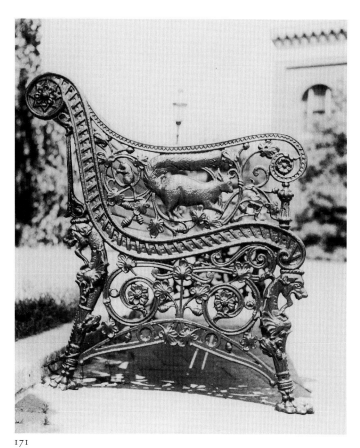

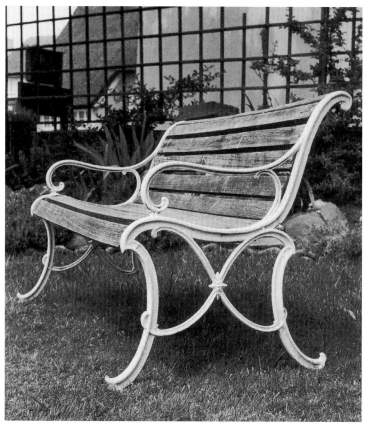

171

172

171. Glasgow, George Smith & Co., 1868          172, 173. London, Andrew McLaren & Co., 1869

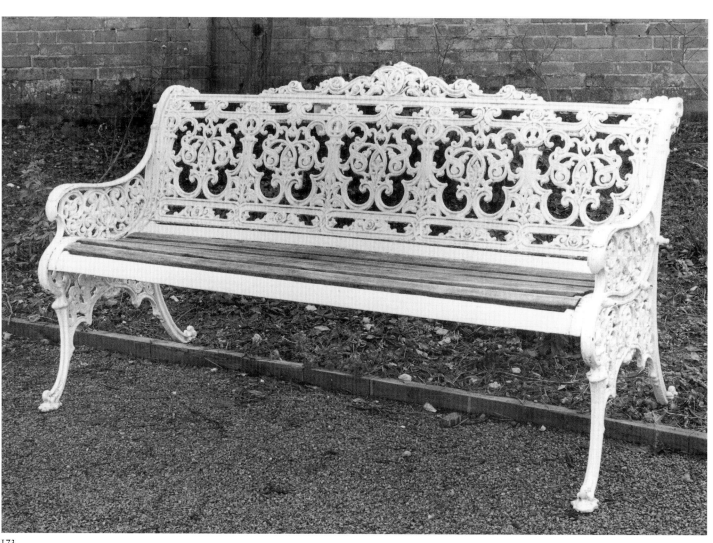

173

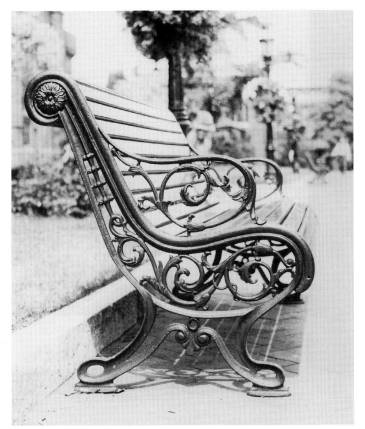

174

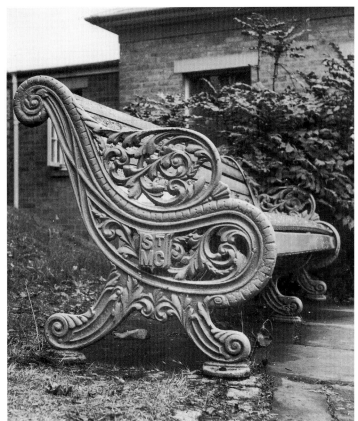

175

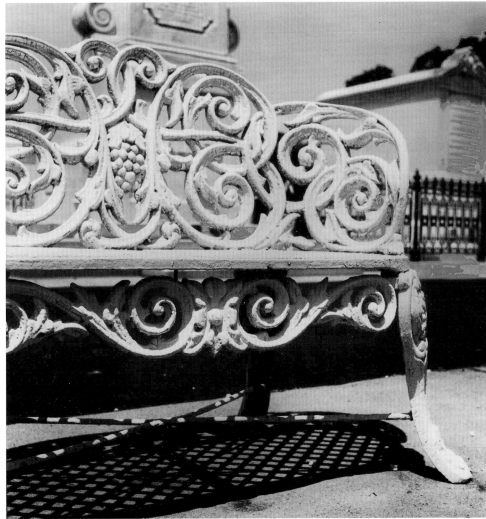

174. Glasgow, James Allen sen., 1867

175. Derby, Standard Manufacturing
Company, c. 1870

176. New York, J. W. Fiske, 1868

176

177

178

179

177. Rotherham, The Masbro Stove Grate Company, 1868

178. Rotherham, Wheathill Foundry William Owen, 1871

179. Rotherham, Morgan, Macauly & Waide, 1870

180

180. Falkirk, 1870

181. Coalbrookdale, 1873

181

182

183

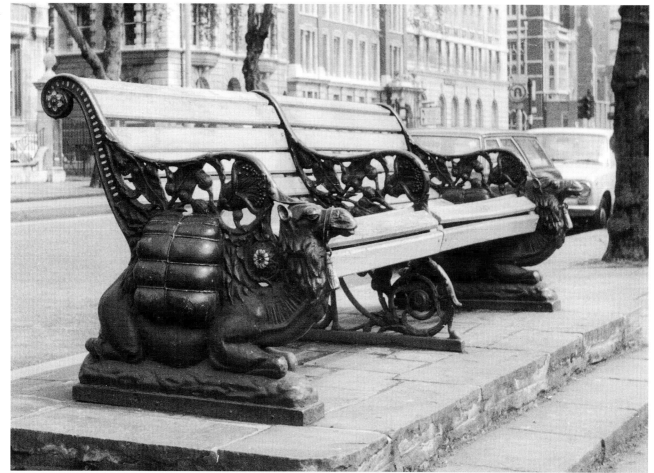

184

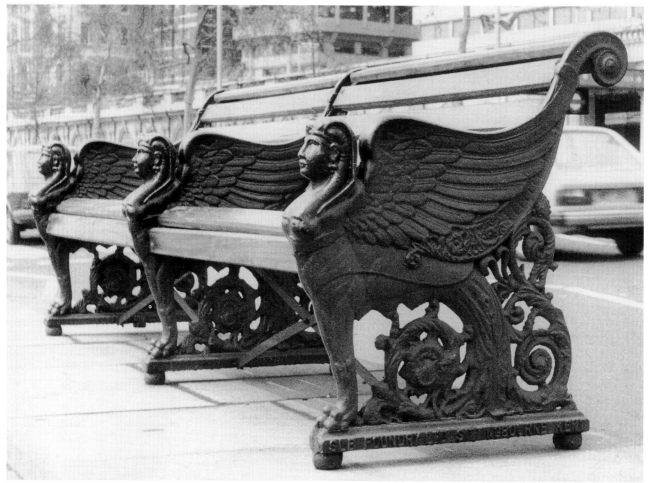

185

184. Westminster, J. D. Berry & Son, 1874    185. Sittingbourne, Kent, SLB Foundry, c. 1875

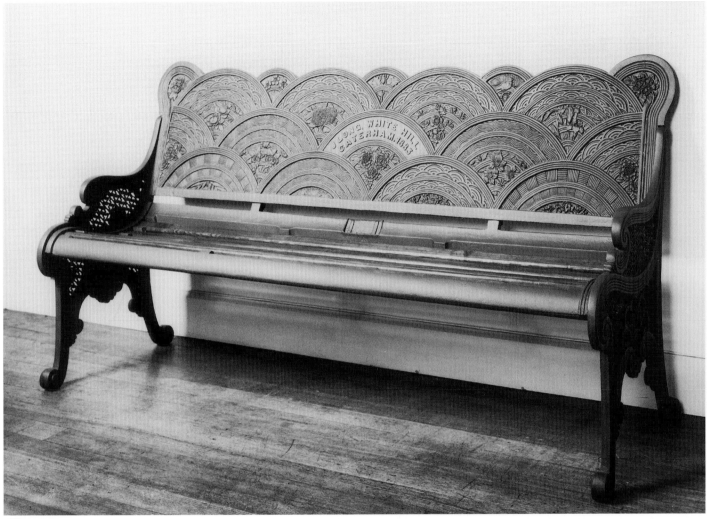

186

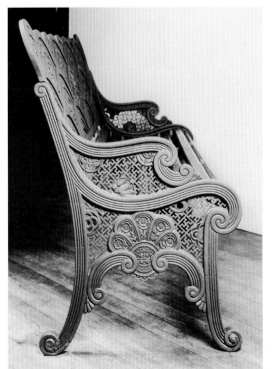

187

186. Norwich, Barnard, Bishop & Barnards, 1876

187. Seitenansicht der Parkbank von Abb. 186
*Side view of park bench shown in Pl. 186*

188. Detail der Lehne von der Parkbank der Abb. 186
*Detail of backrest of park bench shown in Pl. 186*

188

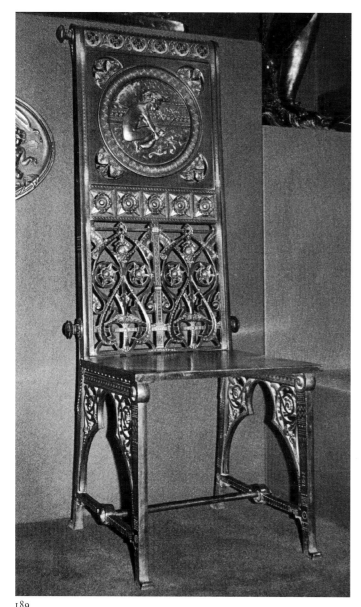

189

189. Coalbrookdale, c. 1875

190. England, 1887

191. Bayern, *Bavaria,* c. 1880/90

192. Rotherham, Yates, Haywood & Co., 1878

193. Larbert, Stirlingshire, Dobbie Forbes & Co., 1884

194. Frankreich, *France,* c. 1880

195. Frankreich, *France,* c. 1890

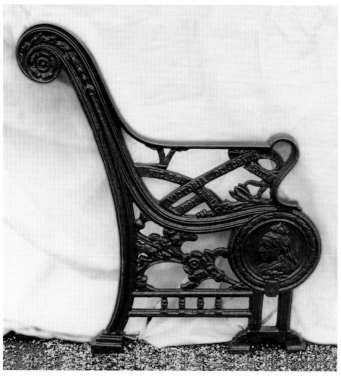

190

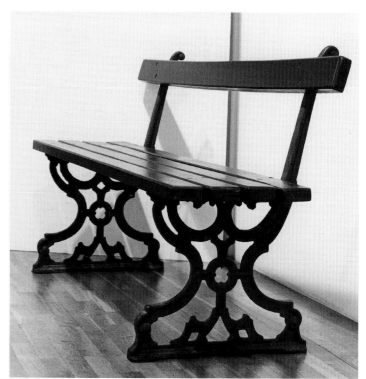

191

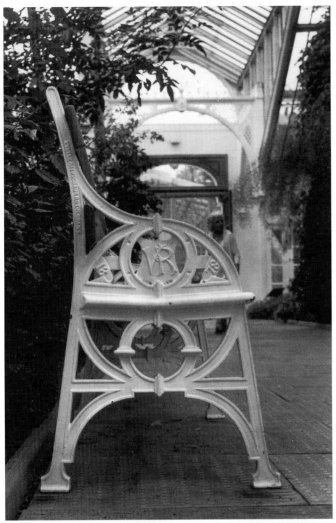

192

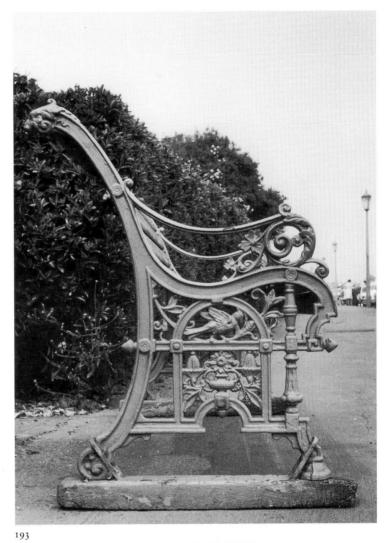

193

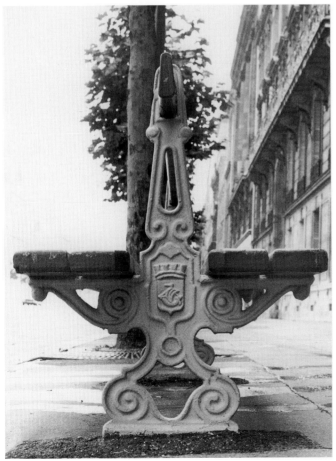

194

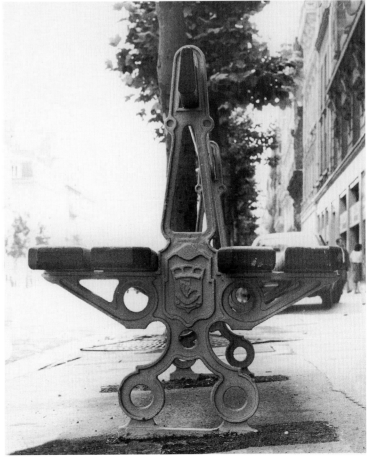

195

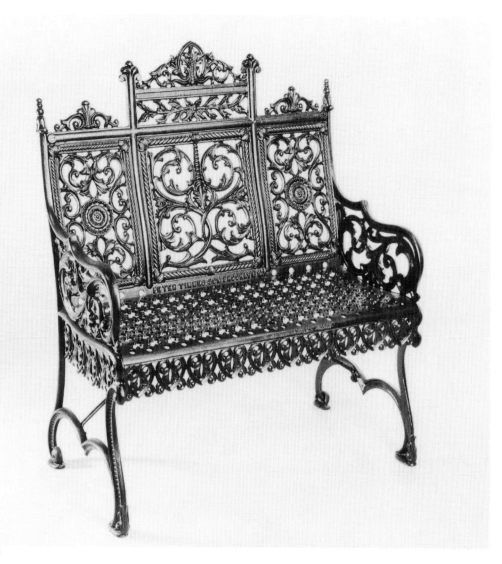

196

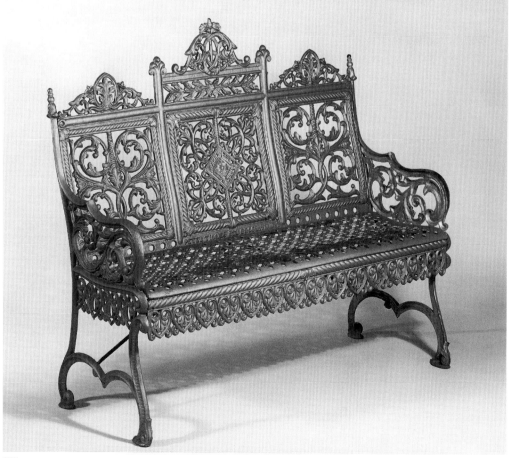

197

196. Brooklyn, Peter Timmes' Son, c. 1878/85

197. Brooklyn, Peter Timmes' Son, 1895

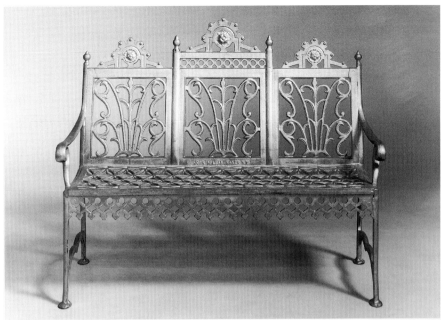

198

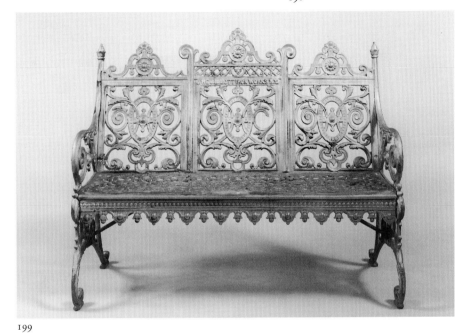

199

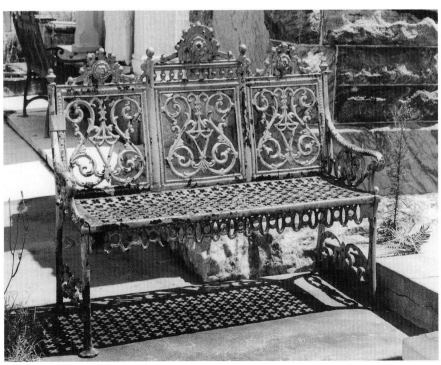

198. New York, John McLean, c. 1880

199. New York, J. L. Mott, c. 1880

200. Philadelphia, Wilhalm Adams, c. 1887/90

200

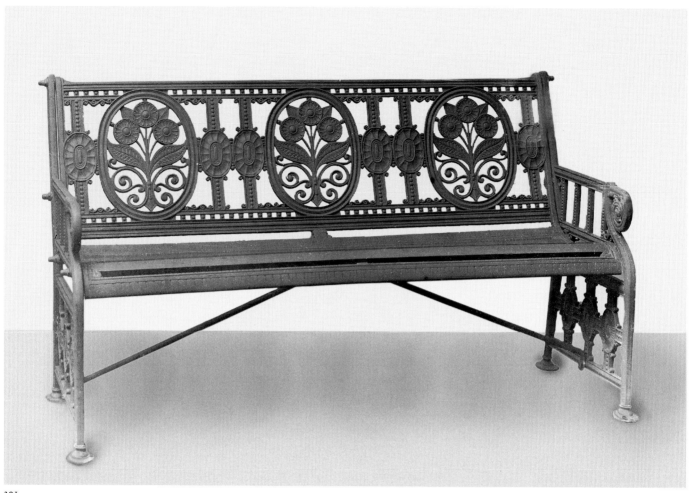

201

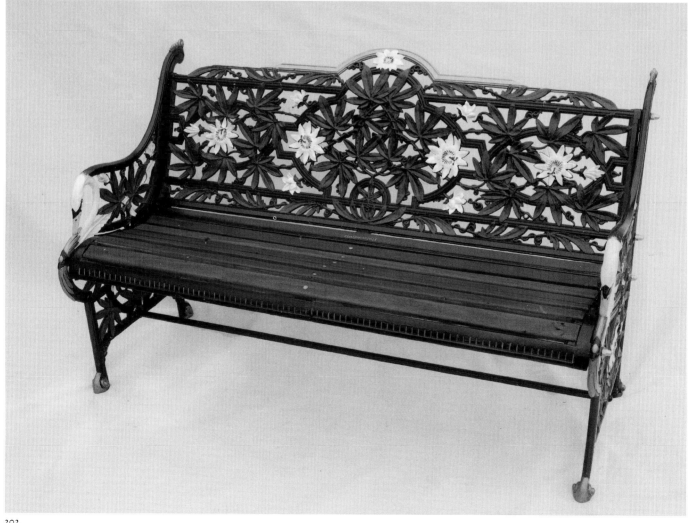

202

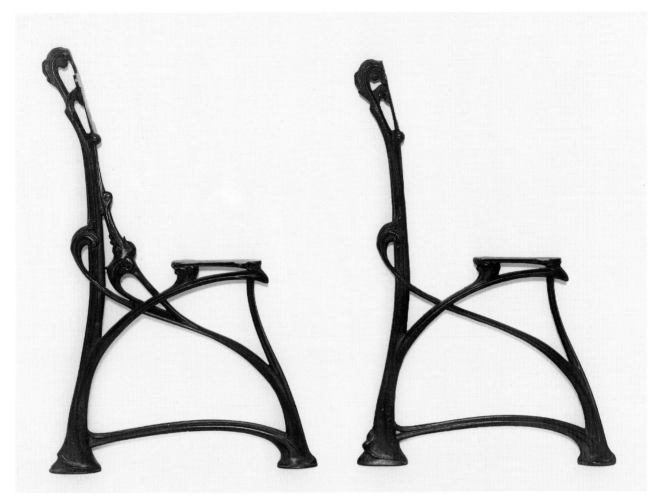

203

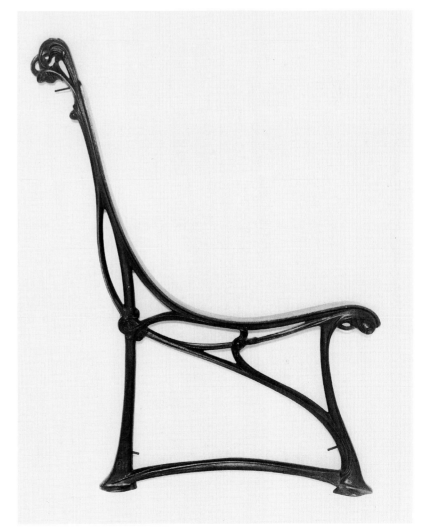

201. Coalbrookdale, 1883
202. Coalbrookdale, 1884

203, 204. Saint-Dizier, 1905/07

204

205

206

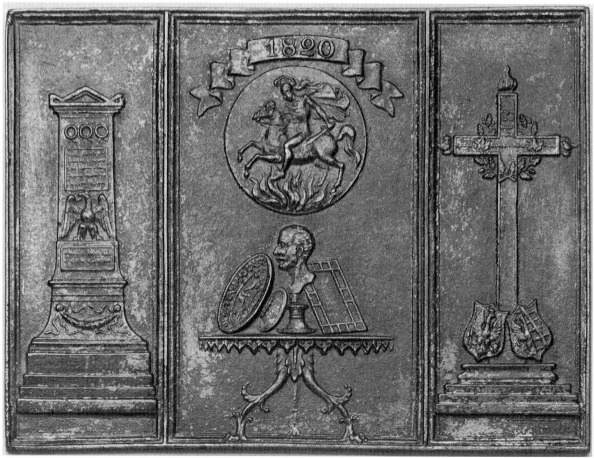

207

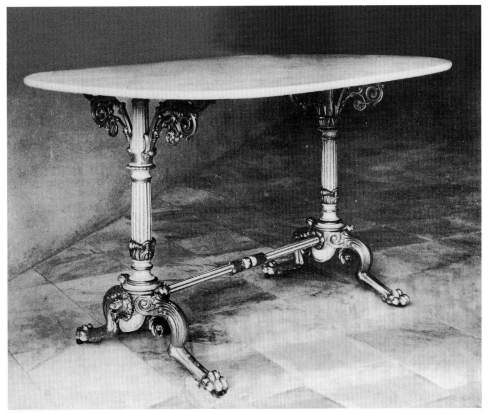

208

205. Liverpool, William Bullock, 1805/15

206. Berlin, c. 1825

207. Berlin, Neujahrsplakette für 1820
*Berlin, New Year's plaque for 1820*

208. Berlin, c. 1831

209. Berlin, c. 1830

210. Berlin, c. 1831

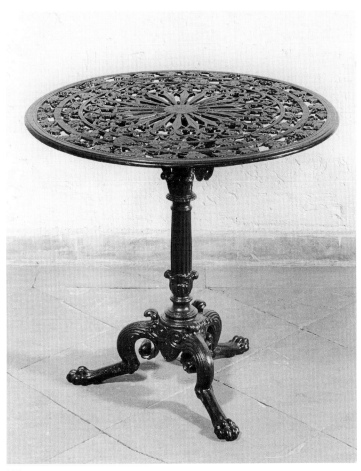

209

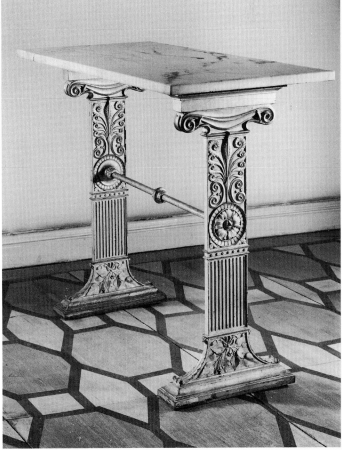

210

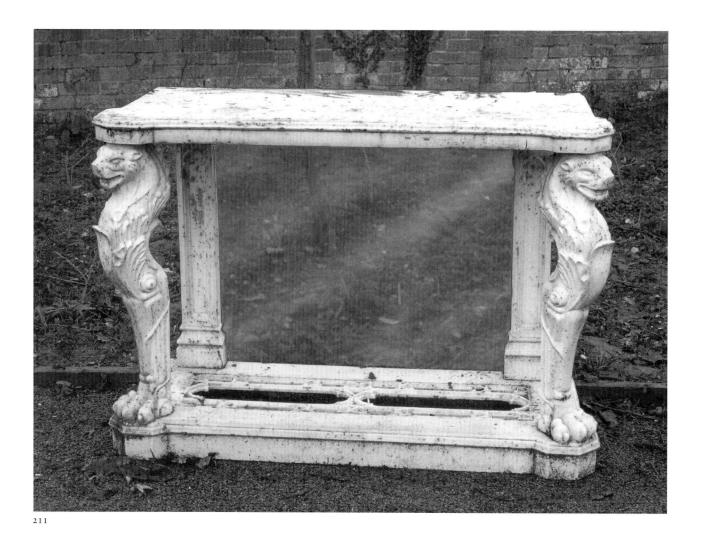

211

211. England oder Schottland, *England or Scotland,* c. 1835     213. Philadelphia, Robert Wood, c. 1850

212. Rotherham, Yates, Haywood & Co., 1851

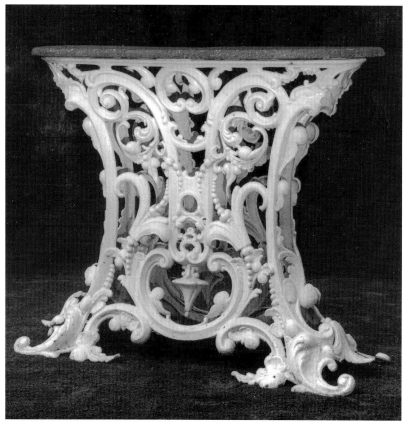

212

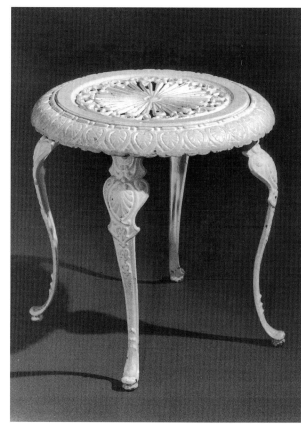

213

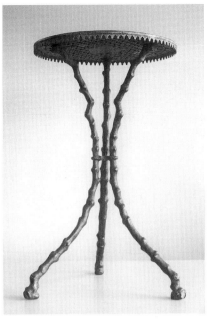

214

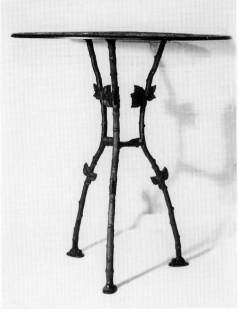

215

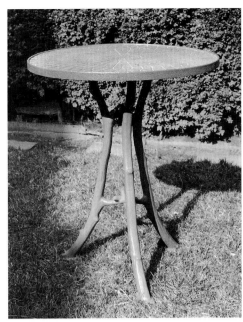

216

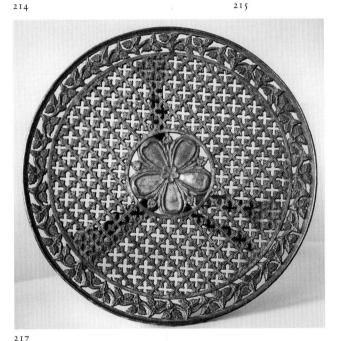

217

214. Lauterberg im Harz, c. 1850

215. Isselburg, c. 1845/50

216. Güstrow, c. 1845/50

217. Platte des Tisches der Abb. 214
*Top of table shown in Pl. 214*

218. Horowitz, c. 1830/40

219. Coalbrookdale, 1845

220. New Orleans, Hinderer's Iron Works, c. 1845/50

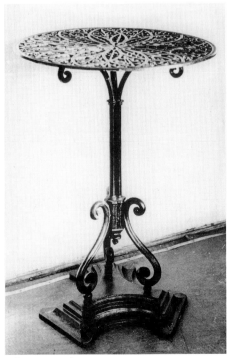

218

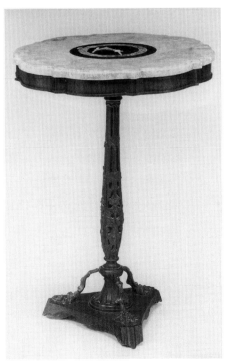

219

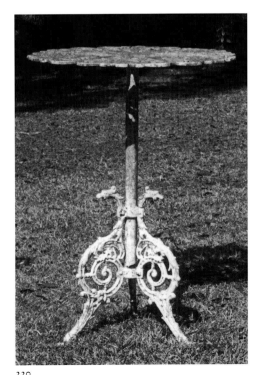

220

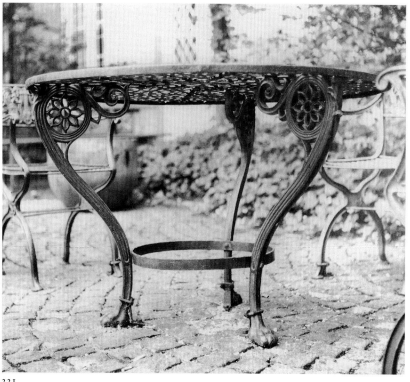

221

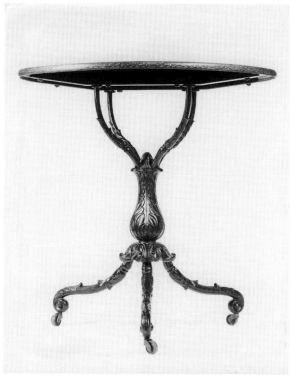

222

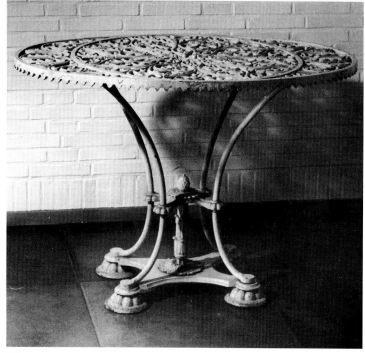

223

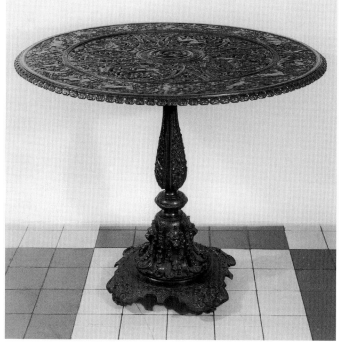

224

221. Berlin (?), 1835     222. Troy, NY, Noyes & Hutton (?), c. 1845

223. Rendsburg, c. 1845     224. Wasseralfingen, c. 1850

225. Wasseralfingen, c. 1850

226. Detail der Platte vom Tisch der Abb. 224
*Detail of top of table shown in Pl. 224*

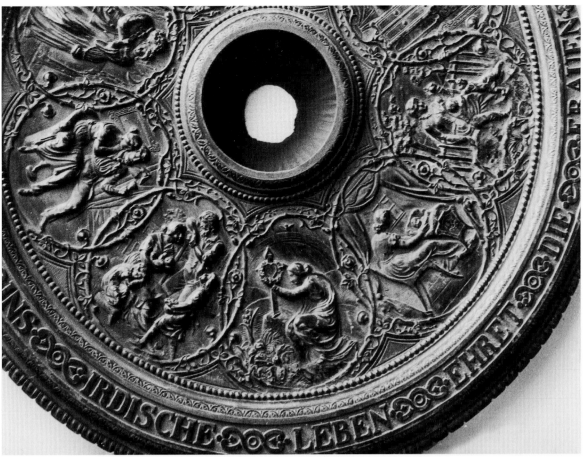

225

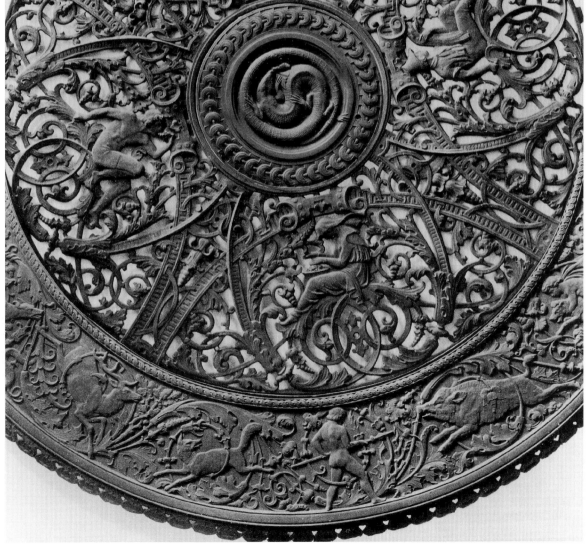

226

227

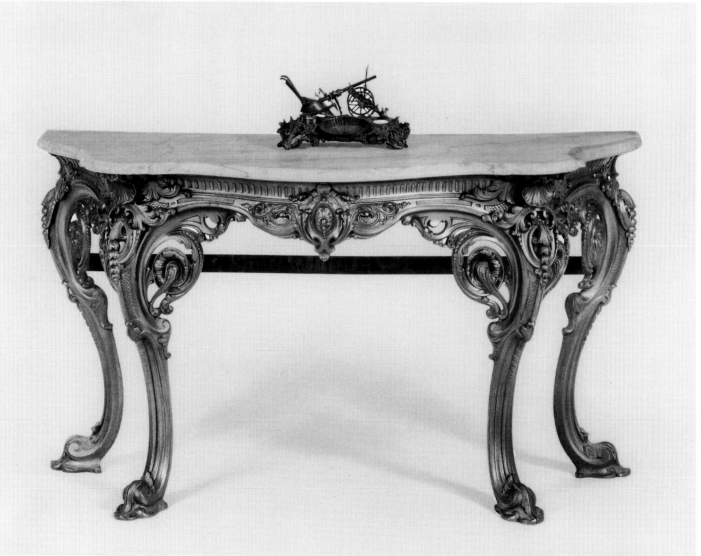

228

227. Coalbrookdale, 1855

228. Rotherham, Yates, Haywood & Co., 1854

229. Coalbrookdale, c. 1855

230. Coalbrookdale, 1855

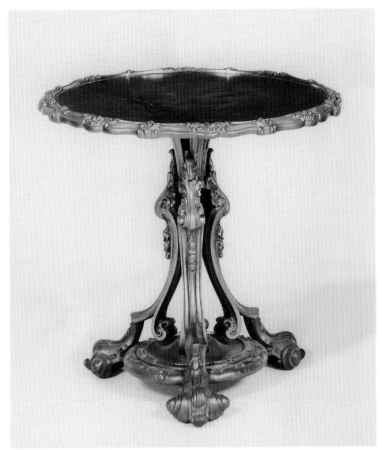

229

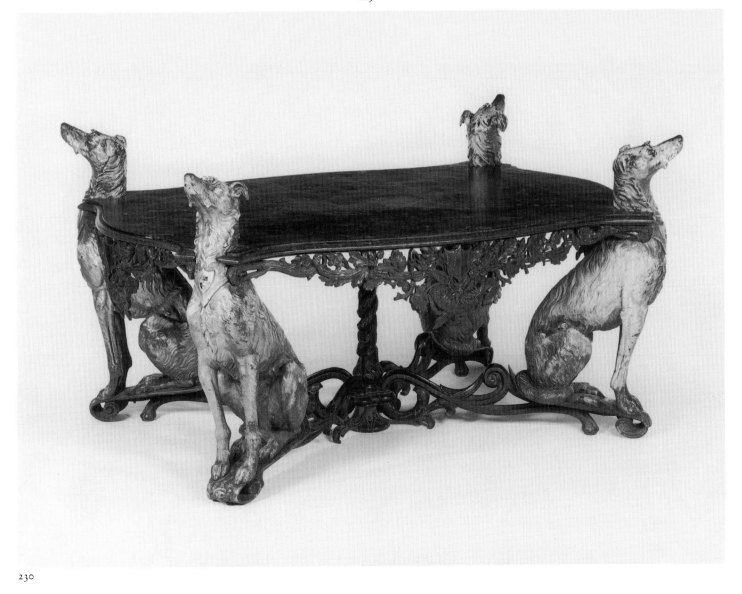

230

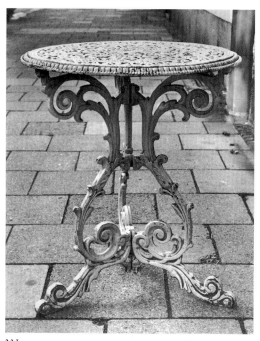

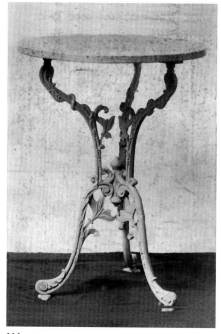

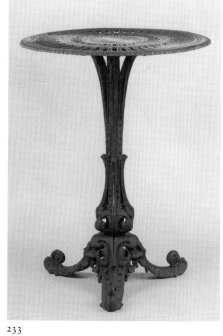

231

232

233

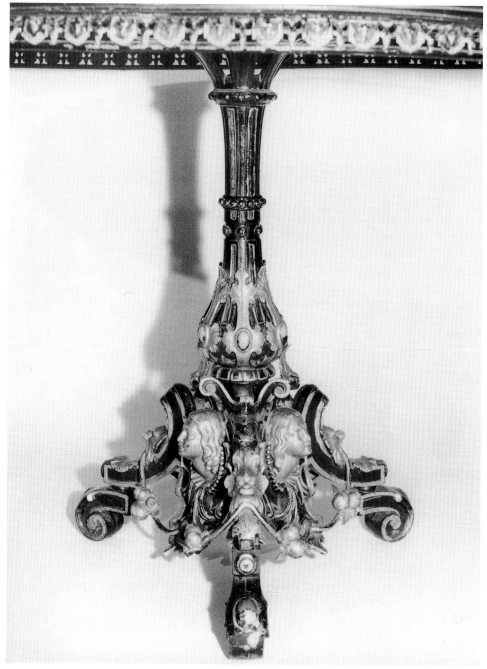

231. England oder Schottland, *England or Scotland,* c. 1855

232. Coalbrookdale, c. 1855

233. Oslo (Christiania), O. Mustad & Søn, c. 1860

234. Steiermark (?), *Styria (?),* c. 1855/60

234

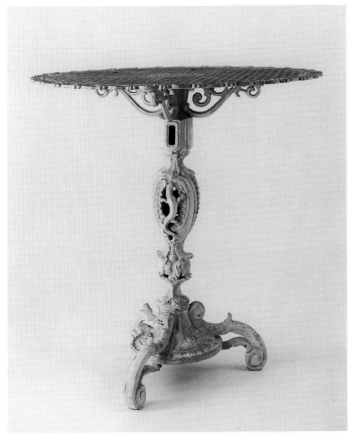

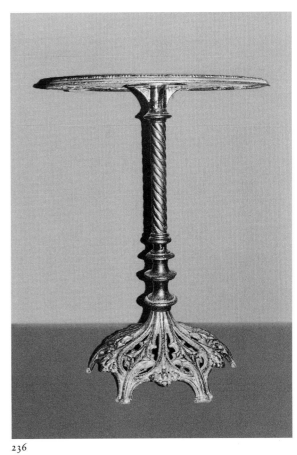

235

236

235. 's Gravenhage, L. I. Enthoven & Co., c. 1855   236. Rotherham, Yates, Haywood & Drabble, 1856

237. 's Gravenhage, L. I. Enthoven & Co., c. 1850/60   238. Stockholm, J. & C. G. Bolinder, 1856

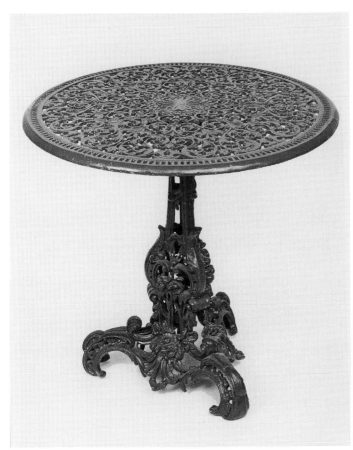

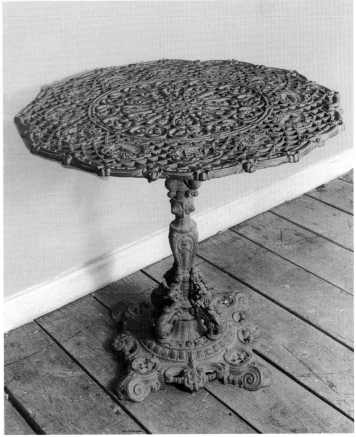

237

238

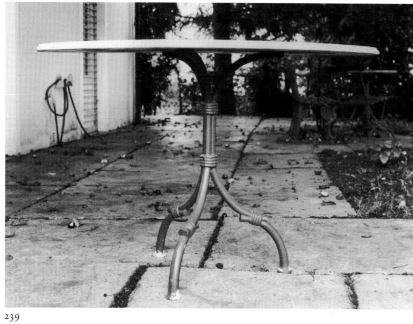

239

239. Böhmen (?), *Bohemia (?)*, c. 1860
240. Solothurn, c. 1865
241. Mägdesprung, 1865
242. New Orleans (?), c. 1860
243. Gleiwitz, c. 1860

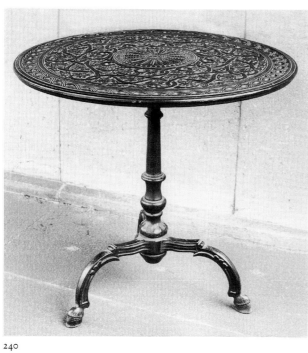
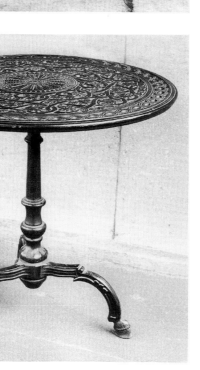

240

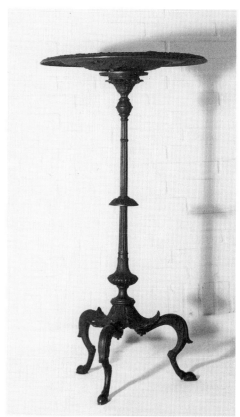

241

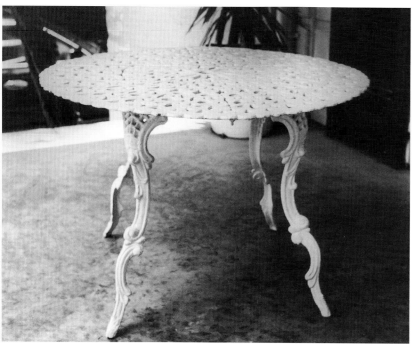

242

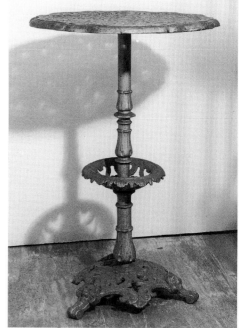

243

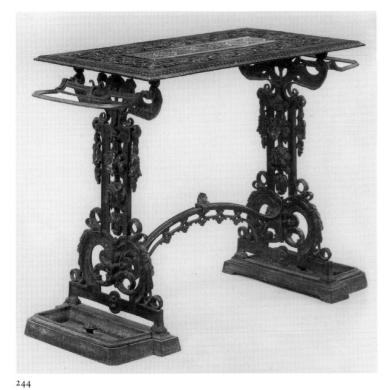

244

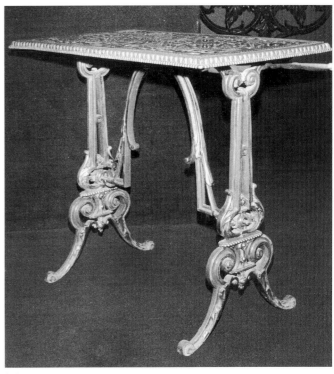

245

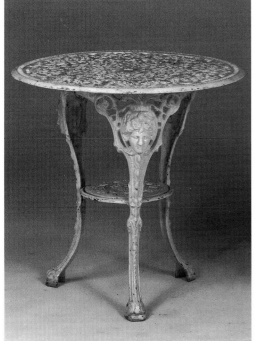

244. Birmingham, Henry Crichley & Co., 1864

245. Coalbrookdale, 1865

246. England oder Schottland, *England or Scotland*, c. 1860/70

247. Coalbrookdale, 1862

248. Bradford, Lund & Reynolds, c. 1855/60

246

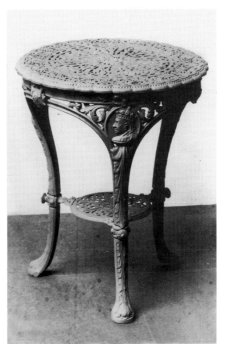

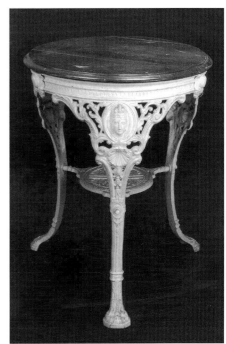

247

248

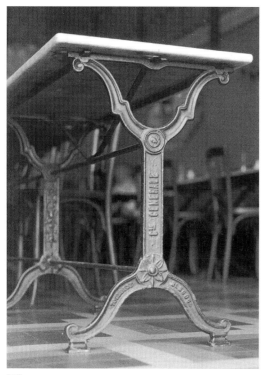

249

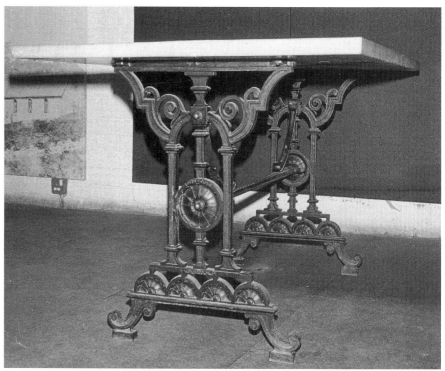

250

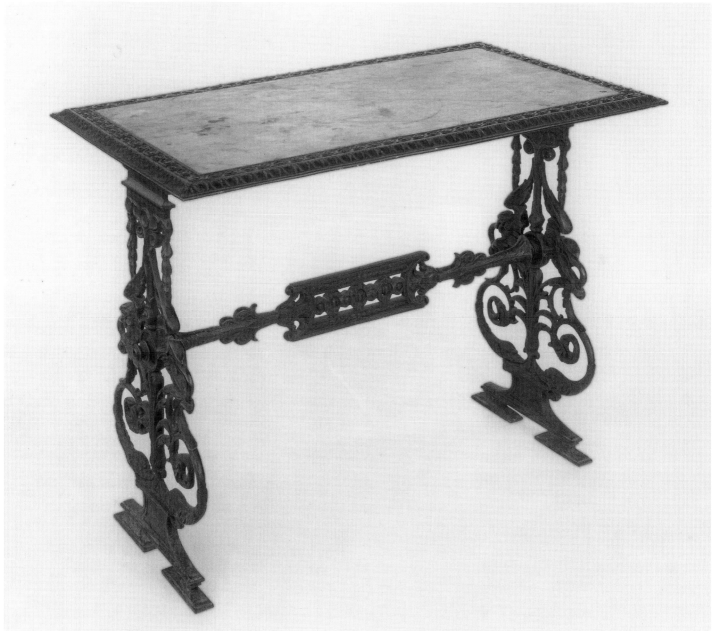

251

249. Toulouse, c. 1880/90

250. Coalbrookdale, c. 1865/70

251. Sheffield, Henry E. Hoole & Co., c. 1857

252. England oder Schottland, *England or Scotland*, c. 1875

253. Deutschland, *Germany*, c. 1875

254. Blansko, c. 1875

255. Hof in Krain, c. 1895

256. Gleiwitz, c. 1890

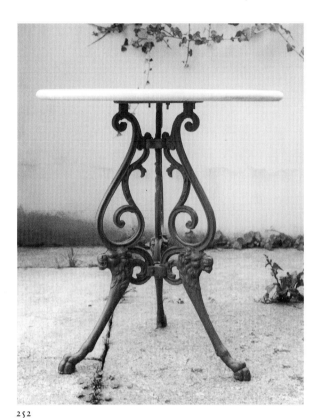

252

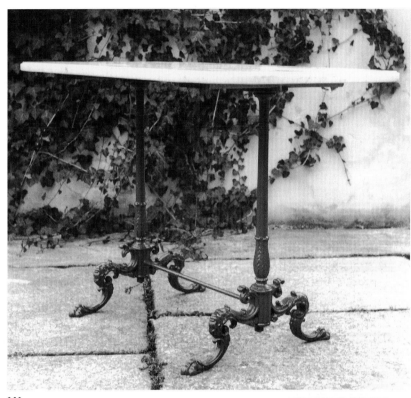

253

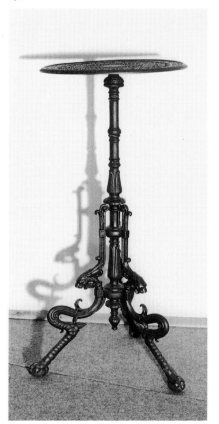

254

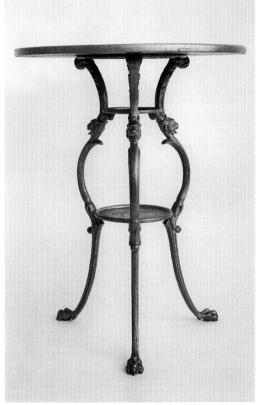

255

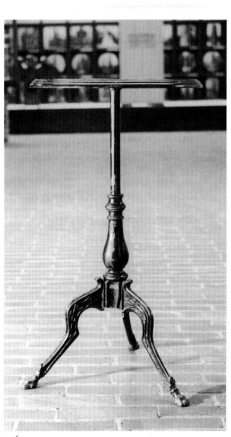

256

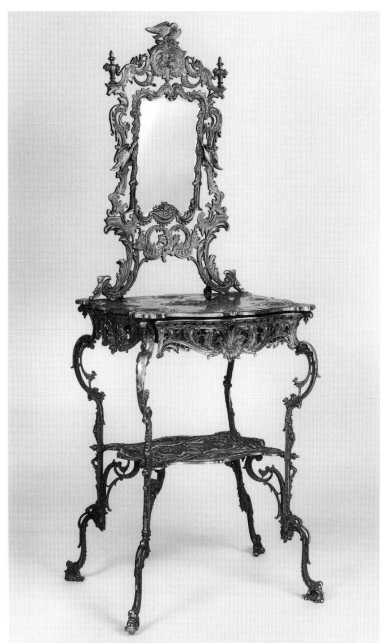

257

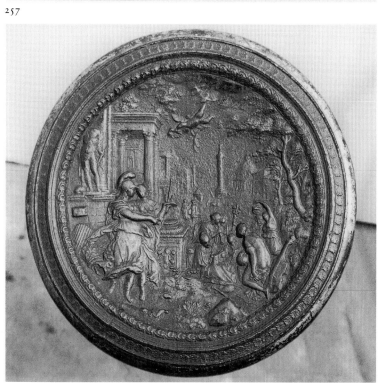

258

257. Mägdesprung, c. 1895

258. Platte des Tisches von Abb. 259
*Top of table shown in Pl. 259*

259. Gleiwitz, c. 1890

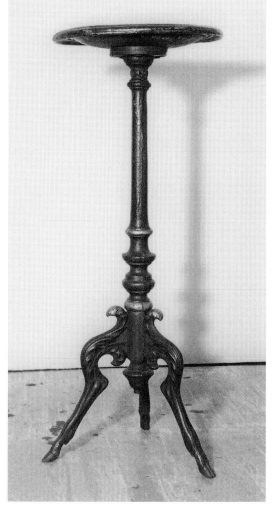

259

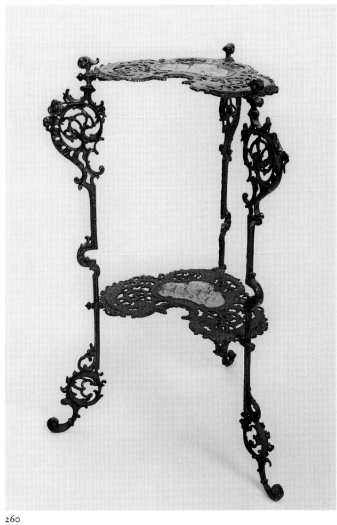

260

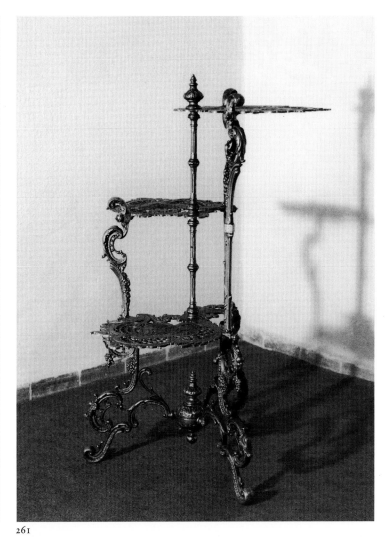

261

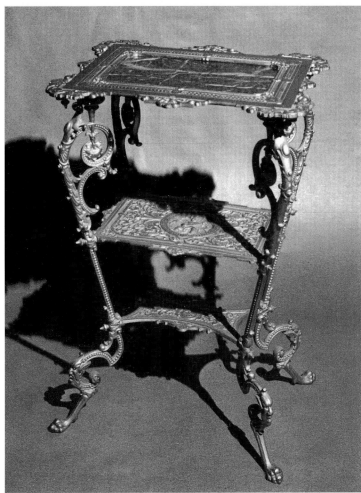

262

260. Niederlande, *The Netherlands,* c. 1880/90

261. Blansko, c. 1890

262. Mägdesprung, c. 1890

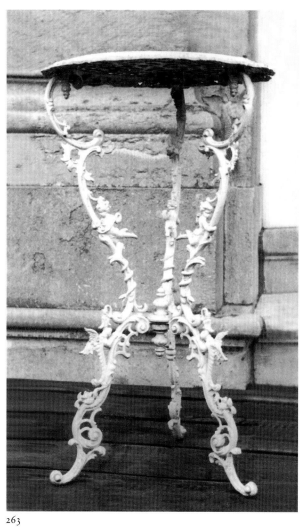

263

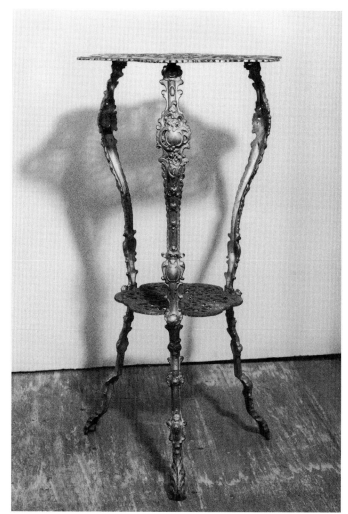

264

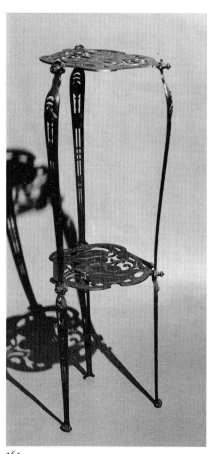

265

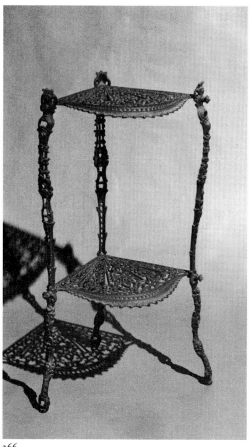

266

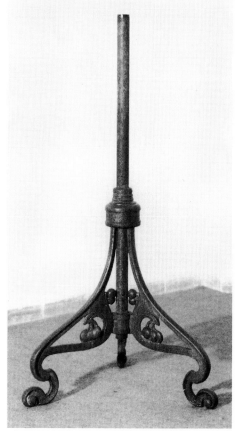

267

263. Niederlande, *The Netherlands,* c. 1880/90

264. Mägdesprung, c. 1890

265. Mägdesprung, c. 1900

266. Mägdesprung, c. 1890

267. Blansko, c. 1905

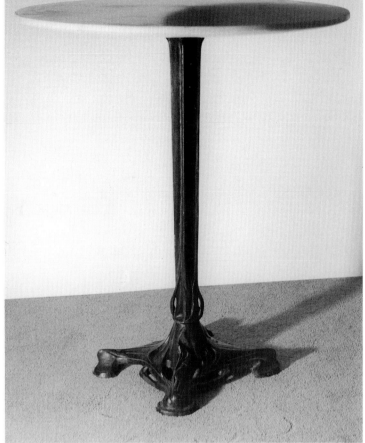

269

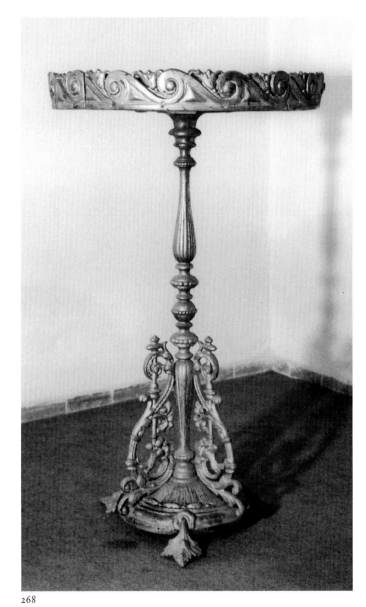

268

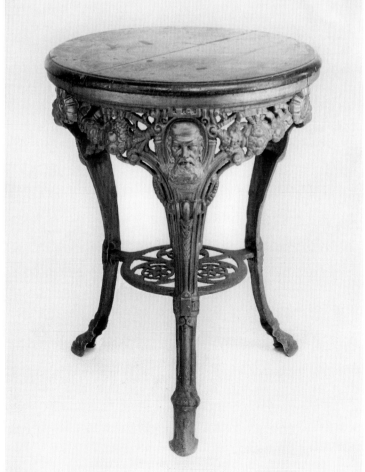

270

268. Blansko, c. 1895

269. Saint-Dizier, c. 1905

270. England oder Schottland, *England or Scotland,* c. 1900

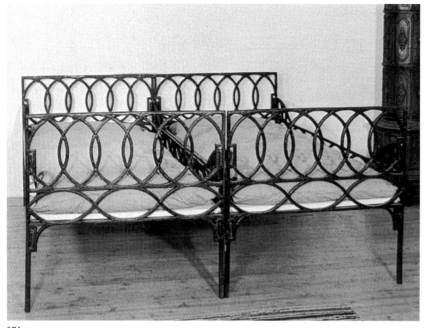

271

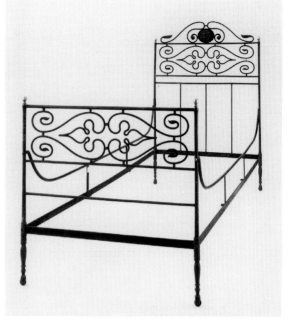

272

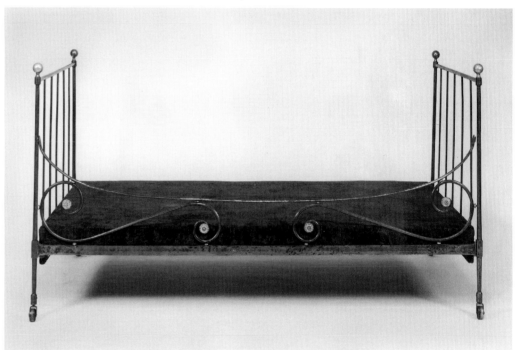

273

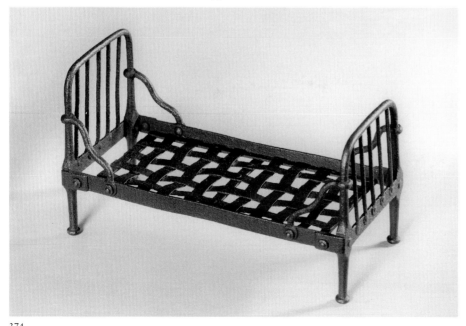

274

271. Mariazell, c. 1800
272. England/USA, c. 1850/55
273. Frankreich, *France,* c. 1810
274. Frankreich, *France,* c. 1820/50

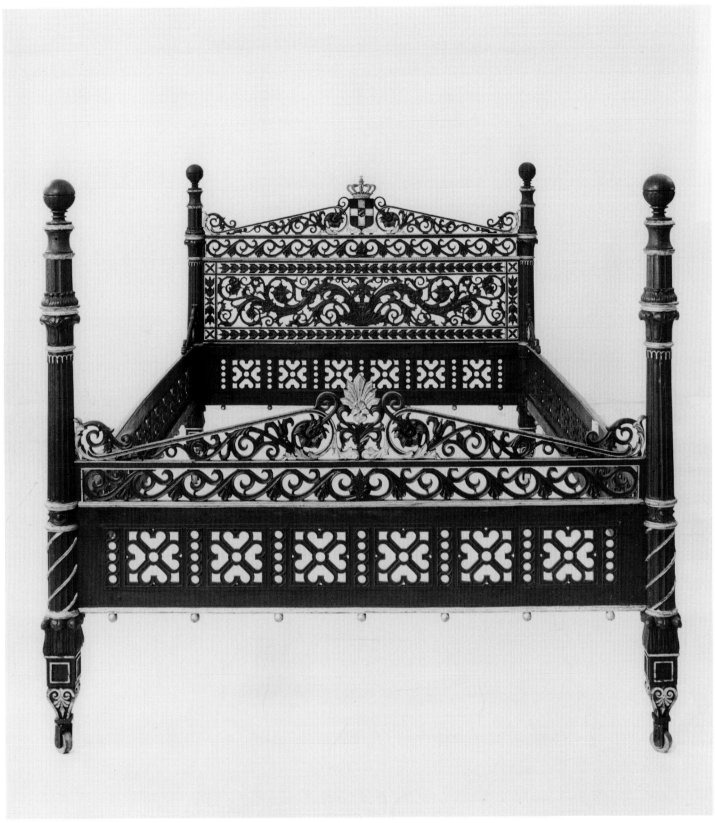

275

275. Oberpfalz, *Upper Palatinate*, 1832

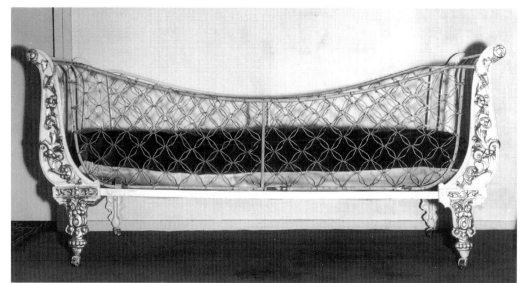

276

276. 's Gravenhage, De Prins van Oranje, c. 1840

277, 278. Frankreich, *France,* c. 1840

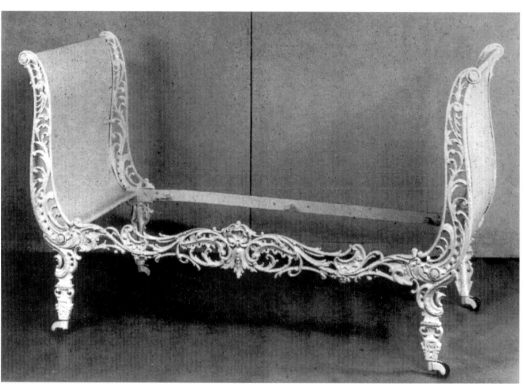

277

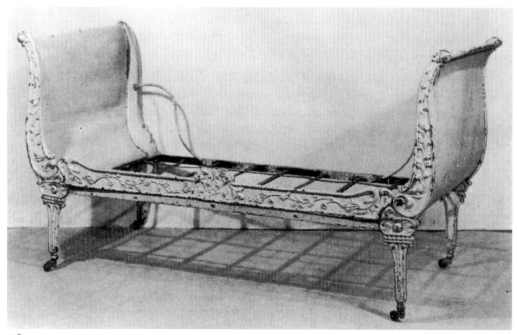

279. 's Gravenhage, L. I. Enthoven, c. 1850

280. Ruszkábánya (?), c. 1840

278

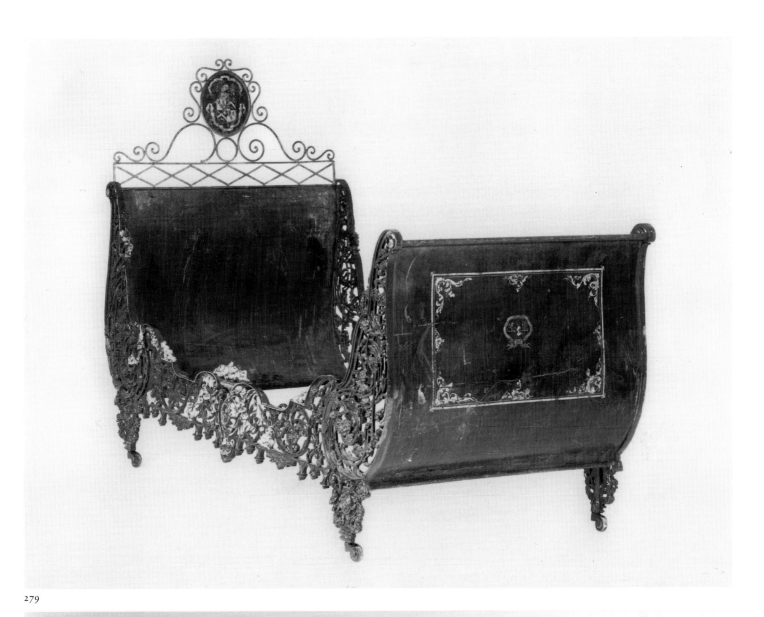

279

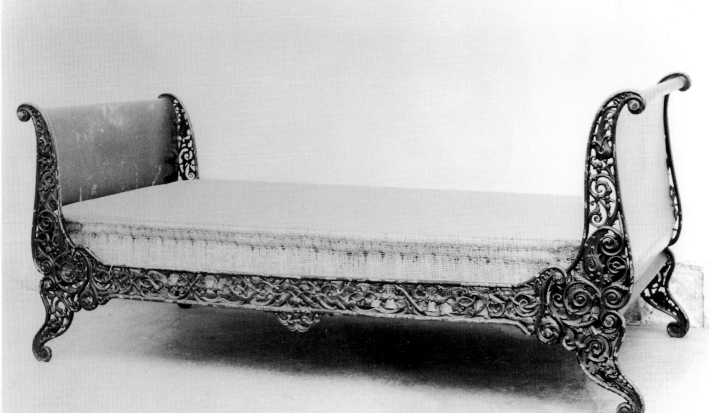

280

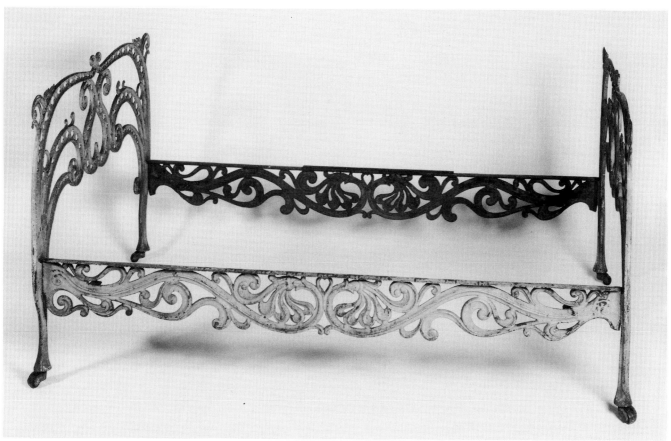

281

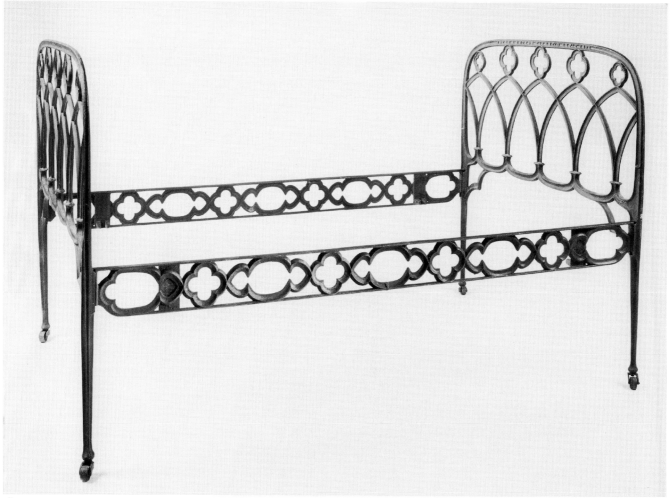

282

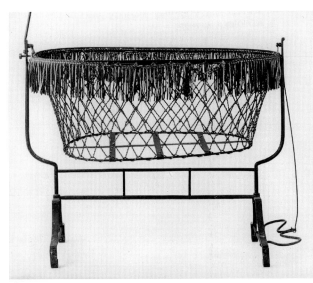

283

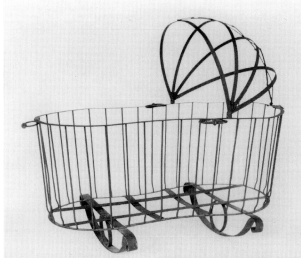

284

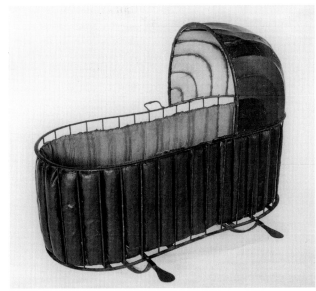

286

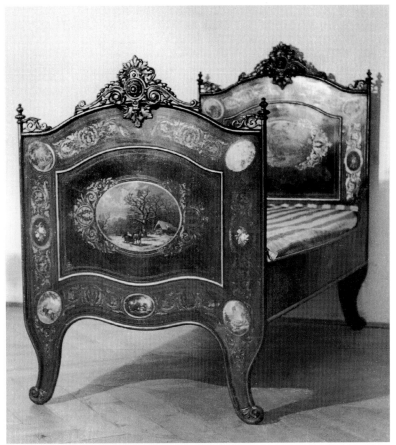

285

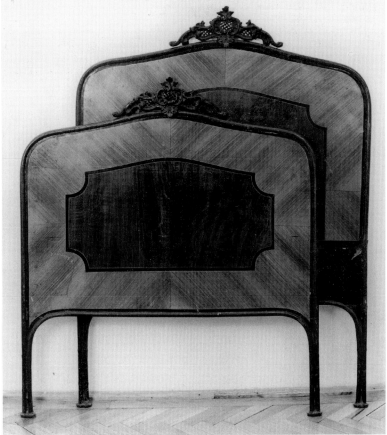

287

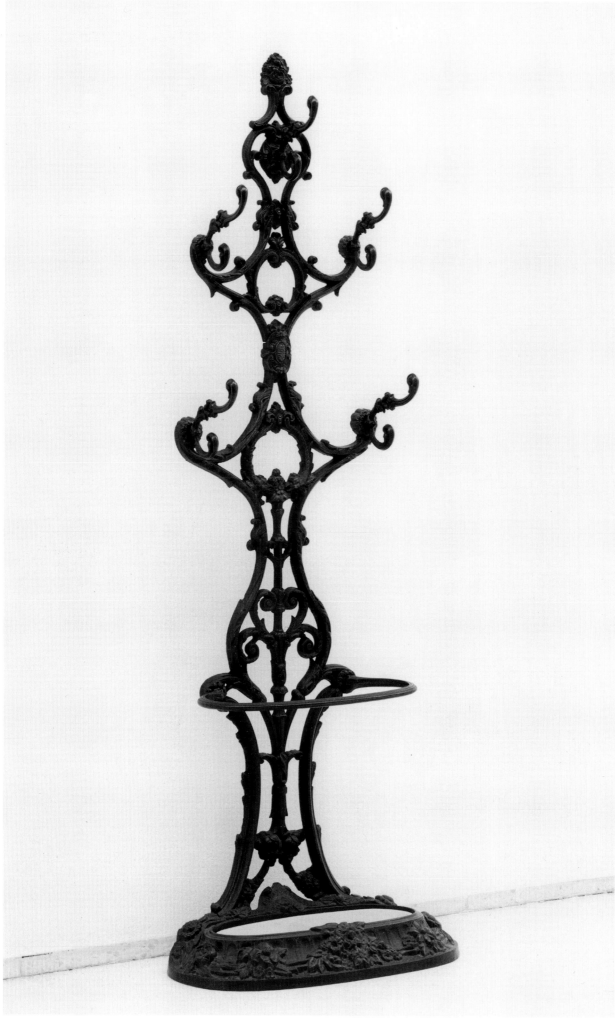

288

288.  Charleville, Corneau Frères, c. 1850/55

289.  Rotherham, Yates, Haywood & Co., 1854

290.  Boston, Chase Brothers & Co., c. 1850/55

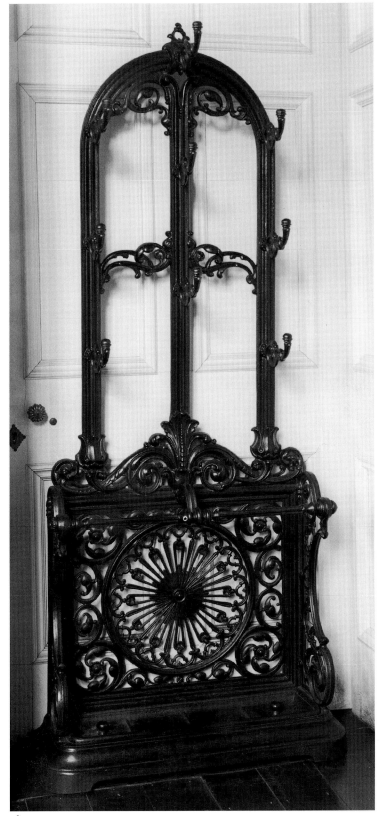

289

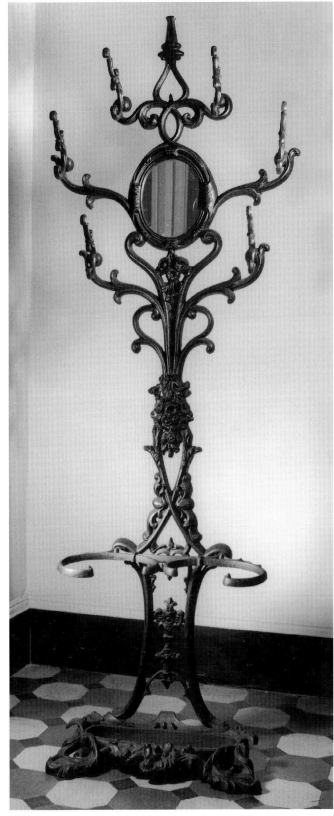

290

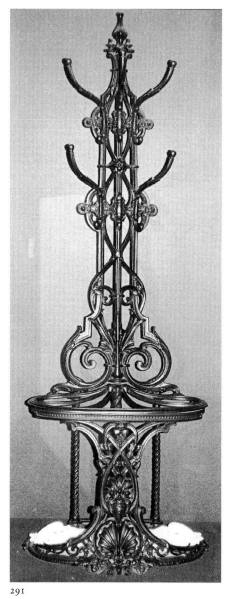

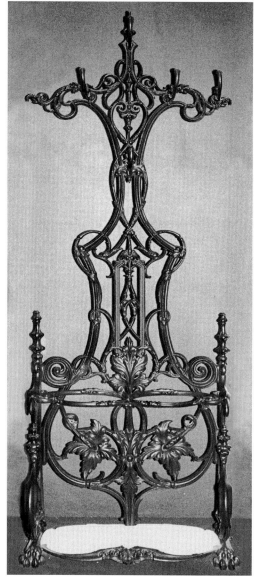

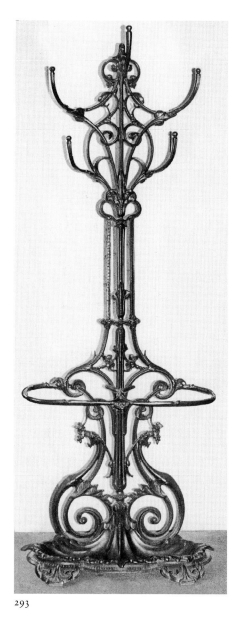

291

292

293

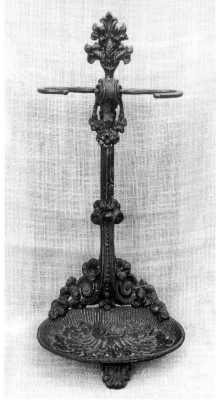

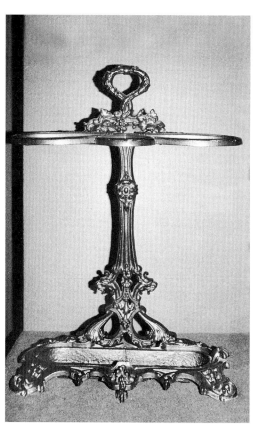

294

295

291. Coalbrookdale, 1855

292. Coalbrookdale, 1853

293. Coalbrookdale, 1855

294. Lünen, c. 1845

295. Coalbrookdale, 1846

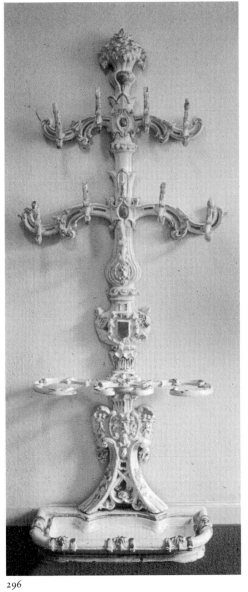

296

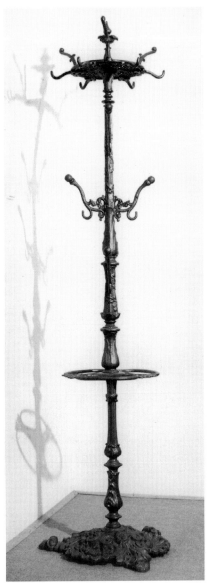

297

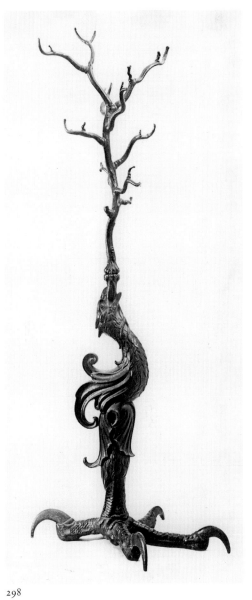

298

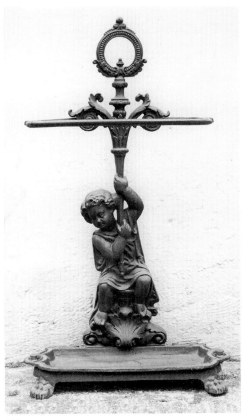

299

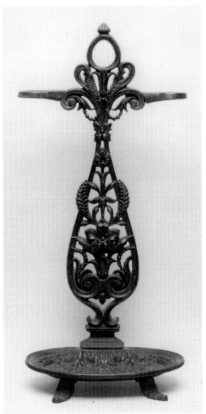

300

296. 's Gravenhage, L. I. Enthoven & Co.,
c. 1855/60

297. Blansko, c. 1860

298. Ungarn, *Hungary*, c. 1855

299. Solothurn, c. 1860

300. Lauchhammer, c. 1850

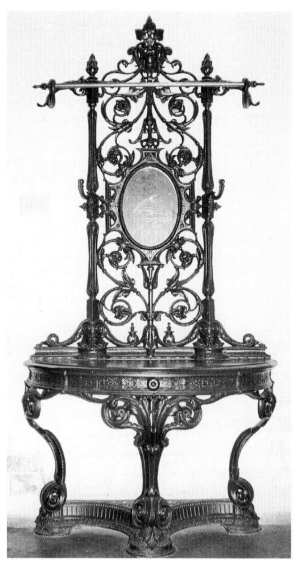

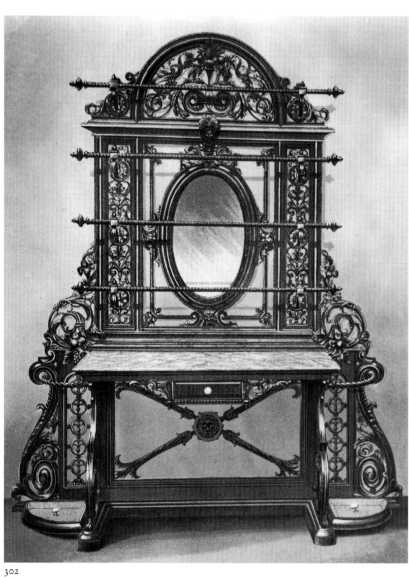

301

302

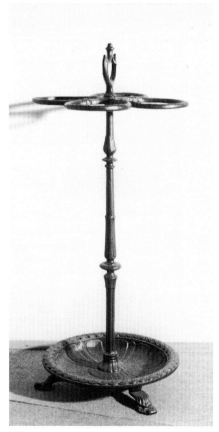

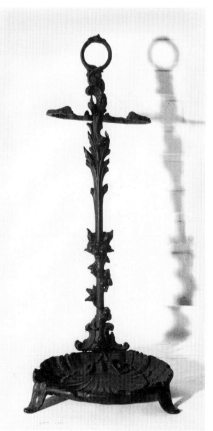

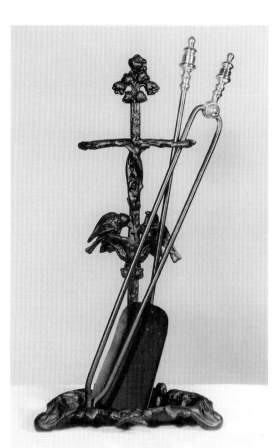

303

304

305

301. Coalbrookdale, 1859

302. London, Yates, Haywood
& Drabble, 1861

303. Blansko, c. 1860

304. Rendsburg, c. 1850

305. USA, c. 1855

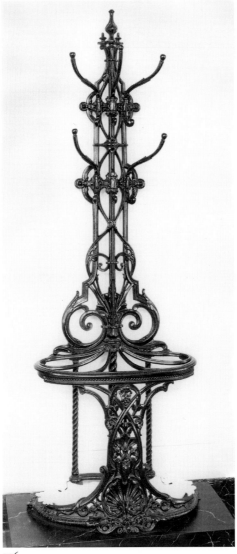

306

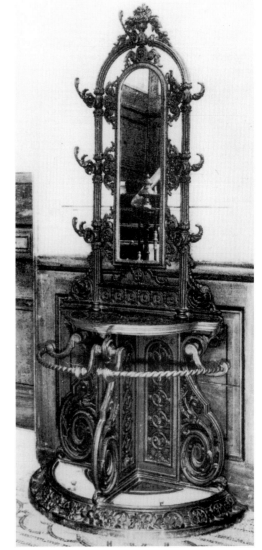

307

306. Coalbrookdale, 1862

307. Rotherham, Yates, Haywood &
Drabble, 1861

308, 309. Blansko, c. 1860

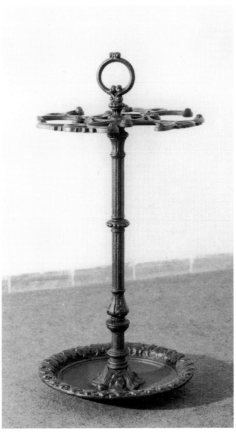

308

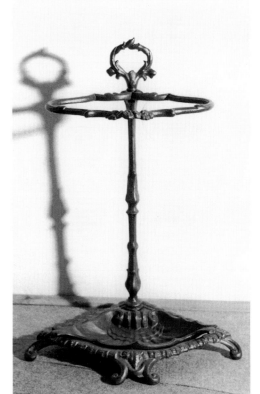

309

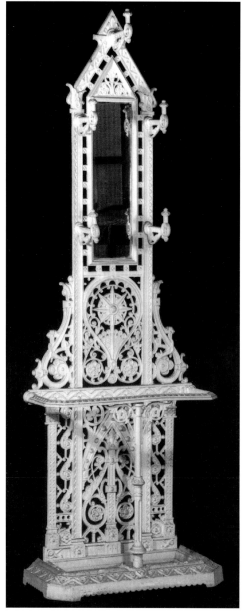

310

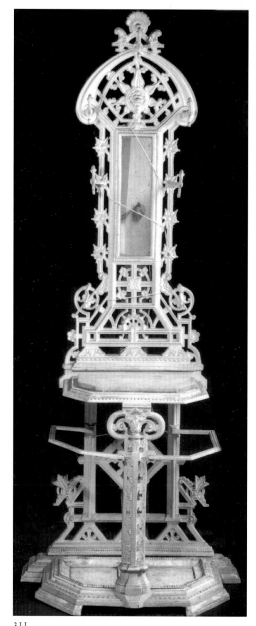

311

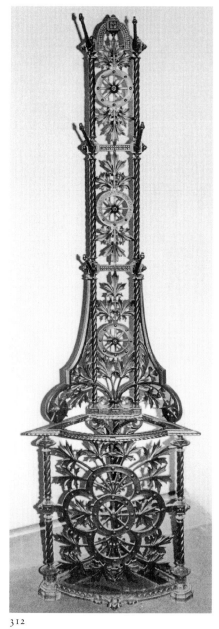

312

313

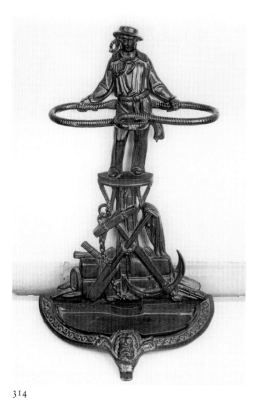

314

310. Falkirk, c. 1860/65

311. Birmingham, J. & C. Lawrence, 1876

312. Coalbrookdale, 1866

313. Lünen, c. 1860

314. Lünen, c. 1865

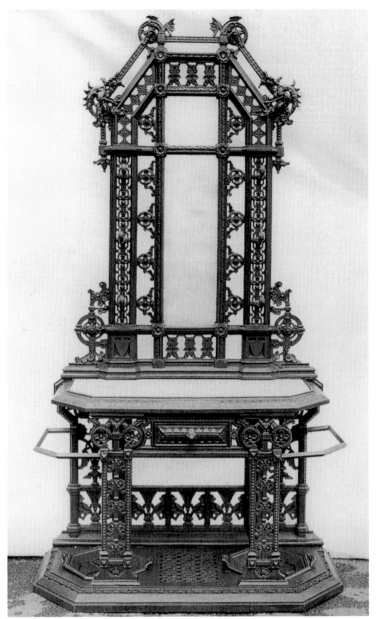

315

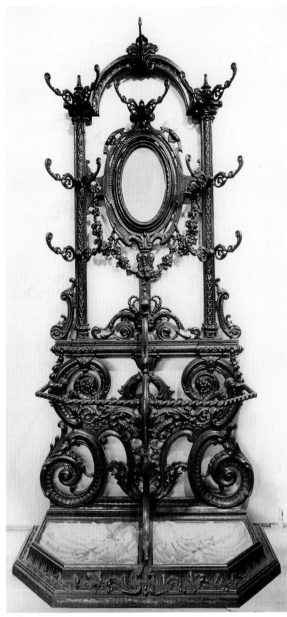

316

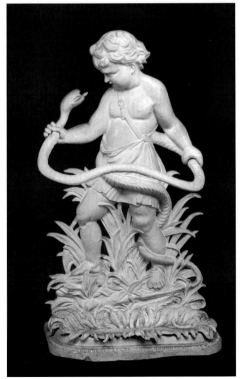

317

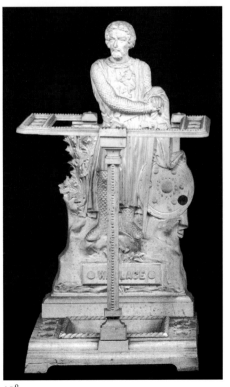

318

315. Coalbrookdale, 1874

316. 's Gravenhage, L. I. Enthoven
& Co., c. 1865

317. Sheffield, Edwin & Theophilus
Smith, 1866

318. Schottland, *Scotland,* c. 1865/70

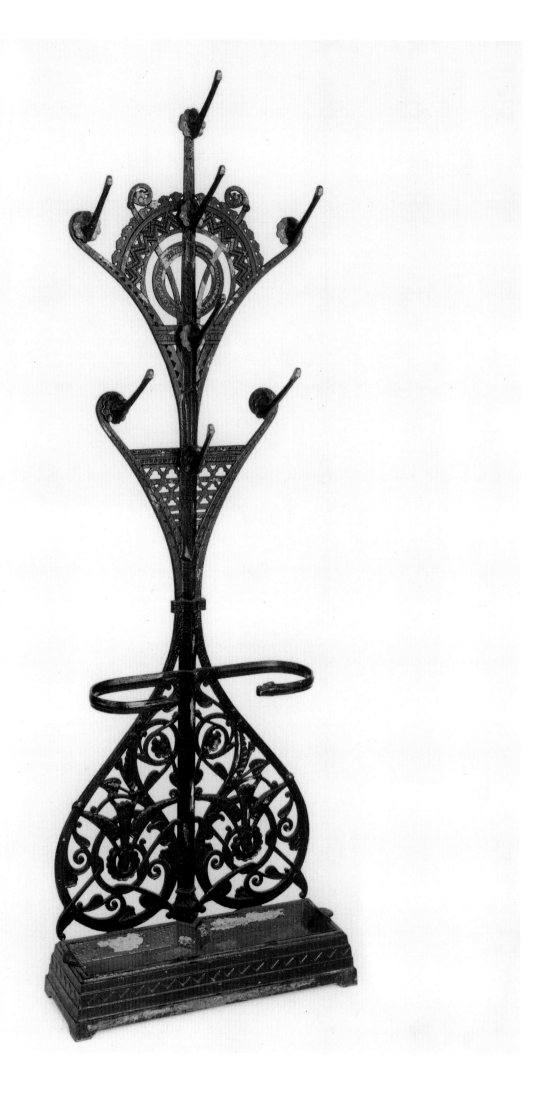

319. Coalbrookdale, 1867

320. Coalbrookdale, 1872
321. Coalbrookdale, 1867
322. Birmingham, Charles Hufton, 1869
323. Dudley, John Finch, 1877

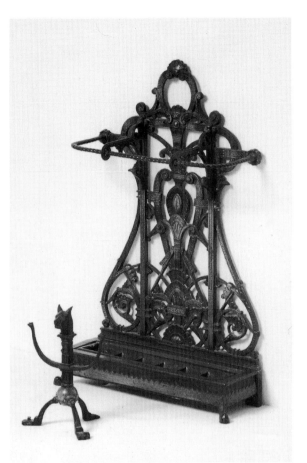

320

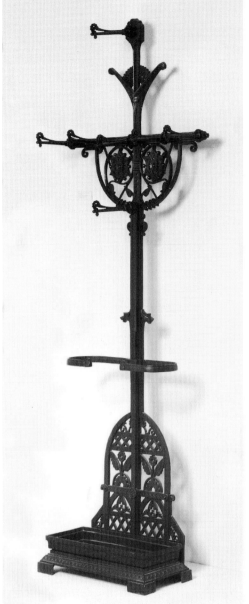

321

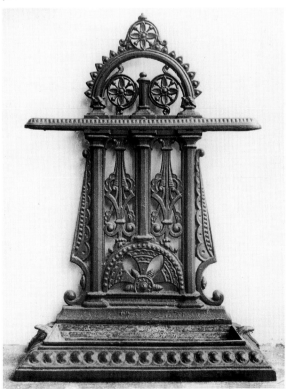

322

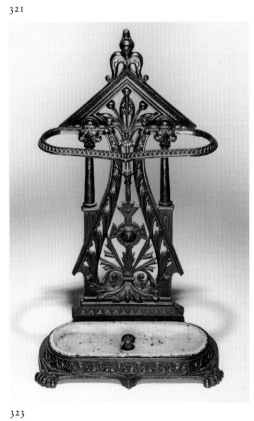

323

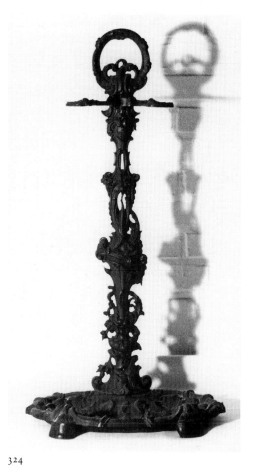

324

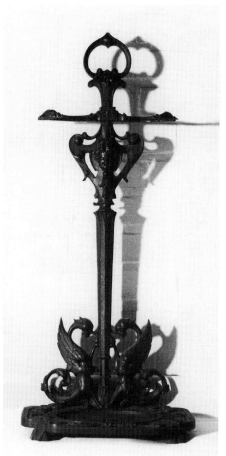

325

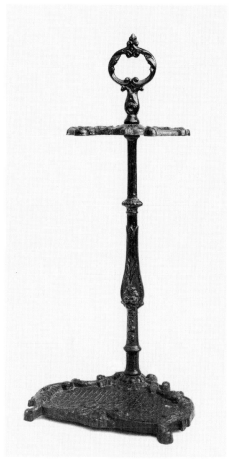

326

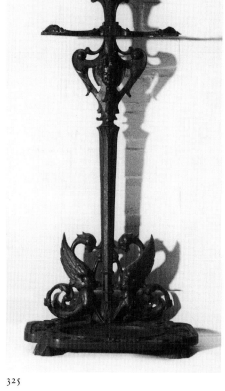

327

328

324. Rendsburg, c. 1880

325. Rendsburg, c. 1870/75

326. Val d'Osne (?), c. 1880

327. London, O'Brien, Thomas & Co.,
c. 1850/55

328. Rotherham, W. H. Micklethwait & Co.,
1874

329. Gleiwitz, c. 1880/90

330. Rendsburg, c. 1880

331. Rotherham, W. H. Micklethwait & Co.,
1880

332. Mägdesprung, c. 1900

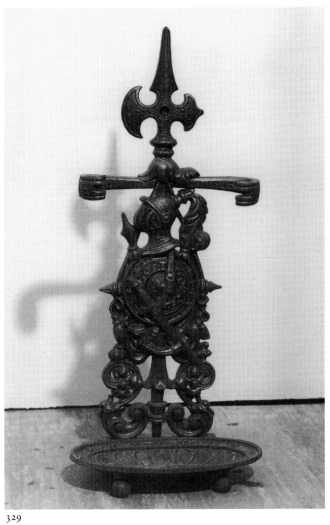

329

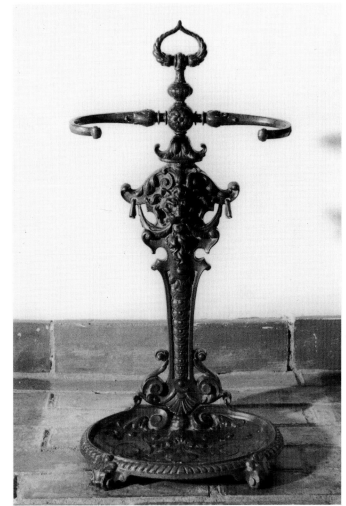

330

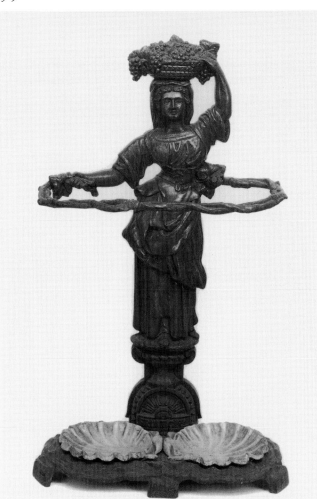

331

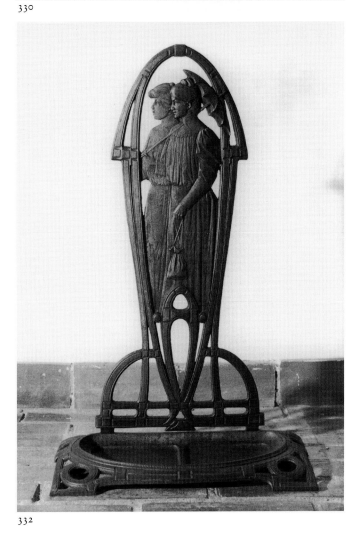

332

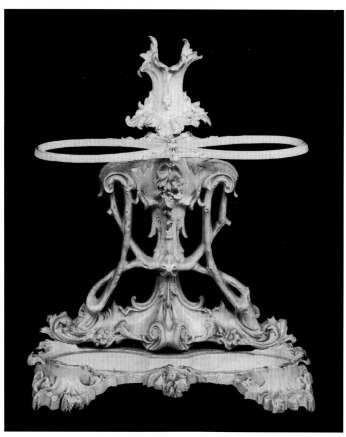

333

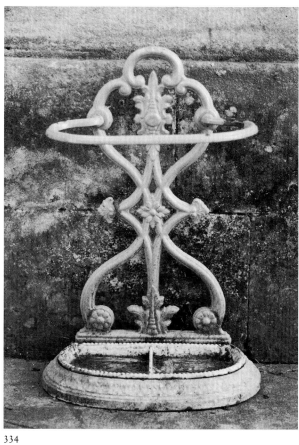

334

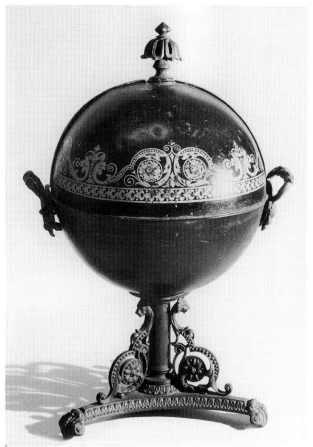

335

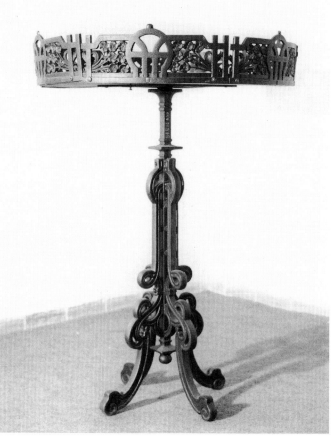

336

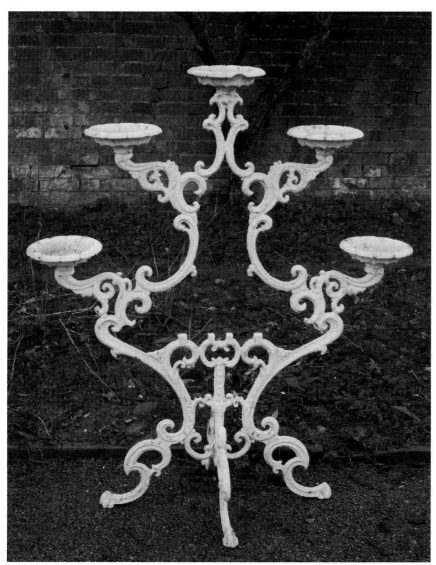

337

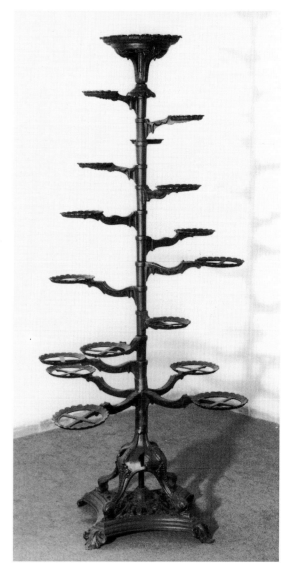

338

339

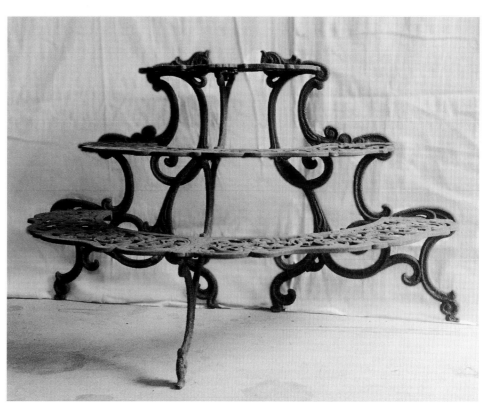

340

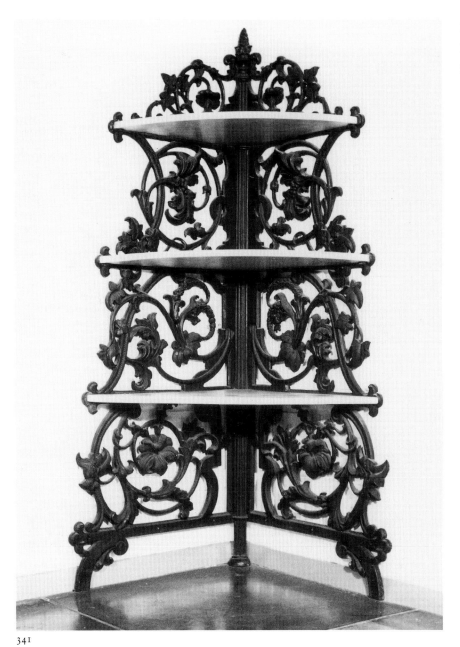

341

342

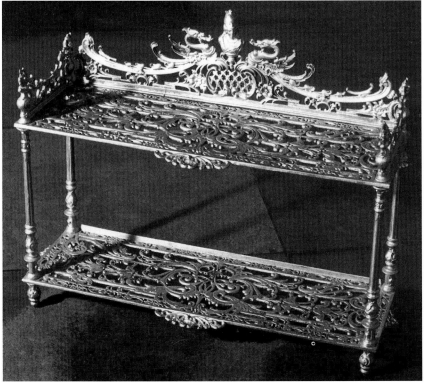

343

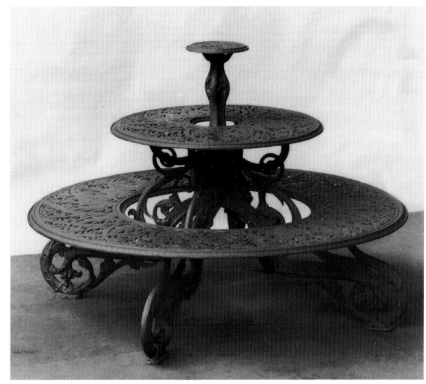

345

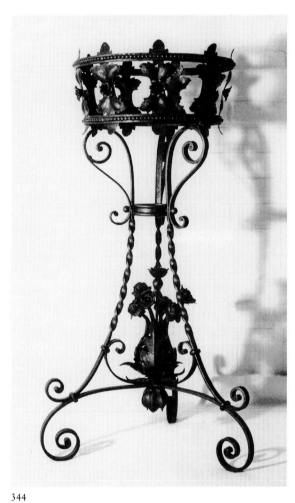

344

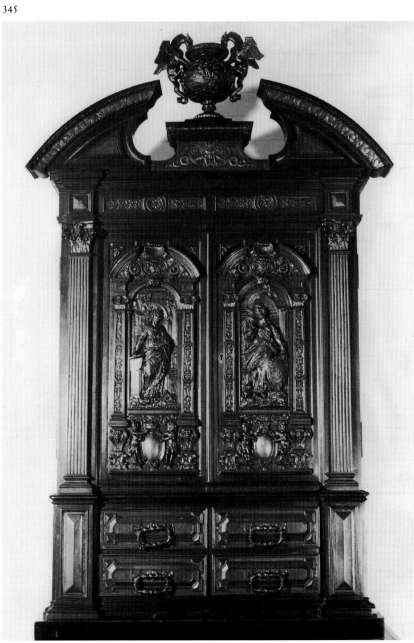

344.  Rendsburg (?), c. 1880/90

345.  Coalbrookdale, 1869

346.  Ilsenburg, c. 1900

346

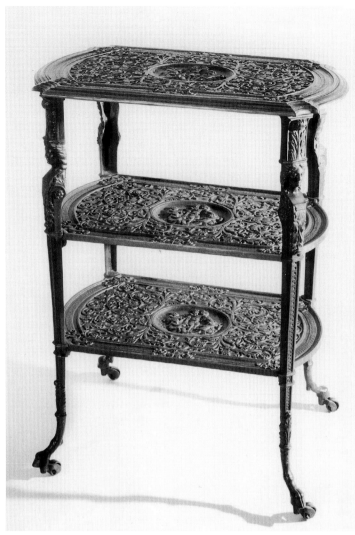

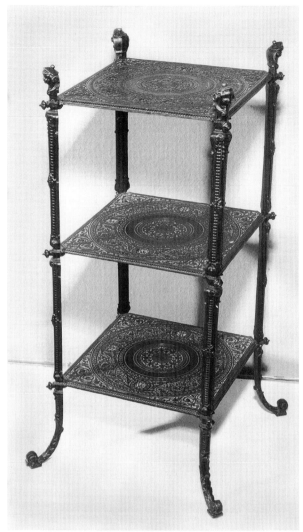

347

348

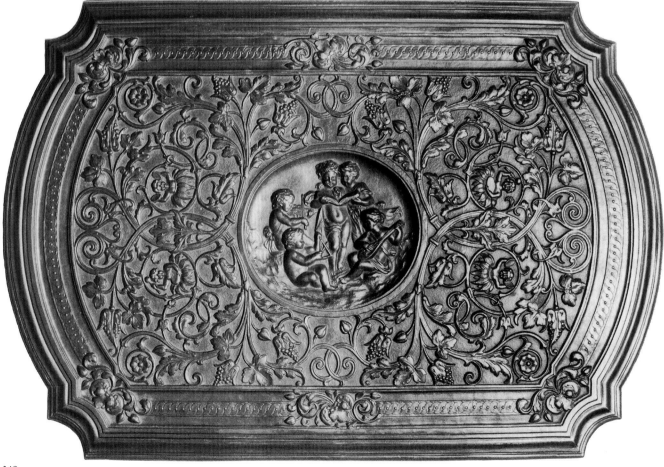

349

347. Mägdesprung, c. 1880

348. Ilsenburg, c. 1880

349. Detail der Etagere von Abb. 347
*Detail of Pl. 347*

350. Deutschland, *Germany*, 1901

351. l: Norwich, John Glendening, 1880
r: Sterling, IL, Charles H. Presbrey, 1873

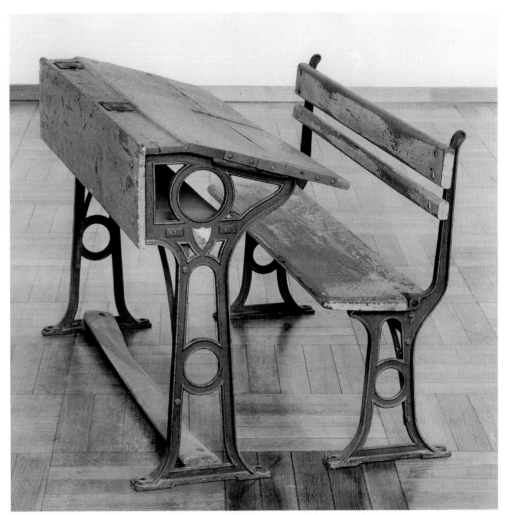

350

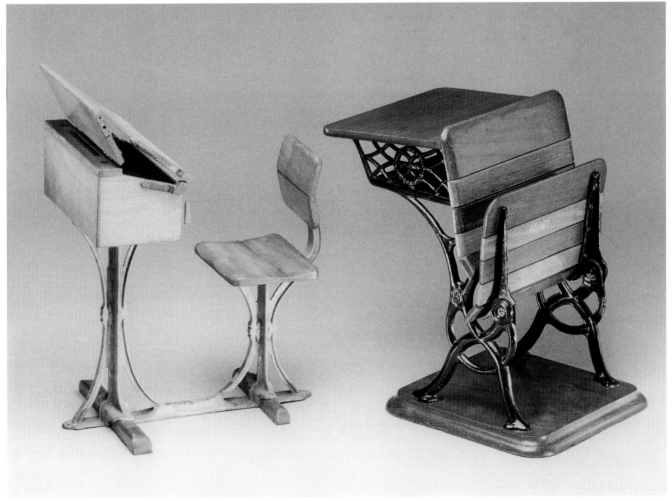

351

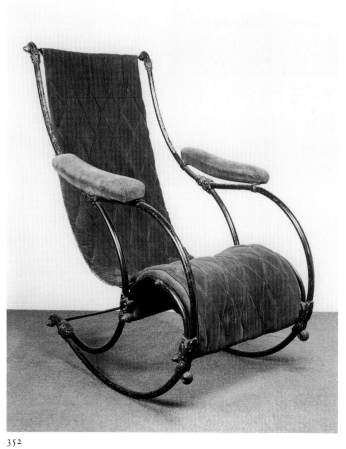

352

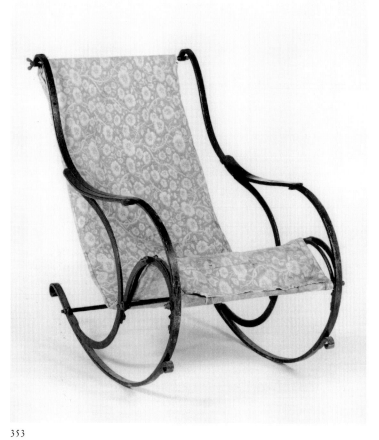

353

352, 353. England, c. 1850
354. Ungarn, *Hungary*, c. 1840

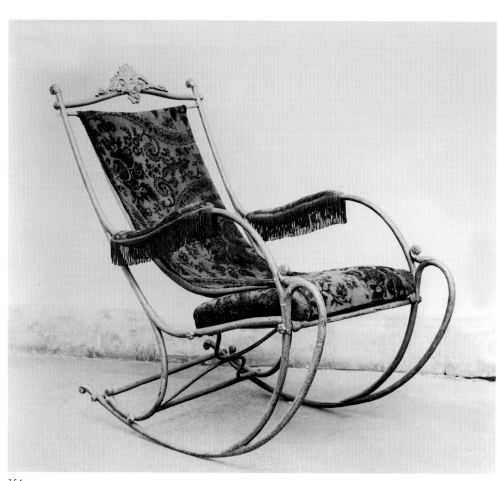

354

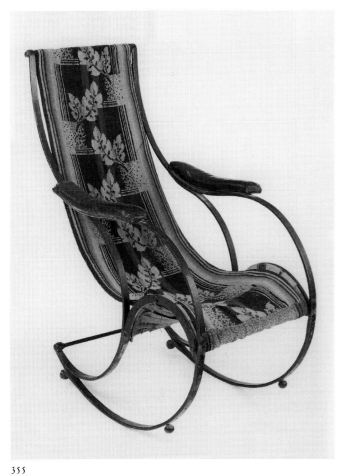

355

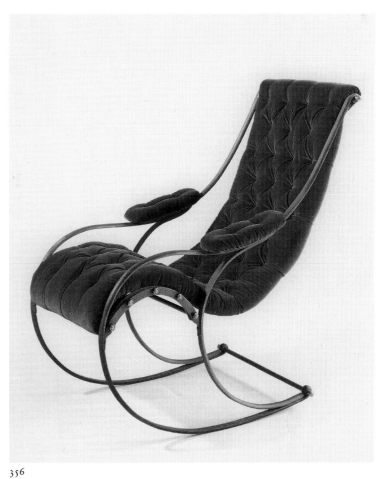

356

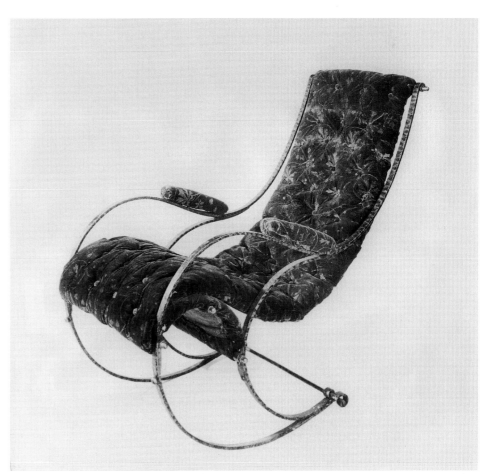

355. England, c. 1850

356. London, John Porter (?), c. 1839

357. New York, Richard Hoffmann (?), 1867

357

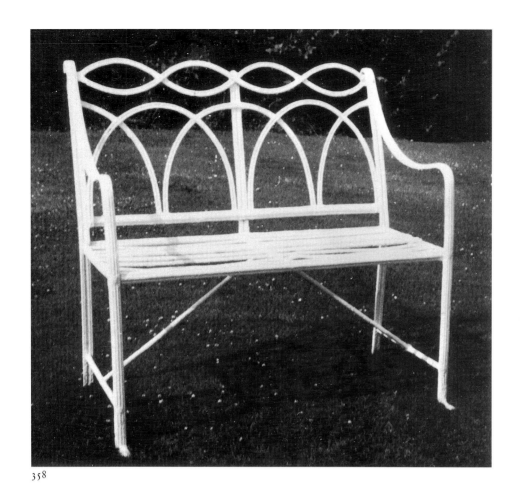

358

358, 359. England, c. 1800

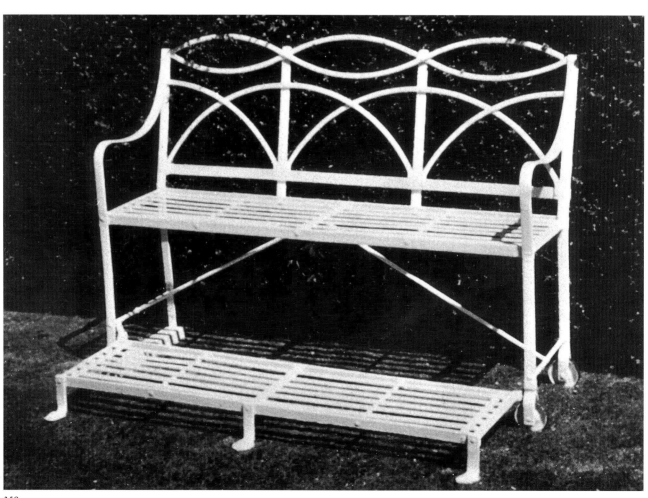

359

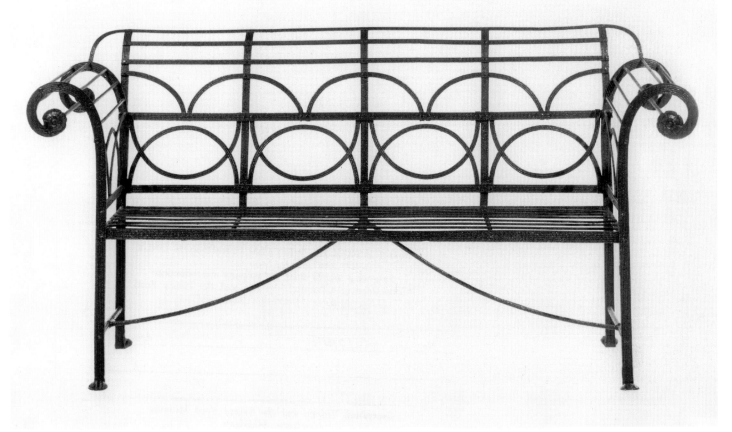

360

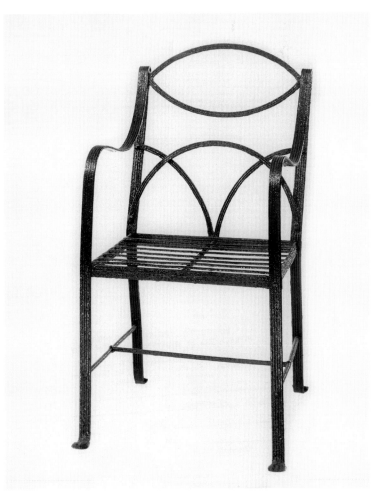

360.  England, c. 1795    361. England, c. 1800

361

362. England, c. 1820

363, 364. England, c. 1835

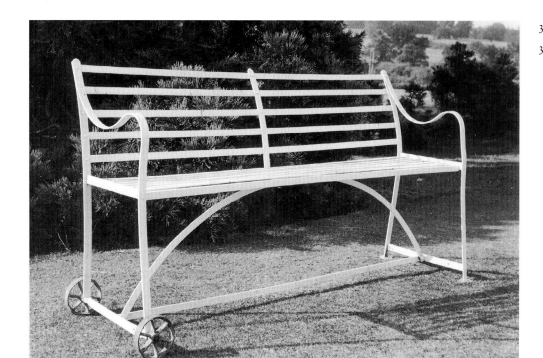

362

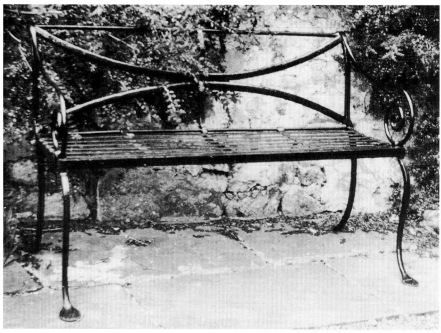

363

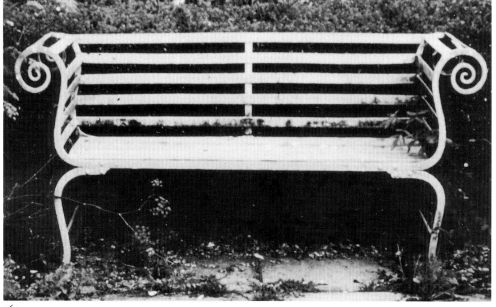

364

365, 366. England, c. 1820

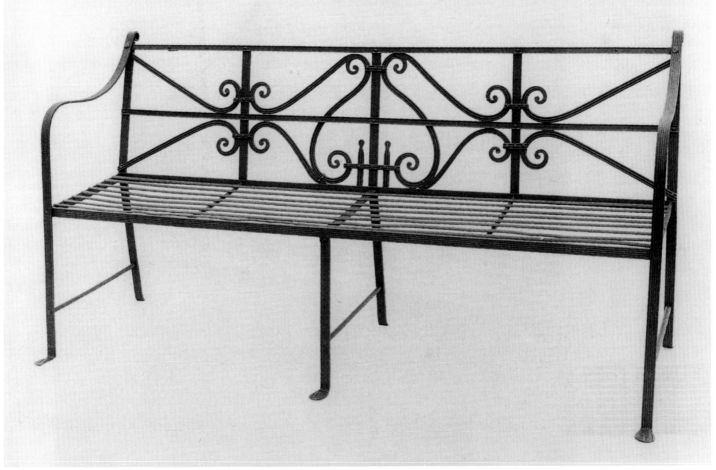

365

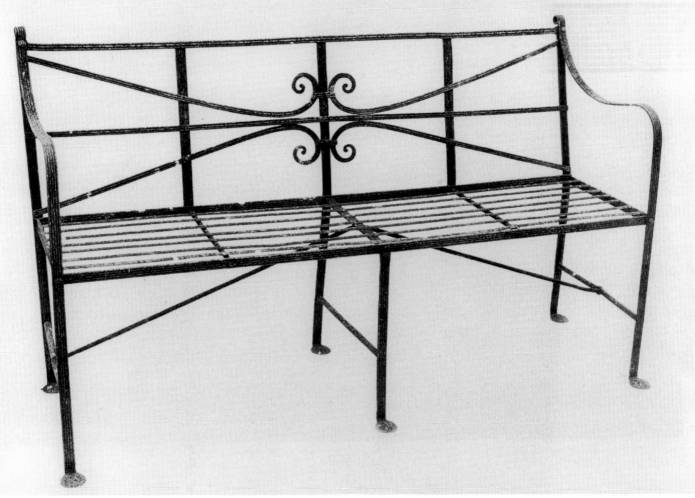

366

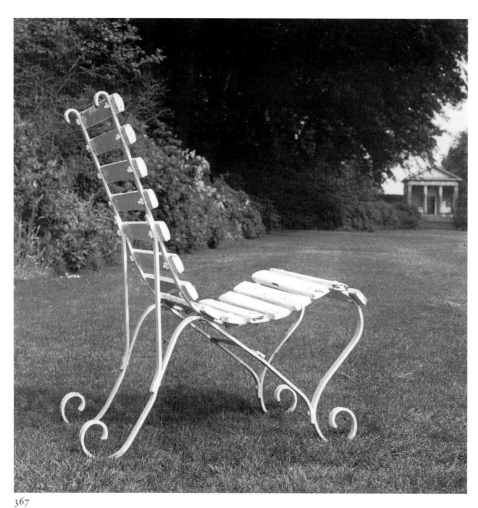

367

368

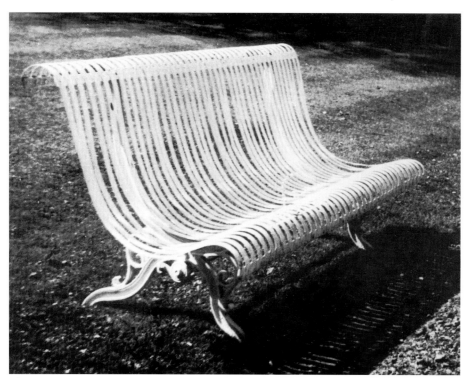

369

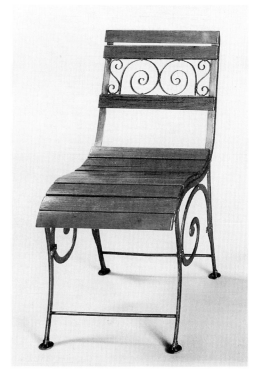

370

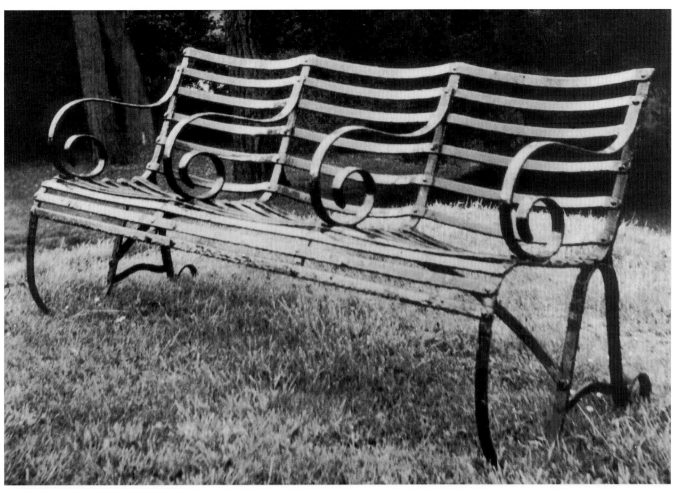

371

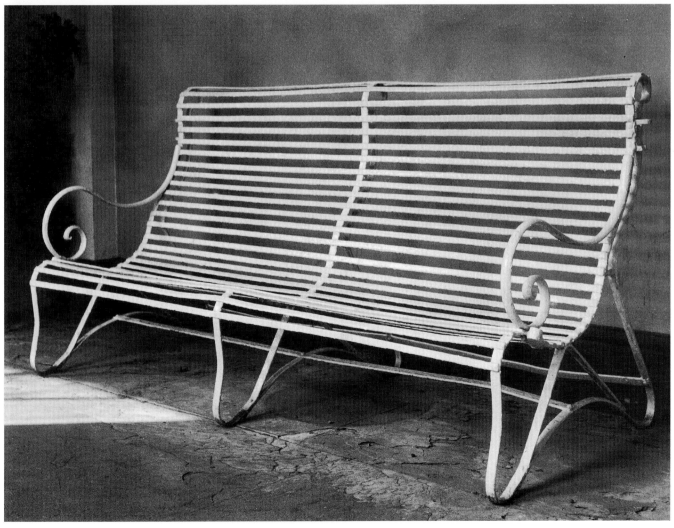

372

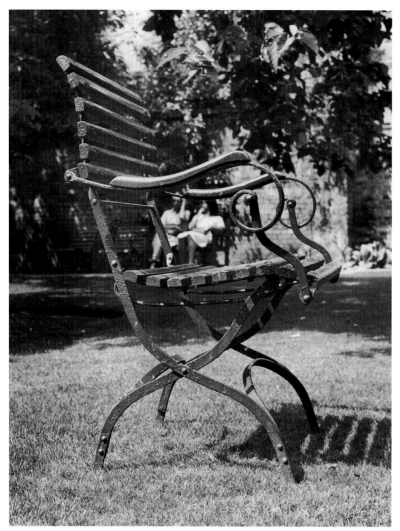

373

374

375

376

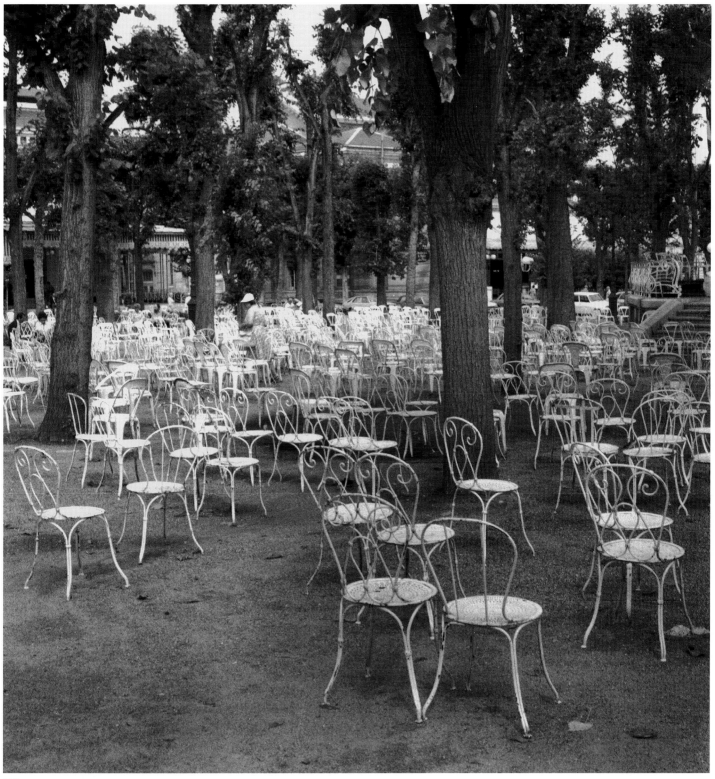

377

377. Im Kurpark von Vichy
*In the spa park at Vichy*

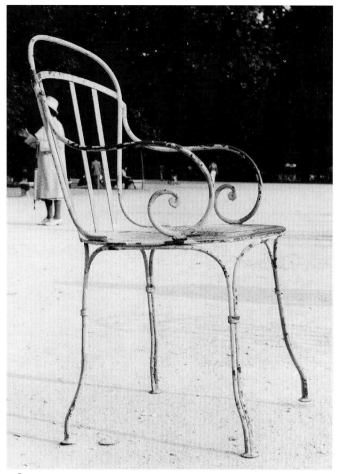

378

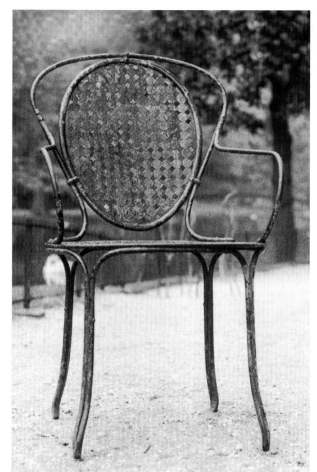

379

378. Frankreich, *France,* c. 1850

379. Frankreich, *France,* c. 1860

380. München, J. L. Kaltenecker & Sohn (?),
c. 1850/60

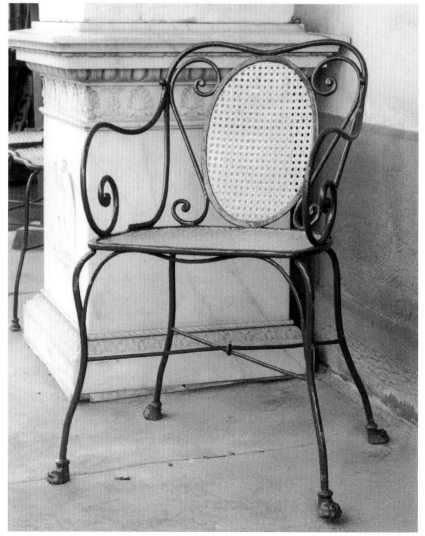

380

381

382

383

384. Deutschland, *Germany,* c. 1850/60      385. München, J. L. Kaltenecker & Sohn (?), c. 1860

384

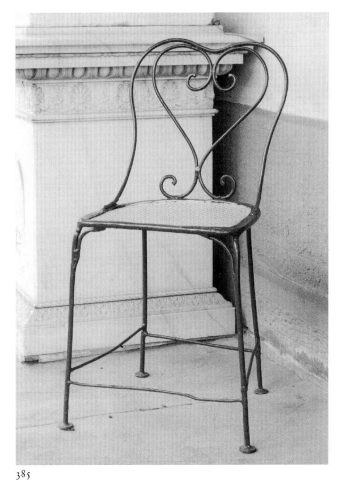

385

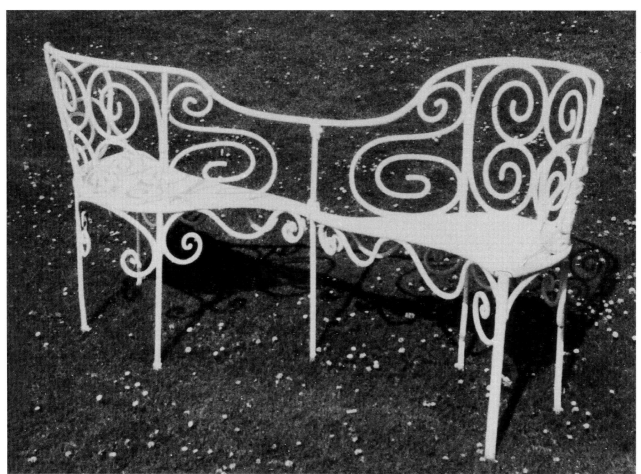

386

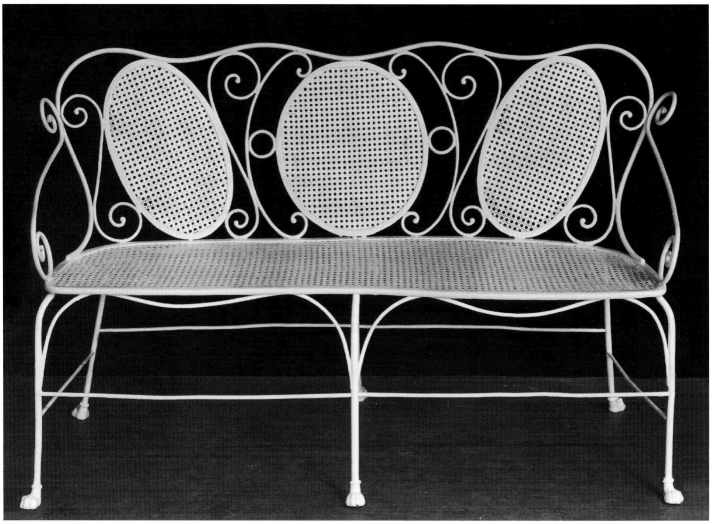

387

386. England, c. 1860

387. Frankreich oder Niederlande, *France or The Netherlands*, c. 1860

388. München, J. L. Kaltenecker & Sohn, c. 1865/70

389, 390, 391. München, J. L. Kaltenecker & Sohn, c. 1855

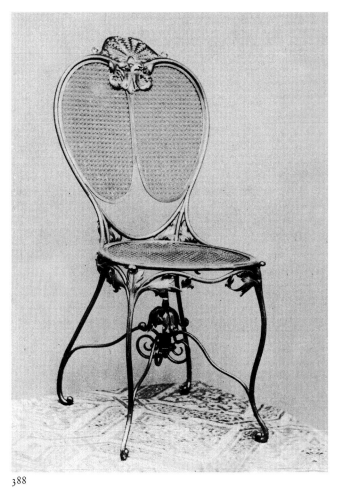

388

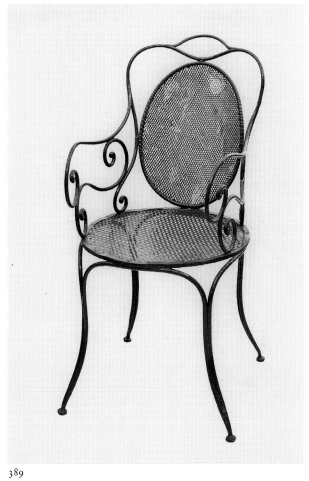

389

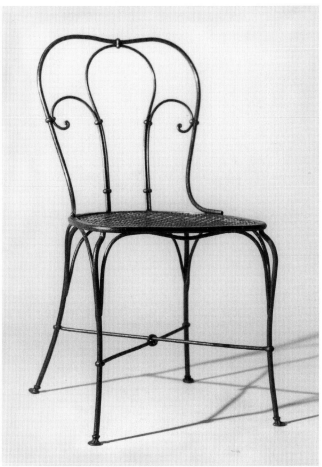

390

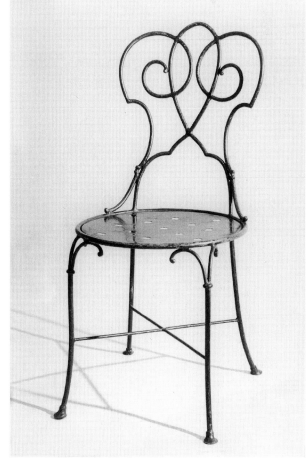

391

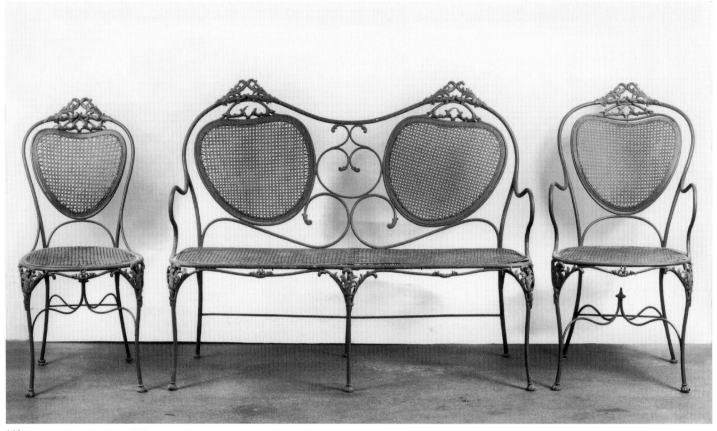

392

392. Österreich (?), *Austria (?)*, c. 1870

393. Deutschland (?), *Germany (?)*, c. 1850

394. New York, c. 1860

395. Paris, François A. Carré, 1860

396. Frankreich, *France*, c. 1860

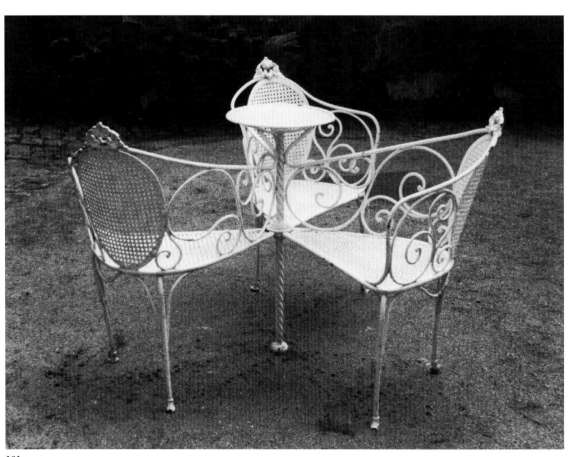

393

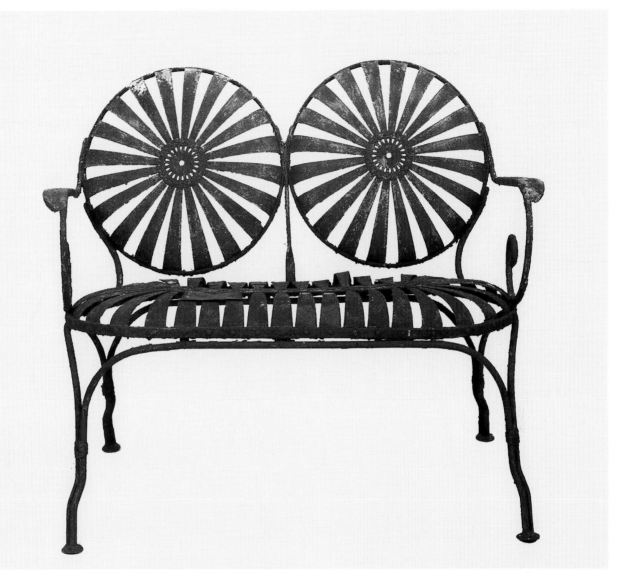

394

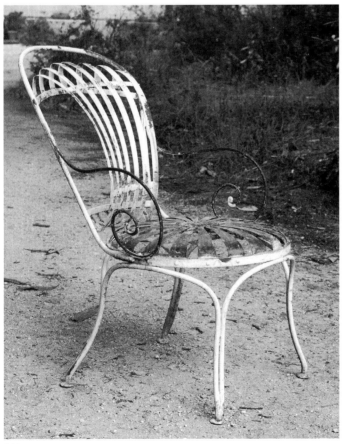

395

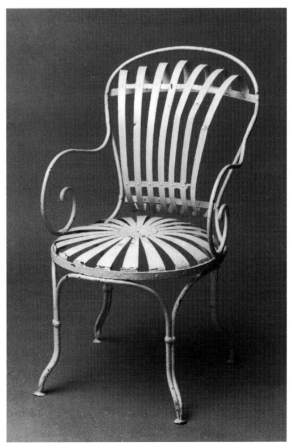

396

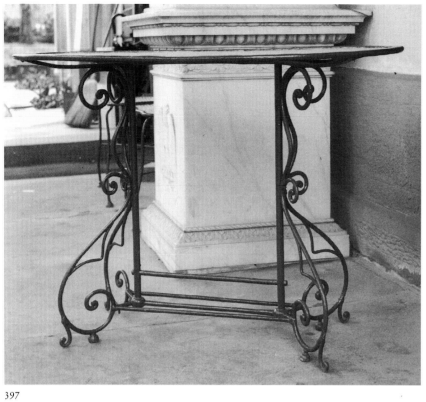

397

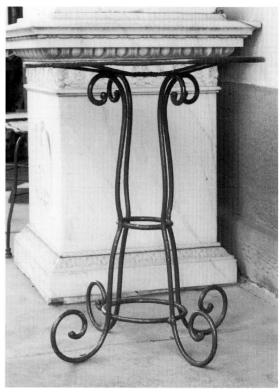

398

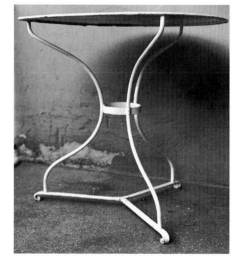

399

397, 398. München, J. L. Kaltenecker & Sohn (?), c. 1860

399. Deutschland, *Germany*, c. 1900

400. Frankreich, *France*, c. 1850/60

401. Niederlande, *The Netherlands*, c. 1895-1900

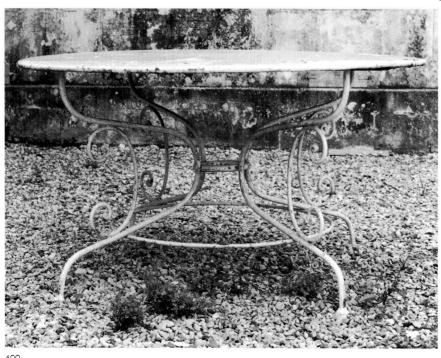

400

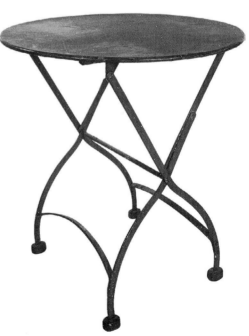

401

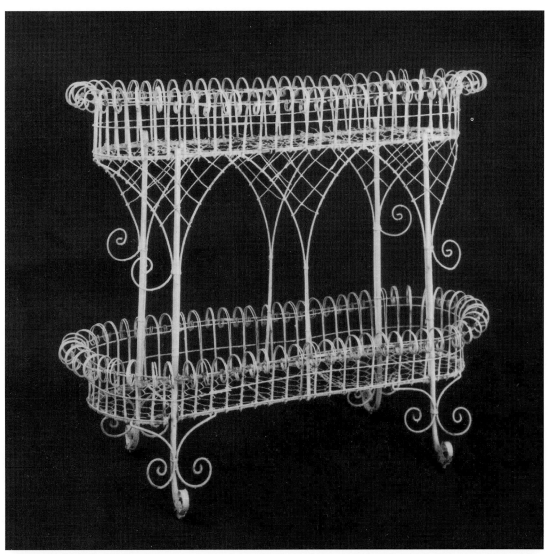

402

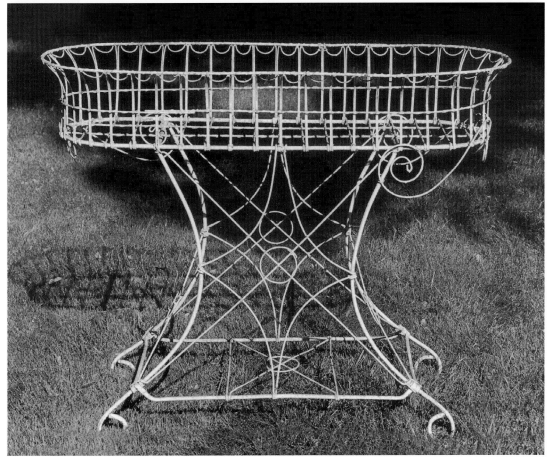

402. USA, c. 1840/50
403. England, c. 1840/50

403

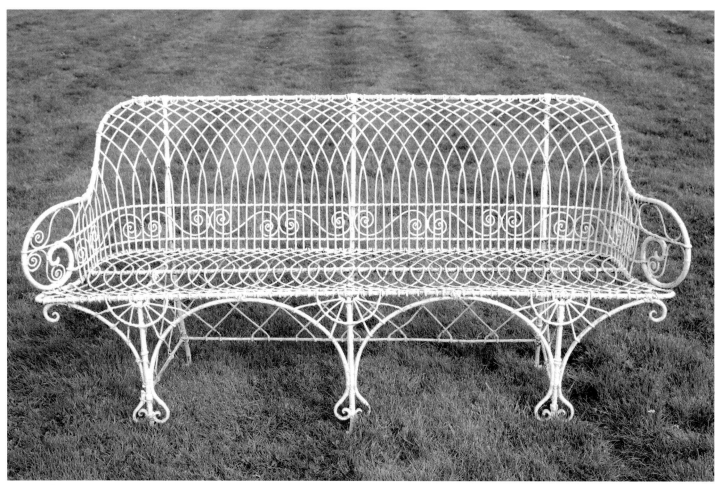

404

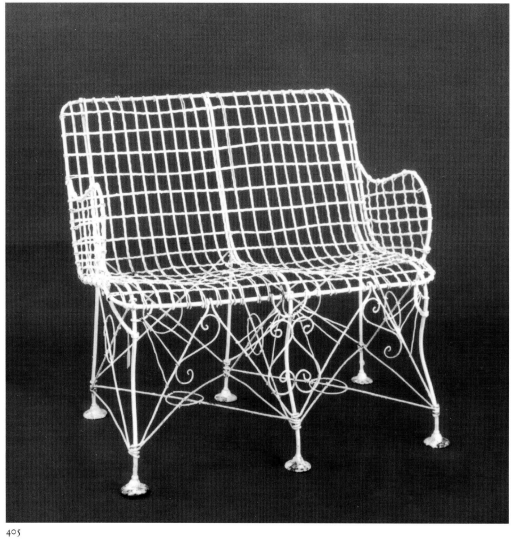

404. England, c. 1850/60

405. USA, c. 1860

405

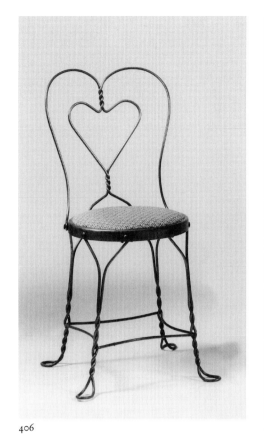

406

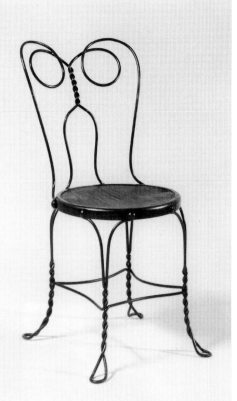

407

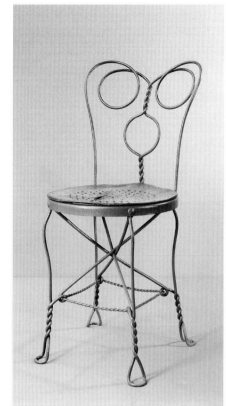

408

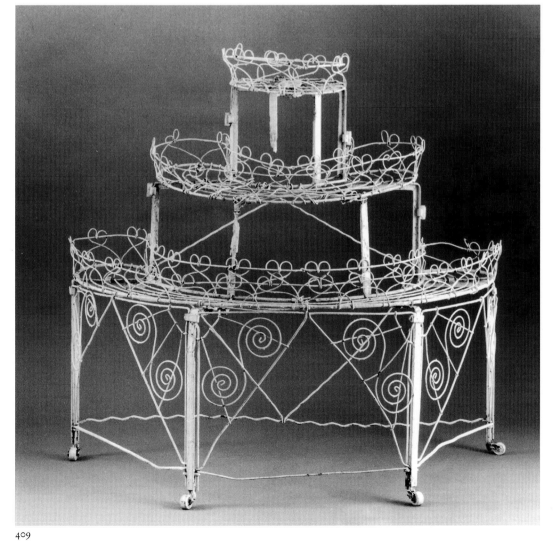

409

406. Chicago, Royal Metal Manu-
facturing Company, c. 1895

407. Chicago, Royal Metal Manu-
facturing Company, c. 1894

408. Skönnarbo, 1892

409. USA, c. 1850

410. New York, Marks Adjustable Folding Chair
Company, 1876

411. «Invalid Chair» von Abb. 410 mit ausgeklapptem
Fußteil
*Invalid Chair* shown in Pl. 410 with expanded foot rest

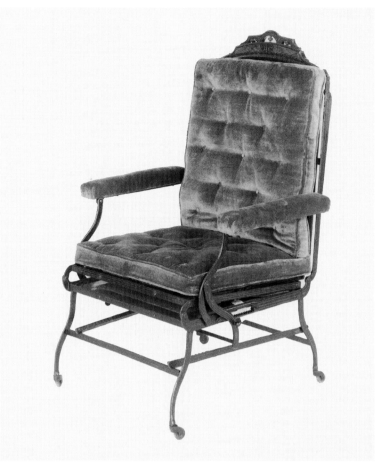

410

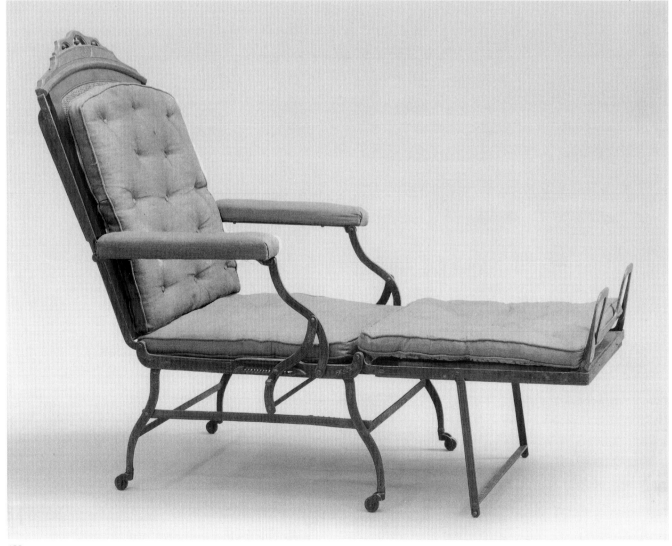

411

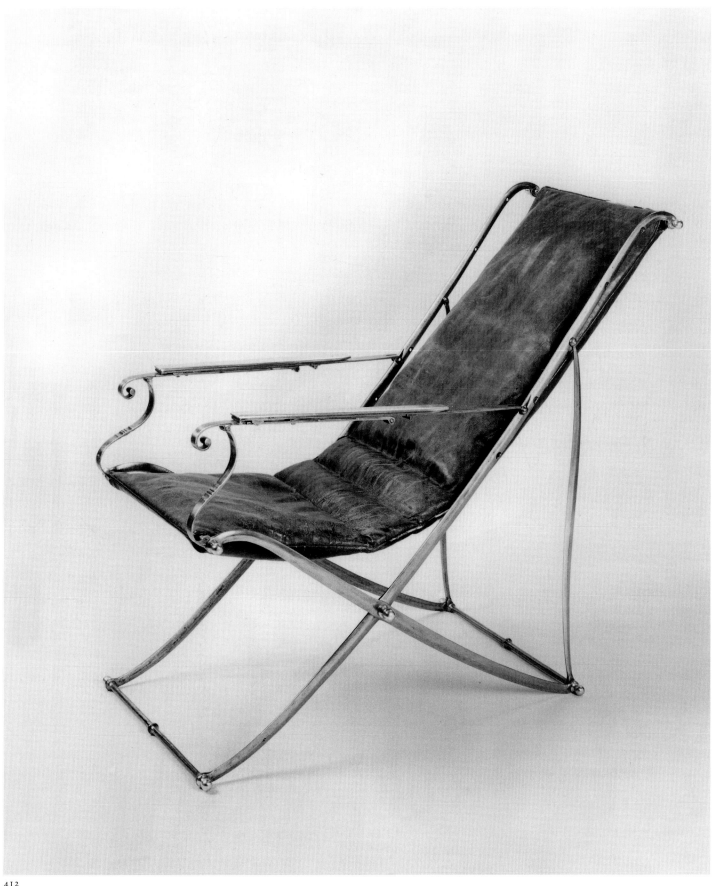

413. England, c. 1880
414. London, S. Griffin, 1882

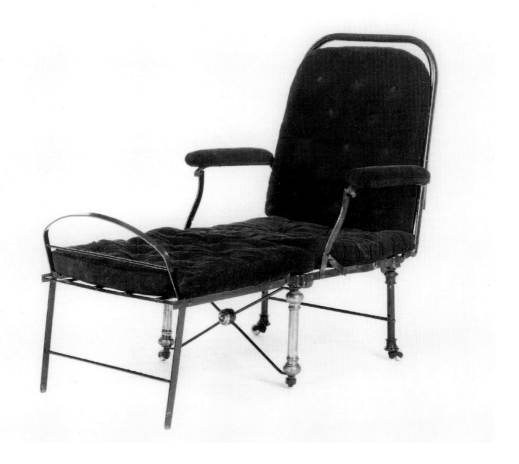

413

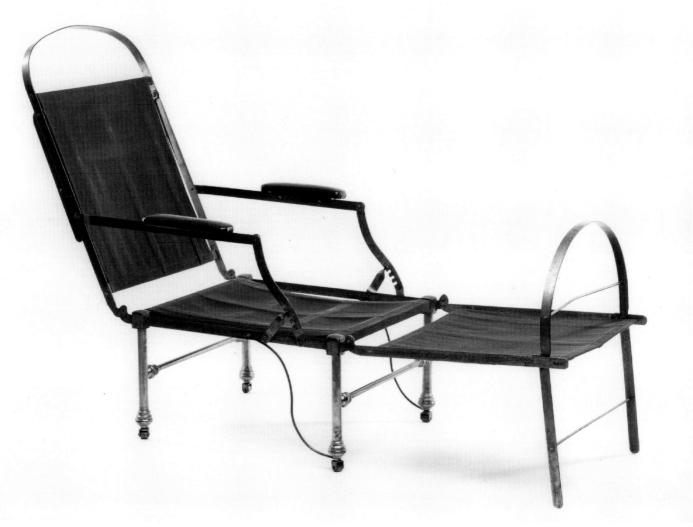

414

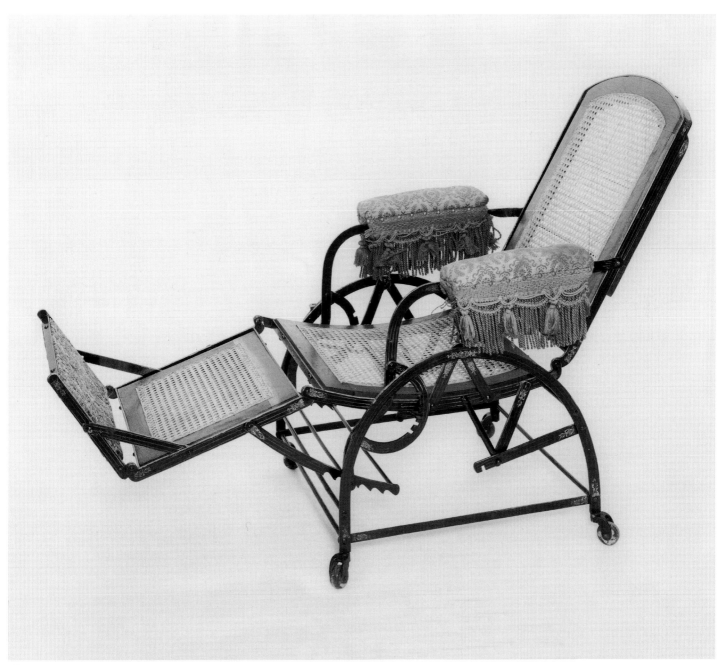

415

415. Chicago, George Wilson, 1871

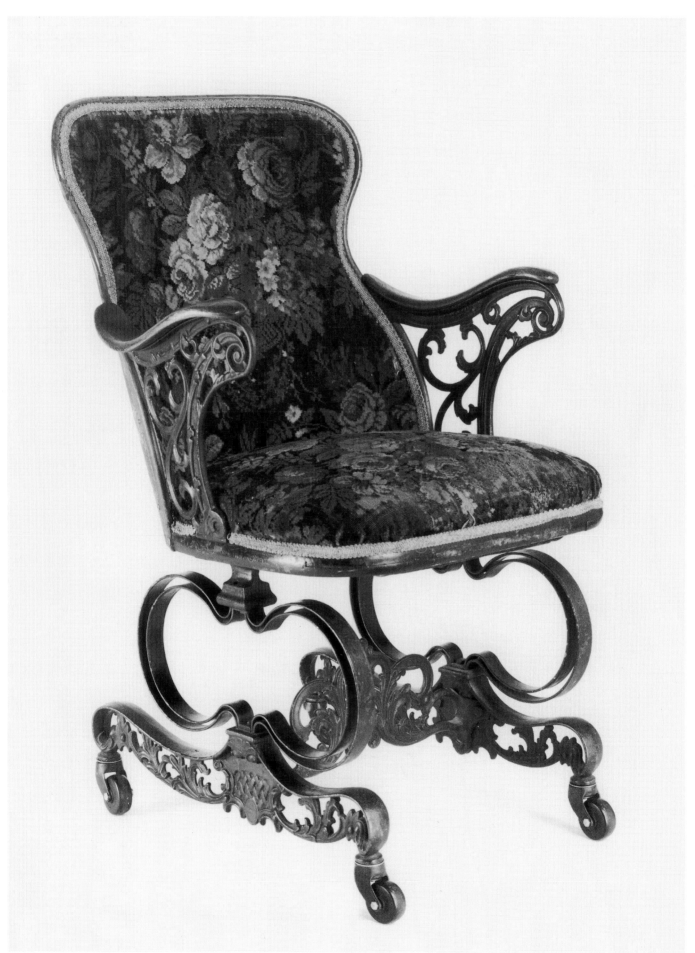

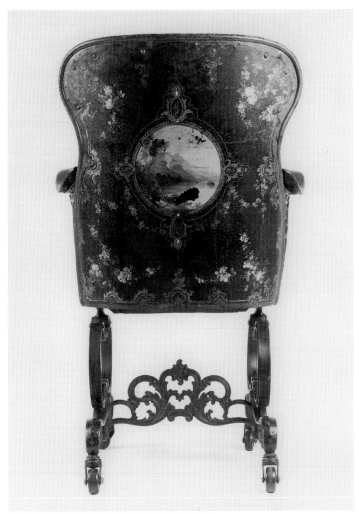

417

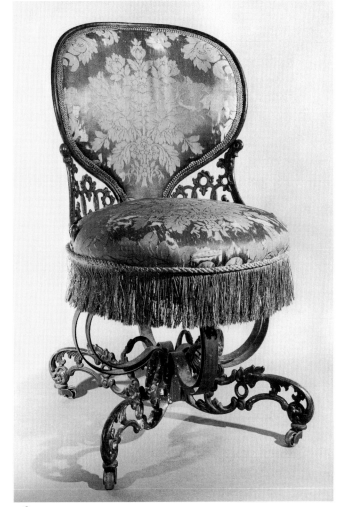

418

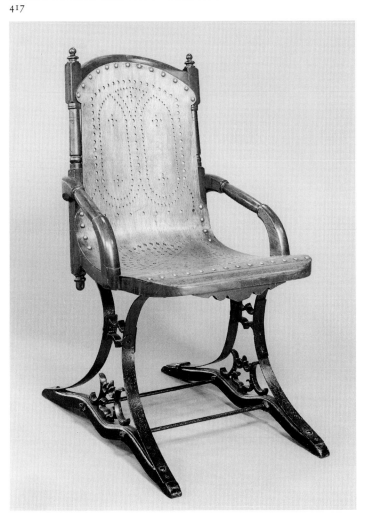

419

417. «Spring Arm Chair» von Abb. 416, Rückseite
*Back of ‹Spring Arm Chair› shown in Pl. 416*

418. Troy, NY, American Chair Company, 1849

419. New York, Gardner & Co., 1872

# Notes on plates

1. Roman folding chair. Before mid-3rd century AD. From the Weissenburg temple treasure in Bavaria. Munich, Prähistorische Staatssammlung. *Photograph:* museum.

2. Folding chair with bronze inlays. Lombardy, 6th century. London, British Museum. *Photograph:* museum.

3. Folding chair in pl.2 in folded position. London, British Museum. *Photograph:* museum.

4. Folding chair. Upper Italy, 10th/11th century. London, Victoria and Albert Museum. *Photograph:* museum.

5. Bishop's throne. France, late 14th century. Bayeux, cathedral. *Reproduced from:* P. Devinoy et al. *Le Siège en France du Moyen Age à Nos Jours.* Paris 1948, pl.7.

6. Lectern. Spain, 16th century. Baltimore, The Walters Art Gallery. *Photograph:* museum.

7. Lectern. France, 15th century. Paris, Musée de Cluny. *Photograph:* museum.

8. Folding chair. Spain, early 16th century. Munich, Bayerisches Nationalmuseum. *Photograph:* museum.

9. Folding chair. Italy *c.*1600. Sotheby's London 1981. *Photograph:* Sotheby's.

10. Trap chair. South Germany/Austria, 2nd half of 16th century. Innsbruck, Schloss Ambras. *Photograph:* Kunsthistorisches Museum Vienna.

11. Showpiece chair. Augsburg, Thomas Rucker, 1574. Longford Castle, Wiltshire. *Photograph:* private.

12. Rear view of upper part of back rest of state chair in pl.11.

13. Armchair. Tula, 1744. Potsdam, Schloss Charlottenhof. *Photograph:* Stiftung Preussische Schlösser und Gärten, Berlin-Brandenburg.

14. Folding chair. Paris, *c.*1800. From the estate of Caroline Bonaparte, wife of Joachim Murat, Paris, Musée de l'Armée. *Photograph:* museum.

15. Garden armchair from Temple Newsam House, West Yorkshire. England, *c.*1790. London, Victoria and Albert Museum. *Photograph:* museum.

16. Garden table. England or America, *c.*1770/90. Winterthur DE., The Henry Francis du Pont Winterthur Museum. *Photograph:* museum.

17. Small table. Tula, 1801. St Petersburg, Hermitage. *Photograph:* museum.

18. Chair, dressing-table and footstool. Tula, 1798. Pavlovsk castle near St Petersburg. *Photograph:* Hermitage, St Petersburg.

19. Chest with iron mounts. France, 1st half of 14th century. Paris, Musée de Cluny. *Photograph:* museum.

20. Chest with iron mounts. Bavaria, late 14th century. Andechs Benedictine Monastery, Upper Bavaria. *Photograph:* Bayerisches Nationalmuseum Munich.

21. 'Domesday Chest'. London, early 15th century. London, Public Record Office. *Photograph:* Public Record Office.

22. Chest. Tyrol, *c.*1600, wooden pedestal late 18th century. Salzburg, Landesgalerie. *Photograph:* museum.

23. Small chest. Germany, 15th century. Munich, Bayerisches Nationalmuseum. *Photograph:* museum.

24. Strongbox. Flanders, 1st half of 16th century. London, Victoria and Albert Museum. *Photograph:* museum.

25. Safe cupboard. South Tyrol, 1st quarter of 16th century. Munich, Neumeister, 1979. *Photograph:* art trade.

26. Safe cupboard. South Tyrol, 2nd half of 15th century. Vienna, Reinhold Hofstätter, 1982. *Photograph:* art trade.

27. Safe cupboard. Styria/Carinthia, 16th/17th century. Munich, Neumeister, 1978. *Photograph:* art trade.

28. Safe cupboard of Göttingen city tribunal. Göttingen, *c.*1600. Göttingen, Städtisches Museum. *Photograph:* museum.

29. Casket. The Netherlands, *c.*1630. Sotheby's Zurich 1983. *Photograph:* Sotheby's.

30. Strongbox. Klagenfurt, *c.*1710/20. Vienna, Technisches Museum. *Photograph:* museum.

31. Chest on stand. Germany, 1716. London, Victoria and Albert Museum. *Photograph:* museum.

32. Showpiece chest. Masterpiece of Johann Gottlieb Dittmann, after design of town locksmith Sigmund Galckenhauer, 1733. Graz, Österreichisches Museum für Schloss und Schlüssel. *Photograph:* Colnaghi, London.

33. *Kunstkammer* cupboard. Milan, Giovanni Battista Serabaglio and Marc Antonio Fava, *c.*1560/65; the statuettes at the top added in Vienna in 1567. Vienna, Kunsthistorisches Museum. *Photograph:* museum.

34. Casket. Austria, *c.*1730/35. Sotheby's London 1982. *Photograph:* Sotheby's.

35. Strongbox. Vienna, early 19th century. Vienna Technisches Museum. *Photograph:* museum.

36. Strongbox in form of chest-of-drawers. Lower Rhine, *c.*1760. Privately owned. *Photograph:* private.

37. Guild chest of Viennese gingerbread bakers. Vienna 1822. Vienna, Historisches Museum. *Photograph:* museum.

38. Safe. Berlin, Karl Hauschild, 1862. Exhibited at International Exhibition, London 1862. *Reproduced from:* Waring, pl.30.

39. Safe. Vienna, F. Wertheim & Co., designed and made by Anton Batsche, 1873. Exhibited at Universal Exhibition, Vienna 1873. Rümlang bei Zürich, Bauer safe factory. *Photograph:* author.

40. Detail of interior of safe in pl.39. *Photograph:* author.

41. Console table. North France, c.1725. La Rochelle, St-Sauveur. *Photograph:* author.

42. 'Jewel cupboard'. Berlin, A.L. Benecke, designed by Ihne and Stegmüller, 1879. Exhibited at the Gewerbe-Ausstellung 1879. *Reproduced from:Gewerbehalle* 18. 1880, pl.43.

43. Console table. Avignon, master locksmith Alexis Benoît, after 1725. Avignon, Musée Calvet. *Photograph:* museum.

44. Lectern. South Germany, 1st half of 18th century. Munich, Bayerisches Nationalmuseum. *Photograph:* museum.

45. Table. France, mid-18th century. Rouen, Musée Le Secq des Tournelles. *Photograph:* Ellebé, Rouen.

46. Double tester bed. Italy, c.1620/40. Montegufoni, Castello. *Photograph:* Fratelli Alinari.

47. Double bed. Italy, c.1620/40. Montegufoni, Castello. *Photograph:* Fratelli Alinari.

48. Nativity crib. France, 2nd half of 17th century. Rouen, Musée Le Secq des Tournelles. *Photograph:* museum.

49. Cradle. Italy c.1620. Oxford, Ashmolean Museum. *Photograph:* museum.

50. Bed with brass mounts. Paris, Jacques-Antoine Courbin(?), c.1785. Sotheby's Monaco 1987. *Photograph:* Sotheby's.

51. 'Tent bed'. *Reproduced from: Magazin für Freunde des guten Geschmacks* 1796, vol.2, no.5, pl.2.

52. George Washington's field bed. America c.1780. Dearborn MI., The Henry Ford Museum. *Photograph:* museum.

53. Napoleon's field bed. Paris, master locksmith Desouches, 1809. Paris, Musée de l'Armée. *Photograph:* museum.

54. Showpiece bed. France, 2nd quarter of 19th century. Sotheby's London 1989. *Photograph:* Sotheby's.

55. Segment-shaped garden bench. Berlin, Königliche Eisengiesserei, c.1824/26, designed by Karl Friedrich Schinkel for the royal gardens in Berlin and Potsdam. Potsdam, Römische Bäder. *Photograph:* Stiftung Preussische Schlösser und Gärten, Berlin-Brandenburg.

56. Two-seat garden bench. Berlin, Königliche Eisengiesserei, c.1824/26, designed by Karl Friedrich Schinkel for the royal gardens in Berlin and Potsdam. Potsdam, Römische Bäder. *Photograph:* Stiftung Preussische Schlösser und Gärten, Berlin-Brandenburg.

57. Three-seat garden bench with marble seat. Berlin, Königliche Eisengiesserei, c.1824/26, designed by Karl Friedrich Schinkel for the royal gardens in Berlin and Potsdam. Potsdam, Römische Bäder. *Photograph:* Stiftung Preussische Schlösser und Gärten, Berlin-Brandenburg.

58. Garden bench. Berlin, Königliche Eisengiesserei, c.1828, designed by Karl Friedrich Schinkel. Berlin, Märkisches Museum. *Photograph:* museum.

59. Garden bench. Berlin, Königliche Eisengiesserei, c.1828, designed by Karl Friedrich Schinkel for the royal gardens in Berlin and Potsdam. Berlin, Schlosspark Glienicke. *Reproduced from:* Sievers, fig.61.

60. Garden chair. Berlin and Gleiwitz, Königliche Eisengiessereien, c.1824/26, designed by Karl Friedrich Schinkel. Formerly Berlin, Schlosspark Glienicke. *Reproduced from:* Sievers, fig.65.

61. Garden armchair. All Prussian iron foundries, c.1830, copies cast by many foundries. Simplified model after Karl Friedrich Schinkel. Berlin, Märkisches Museum. *Photograph:* museum.

62. Garden armchair. Sayn, Königlich Preussische Eisengiesserei, c.1830; copies cast by all Prussian iron foundries and many others. Simplified model after Karl Friedrich Schinkel. Berlin, Schloss Charlottenburg. *Photograph:* Stiftung Preussische Schlösser und Gärten, Berlin-Brandenburg.

63. Garden armchair. All Prussian iron foundries, c.1830, copies cast by many foundries. Designed by Karl Friedrich Schinkel. Potsdam, Römische Bäder. *Photograph:* Stiftung Preussische Schlösser und Gärten, Berlin-Brandenburg.

64. Garden chair. All Prussian iron foundries, c.1830, after Karl Friedrich Schinkel. Potsdam, Römische Bäder. *Photograph:* Stiftung Preussische Schlösser und Gärten, Berlin-Brandenburg.

65. Garden chair. Rendsburg, Carlshütte, c.1830/40. Rendsburg, Eisenkunstgussmuseum. *Photograph:* author.

66. Garden armchair. Stiepenau, Bohemia, c.1830, also cast by the Prinz Rudolph-Hütte, Dülmen. Privately owned. *Photograph:* private.

67. Garden stool. Güstrow, Andersen iron foundry and machine factory, c.1846. Güstrow, Museum der Stadt. *Photograph:* author.

68. Two-seat garden bench. The Netherlands, c.1830, after Karl Friedrich Schinkel. The Hague, Royal Gardens. *Photograph:* Dienst Verspreide Rijkskollecties, s'Gravenhage.

69. Garden bench. Berlin, Königliche Eisengiesserei, c.1840. Berlin, Schloss Charlottenburg. *Photograph:* Stiftung Preussische Schlösser und Gärten, Berlin-Brandenburg.

70. Garden bench. Güstrow, Andersen iron foundry and machine factory, c.1846. Güstrow, Museum der Stadt. *Photograph:* author.

71. Garden bench. Cold-Spring-on-Hudson, N.Y., West Point Foundry, 1836. Designed by George Harvey after an idea of Washington Irving. Tarrytown, N.Y., Sunnyside. *Photograph:* museum.

72. Street bench. New Orleans c.1850. New Orleans, Jackson Square. *Photograph:* author.

73. Two-seat bench. American, c.1840, after Karl Friedrich Schinkel. New Orleans, Sigle's Antiques. *Photograph:* author.

74. Garden armchair. America, c.1845. New Orleans, Gallier House. *Photograph:* author.

75. Park bench. Konga, Småland (Sweden), Örmo Bruk, c.1835/40. Copenhagen. *Photograph:* author.

76. Park bench. Denmark(?), *c.*1835/40. Copenhagen. *Photograph:* author.

77. Park bench. Lessebo, Sweden, *c.*1840. (Modern casting.) *Photograph:* Byarums Bruk AB, Vaggeryd.

78. Garden chair. New York, J.W. Fiske, *c.*1840. Also cast by John A. Winn & Co., Boston. Dearborn MI., The Henry Ford Museum. *Photograph:* museum.

79. Street bench. Scandinavia, *c.*1835. Copenhagen, Kongens Nytorv. *Photograph:* author.

80. Folding footstool. America, *c.*1840/50. Toronto, Royal Ontario Museum. *Photograph:* museum.

81. 'Tabouret'. Val d'Osne, *c.*1840/50. Paris, Musée des Arts Décoratifs. *Photograph:* museum.

82. Garden stool. Wasseralfingen, Königlich Württembergische Eisengiesserei, *c.*1845. Wasseralfingen, Werksammlung. *Photograph:* author.

83. Garden bench. Rotherham, James Yates, Effingham Works, *c.*1840. Also cast by other foundries; this example by Janes, Kirtland & Co., New York. New York, Metropolitan Museum of Art. *Photograph:* museum.

84. Pin cushion. Gleiwitz, Königlich Preussische Eisengiesserei, *c.*1830/34. Berlin, Kunstgewerbemuseum. *Photograph:* museum.

85. Pin cushion. Gleiwitz, Königlich Preussische Eisengiesserei, *c.*1830/34. Frankfurt, Museum für Kunsthandwerk. *Photograph:* museum.

86. Garden chair. Rendsburg, Carlshütte, *c.*1845/50. Rendsburg, Eisenkunstgussmuseum. *Photograph:* author.

87. Three-legged chair. The Hague, L.J. Enthoven & Co., *c.*1845/50. Arnhem, Rijksmuseum voor Volkskunde. *Photograph:* museum.

88. Chair. Val d'Osne, *c.*1840. Paris, Musée des Arts Décoratifs. *Photograph:* museum.

89. 'Ornamental Chair'. The Coalbrookdale Company, registered 5.5.1847, no.42 981. Also cast by many other foundries, mainly in America. New York, Metropolitan Museum of Art. *Photograph:* museum.

90. 'Hall Chair'. Glasgow, McDowall, Steven & Co., *c.*1850. Also cast by German (Rendsburg), American and Australian foundries. Munich, privately owned. *Photograph:* private.

91. Garden bench. Rendsburg, Carlshütte, *c.*1845/50. Rendsburg, Eisenkunstgussmuseum. *Photograph:* author.

92. 'Gothic Settee'. Stirlingshire, Carron Company, registered 16.3.1846, no.34 358. Also cast by many other foundries, mainly in America; this example marked 'Brown & Owen'. Atlanta, GA., The High Museum of Art. *Photograph:* museum.

93. Garden bench. America, *c.*1840. Washington, Smithsonian Institution, Edith H. Haupt Garden. *Photograph:* author.

94. Park bench. The Hague, De Prins van Oranje, *c.*1840. Similar models by other Dutch and English foundries, and by Georg Neher, Lauffen. Arnhem, Gemeentemuseum. *Photograph:* author.

95. Park bench. Zöpfau, Bohemia, *c.*1840. Vizmberk, Czech Republic, castle grounds. *Photograph:* Dr Josef Kuba, Prague.

96. Garden bench. The Coalbrookdale Company, registered 6.4.1844, no.17 597. Also cast by Örmo Bruk, Konga, Sweden. Kentwell Hall, Long Melford, Suffolk. *Photograph:* author.

97. Park bench. England, *c.*1840. Munich, privately owned. *Photograph:* author.

98. Two-seat bench. Probably New Orleans, *c.*1850. New Orleans, Sigle's Antiques. *Photograph:* author.

99. Park bench. The Netherlands, *c.*1850. Cast by Keppel's iron foundry, L.J. Enthoven and Van Lohuizen, The Hague as well as by Von Roll, Solothurn. Edam. *Photograph:* author.

100. Park bench. France, *c.*1845/50. Pons, Charente-Maritime, Jardin Public. *Photograph:* author.

101. Park bench. France, *c.*1845/50. Pons, Charente-Maritime, Jardin Public. *Photograph:* author.

102. Park bench. England, *c.*1840. Derby, Arboretum. *Photograph:* Dr Clive Wainwright, London.

103. Park bench. Wasseralfingen, Königlich Württembergische Eisengiesserei, 1847. Also cast (this example) by Potthoff & Flume, Lünen. Lünen, Museum der Stadt. *Photograph:* museum.

104. Park bench. The Netherlands, *c.*1850. Cast by the Keppel's iron foundry, L.J. Enthoven, The Hague and by L. Denon-villier, Paris. Edam. *Photograph:* author.

105. Garden armchair. Glasgow, McDowall, Steven & Co., *c.*1840. Also cast by American foundries. New York, Metropolitan Museum of Art. *Photograph:* museum.

106. 'Rustic Settee'. Glasgow, McDowall, Steven & Co., *c.*1840. Also cast by American foundries. New York, Metropolitan Museum of Art. *Photograph:* museum.

107. Park bench. Wasseralfingen, Königlich Württembergische Eisengiesserei, 1847. Also cast by Potthoff & Flume, Lünen. Wasseralfingen, Werksammlung. *Photograph:* author.

108. End of a park bench. Wasseralfingen, Königlich Württembergische Eisengiesserei, *c.*1845/50. Wasseralfingen, Werksammlung. *Photograph:* author.

109. Garden bench. England, *c.*1850. Blickling Hall, Aylsham, Norfolk. *Photograph:* author.

110. End of a garden bench. France, *c.*1850. Château Colombier near Nancras, Charente-Maritime. *Photograph:* author.

111. Side view of garden bench in pl.118. Kentwell Hall, Long Melford, Suffolk. *Photograph:* author.

112. 'Vine Pattern Garden Seat'. Variant of the garden bench in pl.114, with no rim, different legs and a different seat. Probably Philadelphia, Wood & Perot, 1858. Baltimore, Peale Museum. *Photograph:* author.

113. Detail of the garden bench in pl.114. Dearborn MI., The Henry Ford Museum. *Photograph:* author.

114. 'Vine Pattern Garden Seat'. Edinburgh, Charles D. Young & Co., *c.*1850. Cast by many foundries, this example by E.T. Barnum, Detroit MI. Dearborn MI., The Henry Ford Museum. *Photograph:* museum.

115. Garden bench. The Coalbrookdale Company(?), c.1853 (cf. pl.116). Also cast by Wood & Perot, Philadelphia, and Shickle, Harrison & Co., St Louis. Bavaria, privately owned. *Photograph:* author.

116. Garden bench. The Coalbrookdale Company, registered 28.4.1853, no. 90 929. Also cast by McDowall, Steven & Co., Glasgow and A. Kenrick & Sons, West Bromwich. Sotheby's Sussex 1988. *Photograph:* Sotheby's.

117. Garden bench. Rotherham, Yates, Haywood & Co., registered 24.2.1854, no. 95 165. Also cast by L.J. Enthoven (this example) and De Prins van Oranje, The Hague, O. Mustad & Son, Christiania, Robert Wood & Co., Philadelphia and James McEwan & Co., Melbourne. Utrecht, Centraal Museum. *Photograph:* museum.

118. Garden bench. The Coalbrookdale Company, registered 7.5.1851, no. 78 766. Sotheby's Sussex 1983. *Photograph:* Sotheby's.

119. Garden bench. The Coalbrookdale Company, registered 5.2.1855, no. 99 277. Also cast by Shickle, Harrison & Co., St Louis. Surbiton, Surrey. *Photograph:* art trade.

120. Park bench. Philadelphia, Robert Wood, c.1850/55. Must also have been cast in England. Sotheby's Sussex 1987. *Photograph:* Sotheby's.

121. Side view of bench in pl.119. Holkham Hall, Wells, Norfolk. *Photograph:* author.

122. Garden chair. Hochstein iron foundry, Pfalz, c.1855. Also cast by the Carlshütte, Rendsburg. Eisenberg bei Kaiserslautern, privately owned. *Photograph:* Landesamt für Denkmalpflege, Mainz.

123. Armchair. West Bromwich, Archibald Kenrick & Sons, registered 18.2.1853, no. 89 742. Sotheby's London 1989. *Photograph:* Sotheby's.

124. Garden armchair. Rendsburg, Carlshütte, c.1855. Rendsburg, Eisenkunstgussmuseum. *Photograph:* author.

125. Armchair. Sheffield, Crichley, Wright & Co., registered 28.3.1859, no.119 119. Sotheby's Sussex 1993. *Photograph:* Sotheby's.

126. Chair. England, c.1850/55. Also cast in Melbourne. Sotheby's Belgravia 1981. *Photograph:* Sotheby's.

127. Garden bench, marked 'NAVILLUS 234'. America, c.1855. New York, Metropolitan Museum of Art. *Photograph:* museum.

128. Double park bench. Follonica, Officine Meccaniche Ilva, c.1850/60. Follonica, Museo del Ferro e della Ghisa. *Photograph:* author.

129. Park bench. France, c.1850/60. Saintes, Charente-Maritime. *Photograph:* author.

130. Double park bench. Val d'Osne, Barbezat & Cie., 1858. Also cast in Bohemia (this example). Vizmberk, castle grounds. *Photograph:* Dr Josef Kuba, Prague.

131. End of a park bench. Horowitz, Gräflich Wrbnasche Eisenwerke, c.1850/60. Beroun, Czech Republic, district museum. *Photograph:* museum.

132. Park bench. France, c.1850/60. Bordeaux, Jardin Public. *Photograph:* author.

133. Side of a park bench. Val d'Osne, Barbezat & Cie., before 1858. Also cast by Kockums Jernwerk, Konga, Sweden, Keppel's iron foundry, The Netherlands, Potthoff & Flume, Lünen, Horowitz iron works, and Wood & Perot, Philadelphia. Wasseralfingen, Werksammlung. *Photograph:* author.

134. Side of a park bench. Blansko, Bohemia, Gräflich Salmsche Hütte, c.1860/70. Similar models cast in Horowitz, Bohemia and by Von Roll, Solothurn. Prague, Technisches Museum. *Photograph:* museum.

135. Side of a park bench. Blansko, Bohemia, Gräflich Salmsche Hütte, c.1850/60. Blansko, Czech Republic, Museum. *Photograph:* author.

136. 'Banc de Ville'. Val d'Osne, Barbezat et Cie., 1858. Also cast by Näfvequarns Bruk, Sweden, Van Lohuisen et Cie, Vaassem and Von Roll, Solothurn. Wasseralfingen, Werksammlung. *Photograph:* author.

137. Park bench. Probably Baltimore, Bartlett, Robbins & Co. c.1860. Baltimore, Federal Hill. *Photograph:* author.

138. Street bench. Glasgow, Walter Macfarlane & Co., registered 1.12.1860, no.136 248. Richmond, Surrey. *Photograph:* author.

139. Park bench. Dudley, Thomas Marsh & Son, registered 30.3.1858, no.113 320. Also cast by J.& C.G. Bolinder, Stockholm. American cast copy. New Orleans. *Photograph:* author.

140. 'Banc de Ville'. Sommevoir, A. Durenne, c.1860. Versailles. *Photograph:* author.

141. Street bench. Scandinavia, c.1860. Copenhagen. *Photograph:* author.

142. 'Fern and Blackberry Settee'. The Coalbrookdale Company, registered 30.4.1858, no.113 617. Also cast by many foundries, predominantly in America. Dearborn MI., The Henry Ford Museum. *Photograph:* author.

143. 'Oak and Ivy Settee'. The Coalbrookdale Company, registered 8.4.1859, no. 119 253, designed by John Bell. Sotheby's Sussex 1987. *Photograph:* Sotheby's.

144. Park bench. England, c.1860/65. Ely, Cambridge. *Photograph:* author.

145. 'Wheat and Cockleshell Settee'. The Falkirk Iron Company, c.1860. Sotheby's Sussex 1993. *Photograph:* Sotheby's.

146. 'Convolvulus Settee'. The Coalbrookdale Company, c.1855. Also cast in the Carlshütte, Rendsburg (this example) and by Wood & Perot, Philadelphia. Rendsburg, Eisenkunstgussmuseum. *Photograph:* author.

147. 'Laurel Settee'. The Coalbrookdale Company, registered 25.5.1860, no.129 358. Sotheby's Sussex 1988. *Photograph:* Sotheby's.

148. 'Morning Glory Chair'. New York, Hutchinson & Wickersham, c.1855. Also cast by many American foundries

and at the Carlshütte, Rendsburg. New Orleans, Gallier House. *Photograph:* author.

149. 'The Passion Flower Settee'. The Coalbrookdale Company, registered 8.2.1862, no.149 230. Also cast by J.L. Mott, New York and the Kramer brothers, Dayton. New York, Metropolitan Museum of Art. *Photograph:* museum.

150. 'Fern and Blackberry Garden Seat'. The Coalbrookdale Company, 1858. Also cast by many other foundries, mainly in America. New York, Metropolitan Museum of Art. *Photograph:* museum.

151. Church pews from Mrtnik, Beroun district, Czech Republic. Horowitz Gräflich Wrbnasche Eisenwerke, *c.*1860. *Photograph:* Dr Josef Kuba, Prague.

152. Church pew. Glasgow, Walter Macfarlane & Co., *c.*1860/65. Sotheby's Sussex 1988. *Photograph:* Sotheby's.

153. Garden bench. The Hague, L.J. Enthoven & Co and De Prins van Oranje. Also cast by Potthoff und Flume, Lünen. Stuttgart, privately owned. *Photograph:* private.

154. Seasons armchair. Northampton, W. Roberts, registered 24.5.1859, no.120 084. Sotheby's London 1988. *Photograph:* Sotheby's.

155. Garden bench. The Coalbrookdale Company, registered 13.3.1862, no.149 933. Also cast by Shickle, Harrison & Co., St Louis MO. London, Victoria and Albert Museum. *Photograph:* museum.

156. Garden bench. Berlin, Königliche Eisengiesserei. 1866, Berlin, Märkisches Museum. *Photograph:* museum.

157. Small bench. The Coalbrookdale Company, registered 23.3.1864, no.172 871. Ironbridge Gorge Museum. *Photograph:* author.

158. 'Lily of the Valley Settee'. The Coalbrookdale Company, registered 8.2.1864, no.171 578, after the matching armchair on 21.3.1863, no.160 758. Sotheby's Sussex 1988. *Photograph:* Sotheby's.

159. Park bench. The Falkirk Iron Company, registered 3.11.1862, no.157 198. London, Kensington Garden. *Photograph:* author.

160. 'Blackberry Seat'. The Falkirk Iron Company, registered 20.3.1865, no.185 000. Also cast by the Excelsior Foundry, Melbourne. Kentwell Hall, Long Melford, Suffolk. *Photograph:* author.

161. 'Bouquet Settee'. Dalkeith, W. & R. Mushet, registered 19.1.1866, no.194 634. Also cast by Pequonnock Foundry, Bridgeport CT. (this example) and J.L. Mott, New York. Washington, Smithsonian Institution. *Photograph:* author.

162. 'Victoria Settee.' Dalkeith, W. & R. Mushet, registered 8.3.1865, no.184 619. Also cast by J.L. Mott, New York. Washington, Smithsonian Institution, Edith H. Haupt Garden. *Photograph:* author.

163. Street bench. France, *c.*1865/70. Corme Ecluse, Charente-Maritime. *Photograph:* author.

164. Street bench. New Orleans(?), *c.*1865/70. New Orleans, Garden District, Lafayette Cemetery. *Photograph:* author.

165. Garden bench, marked: BIRLANT. New Orleans(?), *c.*1865. New Orleans, Hermann-Grima House. *Photograph:* author.

166. 'Waterplant Settee'. The Coalbrookdale Company, registered 18.2.1867, no.206 162, designed by Christopher Dresser. Sotheby's Sussex 1988. *Photograph:* Sotheby's.

167. 'Waterplant Chair'. The Coalbrookdale Company, registered 18.2.1867, no.206 162, designed by Christopher Dresser. Privately owned. *Photograph:* Rheinisches Bildarchiv Köln.

168. 'Horse-chestnut Settee'. The Coalbrookdale Company, registered 23.3.1868, no.217 568. Also cast by J. & C.G. Bolinder, Stockholm. Sotheby's Sussex 1993. *Photograph:* Sotheby's.

169. Garden bench. Dalkeith, W. & R. Mushet, registered 18.3.1865, no.184 990. Also cast by J.L. Mott, New York. Washington, Smithsonian Institution, Edith H. Haupt Garden. *Photograph:* author.

170. 'Nasturtium Bench'. The Coalbrookdale Company, registered 1.3.1866, no.195 629. Ironbridge Gorge Museum. *Photograph:* author.

171. 'Squirrel Settee'. Glasgow, George Smith & Co., registered 4.5.1868, no.218 558. Also cast by J.L. Mott, New York. Washington, Smithsonian Institution, Edith H. Haupt Garden. *Photograph:* author.

172. Park bench. London, Andrew McLaren & Co., registered 13.1.1869, no.226 333. Cavendish, Suffolk. *Photograph:* author.

173. Garden bench. London, Andrew McLaren & Co., registered 8.1.1869. Sotheby's Sussex 1993. *Photograph:* Sotheby's.

174. Park bench. Glasgow, James Allen sen., registered 17.4.1867, no.207 572. Also cast by J.L. Mott, New York. Washington, Smithsonian Institution, Edith H. Haupt Garden. *Photograph:* author.

175. Park bench. Derby, Standard Manufacturing Company, *c.*1870. London, Strawberry Hill. *Photograph:* author.

176. 'Scroll Settee'. New York, J.W. Fiske, 1868. Also cast by Janes, Kirtland & Co., New York and The Phoenix Iron Works, Utica, N.Y. New Orleans, St Louis Cemetery III. *Photograph:* author.

177. Chair. Rotherham, The Masbro Stove Grate Company, registered 15.7.1868, no.219 825, designed by Charles Green. Sotheby's Belgravia 1980. *Photograph:* Sotheby's.

178. Chair. Rotherham, Wheathill Foundry, William Owen, registered 10.2.1871, no.250 261. Sotheby's Sussex 1993. *Photograph:* Sotheby's.

179. Garden chair. Rotherham, Morgan Macauly & Waide, 1870. Also cast by Hansen & Kirk, Philadelphia and Peter Timmes' Son, Brooklyn N.Y. New Orleans, St. Louis Cemetery III. *Photograph:* author.

180. Garden chair. The Falkirk Iron Company, registered 19.9.1870, no.244 977. London, privately owned. *Photograph:* author.

181. 'Osmunda Fern Settee'. The Coalbrookdale Company, registered 30.5.1873, no.273 254. Sotheby's London 1993. *Photograph:* Sotheby's.

182. Garden bench with seasons. Rotherham, Morgan, Macauly & Waide, registered 5.4.1870, no.240 338. New Orleans, Esplanade. *Photograph:* author.

183. Garden bench. The Coalbrookdale Company, registered 22.4.1870, no.240 809. London, Victoria and Albert Museum. *Photograph:* museum.

184. Street bench. Westminster, J.D. Berry & Son, 1874, designed by C.G. Vulliamy. London, Victoria Embankment. *Photograph:* author.

185. Street bench. Sittingbourne, Kent, SLB Foundry, *c.*1875. London, Victoria Embankment. *Photograph:* author.

186. Park bench. Norwich, Barnard, Bishop & Barnards, 1876, registered 23.7.1877, no.311 249 (this example 1883), designed by Thomas Jeckyll for the Philadelphia Centenary Exhibition. London, Haslam & Whiteway Ltd. *Photograph:* art trade.

187. Side view of park bench in pl.186. *Photograph:* art trade.

188. Detail of back rest of bench in pl.186.

189. 'Medieval High-Backed Chair'. The Coalbrookdale Company, *c.*1875, designed by Christopher Dresser, medallion by J. Moyr-Smith. The Ironbridge Gorge Museum. *Photograph:* author.

190. Side of a park bench, cast on the occasion of the Golden Jubilee of Queen Victoria's accession to the throne. England 1887. Sotheby's Sussex 1993. *Photograph:* Sotheby's.

191. Street bench. Bavaria, *c.*1880/90. Munich. *Photograph:* Bayerische Verwaltung der Staatlichen Schlösser, Gärten und Seen, Munich.

192. Street bench. Rotherham, Yates, Haywood & Co., 1878. London, Kew Gardens. *Photograph:* author.

193. Street bench. Larbert, Stirlingshire, Dobbie Forbes & Co., registered 19.4.1884, no.5432. Frinton on Sea, Essex. *Photograph:* author.

194. 'Banc de Ville'. France *c.*1880. Paris, Boulevard Haussmann. *Photograph:* author.

195. 'Banc de Ville'. France *c.*1890. Paris, Boulevard Haussmann. *Photograph:* author.

196. 'Renaissance Settee'. Brooklyn, Peter Timmes'Son, *c.*1878/85. New York, Metropolitan Museum of Art. *Photograph:* museum.

197. 'Three Seat Renaissance Settee'. Brooklyn, Peter Timmes'Son, patented 7.5.1895. New York, Brooklyn Museum. *Photograph:* museum.

198. 'Renaissance Settee'. New York, John McLean, *c.*1880. Sotheby's New York 1981. *Photograph:* Sotheby's.

199. 'Renaissance Settee'. New York, J.L. Mott, *c.*1880. Also cast by The North American Iron Works, New York. Sotheby's New York 1981. *Photograph:* Sotheby's.

200. 'Three Seat Curtain Settee'. Philadelphia, Wilhalm Adams, *c.*1887/90. Also cast by Hinderer's Iron Works, New Orleans (this example) and Peter Timmes'Son, Brooklyn. New Orleans, Greenwood Cemetery. *Photograph:* Gallier House, New Orleans.

201. Garden bench. The Coalbrookdale Company, registered 5.5.1883, no.397 749. The Ironbridge Gorge Museum. *Photograph:* museum.

202. Garden bench. The Coalbrookdale Company, registered 13.3.1884, no.3511. The naturalistic painting is not original. Sotheby's Sussex 1993. *Photograph:* Sotheby's.

203. Ends of park benches. Saint-Dizier, Fonderies Artistiques, 1905/07, designed by Hector Guimard. Paris, Musée d'Orsay. *Photograph:* museum.

204. End of a park bench. Saint-Dizier, Fonderies Artistiques, 1905/07, designed by Hector Guimard. Paris, Musée d'Orsay. *Photograph:* museum.

205. Gueridon. Base and top wood, stucco and marble. Legs signed: W. BULLOCK PUB. 1 JUNE 1805. Liverpool, William and George Bullock, 1805/15. London, H. Blairman & Sons Ltd. *Photograph:* art trade.

206. Ornamental table. Berlin, Königliche Eisengiesserei, *c.*1825, designed by Karl Friedrich Schinkel. Formerly Berlin, Schloss. *Reproduced from:* Sievers fig.56.

207. New Year plaque for 1820 of the Königliche Eisengiesserei, Berlin. Detail showing the first table cast in Berlin and Gleiwitz. Berlin Museum. *Photograph:* museum.

208. Table. Berlin, Königliche Eisengiesserei, *c.*1831, designed by Karl Friedrich Schinkel. Formerly Berlin, Palais Prinz Albrecht. *Reproduced from:* Sievers fig.51.

209. Garden table. Berlin, Königliche Eisengiesserei, *c.*1830, designed by Karl Friedrich Schinkel. Berlin, Märkisches Museum. *Photograph:* museum.

210. Table. Berlin, Königliche Eisengiesserei, *c.*1831, designed by Karl Friedrich Schinkel. Berlin, privately owned. *Photograph:* Stiftung Preussische Schlösser und Gärten, Berlin-Brandenburg.

211. Console table. England or Scotland, *c.*1835. Sotheby's Sussex 1988. *Photograph:* Sotheby's.

212. 'Side Table'. Rotherham, Yates, Haywood & Co., registered 8.3.1851, no.77 290. Sotheby's Sussex 1993. *Photograph:* Sotheby's.

213. 'Flower Pot Stand'. Philadelphia, Wood & Perot, *c.*1850. Similar stands by James McEwan & Co., Melbourne. Dearborn, MI., The Henry Ford Museum. *Photograph:* museum.

214. Ornamental table. Lauterberg im Harz, Königlich Hannoversches Eisenwerk Königshütte, *c.*1850. Frankfurt, Dr Ludwig Baron Döry. *Photograph:* private.

215. Small table. Isselburg, J. Nehring, Bogel & Co., *c.*1845/50. Rendsburg, Eisenkunstgussmuseum. *Photograph:* author.

216. Small table. Güstrow, Giesserei Andersen & Alban, *c.*1845/50. Güstrow, Städtisches Museum. *Photograph:* author.

217. Top of table in pl.214.

218. Ornamental table. Horowitz, Gräflich Wrbnasche Eisenwerke, *c.*1830/40. Beroun, Czech Republic, district museum. *Photograph:* museum.

219. Ornamental table. Yellow marble top on walnut rim with inlaid motto: *'Pro rege et patria'*. The Coalbrookdale Company. Registered 6.6.1845, no.27 954. Sotheby's Belgravia 1980. *Photograph:* Sotheby's.

220. Ornamental table. New Orleans, Hinderer's Iron Works, *c.*1845/50. Baton Rouge, LA., Louisiana State University, Museum of Rural Life. *Photograph:* museum.

221. Garden table. Probably Königlich Preussische Eisengiessereien, *c.*1835. Munich, Stadtmuseum. *Photograph:* author.

222. Table with richly painted top: American views after drawings by William Bartlett (1809–1854). Troy N.Y., Noyes & Hutton(?), *c.*1845. New York, Brooklyn Museum. *Photograph:* museum.

223. Garden table. Rendsburg, Carlshütte, *c.*1845. Rendsburg, Eisenkunstgussmuseum. *Photograph:* author.

224. Table depicting the seasons. Wasseralfingen, Königlich Würrtembergische Eisengiesserei, *c.*1850. Wasseralfingen, Werksammlung. *Photograph:* Schwäbische Hüttenwerke Wasseralfingen.

225. Table top with scenes representing Schiller's poem 'Ehret die Frauen'. Wasseralfingen, Königlich Würrtembergische Eisengiesserei, *c.*1850. Wasseralfingen, Werksammlung. *Photograph:* author.

226. Detail of top of table in pl.224. *Photograph:* author.

227. Console table. The Coalbrookdale Company, registered 6.2.1855, no.99 289. The Ironbridge Gorge Museum. *Photograph:* author.

228. Console table. Rotherham, Yates, Haywood & Co., registered 4.8.1854, no.96 549. Sotheby's London 1988. *Photograph:* Sotheby's.

229. Ornamental table. The Coalbrookdale Company, *c.*1855. Sotheby's London 1988. *Photograph:* Sotheby's.

230. 'Deerhound Centre Table'. The Coalbrookdale Company, 1855, designed by John Bell. London, Victoria and Albert Museum. *Photograph:* museum.

231. Garden table. England or Scotland, *c.*1855. Munich, Wolfgang Maurer. *Photograph:* author.

232. Ornamental table. The Coalbrookdale Company, *c.*1855. The Ironbridge Gorge Museum. *Photograph:* museum.

233. Ornamental table. Oslo (Christiania), O. Mustad & Søn, *c.*1860. Must also have been cast in America. New York, Metropolitan Museum of Art. *Photograph:* museum.

234. Drawing-room table with zinc mounts and painted top. Most probably Styria, *c.*1855/60. Privately owned. *Photograph:* private.

235. Ornamental table. The Hague, L.J. Enthoven & Co., *c.*1855. Leiden, Stedelijk Museum de Lakenhal. *Photograph:* museum.

236. Ornamental table. Rotherham, Yates, Haywood & Drabble, registered 31.5.1856, no.104 834. The Ironbridge Gorge Museum. *Photograph:* author.

237. Garden table. The Hague, L.J. Enthoven & Co. *c.*1850/60. Also cast by De Prins van Oranje, The Hague, J. & C.G. Bolinder, Stockholm, possibly also in America. Arnhem, Rijksmuseum voor Volkskunde. *Photograph:* museum.

238. Garden table. Stockholm, J. & C.G. Bolinder, 1856. Also cast by J. Nehring, Bogel & Co., Isselburg. Närke, Sweden, Stjernsunds slott. *Photograph:* Antikvarisk-Topografiska Arkivet, Stockholm.

239. Garden table. Bohemia(?), *c.*1860. Bavaria, privately owned. *Photograph:* author.

240. Garden table. Solothurn, Von Rollache Eisenwerke, *c.*1865. Werksammlung. *Photograph:* author.

241. Ornamental table. Mägdesprung, Fürstlich Anhaltisches Eisenhüttenwerk, 1865. Marked: 'GATH Musterschutz 1865 MÄGDESPRUNG AM HARZ'. Rendsburg, Eisenkunstgussmuseum. *Photograph:* author.

242. Garden table. New Orleans (?), *c.*1860. New Orleans, privately owned. *Photograph:* author.

243. Ornamental table. Gleiwitz, Königlich Preussische Eisengiesserei, *c.*1860. Gliwice, Poland, Muzeum w Gliwicach. *Photograph:* author.

244. Hall table with umbrella stand. Birmingham, Henry Crichley & Co., registered 22.9.1864, no.178 829. Sotheby's Belgravia 1981. *Photograph:* Sotheby's.

245. Table, painted green and gold. The Coalbrookdale Company, registered 18.4.1865, no.186 025. Could also be supplied with integrated umbrella stands. The Ironbridge Gorge Museum. *Photograph:* author.

246. Small table. England or Scotland, *c.*1860/70. Sotheby's London 1984. *Photograph:* Sotheby's.

247. 'Queen Victoria Table'. The Coalbrookdale Company, 1862. The Ironbridge Gorge Museum. *Photograph:* museum.

248. Small 'Britannia' table with mahogany top. Bradford, Lund & Reynolds, *c.*1855/60. Sotheby's Belgravia 1979. *Photograph:* Sotheby's.

249. Table with marble top. Toulouse *c.*1880/90. Marked: 'C.IE GENERALE/TOULOUSE U.F.DGDS'. Saujon, Charente-Maritime, café. *Photograph:* author.

250. Table with marble top. The Coalbrookdale Company, *c.*1865/70. The Ironbridge Gorge Museum. *Photograph:* author.

251. Table with marble top. Sheffield, Henry E. Hoole & Co., *c.*1857, designed by Alfred Stevens (worked for Hoole 1850–7). Eighteen of these tables were supplied to the South Kensington Museum in 1868. London, Victoria and Albert Museum. *Photograph:* museum.

252. Round table with marble top. England or Scotland, *c.*1875. Bavaria, privately owned. *Photograph:* author.

253. Table with marble top. Germany *c.*1875. Bavaria, privately owned. *Photograph:* author.

254. Ornamental table. Could also be supplied as a flower table with a smooth top and a surround in the form of a wreath of foliage. Blansko, Gräflich Salmsche Hütte, *c.*1875. Blansko, Czech Republic, Museum. *Photograph:* author.

255. Ornamental table with wooden top. Could also be supplied with an openwork iron top and different fixings. Hof in Krain, Eisengiesserei, c.1895. Graz, Landesmuseum Joanneum. *Photograph:* museum.

256. Ornamental table. Gleiwitz, Königlich Preussische Eisengiesserei, c.1890. Gliwice, Poland, Muzeum w Gliwicach. *Photograph:* author.

257. Dressing table. Mägdesprung, Fürstlich Anhaltisches Eisenwerk, c.1895. St Petersburg, Hermitage. *Photograph:* museum.

258. Top of table in pl.259. Also cast by the Carlshütte in Rendsburg with a different frame. *Photograph:* author.

259. Ornamental table. Gleiwitz, Königlich Preussische Eisengiesserei, c.1890. Gliwice, Poland, Muzeum w Gliwicach. *Photograph:* author.

260. Small occasional table. The Netherlands, c.1880/90. Arnhem, Rijksmuseum voor Volkskunde. *Photograph:* museum.

261. Small occasional table. Blansko, Gräflich Salmsche Hütte, c.1890. Blansko, Czech Republic, Museum. *Photograph:* author.

262. Occasional table. Mägdesprung, Fürstlich Anhaltisches Eisenwerk, c. 1890. Wetzlar, Sammlung Buderus. *Photograph:* museum.

263. Ornamental table. The Netherlands, c.1880/90. Dienst Verspreide Rijkscollecties. *Photograph:* Dr J.M.W. van Voorst tot Voorst, Warmond.

264. Ornamental table. Mägdesprung, Fürstlich Anhaltisches Eisenwerk, c.1890. Gliwice, Poland, Muzeum w Gliwicach. *Photograph:* author.

265. Small occasional table. Mägdesprung, Fürstlich Anhaltisches Eisenwerk, c.1900. Wetzlar, Sammlung Buderus. *Photograph:* museum.

266. Occasional table. Mägdesprung, Fürstlich Anhaltisches Eisenwerk, c.1890. Wetzlar, Sammlung Buderus. *Photograph:* museum.

267. Mirror stand. Blansko, Gräflich Salmsche Hütte, c.1905. Blansko, Czech Republic, Museum. *Photograph:* author.

268. Flower table. Blansko, Eisenwerke Breitfeld, Danek & Co, c.1895. Blansko, Czech Republic, Museum. *Photograph:* author.

269. Small round table with marble top. Saint-Dizier, Fonderies Artistiques, c.1905, designed by Hector Guimard. Bavaria, privately owned. *Photograph:* author.

270. 'W.G. Grace Table' with mahogany top. England or Scotland, c.1900. Sotheby's Belgravia 1979. *Photograph:* Sotheby's.

271. Double bed. Maria Zeller Eisengusswerk, c.1800. Mariazell, Lower Austria, Heimatmuseum. *Photograph:* museum.

272. Bedstead with brass knobs. England or America, c.1850/55. Sotheby's Los Angeles 1981. *Photograph:* Sotheby's.

273. Bed. France, c.1810. Sotheby's London 1985. *Photograph:* Sotheby's.

274. Doll's bed. France, c.1820/50. Rouen, Musée Le Secq des Tournelles. *Photograph:* museum.

275. Bed of King Otto of Greece. Oberpfalz, 1832, designed by Leo von Klenze. Bamberg, Neue Residenz. *Photograph:* Bayerische Verwaltung der Staatlichen Schlösser, Gärten und Seen, Munich.

276. Child's bed. The Hague, De Prins van Oranje, c.1840. Privately owned. *Photograph:* Dr J.M.W. van Voorst tot Voorst, Warmond.

277. Bed with sheet metal inserts on both bed-ends. France, c.1840. Paris, formerly Jansen collection. *Photograph:* From Nicole de Reyniès *Principes d'analyse scientifique.* Paris 1987, vol.1, fig.836.

278. Bed with sheet metal inserts on both bed-ends. France, c.1840. Paris, privately owned. *Photograph:* From Nicole de Reyniès *Principes d'analyse scientifique.* Paris 1987, vol.1, fig.835.

279. Bed with painted sheet metal on both bed-ends. The Hague, J.L. Enthoven, c.1850. Sotheby's London. *Photograph:* Sotheby's.

280. Bed, with fabric stretched over both bed-ends. Ruszkábánya(?), Hungary (now Romania), c.1840. Budapest, Iparmüvészeti Múzeum. *Photograph:* museum.

281. 'Lyre-Bedstead'. Philadelphia, J.B. Wickersham, c.1855. Washington, The National Museum of American History. *Photograph:* museum.

282. Child's bed. Troy N.Y., Noyes & Hutton, 1851. Marked: 'NOYES & HUTTON/PATEN'D SEP'T 1851'. Also cast by Chase Brothers & Co. and J.B. Wickersham. Washington, The National Museum of American History. *Photograph:* museum.

283. Cradle with rocking mechanism. Sweden, c.1850/75. Stockholm, Nordiska Museet. *Photograph:* museum.

284. Cradle. Germany, c.1850–75. Kevelaer, Niederrheinisches Museum für Volkskunde. *Photograph:* museum.

285. Bed with richly painted sheet-metal inserts. From a hotel in Kastély Szálló-Bük. Hungary, c.1850/60. Budapest, Iparmüvészeti Múzeum. *Photograph:* museum.

286. Cradle with original lining. Germany, c.1850/75. Kevelaer, Niederrheinisches Museum für Volkskunde. *Photograph:* museum.

287. Bed with sheet-metal inserts 'painted in two-tone walnut'. Hungary, c.1890. Budapest, privately owned, bought in 1891 from the Budapest furniture store Sandor Buchwald. *Photograph:* private.

288. Hall stand. Charleville, Corneau Frères, c.1850/55. Very similar one also cast by L.J. Enthoven & Co., The Hague. Rotterdam, Museum Boymans-van Beuningen. *Photograph:* Tom Hartsen, Ouderkerk a.d. Amstel.

289. Hall stand. Rotherham, Yates, Haywood & Co., registered 1.9.1854. No.96 750. Also cast by James McEwan & Co., Melbourne. London, Ham House. *Photograph:* Victoria and Albert Museum, London.

290. Hall stand. Boston, Chase Brothers & Co., c.1850/55. Also cast by J.W. Fiske, New York. Tarrytown N.Y., Sleepy Hollow Restaurations. *Photograph: museum.*

291. Hall stand. Coalbrookdale Company, reg. 1.6.1855, no.100 228. Ironbridge Gorge Museum. *Photograph: author.*

292. Hall stand. Coalbrookdale Company, reg. 20.4.1853, no.90 827. Ironbridge Gorge Museum. *Photograph: author.*

293. Hall stand. Coalbrookdale Company, reg. 1.6.1855, no.100 227. Ironbridge Gorge Museum. *Photograph: author.*

294. Fire-iron stand. Lünen, Potthoff & Flume, c.1845. Also cast by the Prinz-Rudolph-Hütte, Dülmen and the Gewerkschaft Eisenhütte Westfalia, Lünen. Lünen, Museum der Stadt. *Photograph: Dr Wingolf Lehnemann, Lünen.*

295. Umbrella stand. The Coalbrookdale Company, registered 2.5.1846, no.34 882. The Ironbridge Gorge Museum. *Photograph: author.*

296. Hall stand. The Hague, L.J. Enthoven & Co., c.1855/60. Also cast by the Gienandtsches Eisenwerk Hochstein, Pfalz. Eisenberg near Kaiserslautern, privately owned. *Photograph: Landesamt für Denkmalpflege, Mainz.*

297. Hall stand. Blansko, Gräflich Salmsche Hütte, c.1860. Similar stands cast by the Westfalia Hütte, Lünen. Blansk, Czech Republic, Museum. *Photograph: author.*

298. Hall stand. Hungary, c.1855. Budapest, Iparmüvészeti Múzeum. *Photograph: museum.*

299. Umbrella stand. Solothurn, L. von Roll's Iron Works, c.1860. Werksammlung. *Photograph: author.*

300. Fire-iron stand. Lauchhammer, Gräflich Einsiedelsches Eisenwerk, c.1850. Bremen, Bolland & Marotz 1988. *Photograph: art trade.*

301. 'Hallstand'. The Coalbrookdale Company, registered 7.2.1859, no.118 373. Could be supplied with a marble top or a marbled iron top, the lower part could also be supplied on its own as a console table. The Ironbridge Gorge Museum. *Photograph: author.*

302. 'Hall Table'. London, Yates, Haywood & Drabble, registered 18.4.1861, no.139 879. Exhibited at the 1862 International Exhibition in London. Also cast by James McEwan & Co., Melbourne with a slightly altered under-frame. *Reproduced from:* J.B. Waring *Masterpieces of Industrial Art & Sculpture at the International Exhibition 1862.* London 1863, pl.122.

303. Umbrella stand. Blansko, Gräflich Salmsche Hütte, c.1860. Blansko, Czech Republic, Museum. *Photograph: author.*

304. Fire-iron stand. Rendsburg, Carlshütte, c.1850. Rendsburg, Eisenkunstgussmuseum. *Photograph: author.*

305. Fire-iron stand. America, c.1855. Similar stands also cast by the Gewerkschaft Eisenhütte Westfalia, Lünen. Tarrytown N.Y., Sleepy Hollow Restaurations. *Photograph: museum.*

306. Hall stand. The Coalbrookdale Company, registered 30.7.1862, no.153 466. London, Victoria and Albert Museum. *Photograph: museum.*

307. Hall stand. Rotherham, Yates, Haywood & Drabble, registered 25.9.1861, no.144 136. Also cast by Corneau Frères, Charleville (this example). Montpellier, Musée Sabatier d'Espeyran. After Nicole de Reyniès *Principes d'analyse scientifique.* Paris 1987, vol.1, fig.2240.

308. Umbrella stand. Blansko, Gräflich Salmsche Hütte, c.1860. Blansko, Czech Republic, Museum. *Photograph: author.*

309. Umbrella stand. Blansko, Gräflich Salmsche Hütte, c.1860. Blansko, Czech Republic, Museum. *Photograph: author.*

310. Hall stand. The Falkirk Iron Company, c.1860/65. Sotheby's London 1979. *Photograph: Sotheby's.*

311. Hall stand. Birmingham, J. & C. Lawrence, registered 12.9.1876, no.303 468. Sotheby's London 1979. *Photograph: Sotheby's.*

312. Corner hall stand. The Coalbrookdale Company, registered 12.2.1866, no.195 186. The Ironbridge Gorge Museum. *Photograph: author.*

313. Fire-iron stand. Lünen, Gewerkschaft Eisenhütte Westfalia, c.1860. Also cast by the Prinz Rudolph-Hütte, Dülmen. Lünen, Museum der Stadt. *Photograph: Dr Wingolf Lehnemann, Lünen.*

314. Umbrella stand. Lünen, Potthoff & Flume, before 1865. Also cast by the Gewerkschaft Eisenhütte Westfalia, Lünen, L.J. Enthoven & Co., The Hague and the Gräflich Salmsche Hütte, Blansko. Trier, Städtisches Museum. *Photograph: museum.*

315. 'Hall Table' with marble top, the guide rails for the umbrellas in brass, mahogany drawer. The Coalbrookdale Company, registered 18.9.1874, no.285 332. Sotheby's Sussex 1993. *Photograph: Sotheby's.*

316. Hall stand. The Hague, L.J. Enthoven & Co., c.1865. Also cast with slightly altered lower part by De Prins van Oranje, The Hague and James McEwan & Co., Melbourne. Hannover, Historisches Museum. *Photograph: museum.*

317 Umbrella stand. Sheffield, Edwin & Theophilus Smith, registered 12.7.1866, no.198 976. Sotheby's Belgravia 1979. *Photograph: Sotheby's.*

318. 'William Wallace' umbrella stand. Scotland c.1865/70. May also have been cast in Australia. Sotheby's Belgravia 1979. *Photograph: Sotheby's.*

319. Hall stand. The Coalbrookdale Company, registered 11.12.1867, no.214 963, designed by Christopher Dresser. London, Victoria and Albert Museum. *Photograph: museum.*

320. Umbrella stand. The Coalbrookdale Company, 1872(?), designed by Christopher Dresser. England, privately owned. *Photograph: Rheinisches Bildarchiv Köln.*

321. 'Hat and umbrella stand with geometric Gothic decoration'. The Coalbrookdale Company, registered 11.12.1867, no.214 962, designed by Christopher Dresser. England, privately owned. *Photograph: Rheinisches Bildarchiv Köln.*

322. Umbrella stand. Birmingham, Charles Hufton, registered 4.2.1869. London, privately owned. *Photograph:* Dr Clive Wainwright, London.

323. Umbrella stand. Dudley, John Finch, registered 17.8.1877, no.313 070. London, H. Blairman & Sons. *Photograph:* A.C. Cooper, London.

324. Fire-iron stand. Rendsburg, Carlshütte(?), c.1880. Rendsburg, Eisenkunstgussmuseum. *Photograph:* author.

325. Fire-iron stand. Rendsburg, Carlshütte, c.1870/75. Rendsburg, Eisenkunstgussmuseum. *Photograph:* author.

326. Fire-iron stand. Val d'Osne(?), c.1880. St. Rémy de Provence, privately owned. *Photograph:* author.

327. Umbrella stand. London. O'Brien, Thomas & Co., c.1850/55. Sotheby's Belgravia 1979. *Photograph:* Sotheby's.

328. 'Reaper' umbrella stand. Rotherham, W.H. Micklethwait & Co., registered 10.7.1874, no.283 410. Sotheby's Belgravia 1979. *Photograph:* Sotheby's.

329. Fire-iron stand. Gleiwitz, Königlich Preussische Eisengiesserei, c.1880/90. Gliwice, Poland, Muzeum w Gliwicach. *Photograph:* author.

330. Fire-iron stand. Rendsburg, Carlshütte, c.1880. Gliwice, Poland, Muzeum w Gliwicach. *Photograph:* author.

331. 'Fruit Girl' umbrella stand. Rotherham, W.H. Micklethwait & Co., registered 11.3.1880, no.347 423. Sotheby's Belgravia 1979. *Photograph:* Sotheby's.

332. Umbrella stand. Mägdesprung, Fürstlich Anhaltisches Eisenhüttenwerk, c.1900. Gliwice, Poland, Muzeum w Gliwicach. *Photograph:* author.

333. Umbrella stand, could also be supplied with coat stand on top. The Coalbrookdale Company, registered 5.5.1864. No.174 442. Also cast by L.J. Enthoven, The Hague. Sotheby's Belgravia 1979. *Photograph:* Sotheby's.

334. Umbrella stand. Val d'Osne(?), c.1860/65. Château Colombier near Nancras, Charente-Maritime. *Photograph:* author.

335. Coal scuttle. Wolverhampton, Frederick Walton & Co., registered 9.9.1861, no.143 323. Privately owned. *Photograph:* private.

336. Flower table. Blansko, Gräflich Salmsche Hütte, c.1900. Blansko, Czech Republic, Museum. *Photograph:* author.

337. Flowerpot stand (middle section broken off). Birmingham, A. Kenrick & Sons, c.1860. Also cast by De Prins van Oranje, The Hague. Sotheby's Sussex 1988. *Photograph:* Sotheby's.

338. Flowerpot stand. Blansko, Gräflich Salmsche Hütte, c.1860/70. Blansko, Czech Republic, Museum. *Photograph:* author.

339. 'Arborette' to stand above flowers. Philadelphia, Robert Wood, before 1857. Washington, Smithsonian Institution, Office of Horticulture. *Photograph:* museum.

340. Flowerpot stand. Rendsburg, Carlshütte(?), c.1860. Flensburg, Städtisches Museum. *Photograph:* museum.

341. Corner *étagère*. Rendsburg, Carlshütte, c.1855. Rendsburg, Eisenkunstgussmuseum. *Photograph:* author.

342. Wall bracket. America, c.1850. Tarrytown N.Y., Sleepy Hollow Restaurations. *Photograph:* museum.

343. Wall shelf. Mägdesprung, Fürstlich Anhaltisches Hüttenwerk, c.1867/80. Rendsburg, Eisenkunstgussmuseum. *Photograph:* author.

344. Flowerpot stand. Rendsburg, Carlshütte(?), c.1880/90. Rendsburg, Eisenkunstgussmuseum. *Photograph:* author.

345. Flowerpot stand. The Coalbrookdale Company, registered 19.4.1869, no.228 751. The Ironbridge Gorge Museum. *Photograph:* museum.

346. Jewellery safe. Ilsenburg, Fürstlich Stolbergische Hütte, c.1900. Rendsburg, Eisenkunstgussmuseum. *Photograph:* author.

347. *Étagère*. Mägdesprung, Fürstlich Anhaltisches Hüttenwerk, c.1880. Privately owned. *Photograph:* private.

348. *Étagère*. Ilsenburg, Fürstlich Stolbergische Hütte, c.1880. Rendsburg, Eisenkunstgussmuseum. *Photograph:* author.

349. Detail of *étagère* in pl.347.

350. School bench. Germany, 1901. From Öttingen. Munich, Bayerisches Nationalmuseum, Schulmuseum Ichenhausen. *Photograph:* museum.

351. Models of school benches for submission to Patent Office in Washington. *Left:* John Glendening, Norwich, 3.2.1880, no.224,174. *Right:* Charles H. Presbrey, Sterling IL., 21.1.1873, no.135,154. Washington, National Museum of American History. *Photograph:* museum.

352. Rocking-chair made of bent and lacquered iron tubes with cast decorations. England, c.1850. London, Victoria and Albert Museum. *Photograph:* museum.

353. Rocking-chair made of iron strap with bent stops. England. c.1850. Sotheby's London 1988. *Photograph:* Sotheby's.

354. Rocking-chair made of bent tubes. Hungary, c.1840. Budapest, Iparművészeti Múzeum. *Photograph:* museum.

355. Rocking-chair made of iron strap with replaceable ball stops. England, c.1850. Sotheby's Belgravia 1978. *Photograph:* Sotheby's.

356. Rocking-chair made of bent semi-round rod. Most probably invented by John Porter, London c.1839. Munich, Die Neue Sammlung. *Photograph:* S.R. Gnamm, Munich.

357. Rocking-chair made of iron strap painted to resemble tortoiseshell. Perhaps New York, Richard Hoffmann, 1867. New York, Cooper Hewitt Museum. *Photograph:* museum.

358. Double garden seat. England c.1800. Shelleys Hare Hatch, Twyford, Berkshire. *Photograph:* G.S. Thomas, Horsell.

359. Garden bench. England c.1800. Sizergh Castle, The National Trust, Cumbria. *Photograph:* G.S. Thomas, Horsell.

360. Garden bench. England, late 18th century. Dearborn MI., The Henry Ford Museum. *Photograph:* museum.

361. Garden armchair. England, c.1800. Dearborn MI., The Henry Ford Museum. *Photograph:* museum.

362. Garden bench. England, *c.*1820. Audley End, Saffron Walden, Essex. *Photograph:* author.

363. Garden bench. England, *c.*1835. Clevedon Court, The National Trust, Avon. *Photograph:* G.S. Thomas, Horsell.

364. Garden bench. England, *c.*1835. King John's Hunting Lodge, The National Trust, Axbridge, Somerset. *Photograph:* G.S. Thomas, Horsell.

365. Garden bench. England, *c.*1820. Sotheby's Sussex 1993. *Photograph:* Sotheby's.

366. Garden bench. England, *c.*1820. Sotheby's Sussex 1993. *Photograph:* Sotheby's.

367. Garden chair. England, *c.*1850/60. Blickling Hall, Aylsham, Norfolk. *Photograph:* author.

368. Model of a park bench, Rochester N.Y., William C. Medcalf, registered 16.9.1873, no.142,927. Washington, National Museum of American History. *Photograph:* museum.

369. Park bench. England, *c.*1870. Also made in France. Clandon Park, The National Trust, Guildford, Surrey. *Photograph:* G.S. Thomas, Horsell.

370. Garden chair. France, 1834/40. Frankfurt, Thomas Poller. *Photograph:* art trade.

371. Garden bench. England, *c.*1850/60. Clevedon Court, The National Trust, Avon. *Photograph:* G.S. Thomas, Horsell.

372. Park bench. England, *c.*1860. Holkham Hall, Wells, Norfolk. *Photograph:* author.

373. Garden armchair. England, *c.*1870. Cambridge, Christ's College. *Photograph:* author.

374. Park armchair. America, *c.*1860. Lynchburg VA., privately owned. *Photograph:* private.

375. Garden armchair. The Hague, De Prins van Oranje, *c.*1860. The Hague, Dienst Verspreide Rijkscollecties, formerly Het Loo Palace. *Photograph:* DVR.

376. Double garden seat. America, *c.*1860. From Athens PA. Dearborn MI., The Henry Ford Museum. *Photograph:* museum.

377. French park chairs in the spa park at Vichy. *Photograph:* author.

378. Park armchair. France, *c.*1850. Produced by various firms, including Barbezat & Cie, Val d'Osne (in its 1858 catalogue). Paris, Jardin des Tuileries. *Photograph:* author.

379. Park armchair. France, *c.*1860. Bordeaux, Jardin Public. *Photograph:* author.

380. Park armchair. Munich, J.L. Kaltenecker & Sohn(?), *c.*1850/60. Salenstein, Thurgau, Schloss Arenenberg. *Photograph:* author.

381. Park chair. France, *c.*1850. Château Colombier near Nancras, Charente-Maritime. *Photograph:* author.

382. Park chair. France, *c.*1850. Bordeaux, Jardin Public. *Photograph:* author.

383. Park chair. France, *c.*1850. Produced by various firms, including Barbezat & Cie, Val d'Osne (in its 1858 catalogue). Paris, Jardin des Tuileries. *Photograph:* author.

384. Garden chair. Germany, *c.*1850/60. Munich, Heidy and Karl Stangenberg. *Photograph:* author.

385. Park chair. Munich, J.L. Kaltenecker & Sohn(?), *c.*1860. Salenstein, Thurgau, Schloss Arenenberg. *Photograph:* author.

386. 'Dos à Dos'. England, *c.*1860. Mottisfont Abbey, The National Trust, Hampshire. *Photograph:* G.S. Thomas, Horsell.

387. Park bench. France or The Netherlands, *c.*1860. Nordeinde, castle grounds. *Photograph:* Dienst Verspreide Rijkscollecties, s'Gravenhage.

388. Garden chair. Munich, J.L. Kaltenecker & Sohn, *c.*1865/70. *Photograph:* Kaltenecker.

389. Garden armchair. Munich, J.L. Kaltenecker & Sohn, *c.*1855. Munich, Die Neue Sammlung. *Photograph:* S.R. Gnamm, Munich.

390. Garden chair. Munich, J.L. Kaltenecker & Sohn, *c.*1855. Privately owned. *Photograph:* private.

391. Garden chair. Munich, J.L. Kaltenecker & Sohn, *c.*1855. Privately owned. *Photograph:* private.

392. Set of garden furniture, seat and back rest genuine cane. Austria(?), *c.*1870. Munich, Neumeister 1986. *Photograph:* art trade.

393. Three-seater. Germany(?), *c.*1850. Jugenheim, Hassia, Heidy and Karl Stangenberg. *Photograph:* private.

394. Garden bench. New York, *c.*1860. Sotheby's New York 1981. *Photograph:* Sotheby's.

395. Park armchair, 'U$^N$ Carré Paris' stamped on seat. Paris, François A. Carré, 1860. Also produced by Fourment, Houille & Cie., Val d'Osne, and J.W. Fiske, J.L. Mott and Lalance & Grosjean, all New York. Château Colombier near Nancras, Charente-Maritime. *Photograph:* author.

396. Park armchair. France, *c.*1860. This example must have been made in Germany, early 20th century. Cologne, Stadtmuseum. *Photograph:* Rheinisches Bildarchiv Köln.

397. Garden table. Munich, J.L. Kaltenecker & Sohn(?), *c.*1860. Salenstein, Thurgau, Schloss Arenenberg. *Photograph:* author.

398. Small garden table. Munich, J.L. Kaltenecker & Sohn(?), *c.*1860. Salenstein, Thurgau, Schloss Arenenberg. *Photograph:* author.

399. Garden table. Germany, *c.*1900. Munich, Heidy and Karl Stangenberg. *Photograph:* author.

400. Garden table. France, *c.*1850/60. Château Colombier near Nancras, Charente-Maritime. *Photograph:* author.

401. Garden table. The Netherlands, late 19th century. The Hague, Dienst Verspreide Rijkscollecties. *Photograph:* DVR.

402. Flower basket. America, *c.*1840/50. Sotheby's Los Angeles 1981. *Photograph:* Sotheby's.

403. Flower basket. England, *c.*1840/50. Richmond, Surrey, Mollie Evans Antiques. *Photograph:* C. Bates, Richmond.

404. Garden bench. England, *c.*1850/60. Sotheby's Sussex 1993. *Photograph:* Sotheby's.

405. 'Love Seat'. America, *c.*1860. Sotheby's Los Angeles 1981. *Photograph:* Sotheby's.

406. 'Ice Cream Parlor Chair'. Chicago, Royal Metal Manufacturing Company, before 1895. Sotheby's New York 1981. *Photograph:* Sotheby's.

407. 'Ice Cream Parlor Chair'. Chicago, Royal Metal Manufacturing Company, before 1894. Stuttgart, Württembergisches Landesmuseum. *Photograph:* museum.

408. Wire chair. Skönnarbo, Sweden, Oscar Högberg, Grytgöls Hütte, 1892. Stockholm, Nordiska Museet. *Photograph:* museum.

409. Flower basket. America, *c.*1850. Similar items also produced by J.W. Fiske, New York (in its 1868 catalogue). Sotheby's Los Angeles 1981. *Photograph:* Sotheby's.

410. 'Invalid Chair'. New York, Marks Adjustable Folding Chair Company, invented by Cevedra B. Sheldon, patented 1.2.1876, no.173,071. Dearborn MI., The Henry Ford Museum. *Photograph:* museum.

411. 'Invalid Chair' in pl.410 with foot section opened out. New York, Metropolitan Museum of Art. *Photograph:* museum.

412. Reclining chair. Probably Paris, *c.*1780/90. Sotheby's Zurich 1983. *Photograph:* Sotheby's.

413. Day bed. England, *c.*1880. Sotheby's Belgravia 1981. *Photograph:* Sotheby's.

414. 'Portable Iron Chair Bedstead'. London, S. Griffin, registered 16.12.1882, no.391 577. Düsseldorf, I. Pohl-Steinhöfel. *Photograph:* art trade.

415. 'Adjustable Iron Chair'. Invented by George Wilson, Chicago, patented 21.11.1871, no.3,504. Washington, National Museum of American History. *Photograph:* museum.

416. 'Spring Arm Chair'. Troy N.Y., American Chair Company, invented by Thomas E. Warren, patented 25.11.1849, no.6,740. Washington, National Museum of American History. *Photograph:* museum.

417. 'Spring Arm Chair' in pl.416, rear view. Washington, National Museum of American History. *Photograph:* museum.

418. 'Centripedal Spring Chair'. Troy N.Y., American Chair Company, invented by Thomas E. Warren, 1849. Also produced by Chase Brothers & Co, Boston from *c.*1855. St Louis MA., City Art Museum. *Photograph:* museum.

419. Sprung chair. New York, Gardner & Co., 1872. New York, Metropolitan Museum of Art. *Photograph:* museum.

# Index – Iron foundries

*The names of all foundries are given in the language of original use.*

# Index – People's names